CONSTABLE

The Painter and his Landscape

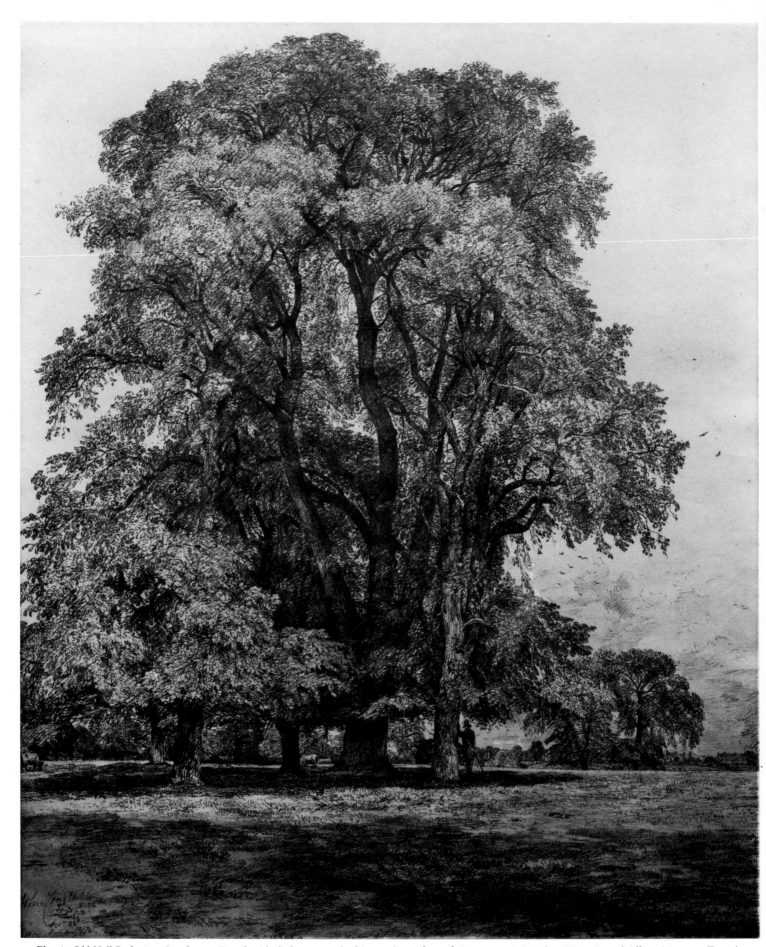

1. *Elms in Old Hall Park* 1817 October 22 Pencil with slight grey and white washes 23¼ × 19½ (59.2 × 49.4). London, Victoria and Albert Museum (R.162)

Constable

THE PAINTER AND HIS LANDSCAPE

Michael Rosenthal

Book Club Associates
London

For my family and friends

This edition published 1983 by Book Club Associates
By arrangement with Yale University Press

Designed by Caroline Williamson and set in Monophoto Bembo
by BAS Printers Limited, Over Wallop, Hampshire

Printed in Italy by Amilcare Pizzi s.p.a., Milan

Contents

Preface

Constable is a painter as popular with the public at large as with art historians. Works like *The Hay Wain* or *The Cornfield* are so familiar via reproductions that we can forget to look at them with the closeness they warrant. This book is designed to provide an historical commentary on Constable's East Anglian subjects. The intention has been to give a detailed account of the various changes in his style and to provide some explanation for them.

When I began work on Constable my intentions were straightforward. In their Tate booklet *John Constable 1776–1837* (1969) Leslie Parris and Conal Shields had indicated the scope that the study of Constable offered. As I had been brought up near Nayland I knew the lower reaches of the Stour Valley fairly well, and meant to check Constable's pictures against the landscapes they portrayed to see if this might foster an understanding of the ways his paintings changed. My research expanded to include local history, and then the social, economic, and agricultural history of Constable's lifetime. I read poetry, not only for pleasure, but also in the hope that a knowledge of literature would be useful in establishing what attitudes to landscape were current during the period 1780–1840. Nevertheless my main subject is, and has been, Constable's art.

Therefore, discussion centres on Constable's drawings and paintings. It is supported not only with information provided through those other disciplines, but also with what can be learned from a close reading of Constable's *Correspondence*. Thanks to the labours of the late R. B. Beckett (who edited the letters) we know more about Constable than about any other British artist. There are inherent dangers in using Constable's letters in the way I have, for we have to take on trust a great deal of what they say. Constable might, for instance, have written what he wanted his correspondents to read: certainly the existence of drafts for some letters suggests that he thought carefully about what he was to write. And on occasions he could evade the truth. In a September 1825 letter to his friend John Fisher he claimed early on to be earning a living from painting, but then went on to write that his finances were not prospering, and that his brother would be sending him £400. In general, though, as long as they are read cautiously, Constable's letters are probably a reasonably accurate guide to his opinions at any one moment. He seems to have been someone who tended not to adjust or disguise his true sentiments. Furthermore, I have drawn most from the letters written either to Maria Bicknell, or to John Fisher, with both of whom Constable was generally completely frank. Although the *Correspondence* contains a vast amount of material, I have, of necessity, had to be sparing in my use of it.

It has not been the labour of R. B. Beckett alone which has made the kind of work I have undertaken possible. Graham Reynolds has done more than anyone else towards sorting Constable's production. Were it not for his exemplary Catalogue of the Victoria and Albert Museum Constables, we should be far less clear about what the artist did, and when he did it. Graham Reynolds's scholarship, together with that of Professor Rhyne, cannot (as their forthcoming *Catalogue Raisonnée* will demonstrate) be too highly praised. Leslie Parris's recent Catalogue of the Tate Constables continues this tradition of excellence and, anyone working on Constable must be grateful for the invaluable Catalogue which he, Ian Fleming-Williams, and Conal Shields compiled for the 1976 Constable bicentenary Exhibition.

Like anyone else carrying out academic research, I owe a large debt of thanks to very many people, not all of whom can be mentioned here. In a general way I picked up a great deal when in East Anglia for various reasons: a trip to Portman Road can take in East Bergholt. I am grateful to Patricia Butler for her help when she was still at Christchurch Mansion, and very much enjoyed working with Robert McPherson on a couple of exhibitions at Gainsborough's House. I have learned a great deal from Malcolm Cormack, who has allowed me free access to the collections over which he has had charge, and I should also like to thank Joy Pepe, who has been a model of helpfulness and humour. In addition Ian Fleming-Williams has offered advice, and kindly allowed me to consult his corrected edition of Constable's *Correspondence*; while Charles Rhyne has invariably sent a prompt, courteous, and full reply to any query. I have been fortunate to have been able to take advantage of the distinguished conversation and scholarship of Nigel Everett. I should like to record my thanks to Nancy Briggs, and her staff at the Essex Records Offices, as well as to the staff of the Suffolk Records Offices at Bury and Ipswich. Among the many others who have helped are Alan Watson, Leslie Parris, Reg Gadney, Duncan Bull, Hilary Watson, Louise Lippincott, Arthur Brown, Terence Doherty, Sue Chandler, Mike Helston, Paulette Goodfellow, John Sunderland, Amanda Simpson, Guy Thomson and Timothy Goodhue. I am grateful to Michael Kitson for supervising the earlier stages of my research, and to Julian Gardner for his general encouragement. I should like to thank Loveday Gee for her help with certain practical problems. I am aware of having learned much about looking at pictures from my colleagues at Warwick, Anthea Callen, Paul Hills and Louise Campbell, and should like to thank the former for commenting on an early draft of the text. The same service was performed by Pete Nicholls, with whom, over the years, I have enjoyed many memorable conversations. I am also very grateful to Ben Read, John Nicoll, Caroline Williamson, Catherine Waley, Anthony McFarlane and Séverine Roberts for their help with the book.

I must single out for particular gratitude John Gage, who not only encouraged me to write the book, but also read through the typescript and made many useful suggestions. My largest debt of thanks, though, is to John Barrell, from whom I have been learning much for some years now. He too encouraged the writing of the book, read through the draft, and made many valuable criticisms. Scholars do not often practice the ideal of sharing knowledge with such zest as he does, and I only hope I have taken sufficient advantage of his information and advice.

Finally, I should like to apologise to and to thank my wife, and various friends, for putting up with me while I was writing the book.

In the captions, measurements are given in inches, with the metric equivalent in parentheses. Catalogue numbers from Graham Reynolds *Catalogue of the Constable Collection in the Victoria and Albert Museum* (London 1973) are preceded by R., and those from Leslie Parris, Ian Fleming-Williams and Conal Shields *Constable Paintings Watercolours & Drawings* (Tate Gallery Exhibition Catalogue 1976) by T.

Paintings are by Constable unless otherwise stated.

Introduction

It is sometimes forgotten that the eminence we think of as Constable's right results from our having imposed ideas of artistic greatness on history. If public recognition is any guide, Constable was not highly regarded by his contemporaries. Although he painted some of the most original landscapes to be seen in the 1810s, they attracted little notice; and in 1819, when thanks to *The White Horse* (Fig. 156) he at last became an Associate of the Royal Academy (along with the professional esteem this signified), Constable was forty-three years old, and had been exhibiting at the Academy for seventeen years. Even then it took until 1829 before he was elected Royal Academician, an honour which fellow painters like Lawrence thought him fortunate to be accorded. Compare this painful rise with the careers of Turner or Callcott, and Constable must appear to have enjoyed little contemporary esteem. Nevertheless we are not wrong in seeing in many of his paintings greatness, and in his work in general some of the most interesting artistic experiments of the earlier nineteenth century.

Certain contemporaries were aware of this. Most prominent amongst them was Charles Robert Leslie. Leslie's *Memoirs of the Life of John Constable* (published in the same year as Volume I of Ruskin's *Modern Painters*) is an eloquent testimony to its author's perspicacity, and his loyalty. Partly he wished posterity to understand just how fine an artist Constable could be, but I suspect that he wished too to salvage something of his friend's reputation. The individual whom Leslie portrayed was kind, sentimental, and witty. Yet Constable had, as the Redgraves later commented, a reputation for sarcasm which nowhere seems demonstrated in Leslie. And from cross-checking Beckett's and Leslie's transcripts of the same letters, it becomes clear that the latter censored passages which might tarnish the image he wished to present. Certainly Constable had all the qualities which Leslie emphasised; but he was also brittle, neurotic, and occasionally brutal in his dealings with others. This apart, however, Leslie also presented Constable as a considerable artist, and with this judgement there can be no disagreement.

Yet, because Leslie knew Constable well only from the later 1820s and was ill-informed on the earlier years, there has been a subsequent tendency to interpret Constable's art as having inexorably developed towards the great Canal Scenes of the 1820s: an 'evolutionary' reading of his oeuvre which this book will not adopt. Constable's artistic career divides into various sections. An interest in art aroused in the early 1790s had become strong enough to have the young man studying in London by the end of that decade. He first exhibited at the Royal Academy in 1802.

By 1808 he began systematically to study the landscapes of the Stour Valley through oil sketches, a practice which was to be continual for the next ten or so years. We think that he met and fell in love with Maria Bicknell in 1809; but it was not until 1816 that they were able to marry. During these years Constable spent protracted periods at home with his family in East Bergholt, so contemporary paintings of East Anglian scenery reflect an intimate contact with place. After marrying he became a permanent Londoner and an enthusiastic father. Maria's health was precarious, and in 1819, the year of *The White Horse*, a house was rented in the village of Hampstead, where the air was purer; and landscapes of that region entered Constable's repertoire (joining those of East Anglia, and of Dorset and Wiltshire, where the pair had honeymooned). As we have seen, from this time Constable enjoyed some success. Maria'a health steadily declined, and from 1824 they took a house at Brighton, for the benefit of the sea air. Consequently Constable began painting and drawing south coast subjects. Maria died in 1828, the year before her husband was at last elected R. A. Constable himself died in 1837.

Considering the variety of terrains—Dorset, Hampstead and the rest—which Constable did paint, it may seem odd to single out works portraying the one region, East Anglia, and to study them apart from the rest. Nevertheless there are good reasons for so doing. One is that Constable was unique in concentrating on a part of the country where his family lived and worked and which he knew so completely. Indeed, so crucial is this point to the discussion, that an expansion of it will form the subject of the first chapter. Then, only East Anglian subjects feature *throughout* Constable's career. When in 1835 he exhibited *The Valley Farm* he was picturing a scene on which, as far as we can tell he had first concentrated in 1802 and to which he had also turned in the 1810s. What also makes the East Anglian landscapes stand out is that their development was erratic, and that, from the early 1820s, they stand stylistically apart from paintings showing other places. A look through the plates in this book will demonstrate those last two points.

For example the 1814 *View of Dedham* (Figs. 95, 103) displays various characteristics. From a high viewpoint it surveys a topographically recognisable Stour Valley landscape where agricultural work is going on; and even if Constable had not stated so himself, we could guess that his style was aimed to representing the appearances of landscape and its components as accurately as possible. And despite its having been painted in London, *The Hay Wain* (Figs. 171, 175) shares these concerns, ones we shall see to have developed gradually as Constable worked at landscape through the 1800s and 1810s. *The Hay Wain* dates to 1821. By 1824 Constable's idea of East Anglian landscape had diametrically changed. *The Leaping Horse* (Figs. 202, 203), produced over the winter of 1824–5, shows an invented terrain, adopts a low viewpoint and is stylistically opposed to what had gone before. As a glance at details will show, whatever other concerns Constable might have had at this period, topographical representation was not a main one. From then on his East Anglian work began to display considerable variety. In 1826 Constable started concentrating on the picturesque, a development which culminated in the magnificent 1828 *Dedham Vale* (Fig. 219). After this his practice became confused and to an extent, aimless. For instance *The Valley Farm* (Fig. 262) maintained the picturesque, but is an exhibition work, one which Constable could not allow to be offensive to the sight of visitors to the exhibition. Stylistically it contrasts with related but private variants of a similar theme (Figs. 258, 259).

And, to illustrate that point about East Anglian work following its own development, we need only compare *The Leaping Horse* with paintings of Hampstead or Brighton done at the same period. A *Hampstead* (Fig. 204), also exhibited at the 1825 Royal Academy, is richer and more picturesque and much less expressively painted than its canal scene companion. And, as the painter himself was

keen to point out, the Hampstead landscape had an important topographical element, unlike *The Leaping Horse*, with its invented scenery. At the same time, working outdoors at Brighton, Constable was making brilliant oil sketches (Figs. 193, 194) with all the disciplined spontaneity which has so spectacularly characterised his East Anglian work of the 1810s. By 1827, it is fascinating to note that, actually at Flatford and studying the motifs he had been ostensibly portraying over the 1820s, Constable's drawing could be nervous and expressive to the point of virtual abstraction (Fig. 223). Again, this contrasts with contemporary or near contemporary drawings of other places, done with far greater control and truth to what could be seen (Fig. 227). Indeed, Constable's relation to East Anglia, particularly as transmitted through his paintings, later became obscure enough for us quite justifiably to consider the brooding 1831 *Salisbury Cathedral from the Meadows* (Figs. 255, 241) has having as much to do with the canal scenes as with Constable's pictures of Salisbury and its environs.

How much real delight have I had with the study of Landscape this summer, either I am myself much improved in 'The Art of seeing Nature' (which Sir Joshua Reynolds calls painting) or Nature has unveiled her beauties to me with a less fastidious hand . . .

Constable to Maria Bicknell, 22 July 1812

Good God—what a sad thing it is that this lovely art—is so wrested to its own destruction—only used to blind our eyes and senses from seeing the sun shine, the feilds bloom, the trees blossom, & to hear the foliage rustle—and old black rubbed-out dirty bits of canvas, to take the place of God's own works.

Constable to C. R. Leslie, 2 March 1833

CHAPTER ONE
The Artist in East Anglia

Amongst contemporary landscape painters, Constable had a unique relationship with the scenes he painted. He had been brought up in the Stour Valley and until 1817 spent long periods at the family house, during which he worked from intimately familiar landscapes. In 1832, travelling on a coach, Constable fell into conversation with two strangers: 'In passing through the valley about Dedham, one of them remarked to me—on my saying it was beautifull—"Yes Sir—this is *Constable's* country!" I then told him who I was lest he should spoil it.'[1] We may forget for the moment that even this late in his career Constable felt a need to justify his art by pointing out the beauties of the Stour Valley, and was uncertain enough of any response to kill a conversation before it could turn nasty. On this occasion the now-clichéd phrase 'Constable's Country' made a significant first appearance. Constable's paintings had become so associated with that one patch of land, bounded on the west by Nayland, and on the east by the sea (Fig. 2), that his name qualified its scenery. Furthermore, the painter himself would have felt proprietorial towards this region not only because of its importance to him as subject-matter, but also because of his strong family connection there.

It may be obvious to observe that Constable's attachment to the Stour Valley landscape was so intimate because that was where his family lived, but he never entirely forsook his ties with the place. He was always to rely on the family business for funds, and kept up connections with Bergholt in other ways too. Late letters to his brother Golding show that he lapsed into phonetic Suffolk spellings, although he may have lost his accent.[2] 'Bargell' for 'Bergholt' in an 1828 letter[3] fits the local pronunciation, with the h silent, and e sounded as a. In this same letter 'My poor boy get on sadly' used the verb the Suffolk way. And a letter from his sister, when John Constable had been a Londoner for many years, suggests his real concern for the dependents of a local labourer, Thomas Chiverton, whose obituary Constable wrote[4] and had published in the *Ipswich Journal* for 6 August 1831. He kept up an interest in Bergholt, then, though seldom visiting it after 1817.

Because of his family ties Constable was as much a villager as artist. At least until 1821 he generally painted places which he knew and with which he was completely familiar. This was a notable deviation from the usual habits of landscape painters. Normally an artist would tour some picturesque region over the late summer and autumn, and spend the winter working up the sketches then made into paintings for the summer exhibitions. Constable's stay-at-home habits contrasted very strongly, for instance, with Turner's voracious appetite for touring,[5] which was more typical of contemporary landscape painters.[6]

The important *Dedham Vale, Morning* (Fig. 55) was, in 1811, the *only* Stour Valley landscape in the Royal Academy exhibition, other artists preferring to paint in Wales, the Lake District, and elsewhere. Landscape-painters were going for the picturesque and the sublime, and wooing a buying public which itself found touring a fashionable way of passing the time. Constable had himself been pandering to this taste with his own series of Lake District scenes, painted between 1807 and 1808, but, perhaps because he was just one amongst many, his paintings had failed to make any impression. The Stour Valley landscapes might have attracted much the same response, but at least Constable was unique in painting this region.

The important differences in the way a tourist rather than an inhabitant might conceive of landscape can be seen by comparing Turner's *Crossing the Brook* (Fig. 226) with Constable's 1828 *Dedham Vale* (Fig. 219). Turner had been impressed enough by a view above the Tamar estuary, seen just the once, briefly, to turn it into a painting, perceiving the scenery as a *motif*, an arrangement of ground and vegetation suitable to be translated into two dimensions. Constable's *Dedham Vale* concluded a series (produced over at least twenty-eight years) of paintings and drawings of this view. He *knew* his landscape, and more, he knew it both over time and from numerous angles. He would have seen it change, and memory would have influenced this late conception. Moreover, as a local person, he would have been conscious of the degree to which a limited area of terrain could be differentiated topographically. For example, in one letter, Constable's mother extolled the beauty of the 'Langham Dedham & Bergholt Vales'.[6] She meant the various parts of the landscape we would term the Stour Valley, and thereby revealed how fine was the local capacity to consider what we would see as a whole, as comprising distinct parts. Again, this was a very different order of knowledge to that which most landscape painters possessed of their subjects, and Constable's unusual intimacy with the region he painted must be stressed.

Until 1817 Constable was constantly returning to Bergholt. He kept a studio there, which his mother called his 'shop' and where he left much painting kit after moving down to London.[7] While lodging with his family he took part in local affairs. On his father's behest he complained about the state of the river at Flatford to the Commissioners of the Stour Navigation, for instance,[8] and his doing this signals something of the family's local position. This position allowed Constable advantages not granted to everyone in East Bergholt. The numbers of drawings, oil sketches, and paintings he did from nature in the environs of East Bergholt reveal that the artist could go over land belonging to the squire, Peter Godfrey (Fig. 1), or to Mrs Roberts (Figs. 26, 60), safe from any suspicion of trespass, while work done at Flatford, for example, featured country over which he had liberty of movement simply because his family owned it. Constable could wander about certain fields safe from challenge, in an age of repressive trespass and game laws, because he was vouched for by his family's social position.[9] Had he been an unconnected stranger around East Bergholt he would have been less able to go so freely.

The Constables were respectable, and there was a line between people like them, and others, the labouring classes, who were rather less free to go where they liked. At this period there were stern constraints on the liberty of movement of the poor. If they strayed locally they might be suspected of dishonest intentions. On a larger scale, the Settlement Act made them keep to their own parishes, on pain of forfeiting poor relief should they need it. Nowhere were these restrictions so manifest as in the Game Laws. In 1811, for example, Mrs Constable wrote to John that a Thomas Stollery had recently had on sale 'seven brace of hares . . . so the true sportsman may well fag, for little or no game'.[10] Since Stollery would either have shot or coursed these hares, we might wonder why he was no 'true sportsman': to Mrs Constable the distinction which denied him this accolade was a clear one, and

was one of class. The Stollerys were a labouring family and Thomas would not, therefore, unlike Constable's father, have had a game certificate.[11] Thus he had been out poaching, and it was this which condemned him. This indicates something of the divide between the respectable and the labouring classes, and it was because the Constables were of the former that their son John had complete liberty of passage over much of the neighbouring countryside.

In contrast, the poor were the subject of real control; numerous writers were concerned to make sure they worked long and hard, attended church regularly, kept off the beer, and bred a brood of future labourers. In 1788 the apparently benign sentiments of the Suffolk agriculturalist and writer Thomas Ruggles revealed this attitude.

> Let us farmers . . . be steady friends to the poor . . . by incitements to honest industry, by an early attempt to fix the industrious principle in the youthful breast; by rewarding extraordinary exertions of it . . . and upon this foundation of honesty, industry, and sobriety, let us lead them on to an improvement of their minds proper for their station, and the burthen of the poors' rates will regularly diminish, the gaols and houses of correction will no longer be crowded with inhabitants, but we shall see greater signs of comfort in our villages, and the vestiges of misery will gradually disappear . . .[12]

The same philosophy informed a short notice in *The Ipswich Journal* for 21 December 1799, at a time when high corn prices meant an increased chance of bread-riots:

> The poor ought to know, and to consider, that there cannot be a more respectable and truly dignified character than an industrious man, with a large family, repelling the approach of poverty, by an unwearied arm, and by sober manners; such a man is the staff of his family; he is a valuable member of the community; he is an honour to human nature.

Both passages concealed an uneasy distrust of the poor. They were necessary because they did the heavy agricultural work, but were, nonetheless, innately unreliable. Left to themselves they would down tools and repair to the ale-house: hence Ruggles's didacticism, his desire to train them up in proper behaviour. Because the poor needed to be guided towards and helped to keep their footing on the straight and narrow path, they were the object of the unwavering attention of those who had an interest in this being accomplished. Amongst these we may count respectable families like the Constables.

The Constables were very comfortably off, thanks to the painter's father, Golding, who had gradually built up a complex and diverse business. At the base of his prosperity was milling. He had inherited Flatford Mill; he appears to have run Dedham Mill on behalf of a consortium of local men of business,[13] and owned as well the windmill on East Bergholt Heath. However his interests were not confined to milling alone. Golding traded in corn and coal out of Mistley, using his own fairly large sloops and storing the coal in a yard at Brantham.[14] In addition he was one of the Commissioners of the River Stour Navigation.[15] The river was fit for navigation as far upstream as Sudbury, and it was these Commissioners' responsibility to keep the locks in order, and to clear the river of any obstruction, in return for which they took tolls on the passage of goods. Golding therefore had further interests here, and there are grounds for believing that he built his own barges for the river trade.[16] When his wife finished a report of extreme winter weather with 'thank God—Vessels Barges & Windmills all safe',[17] she summarised the extent and range of his concerns. By 1774 Golding was sufficiently successful to attempt to make the social transition to the gentry. He bought a piece of land at East

Bergholt, and built a substantial mansion, moving the family up to it from Flatford Mill.

An impression of the Constables in their native environment can be traced through various sources. Documents, and the Enclosure Map (Figs. 2, 106, 123), show Constable's father along with Squire Godfrey (later a Deputy Lieutenant for the County), Sir Richard Hughes, and Mrs Betty Daniell to have been the biggest landholders in East Bergholt.[18] Shoberl reckoned that the residences of Dr Rhudde the rector, Godfrey, Mrs Roberts, and Golding Constable gave Bergholt 'an appearance far superior to that of most villages'.[19] Like many of his contemporaries, this writer judged the aesthetic virtues as well as the prosperity of a place on the number of grand houses it boasted. His judgement was backed up by a visiting miller, John Crosier of Maldon in Essex, who in 1785 noted 'A Mr Constable, a man of fortune and a miller has a very elegant house in the street and lives in the style of a country squire.'[20] This is eloquent of the impression the family made on strangers.

And by the 1790s the Constables were notable enough to be of more general interest: hence the *Ipswich Journal* mentioned them on a number of occasions. In 1791 for instance there was a report of a fire which took hold of East Bergholt House while Golding was off at market, and serious damage was averted only through 'the most uncommon assiduity and kindness of the neighbours', a 'multitude' having appeared bearing buckets of water.[21] One of the most interesting of these pieces, dating to 19 August 1797, gave a full description of the launching of Golding Constable's corn brig, *The Telegraph*. This took place on a fine day, when

> . . . an immense concourse of people were assembled, who testified their
> approbation by repeated acclamations, with good wishes for her success, and
> the long life and property of the worthy owner. An handsome entertainment
> was provided at the Crown Inn, where many loyal, constitutional and
> commercial toasts, appropriate to the occasion, were drank, and the whole
> concluded with the utmost harmony.

This passage tells much both of the way Constable's father conducted his life, and the position he assumed in society. He obviously had substantial capital with which to build a large, new, trading vessel, and its launching must have seemed an event of importance for an 'immense concourse' to turn up to watch. On his part, Golding understood that this occasion was special: he gave an 'entertainment' at the Crown. One can still sense the predominantly mercantile flavour of this feast, with its 'loyal, constitutional and commercial toasts', business-like sentiments which would have been typical of Golding.[22] The family remained of interest to local society. As late as 1810 a writer to the paper described the new altarpiece in Nayland Church as '. . . a very masterly performance, the subject most expressively sublime, and appropriate . . .', which judgement had as much value as information as the news that '. . . it was presented by Mrs Smythe, relict of the late Thomas Smythe, Esq. a native and inhabitant, and was the performance of a respected and ingenious artist, her nephew, and son of Golding Constable Esq., of East Bergholt'.[23] It is reasonable to suspect that the chief interest of the painting was in the fact of its painter being the son of a respected local figure.

Moreover, Golding Constable played a part in county and village affairs appropriate to his social position. In 1806 he served on the Grand Jury at Bury Assizes[24] together with the M.P. Gooch, and Mileson Edgar, Colonel of the Suffolk Yeomanry Cavalry. The following year, along with, among others, Sir William Rowley and Peter Godfrey, he signed a notice cancelling consideration of the Box navigation.[25] The Box is a shallow and winding tributary of the Stour (Fig. 2), and that its canalisation had been contemplated at all is a good indication of the level of local entrepreneurial ambition.

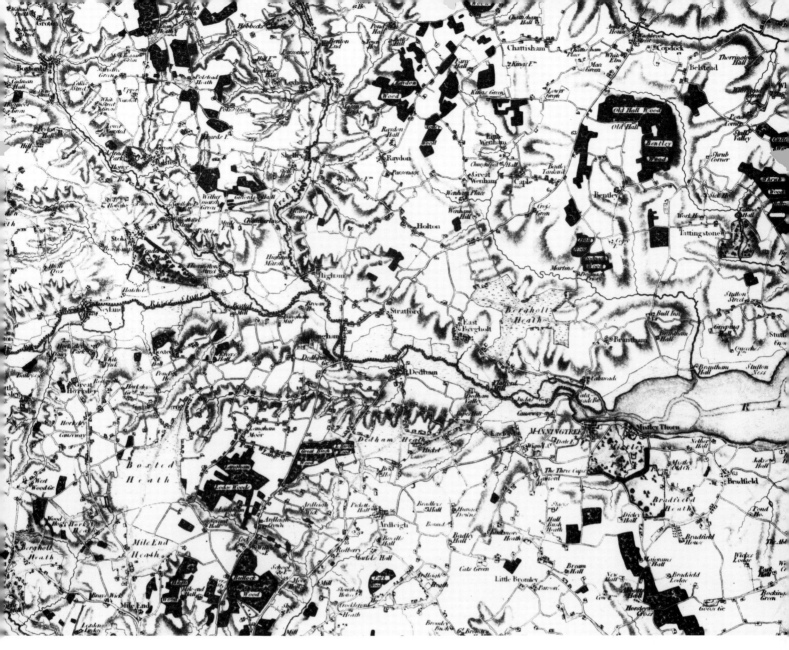

2. 'Constable's Country', taken from 1805 Ordnance Survey Map

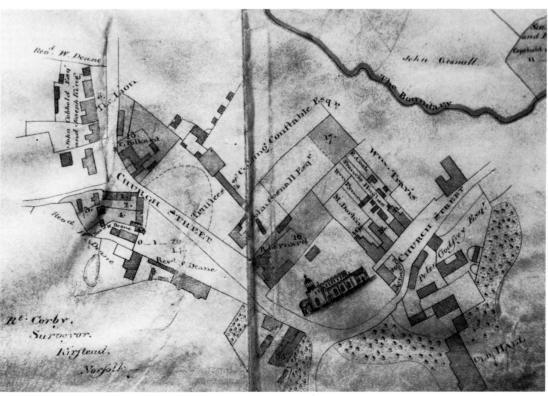

3. 1817 East Bergholt Enclosure Map. Detail showing Golding Constable's House. Suffolk Record Office

In the smaller confines of East Bergholt, Golding also knew what obligations his position entailed. He took up parish office and made generous donations to the poor when he judged them most in need.[26] As Crosier said, he lived 'in the style of a country squire'; he went out shooting, and, as we shall see, cultivated a small farm. The family was comfortably off, and from Mrs Constable's letters to her children we get the idea of a household conducted on a quiet and regular plan. Advertisements in the newspapers reveal that Ipswich (just eight miles distant) was a lively town, offering the theatre, balls, and horse-racing, but we hear little of the Constables' indulging in these pleasures. After some friends had gone off to a concert there, 'where was the Prince Regent & Duke of Clarrence', Mrs Constable called it a 'sudden immersion to Greatness—from our Retirement—and rural Sports'.[27] Such frivolities evidently did not form part of her usual concerns.

The letters Constable's mother regularly sent him in London often mixed gossip with moralising, for she displayed a consistent mercantile protestantism. Existence was beset with temptations, only to be averted by holding to a Christian attitude, and Ann Constable had an inbred habit of thinking from action to its moral consequence. 'This Morning began to Mow the Town Meadow; & Harvest will then be thought of—man was not intended for idleness—or at least incurd the punishment of labour for disobedience.'[28] Or, recording the misfortunes of Peter Firmin, the Dedham attorney, and writing 'to add to his troubles', it came automatically to her to add '(which man is born to)'.[29] She taught this habit of drawing moral conclusions to her offspring, with the consequence that many events in life took on this dimension. Both Abram and John adopted their mother's idea that industriousness was one means of expiating sin. Abram thought that 'idleness can never be happy';[30] in 1813 his brother felt that while he was painting he was 'performing a moral duty'.[31]

Constable had a very stable home background, and the way in which local as much as artistic preoccupations could influence the way he saw and evaluated the landscapes he was to paint might be inferred from such paintings as the 1815 canvases of *Golding Constable's Flower Garden* and *Golding Constable's Kitchen Garden* (Figs. 128, 130). The landscapes lay behind East Bergholt House, and were painted from either an upstairs window or (more probably) the roof. They combine to form a panorama where the eye travels over the village to the left in the *Flower Garden*, past Golding Constable's barn, on to the *Kitchen Garden*, backed by cornfields and harvesting, before reaching the Rectory to the right. Constable was concerned with as naturalistic a representation of these scenes as possible, a quality which extends beyond reproducing local forms or colours in paint, for if the pictures are checked against the 1817 East Bergholt Enclosure Map (Fig. 123) they will be found to follow the topography very closely. Field boundaries match, and buildings are where they ought to be.

Furthermore, Constable's is a social landscape, one where figures, from the solitary thresher in his barn (Fig. 112) to the crowds of harvesters (Fig. 132) to the gardener prove an important influence. In the *Kitchen Garden* we survey the Constable farm. At various points in the distance we discern wheat awaiting the sickle, grazing cattle, what are probably fields of clover, and harvesting. The windmill confirms the destination of the grain, the village identifies those whom it supports. This is an ordered and harmonious representation of landscape, intent on recording fact, the ground plan of the enclosures, or the colours of corn. The formal qualities, though, have largely been dictated by those whom the countryside supports, amongst whom we must include the Constables.

Constable probably painted these canvases partly as records of a familiar landscape, but perhaps, too, out of a sense of pride in how well the home farm was kept. At no time did Golding Constable farm more than ninety-three acres around

the village,[32] and for the Constables farming was more a recreation than a source of livelihood, a kind of large-scale vegetable gardening from which it was accepted, particularly by those writers associated with progressive agriculture, such as Arthur Young,[33] that much pleasure might be derived. Not least was the satisfaction of showing the place off to visitors, as the Constables indeed were pleased to do,[34] and looked at in this way, Constable's paintings of these landscapes are a very appropriate indicator of the kind of pleasure a member of the rural gentry might find.[35]

That the cultivated landscape was a satisfying sight was a traditional enough idea. A chief theme of Gainsborough's *Mr and Mrs Andrews* (Fig. 4) is that Andrews's park is his farm, and in 1874, when the young Frenchman François de la Rochefoucauld had toured Suffolk with Arthur Young, he entered the county at Brantham, a mile or so downstream from Flatford (Fig. 2). There he found country 'even more attractive' than he had seen in Essex, for

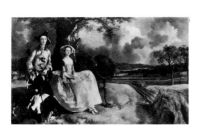

4. T. Gainsborough *Mr & Mrs Andrews* 1748–50 Oil on canvas 27½ × 47 (69.8 × 119.4). London, National Gallery

> . . . the land is better cultivated and there is a larger population. All the small houses scattered over the countryside are wonderfully clean . . .
>
> The whole countryside is pleasantly broken up by valleys. All the fields are small and enclosed; houses and farms abound and all bear the mark of tidiness and prosperity.[36]

The salient equation, that, from the look of a landscape one could infer the social condition of its inhabitants, was common enough, and was also made by Cobbett some forty-six years later. He found that, from Ipswich

> . . . you can, in no direction, go . . . a quarter of a mile without finding views a painter might crave, and then the country round about it so well cultivated; the land in such a beautiful state . . . the ploughman so expert; the furrows, if a quarter of a mile long, as straight as a line and laid as truly as if with a level: in short here is everything to delight the eye, and to make the people proud of their country; and this is the case throughout the whole of this county. I have always found Suffolk farmers great boasters of their superiority over others; and I must say that it is not without reason.[37]

He went on to write, though, that, after a period of agricultural depression, Suffolk had maintained an appearance of prosperity only because of the demands of the large numbers of troops which had been quartered at Ipswich.

As that quotation, however, implied, to farm for pleasure it was necessary to farm for profit, and the Constable farm was a serious and productive concern. After Golding's death the family sold a good quantity of live and dead stock,[38] and during his lifetime he built the neat barn in which the thresher labours in *Golding Constable's Flower Garden*.[39] The Constables would have profited from the mania for improvement that was encouraged by the inflation of agricultural prices during the Napoleonic Wars, and when Ann Constable recorded of her brother

> . . . in his last letter to me he writes thus; 'A Hertfordshire farmer called on me to wish me a Merry Xmas when I found the real cause of his said visit was he wanted *immediately* £400, or he should have a woeful Xmas by the duns of his tradesmen'—surely this must be bad farming in these days.[40]

she emphasised how rare it was not to enjoy good profits at this period. In general the war with France gave a boost to advanced agricultural technology, in the form of crop rotations, selective breeding of stock, the improved design of machinery, and enclosure.[41] These may have seemed innovations elsewhere, but Suffolk farmers had been (as de la Rochefoucauld and Cobbett implied) in the van of experiment. The Norfolk four-course crop rotation was being practised by the

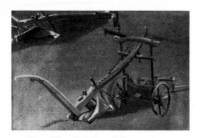

5. *Two Ploughs* 1814 Oil on paper 6¾ × 10¼ (17.2 × 26). Inscr. '2d Novr. 1814'. London, Victoria and Albert Museum (R.136)

1760s,[42] and was commonplace around East Bergholt by the 1780s.[43] This rotated crops on the one field in a simple but profitable cycle. During the first summer turnips were sown for winter feed (in itself a breakthrough, for this benefited stock immeasurably) and the following spring, after the field was cleared and ploughed, a mix of barley and clover was applied. After barley-harvest the clover (itself providing fodder) was left till the following summer, when it was cut for hay, and the field then ploughed to summer fallow, being termed in this condition a 'summerland'. The autumn would see manuring and winter wheat sowing, the cycle beginning again after the following harvest.

Besides using crop-rotations, Suffolk farmers were already geared up to other aspects of the new technology. As early as 1748 Robert Andrews, himself a later contributor to the organ of advanced agricultural theory, Young's *Annals of Agriculture*,[44] had used a seed drill, which for this date was very advanced husbandry, Tull's *The New Horse-Hoeing Husbandry* having been published only in 1731.[45] Later in the century, Robert Ransome, one of the most innovative of agricultural engineers, operated out of Ipswich, and as early as 1810 the *Ipswich Journal* noted 'the now *general* use of the threshing machines'[46] (my italics) (Fig. 238).

Equally, there were no open fields to enclose around East Bergholt;[47] and local farmers were highly sophisticated in their use of manures. Arthur Young gave a detailed description of how local manure supplies were augmented with Kentish chalk and London manure imported to the Stour estuary by the grain vessels which might otherwise have returned empty from London.[48] This was astute management.

As Cobbett wrote, Suffolk farmers were justified in boasting of their superiority over others. There was also real local awareness of the efficiency and profit with which Suffolk farming was conducted (and, as we shall see, Constable's paintings of the 1810s partake of it). The *Ipswich Journal* for 20 March 1802 commented, not without smugness, on 'the rage for the Suffolk system of farming' being such that 'people from every part of the kingdom are eager to embrace it', and on 2 January that year had reported on one of many ploughing matches, themselves an indicator of the seriousness with which improvement was taken. Not only did such matches promote a healthy spirit of rivalry amongst ploughmen, they also played an important part in advancing the design of new and better ploughs.

Constable himself not only understood farming, but he also maintained a close interest in life at East Bergholt. This is suggested, for example, by this letter from his mother: 'we have had before this Snow & Frost—almost Constant Rains—and great Floods—which has greatly impeded Navigation—& dispatch of Business. You see I *meddle* & *interfere* with Business which I well know you think don't Concern me . . .'[49] Her teasing shows what interest her son took in such things, and contemporaries recognised that Constable had a particular knowledge because of his background. In 1821 John Fisher described him in all seriousness as a 'millwright',[50] and Leslie, writing of Constable's time in the family windmill, quoted his brother Abram as saying 'when I look at a mill painted by John, I see that it will *go round*, which is not always the case with those other artists'.[51] Constable also showed the agriculturist's curiosity in farming in general. Only the high gallows wheel plough, shown in an 1814 oil sketch of two ploughs (Fig. 5) was used around Bergholt; the other, a Suffolk swing plough, worked the heavier soils elsewhere in the county.[52] Constable both described the tools exactly, and left a record of the ploughs of Suffolk rather than just East Bergholt. He often sketched agricultural implements, and in 1835 was drawing one of the massive local ploughs in Worcestershire (Fig. 6).

Earlier, I suggested that, by concentrating (in particular over 1808–17) on his native scenes, Constable was behaving eccentrically for an artist. The Constable family had an intimate connection and financial interest in the intensively-cultivated

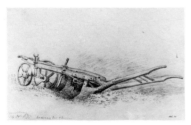

6. *A Plough at Bewdley* 1835 Pencil 8⅛ × 11¼ (20.7 × 28.7) Inscr. 'Worcestershire Plough' and 'Bewdley 14 Oct 1835 Worcestershire'. London, Victoria and Albert Museum (R.384)

Stour Valley landscape, which gave John Constable not only a complete understanding of, but also particular attitudes to his subjects. Indeed, as we shall see, his attitudes were shared by local society rather than by metropolitan connoisseurs.

Yet Constable's position at Bergholt was not altogether straightforward. He appears to have found little to interest him in village life, and sometimes like his mother manifested a lack of relish for frivolity. Thus, when in January 1813 he returned to an East Bergholt that was 'the gayest scene possible—nothing but balls and routs', he added 'as I do not join in these things I cannot tell you many particulars about them'.[53] At times his attitude approached priggishness. In 1815 he had joined a card party at the curate's, but not having understood the game, was almost proud to report that he had fallen asleep. This he told Maria Bicknell, and her dry riposte, 'I am sorry that after you had taken the trouble to go out you should have found the party so dull'[54] shows that by then she was used to his occasional pomposity.

However, while in keeping himself to himself Constable was being his mother's son, and while he certainly needed the solitude to get on with his painting and drawing, he had another motive for removing himself from public view. A main reason for Constable's retiring so frequently to Bergholt during the 1810s was that he escaped thus from London and from the acute emotional stress of being in the proximity of, but without being allowed to meet, Maria Bicknell. This was mainly because Maria's grandfather, the East Bergholt rector Dr Rhudde, from whom the Bicknell family had expectations, objected strongly to the relationship. Constable, by spending so much time in Bergholt, wandering around making landscapes rather than earning money with portraits or applying himself to his father's business, must have done little to advance his cause. For Rhudde seems to have found Constable an objectionable prospect for the simple and understandable reason that he had reached his mid-thirties without engaging himself in a respectable profession.[55] Constable himself made little effort to counter this objection. Although (for instance in 1814)[56] he sometimes sold a landscape, this was not a frequent occurrence, and it was obvious to all that he was happy to be subsidised by his father. And he refused to paint portraits, which would have guaranteed some artistic income. His recalcitrance affected even his family. 'You seem really Anxious to avoid any, or every opportunity of almost earning your daily bread',[57] fumed his mother in 1814. The previous year Dr Rhudde had himself made a telling appraisal of Constable's portrait of William Godfrey, the squire's son: '. . . an excellent portrait it is, and does your *Bro John—the greatest Credit*—if He can paint Such Portraits as these he may get *Money*'.[58]

Constable almost flaunted his lack of diplomacy by staying friendly with John Dunthorne, for to be seen to enjoy the company of the local atheist, a man 'destitute of religious principle',[59] was hardly the way to ingratiate himself with the Rector. And when at last he temporarily renounced the association, this was in 1816, when Constable was almost forty, and had been a regular fixture in East Bergholt for some eight years. It is little wonder that Dr Rhudde baulked at the prospect of his granddaughter marrying a perpetual and ageing art-student, and Constable's tendency to retirement may have been partly to camouflage his presence in the village.

Unfortunately, he probably alienated Rhudde even more simply by retiring to Bergholt to escape the trauma of being barred from seeing Maria in London. This emerges in his determination to pursue landscape, not portraiture, and it is clear, as we shall see, that the former could outweigh other considerations. In 1812 Constable wrote: 'I wish all they could tell me . . . could make me vain of my portraits—but you know I am "*too proud to be vain*" I am however perverse enough to be vain of some studies Landscape which I have done—"Landscape which found me poor at

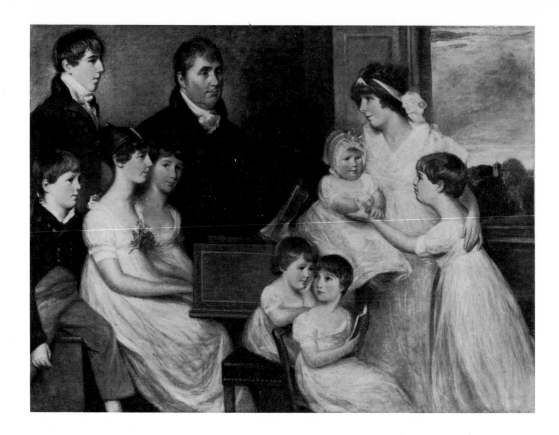

first and keeps me so"'.[60] The artist enjoyed showing off his literacy, not unwittingly adapting Goldsmith, who had in *The Deserted Village* written of poetry keeping him poor. Constable was keen to view himself starving for an ideal—landscape—thus putting his struggle on a plane high above the remunerative drudgery of face-painting.

Yet is was initially through portraiture that Constable was able to exploit the social contacts that were his by virtue of his family's position. *The Bridges Family* (Fig. 7) was painted for one of Golding Constable's business associates; the artist was resident in the house while painting the picture, and was said to be 'a great Friend of the Family at that time'.[61] This put him in a rather different position to the average portrait painter. Peter Firmin, the Dedham lawyer, was another of Golding's business associates, through being involved in running Dedham Mill; and although Lord Dysart of Helmingham knew of Constable before, in 1807 Firmin recommended the young man to him as a copyist of family portraits,[62] and it was this which was to cement a long and friendly relationship with the Tollemache family.

He was to receive similar encouragement from other local friends and acquaintances. Constable spent July 1812 painting a portrait of William Godfrey.[63] This was so successful that it prompted a commission for his daughter's portrait from Major-General Rebow of Wivenhoe Park near Colchester, the General and his wife to be painted at a later date.[64] And Mrs Godfrey herself pestered Captain Western of Tattingstone Hall, until he too agreed to sit to Constable.[65]

Here local connections helped Constable with portrait commissions, but in 1814 the Godfreys showed themselves sensitive to his real ambitions by commissioning a landscape for their daughter Philadelphia, who after marrying would be moving to London. Rather than a view of the old house, as one might have expected, Constable's picture (Fig. 103) surveys the Stour Valley from the boundary of the Old Hall estate, with labourers loading, carting, and ploughing in muck. Evidently people like the squire enjoyed looking out over the cultivated landscape as much as

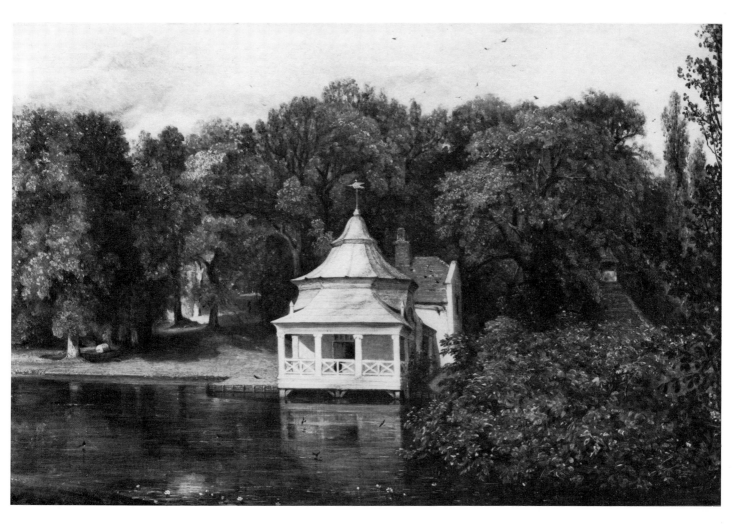

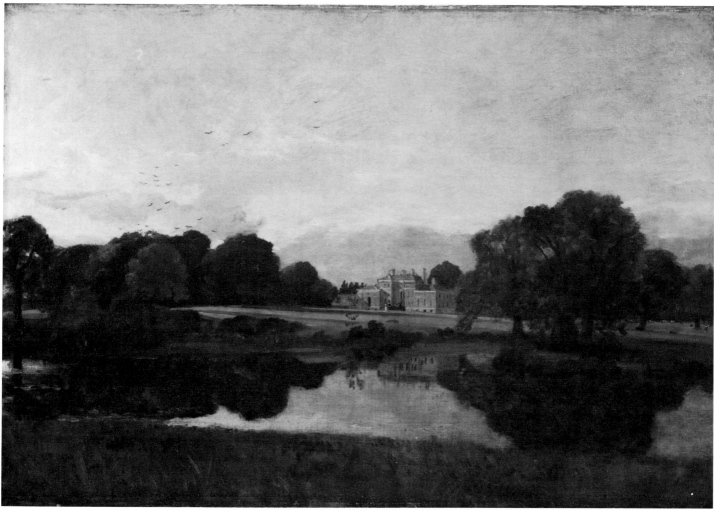

10. *The Quarters, Alresford Hall* 1816
Pencil 9 × 14½ (22.9 × 36.9). Truro,
Royal Institution of Cornwall

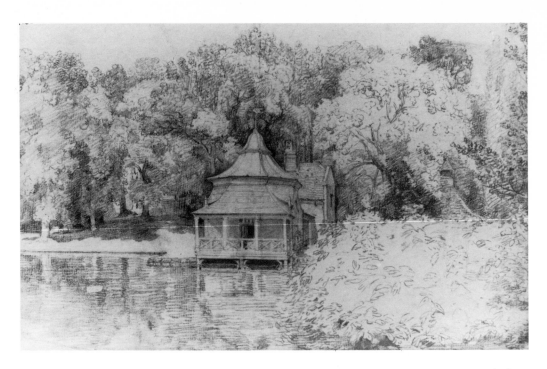

the painter, and both saw husbandry as integral to the scene. Farmers tended to consider manure 'a source of future plenty'[66] and would recognise in this picture that it was being ploughed in as part of the preparation for winter wheat sowing,[67] a subject entirely suitable to autumn, when 'the prophetic eye of taste'[68] as Young called it, by imagining the harvests to come, could ease the melancholy the season provoked.

It is perhaps coincidental that in 1816 the Rebows were also to follow up an earlier portrait commission with a request for a couple of landscapes. These were *The Quarters, Alresford Hall* and *Wivenhoe Park* (Figs. 8, 10, 12, 16). In a letter to Maria Bicknell, Constable described the progress of the latter landscape.

> the great difficulty has been to get in so much as they wanted to make them acquainted with the scene—on my left is a grotto with some Elms—at the head of a peice of water—in the centre is the house over a beautifull wood and very far to the right is a Deer House—what it was necessary to add so that my view comprehended too many degrees—but to day I got over the difficulty—and I begin to like it *myself* . . .[69]

The trouble arose because he had to counter two impulses against topographical specificity: the compositional pattern, and the lay-out of the park itself. The painted view from raised ground across water to a house embosomed in trees (perhaps first devised by Lambert in *Copped Hall* (Fig. 11)) was by then a standard composition for portraits of country houses;[70] Constable himself had used it earlier for *Malvern Hall* (Fig. 9). This introduced a generalising tendency to Constable's picture, which was increased by the fact that Wivenhoe Park had itself been laid out in the style of Capability Brown. Such parks could tend to look interchangeable, and Constable was therefore obliged to add the landmark of the deer house. This made the composition too wide, as Constable himself said, but once he had surmounted the problem, he was pleased with the result. And, as with the Bridges, Constable was a house guest while doing his pictures, although, because he 'lived' in the park, Mrs Rebow was to claim that he was very unsociable.[71] After finishing those earlier portraits for General Rebow, Constable had written that he 'had regretted my departure, and should always consider me as a friend and be glad to see me'.[72] This,

11. G. Lambert *Copped Hall* 1746 Oil on canvas 36½ × 48 (92.7 × 122). Private collection

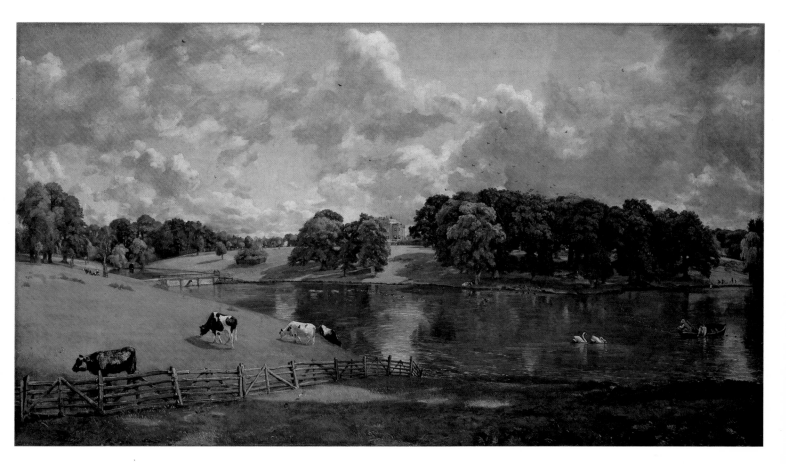

12. *Wivenhoe Park* 1816 Oil on canvas 22⅛ × 39⅞ (56.1 × 101.2). Washington D.C., National Gallery of Art (Widener Collection)

along with their taste for the same kind of terrain, indicated that he and his patron shared social ground.

Other cases of local patronage could be enumerated,[73] and in certain instances we can observe the artist mixing with the farming interest to a notable degree. For instance, it was presumably through the influence of his friend Brooke Hurlock, the Dedham rector, who had married a sister of Sir Thomas Barrett-Leonard, that the latter gave Constable a commission in 1813.[74] In this case he had been given work by a leading agriculturist.[75] Likewise, Captain Western of Tattingstone Hall, whose portrait he had painted around 1813,[76] or Sir William Rowley of Tendring Hall, Stoke by Nayland, who was an acquaintance of the Constable family,[77] were both among the 'distinguished agriculturists' who gathered at the 1805 Harlow agricultural meeting.[78] Therefore, during his Bergholt days, Constable's milieu, practice, and patronage were very different from those of a London-based landscape-painter. Moreover, it was local society, rather than the metropolitan arbiters of taste, which appreciated Constable's landscapes.

It tended also to be the farming interest which found the Stour Valley worth considering aesthetically at all. Farington is the only painter known to have remarked on 'Constable's Country': 'The country about Dedham presents a rich English landscape, the distance towards Harwich particularly beautiful.'[79] Gilpin had been equally terse in his praise of the Stour Valley. Approaching it from Ipswich, he commented that

. . . the road is adorned with two or three beautiful dips, on the left, interspersed with cottages, and a variety of fine wood. Beyond these is a good distance.
Soon after the tower of Dedham-church makes a picturesque appearance.
 Having presented us with these views, the road suddenly shuts in all objects; dives into a sandy bottom; and carries us into Stratford St Mary's . . .[80]

In contrast to this, agricultural writers were generally rather more enthusiastic, not only about the Stour Valley, as de la Rochefoucauld had been, but also with

regard to Suffolk in general, as we saw with Cobbett. Indeed, Arthur Young had been moved to positive enthusiasm by the landscapes of the Stour Valley.

> But one of the finest views, to be seen in Suffolk, is from the hills above Bardfield [Bergholt] . . . where Dedham is seen in the vale: and one, yet more beautiful, is from the hill above Higham, where it commands the two vales of the Brent [sic] and the Stour; the hills are, for the East of England, bold . . . Stoke church a well-placed feature; and the prominence with which the opposite hills project towards the junction of the vallies renders the whole scene interesting.[81]

The self-appointed spokesman for the farming interest, then, had found much to praise, and his singling out of Stoke church as a 'well-placed feature' reminds us that it came to play the same rôle in several of Constable's landscapes (Figs. 55, 81). There are other cases where there are close parallels between what both Young and Constable would choose to notice. One such occurs with Young's description of Mistley Hall and Park, the seat of Richard Rigby. Here, he wrote of the grounds sloping

> . . . in different farms to the Stour, which is two miles wide . . . the new church, built by ADAM; the quay, the warehouses . . . the shipping, the little dockyard, with ships building in the very bosom of a hanging wood;—all conspire to render it a lively beautiful scene, of singular and pleasing features; but it should be viewed when the tide is in.[82]

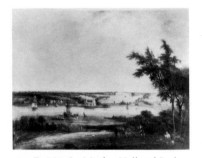

13. E. Martin *Mistley Hall and Park* c. 1776–80 Oil on canvas 23½ × 29½ (60 × 75). Sweden, Nyköpings Museum

It was just these things, the buildings, and shipping, which Constable emphasised in a couple of drawings (Figs. 14, 15). Like Young he preferred to see the estuary with the water up, covering the mudflats, and he adapted easily to what might be termed the traditional way of viewing this particular landscape. Around forty years earlier Elias Martin had painted Mistley Hall from across the estuary at Brantham (Fig. 13). He placed the house and Adam's new church well in the background. The foreground was embellished with ploughmen and the middle distance comprised the estuary filled with shipping, to imply that Rigby's influence lay behind these scenes of husbandry and commerce. He emphasised similar features to those picked out by Young or Constable, with the latter showing that in the 1810s his aesthetic preferences were the traditional ones of the farming interest, in strong contrast with metropolitan academic landscape.[83]

A final illustration of the sympathy the rural bourgeoisie felt towards certain of Constable's subjects is one particular critical piece on the *Landscape, Ploughing Scene in Suffolk* (Figs. 81, 82), exhibited at the Royal Academy in 1814. While working on this picture, Constable was visited by Perry Nursey of Little Bealings in Suffolk. Writing to John Dunthorne, at home in Bergholt, in terms which implied common acquaintanceship, the artist reported how Nursey had admired his composition.[84] I have elsewhere described Constable, Dunthorne, and George Frost as having comprised an 'Ipswich School' of artists,[85] and there is a probable association of these with Nursey, for in 1814 John King at Ipswich published a short-lived magazine, the *East Anglian*, advertised as providing for a cultural need in an area which yielded 'not in wealth, intelligence, or liberal curiosity, to . . . any other portion of the empire'.[86] Frost and Nursey were both associated with this magazine, the former providing illustrations for it, and the latter contributing a paper on picturesque gardening. As it seems unlikely that the Suffolk artistic community was so large that its members were unknown to one another, and as Nursey had paid his visit to Constable's studio, there is probably no accident in the fourth number of the *East Anglian*'s having reported that the 1814 Royal Academy exhibition was 'enriched by two

14. *Mistley* 1817 Pencil $4\frac{3}{8} \times 7\frac{1}{8}$
(11.1 × 18.1). Inscr. 'Augt 20. 1817.
Mistley'. Paris, Louvre (R.F. 32148)

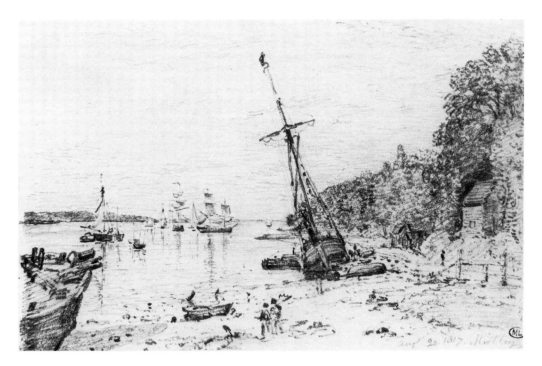

15. *Mistley* 1817 Pencil $4\frac{5}{8} \times 7\frac{3}{8}$
(11.1 × 18.1). Inscr. 'Augt. 20. 1817.
London, Victoria and Albert
Museum (R.181)

pictures by Mr J. Constable of East Bergholt'.[87] Evidently at home he was still considered a local artist.

This reviewer was not to be beguiled by the formal qualities of *Landscape, Ploughing Scene in Suffolk*:[88]

> Independently of its pictorial merits, which are by no means slight, its exhibition in the metropolis, as showing the mode of performing the operation in that County, contrasted with the inferior practice in many others, of ploughing with three or even four horses at *length*, instead of two *abreast*, may be serviceable to the interests of agriculture.

The reviewer was probably right in attaching so much importance to the agricultural subject, for Constable later entitled the mezzotint after the painting *A*

Summerland (see above, p. 12), a term which must be understood, if the painting itself is to be understood.

As we shall see, agricultural landscapes were not uncommon at this period, although a majority of painters preferred the picturesque or sublime, and Constable could be interpreted as having painted a scene which reflected the concerns of the farming interest in deliberate opposition to those of the aficionados of the picturesque.

The picturesque theorist William Gilpin found the cultivated landscape tolerable only at a distance, where it blurred into a varied and intricate visual mix.[89] Richard Payne Knight was less rigid in his views, but with an important proviso: '. . . Pastures with cattle, horses or sheep grazing in them, and enriched with good trees, will always afford picturesque compositions; and enclosures of arable are never completely ugly, *unless when lying in fallow* . . .'[90] [my italics]. As Constable had painted just such an enclosure of arable, lying in fallow, his landscape must, by Knight's criterion, be judged 'completely ugly'. To a farmer, however, a knowledge of the practical usefulness of such fallows could inform a formal judgement. In one of his essays on *Picturesque Farming*, published in Young's *Annals of Agriculture* between 1786 and 1788, Thomas Ruggles (who farmed up the Stour from Bergholt, at Clare) included a passage which approximated very closely to what Constable had painted: '. . . nor do I dislike to see the plough moving in the summer time in a fallow field . . . here and there the sober tint of a summer fallow contrasts beautifully with the general richness of the whole mass.'[91] Earlier he had noted that 'though the culture of pulse . . . may in soils of good heart and condition supersede the constant alternate use of summer fallows; yet it is not consistent either with profit or beauty totally to exclude them'.[92] This was a practical aesthetic, one derived from an appreciation of what the appearance of landscape actually meant.

Constable's subject, then, was one which a farmer or a countryman with farming connections might appreciate, in the same way that, throughout the 1810s, his particular status at East Bergholt significantly informed the landscapes he produced. Yet it was some twelve years before his engagement with place began to reflect in his paintings, before Constable began to find pictorial means of transmitting these conservative and steady aesthetic concerns. And then, after 1822, his Stour Valley paintings veered drastically away from the kind which we have discussed in this chapter. I have suggested that these paintings show an extraordinary individuality, both in reflecting so strongly the tastes of an inhabitant of East Bergholt, and in depicting the Stour Valley at all. This will come to be seen even more forcibly after the development of Constable's landscape over his career has been discussed.

CHAPTER TWO
Early Works

The teenaged Constable was already in the habit of sketching with John Dunthorne, but when in 1795 he was introduced to the connoisseur Sir George Beaumont, who was staying at Dedham with his mother, the sight of Claude's *Hagar* (Fig. 29) must have come as a shock to this raw and earnest provincial. Certainly Constable subsequently showed some artistic ambition. By 1796 he knew John Thomas Smith, urbane son of a print-seller, and author of *Remarks on Rural Scenery* (1797), a minor addition to the canon of picturesque theory. Smith and his friend John Cranch directed the young man's education, the latter sending him a detailed artistic bibliography, listing not only conventional texts like Du Fresnoy's *De Arte Graphica* or De Piles's *Treatise of Beauty*, but also more modern works like Hogarth's *Analysis of Beauty*, and Reynolds's *Discourses*. Cranch advised caution with respect to Reynolds's enthusiasm for History Painting, stating that his precepts were otherwise sound, and suggested that Constable also read poetry and history and get into a habit of constant observation.[1] As far as we can tell, the advice was taken.[2]

Smith influenced Constable more directly. *Remarks on Rural Scenery* advocated the picturesque hovel in preference to the kempt peasant habitations painted by such as Wheatley or Bigg; the text was illustrated with etchings of dilapidated cottages and purveyed a relatively unsophisticated picturesque aesthetic. Constable was impressed enough to make a number of painfully careful imitations (Figs. 17, 18). He solicited subscriptions for the book,[3] and his letters reveal him to have been anxious to oblige this new friend.[4] On his part Smith took some pains over Constable's education, and the latter was a willing pupil. Thus Smith described Gainsborough's early work as 'as exactly *imitative* as possible, and . . . executed with the most careful and laborious precision',[5] and when he first met Farington, the latter reported that Constable preferred early Gainsborough because the later work was 'so wide of nature'.[6]

Smith also helped Constable find out material for himself. In 1797, scouting round Ipswich on the Gainsborough trail, he happened on George Frost, not only a collector of Gainsborough drawings, but also a fund of anecdote.[7] Constable learned how some Orwell landscapes were still associated with Gainsborough, for some of the latter's earlier paintings showed recognisable sites.[8] And when in 1799 Constable fancied he saw Gainsborough 'in every hedge and hollow tree'[9] around Ipswich, the association between artist and locale had become firmly fixed in his mind.

It seems that the glimpse of the wider world of painting which Smith offered was enough to inspire Constable to become a professional artist. By February 1799 he

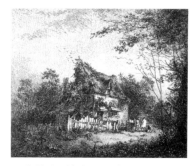

17. J. T. Smith *Near Edmonton Church* from *Remarks on Rural Scenery* London 1797

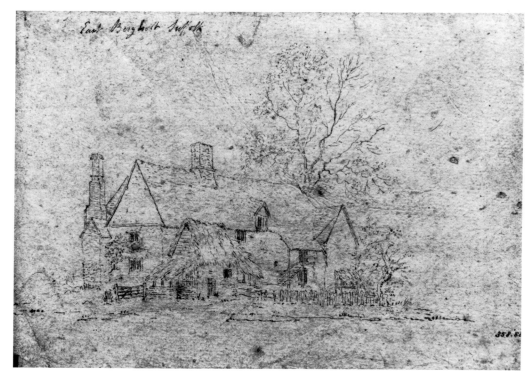

18. *Cottage at East Bergholt* 1796 Pen and ink $7\frac{1}{8} \times 11\frac{3}{4}$ (18×29). London, Victoria and Albert Museum (R.12)

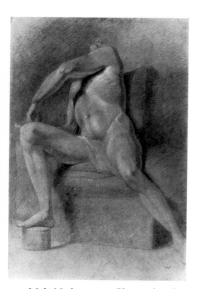

19. *Male Nude c.* 1800 Charcoal and black and white chalk on grey paper $20\frac{3}{8} \times 14\frac{1}{8}$ (51.8×36). London, Victoria and Albert Museum (R.20)

had won his father round, and had been given permission to study in London. Armed with a letter of introduction, his first call was on the influential Academician Joseph Farington. The importance of Farington to Constable was encapsulated in the *Ipswich Journal*, which recorded that Constable had 'been heard to remark that Farington was his *master*, but Nature was his *mistress*'.[10] Certainly we know from Farington's diary[11] that he worked Constable hard, making him copy landscapes by both the Dutch masters and Wilson, and adding his advice and tuition to that of the Royal Academy Schools. Sir George Beaumont was also taking an interest in Constable, letting him copy pictures,[12] or inviting him to dine.[13] Both Farington and Beaumont, older men, steeped in the *landscape* tradition of Richard Wilson, stressed the importance both of hard work, and of learning gradually. Yet, at the Academy Schools, the conventional programme was designed to encourage history painting, with study of the human figure basic to all. Constable's laborious drawings (Fig. 19) give evidence of his painstaking ineptitude. His fellow students found things easier, and Constable would have been both impressed and depressed by the flashy competence of such as Ramsay Richard Reinagle, with whom he enjoyed a brief friendship. The kind of conversation he heard inside the classroom contrasted with the advice he was being given outside it, and the effect was to lower Constable's spirits. He revealed this in letters to Dunthorne,[14] and complained too to Farington on 9 March 1801: 'He said he had been much discouraged by the remarks of Reinagle &c though he did not acknowledge their justness. He said in their criticisms they look only to the surface and not to the mind. The mechanism of painting is their delight. *Execution* is their chief aim.' The gulf which was opening up between him and his contemporaries had, to Constable, a moral dimension: 'I have been among my old acquaintances in the art, and am enough disgusted (between ourselves) with their cold trumpery stuff. The more canvas they cover, the more they discover their ignorance and total want of feeling . . .'[15]

Yet Constable's own works were undistinguished, and notably reliant on the examples of other painters. A picture of *Old Hall* (Fig. 21) is reasonably competent (particularly when considered against the watercolours done the previous year for Lucy Hurlock (Fig. 20)), but, as Farington observed, Constable's 'manner of

20. *Dedham from Langham* 1800 Pen,
ink, and watercolour 13⅝ × 20¾
(34.6 × 52.7). University of
Manchester, Whitworth Art Gallery

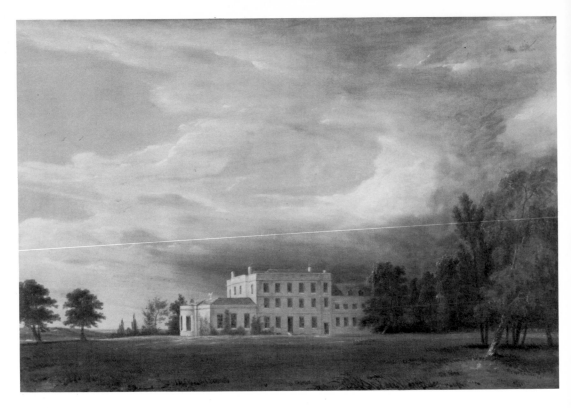

21. *Old Hall, East Bergholt* 1801 Oil
on canvas 28 × 42 (71.1 × 106.7).
Private Collection

22. T. Gainsborough *Cornard Wood*
c. 1748 Oil on canvas 48 × 61
(122 × 155). London, National
Gallery

painting the trees is so like Sir George Beaumont's that they might be taken for his'.[16] Likewise, a painting which was very probably exhibited in 1802[17] (Fig. 23), and possibly showing a scene in Helmingham Park, where Constable had been in July 1800, relies heavily on a Gainsborough-like pictorial vocabulary, even down to the inclusion of a benign-looking donkey (Fig. 22). Constable, like many students, was being less original than he supposed. However, his intentions as he stated them were honourable, and it begins to become clear that he preferred to listen to Beaumont and Farington, rather than follow the pack of students.

Farington and Beaumont had both been brought up to respect and admire Sir Joshua Reynolds and his teaching. Farington was there when the first stone of the Reynolds monument which Beaumont erected at Coleorton was laid, and, fittingly, in 1836 Constable commemorated his mentors in a painting of that monument (Fig. 24).[18] Farington and Beaumont impressed upon Constable the soundness and

23. *Wooded Landscape* 1801–2 Oil on canvas 38 × 28¼ (92 × 72). Toronto, Art Gallery of Ontario (Gift of Reuben Wells Leonard Estate, 1936)

24. *'Cenotaph to the Memory of Sir Joshua Reynolds, erected . . . by the late Sir George Beaumont, Bart.'* 1836 Oil on canvas 52 × 42¾ (132 × 108.5). London, National Gallery

importance of the *Discourses*, which, on his part, Constable unquestioningly accepted.[19] When Farington reported Constable's decrying his contemporaries' obsession with 'mechanism' and 'execution', the terms and attitude had been learned from the second *Discourse*, where Reynolds warned how, while 'the mechanical part of painting'[20] must be acquired, facility was not an end in itself: 'Some who have never raised their minds to the consideration of the real dignity of the Art, and who rate the works of an Artist in proportion as they excel or are defective in the mechanical parts, look on theory as something that may enable them to talk but not to paint better.'[21] Indeed, we shall see below how far Constable found the *Discourses* a support at this crucial period of his career, how they helped him to formulate his own ideas of how art should be practised, and what its pretensions ought to be.

Despite encouragement from Farington and Beaumont, 1801 was an unpleasant year for Constable. The rift with his contemporaries increased his sense of isolation, and must, too, have led him to doubt his own artistic talent; added to which, Golding Constable was urging him to get a proper job.[22] This uncomfortable state of affairs persisted into 1802, when Constable was keeping his own company. His character shines out from a January 1802 letter to Dunthorne, giving news of his anatomy studies.

> Excepting astronomy . . . I beleive no study is really so sublime, or goes more to carry the mind to the Divine Architect. Indeed, the whole machine which it has pleased God to form for the accommodation of the real man, the mind, during its probation in this vale of tears, is as wonderfull as the contemplation of it is affecting. I see, however, many instances of the truth, and a melancholy truth it is, that a knowledge of the thing created does not always lead to a veneration of the Creator. Many of the young men in this theatre are reprobates.[23]

He wrote very much as his mother's son, and such pompous moralising doubtless alienated Constable from his fellows, for art-students are seldom so conservative. In this carefully-composed passage his traditional diction, calling God the 'Divine Architect', or the human body a 'machine', revealed the eighteenth-century basis of his thought. Constable accepted the idea of a divinely-ordered world, where, by contemplating the minute, ideas would inevitably expand to the infinite. Such firm beliefs would have comforted this young countryman, alone in a large and strange city, and a letter dated by Beckett to Spring 1802 told Dunthorne of his having become more settled, and contented in his practice.[24]

This period was crucial to Constable. Rather than give up his artistic ambitions and either return to Bergholt to work for his father, or become a drawing master, in May 1802 he made a firm commitment to landscape painting. Farington and Beaumont had encouraged him to persevere,[25] and having made his decision, on 29 May 1802 Constable wrote to John Dunthorne back in Bergholt, explaining that he had finally opted to become a professional artist, and stating an aesthetic programme to which he was to adhere until the 1820s. So important is this letter, that it must be quoted at length.

Constable opened by saying that to have become a drawing master would have done for his chances as a landscape painter. He continued:

> For these few weeks past I believe I have thought more seriously on my profession than at any other time of my life—that is, which is the shurest way to real excellence. And this morning I am the more inclined to mention the subject having just returned from a visit to Sir G. Beaumont's pictures.—I am returned with a deep conviction of the truth of Sir Joshua Reynolds's observation that 'there is no *easy* way of becoming a good painter' . . .

26

And however one's mind may be elevated, and kept up to what is excellent, by the works of the Great Masters—still Nature is the fountain's head, the source from whence all originally must spring—and should an artist continue his practice without referring to nature he must soon form a *manner*, & be reduced to the same deplorable situation as the French painter mentioned by Sir J. Reynolds, who told him that he had long ceased to look at nature for she only put him out.

For these two years past I have been running after pictures and seeking the truth at second hand. I have not endeavoured to represent nature with the same elevation of mind—but have neither endeavoured to make my performances look as if really *executed* by other men.

I am come to a determination to make no idle visits this summer or to give up my time to common place people. I shall shortly return to Bergholt where I shall make some laborious studies of nature—and I shall endeavour to get a pure and unaffected representation of the scenes that may employ me with respect to colour particularly and any thing else—drawing I am pretty well master of.

There is little or nothing in the exhibition worth looking up to—there is room enough for a natural painture. The great vice of the present day is *bravura*, an attempt at something beyond the truth. In endeavouring to do something better than well they do what in reality is good for nothing. *Fashion* always had, & always will have its day—but *Truth* (in all things) only will last and can have just claims on posterity.[26]

While dithering about his career Constable had been seeking advice from Farington and Beaumont. Thus on 8 April Farington had advised him to 'study nature & *particular* art less', and while discussing the case Beaumont had observed 'the young man wants application'. It seems that the encouragement received from Beaumont on 29 May had inspired the writing of this letter the moment Constable reached home. He had been formulating his ideas over the previous months, and it may be that the visit to Beaumont had fired this long statement. Evidently Beaumont had again taxed him with being weak-willed, citing Reynolds as the example of what application could achieve, and drumming in what Sir Joshua had said students must hear 'again and again',[27] that there was no easy way to become a good painter. And Farington's injunction to study nature, not art, seems to have hit home, for Constable explained at length to Dunthorne how he meant to start doing just this. He had been through a campaign of copying to learn technique; now he was to learn for himself.

While Beaumont and Farington had helped, Constable had also been studying Reynolds, and his assurance of quotation and paraphrase shows him to have been completely familiar both with the *Discourses*, and with Reynolds's notes to Mason's translation of Du Fresnoy's *De Arte Graphica*. Although he twice named Reynolds, the debt to him shows most in Constable's language. By referring to Nature as 'the fountain's head, the source from whence all originally must spring', he reflected two passages; one in the sixth Discourse where Reynolds called Nature 'the fountain which alone is inexhaustible; and from which all excellencies must originally flow',[28] and the other in a note to Du Fresnoy, where Nature was 'the fountain-head from whence all our ideas are derived'.[29] It was the sixth Discourse Constable had in mind here: Reynolds had said that one studied art from artists before going to nature, and later censured a manner based on one master,[30] as Constable himself condemned a style founded on art alone. Constable's French painter, however, was Boucher, mentioned by Reynolds in the twelfth Discourse. Here the warning 'you are never to lose sight of nature; the instant you do , you are all abroad, at the mercy

of every gust of fashion' was driven home by holding up Boucher, who had left off using models, as an example of the kind of painter who found that *nature only put them out*.[31] Constable had not queried the *Discourses*, and had found Reynolds's teaching relevant to his own theories.

Consequently we can understand more of the background to his stated aims. Ignoring Reynolds's concern with History and ideal nature, Constable (perhaps remembering Cranch's advice) took what he needed from his writing. Truth was, consequently, for both the ideal, but for Constable Truth was to do with particular appearance, a 'pure and unaffected' *representation*. On the other hand, he accepted that technique was to be learned from the masters, as Reynolds argued through much of the sixth Discourse. 'The great use of studying our predecessors is to open the mind, to shorten our labour',[32] he had written, reiterating in the Twelfth Discourse that '*The art of seeing Nature*, or in other words the art of using Models, is in reality . . . the point to which all our studies are directed'.[33] The vital thing, however, was to use artistic learning to approach nature direct.

The significance of 'the art of seeing Nature, or . . . the art of using models' has been brilliantly demonstrated by Sir Ernst Gombrich.[34] The basic premise is that a prior knowledge of an object's appearance will help an artist attempting to depict that object, and that such knowledge was to be had through the study of art. Acquainted with the pictorial schemata this provides, the artist should be eased of

25. *Dedham Vale* 1802 Oil on canvas 13⅛ × 16⅜ (33.3 × 41.6). New Haven, Yale Center for British Art, Paul Mellon Collection

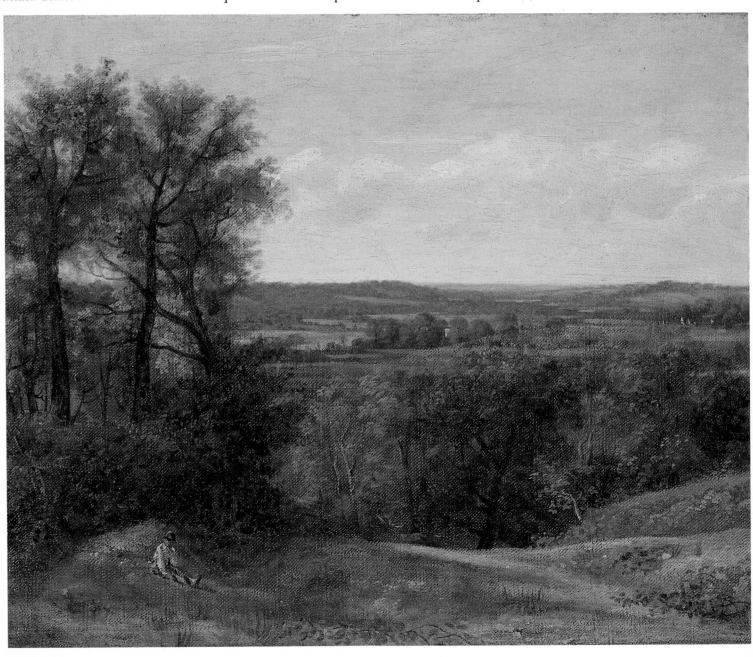

26. *Dedham Vale, Evening* 1802 Oil on canvas 12½ × 17 (31.8 × 43.2). Inscr. 'July 1802'. London, Victoria and Albert Museum (R.36)

some of the enormous amount of seeing, thinking and perceptual sorting that confrontation with the particular demands. Constable had not met this for the first time in Reynolds, for he was already familiar with it from J. T. Smith: 'Acquainted with the modes by which the most eminent artists have expressed their conceptions, we view Nature with more delight, and come to perceive more beauties in her, and those more readily, that we possibly can by studying merely on our own personal stock.'[35]

He would have read similar ideas elsewhere,[36] and probably had them explained to him by Farington as he was put through his programme of copying. Constable accepted that, having assimilated previous knowledge from art, the painter must confront nature and advance knowledge of its appearance. This was a 'natural painture', a natural style, which could then serve later artists intent on pursuing the same ends. Hence art would evolve. The idea of discovery, of laying bare new data about the way the world looked, was something Constable valued in others: his later praise of Richard Wilson attributed his greatness to his having discovered, via art, previously unknown truths in nature.[37] This, though, was in the 1820s. In 1802 Constable concluded that there was room enough for a 'natural painture', a style based on nature and endorsed by Reynolds, for the simple enough reason that no else seemed to be pursuing it. Constable therefore planned to return to Bergholt and would achieve through 'laborious' study, a 'pure and unaffected' *representation*, 'Truth', which was all that could last.

True to his word, in the summer of 1802, Constable *did* go home, and made some very fine oil studies, an analysis of which reveals not only that they achieved Constable's stated intentions, but also, incidentally, that they were instances of picturesque landscape.[38] Between July and October Constable made at least seven very careful oil paintings of landscapes around East Bergholt (Figs. 25, 26, 27, 30, 31, 32). It should be emphasised that these are studies, not sketches, with none of the speedy facility of execution the latter term implies. Save for two cases, one showing a wood (Fig. 30), which could be anywhere, and the other (Fig. 27) a valley too enclosed for the Stour, and possibly that of the nearby Brett, Constable depicted subjects like Dedham from Langham (Fig. 31) or Willy Lott's farm (private collection), which were to become famous as he repeated them. The studies were on canvases of around 13 × 17 inches, a size small enough to be portable, but not so small as to cramp his style.[39] Compared with his later practice, when his oil sketches varied widely in size, this uniformity would be evidence that Constable worked on them as part of one campaign.

A close look reveals the amount of work which Constable put into them. They are, as he intended them to be, laborious. He composed his landscapes scrupulously, and deployed elements like trees, fields or hills meticulously to enhance, with varying success, the overall stability. Constable delineated the boughs of individual trees, and where he found no honest way of covering his canvas, left the brown ground exposed. In some cases (Figs. 25, 27, 32), he painted thinly, suggesting fields and distances with washes, and foliage via dabs of paint, agglomerated where leaves form masses. Colours were muted, and narrow in range, chiefly blues, greens, yellows, and browns. Sometimes he impasted his paint to achieve spectacular effects, like the sunset over Mrs Roberts's fields (Fig. 26), where the position of the painter facing the light meant that detail was obliterated. However, these pictures also took more than a little from the study Constable had made of the Masters. That in their style and technique they can be reminiscent of both the early Gainsborough (Figs. 22, 211) and Claude (Fig. 28) is no accident. Constable's 1802 Academy exhibit (Fig. 23) showed that he had already learned a good deal from those early Gainsboroughs which, because they were 'exactly imitative', were apt models for a 'natural painture' conceived with just that aim.

The young Gainsborough drew boughs, and represented foliage as dabs of paint. He brushed in the background broadly, allowed the canvas ground to play a rôle in the pictorial structure, and used a palette of greens, greys, blues, browns, and yellows. Constable took over something of this, but I think that, for the same reasons, he had also studied Claude's *Landscape with a Goatherd* in the Beaumont collection (Fig. 28). At this period Claude had a reputation for having worked from nature,[40] and later, in 1823, Constable thought that this picture had been 'done on the spot'.[41] It is carefully and descriptively painted; in places the canvas ground is visible, and tree limbs are delineated, with their leaves indicated by concentrations of dabbed brushstrokes. This technique, then, could seem suitable for working from nature. These studies are the result of Constable's carrying out his stated intention of checking what he learned from art against what he could see. As Gainsborough and Claude had both produced works then thought to have been done from nature, these were fit models for a 'natural painture', and Constable adjusted their techniques and palettes to what he himself perceived. Hence, when the style was inappropriate to the subject, as with that sunset, it changed.

These studies made encouraging advances in the 'natural painture', and did it by following the programme laid down that May. Yet, while they represented recognisable landscapes as truthfully as possible, they also showed a sharp eye for the picturesque, the implications of which are important for what they reveal of Constable's relation with subject-matter.

27. *Valley Scene* 1802 Oil on canvas
14⅛ × 12⅞ (35.9 × 32.6). London,
Victoria and Albert Museum (R.39)

The Reverend William Gilpin had been the first to use the term 'picturesque
beauty' for objects neither sublime nor beautiful, but which were pleasing for their
pictorial qualities.[42] By the 1790s the aesthetic debate had developed considerable
literary back-up. Not only were there Gilpin's *Observations* on various parts of the
country, but also the writings of Richard Payne Knight, Uvedale Price, and, to a
lesser degree, Humphrey Repton. Gilpin's work in particular had considerable
popular appeal,[43] and the extent of the rage for the picturesque can be gauged by
J. T. Smith's attempt to exploit it in 1797 with *Remarks on Rural Scenery*.

A knowledge of picturesque theory helped tourists appreciate the landscapes
through which they passed, according to criteria derived from a knowledge of
pictures. Hence, to Gilpin in particular, it was not only necessary to look for a
vantage point from which a scene would arrange itself into fore-, mid-, and
backgrounds; but also to perceive such pictorial qualities as roughness, sudden
variation, or broken tints. Picturesque principles helped the informed and formal
evaluation of a place. One could consider it in terms of its success or failure to attain
such objective qualities as Gilpin (and other writers) enumerated. They taught, too,
a jargon, for signalling one's expertise, and thus degree of cultivation, in discussions
with fellow tourists.[44]

Despite his familiarity with the landscapes he portrayed in these studies, except in
two cases[45] Constable happily adopted the picturesque both in colouring and in

28. (above left). Claude Lorrain
Landscape with a Goatherd and Goats
c. 1636 Oil on canvas 20¼ × 16¼
(52 × 41). London, National Gallery

29. (above right). Claude Lorrain
Landscape, Hagar and the Angel 1646/7
Oil on canvas on wood 20¾ × 17¼
(52 × 44). London, National Gallery

30. *A Wood* 1802 Oil on canvas
13½ × 17 (34.3 × 43.2). London,
Victoria and Albert Museum (R.40)

31. (facing page). *Dedham from
Langham* 1802 Oil on canvas
17⅛ × 13½ (43.5 × 34.4). London,
Victoria and Albert Museum (R.37)

33

principles of composition. His colouring was not strident, being greens, browns and yellows. As Uvedale Price observed, autumnal tints were more picturesque than spring ones, which were 'generally too cold for painting'.[46] Likewise, landscape painting could help one discover picturesque compositions in nature, and we may preface a discussion of Constable's studies from this point of view by describing the way art could interact with landscapes.

Gainsborough profoundly influenced the picturesque, and Price above all appears to have been taught to see nature chiefly through the medium of Gainsborough's paintings.[47] This certainly applies to this description of a scene in a wooded lane with sandy banks, from his *Dialogue on . . . the Picturesque*:

> A little further, but in sight from the entrance, stood a cottage, which was placed in a dip of the bank near the top. Some rude steps led from it to the lane, and a few paces from the bottom of these steps, the rill which ran on the same side of the lane, had washed away the soil and formed a small pool under the hollow of the bank. At the edge of the water, some large flat stones had been placed, on which a woman and some girls were beating clothes; and a little boy stood looking on; some other children sat upon the steps, and an old woman was leaning over the wicket of the cottage porch, while her dog and cat lay basking in the sun before it.[48]

Here one of Gainsborough's cottage scenes had been discovered in 'reality'—but Price only noticed it because art had enlightened him to the qualities of such subjects.

It was likewise with Constable. As with earlier works (Fig. 23), Gainsborough's woodland scenes (Figs. 22, 211) probably influenced his choosing similar ones (Fig. 30): works like *Cornard Wood* (Fig. 22) helped him appreciate comparable scenes in nature. And perhaps Smith's enthusiasm for the rustic cottage (complicated through Smith himself having probably been inspired by Gainsborough) lay behind Constable's choice of Willy Lott's house. Again the selection of landscape motif was dictated by picturesque principles.

The dominant influence in 1802, though, was Claude's. Witness the familiar comparison of *Hagar and the Angel* (Fig. 29) with *Dedham from Langham* (Fig. 31).[49] Constable's *repoussoir* of trees—elms which we suspect from other sketches (Fig. 65) to have existed—was deliberately imitative, and he discovered too that the ones along the river bank in the middle distance corresponded conveniently with Claude's rocky bridge. However, rather than derive his composition from *Hagar*, Constable's memory of the painting aided him, in a classically picturesque manner, in recognising a similar composition in actual landscape. There are also connections between *Fen Bridge Lane* (Fig. 32) and *Narcissus* (Fig. 33). The elm in the near distance recalls the tree sheltering Narcissus and the path to the right Claude's subsidiary perspective to the left, while each work has a broad and light distance.

These picturesque studies reveal Constable in 1802 to have taken mainly a formal interest in his native scenes. A knowledge of picturesque principles allowed one, as we have said, to assess landscapes objectively, irrespective of any content or meaning they might have had. Constable's espousal of them was doubtless automatic in one whose masters had been Smith, Farington, and Beaumont. But it might reflect, too, a sense that, although there was much of value to be learned from Reynolds's writings, the history painting he advocated was in 1802 meaningless, and the artist was consequently at liberty to choose what subjects he might on which to practise the lessons Reynolds had taught.

Yet Constable benefited much from his study of Claude, and it is of interest that, at that period, Claude's paintings were not admired on formal grounds alone. By the

late eighteenth century Claude was thought to have visualised the landscapes of the Golden Age, where nature was at her kindliest, and people lived harmoniously and happily off what their earth provided.[50] In his *Letter on Landscape Painting* Gessner gave an example of this interpretation:

> The mere view of [Claude's] pictures excites that sweet emotion, those delicious sensations that a well-chosen prospect has the power to produce in the mind. His fields are rich without confusion, and variegated without disorder; every object presents the idea of peace and prosperity; we continually behold a happy soil that pours its bounteous gifts on the inhabitants; a sky serene and bright, under which all things spring forth, and all things flourish.[51]

Phrases like 'peace and prosperity', perhaps translated to recall the peace and plenty which, for Pope, told of the blessings of a Stuart's reign,[52] reveal a socialised landscape. There is an equation between the bounteous soil and the ordered peace of those whom it benefits: thus the harmonious (and therefore pleasing) arrangement of both landscape and inhabitants. Here, then, we may gaze on scenes of the golden age: that blissful period from which humanity had declined, but to which, as Virgil argued in his *Georgics*, it could, through honest toil and good government, return. Claude realised its image. Consequently, by adapting an actual terrain to the Claudean *leitmotiv*, the characteristic composition,[53] a painter could refer his or her own form to that ideal content, as Turner was to do along the Thames in the 1800s, and Constable in the Stour Valley in the 1810s.

In Claude beautiful form and ideal content were in harmony. Yet, while the latter helped define the former, a formal divorce of the one from the other was always possible, and one could see Claude's beauty as abstracted and objective. The connection of *Dedham from Langham* with *Hagar* allows it to achieve beauty not because of *what* it represents, but through *how* it is represented. The connection is formal, not iconographical. Indeed, it appears that habits of thought which judged the beauty of objects according to what qualities they expressed, were common, and that non-initiates had to be convinced that expertise in the application of picturesque principles enabled one to appreciate the qualities of representations regardless of any content.

Picturesque qualities were peculiar to paintings, and therefore to be learned from them. By divesting the sign of signification, 'ideas', the knowledge of art learned via its study, could nullify the power of the most disgusting subjects: 'beautiful tints and lights, and shadows, when separated, in the imitation, from the disagreeable qualities with which they were united, are as truly beautiful as if they had never been united with any such qualities'.[54] Gilpin was particularly exercised by this problem. In one passage, for example, he allowed that of those interested in landscape most preferred cultivated to wild country, but argued that it was fallacious therefore to call fields of corn or whatever 'picturesque', for this associated non-pictorial ideas and visual impression, although in reality these should be kept apart. He went on '. . . to evince that a scene, tho it abounds with circumstances of *horror*, may be very *picturesque*; while another may be entirely the *reverse*, tho replete with incidents that produce joy and happiness.'[55] Earlier, he had contended that moral and picturesque ideas 'need not coincide'; hence the 'loitering peasant' was more picturesque a subject than the 'industrious mechanic'.[56] This thesis was calculated to outrage a majority of his readership, which would have concurred with Ruggles's ideal of the honest, sober, and industrious labourer breeding up a large family, and working without complaint.[57] I have suggested above that behind his philanthropy lay a distrust of what the poor might get up to if left to their own devices, something more starkly articulated in Billingsley's *General View of the Agriculture of the County of Somerset* (of

32. *Fen Bridge Lane* 1802 Oil on canvas 13⅛ × 16⅜ (33.3 × 41.5). New Haven, Yale Center for British Art, Paul Mellon Collection

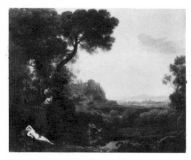

33. Claude Lorrain *Landscape, Narcissus* 1644 Oil on canvas 37¼ × 46½ (94.5 × 118). London, National Gallery

which the second edition was published in 1798). For Billingsley, what was wrong with the poor was that their *inherent* indolence and lack of ambition:

> . . . if he can earn eight or nine shillings in *four* days of the week, the remaining *two* days are devoted to pleasure, or luxury, and the wife and children are in a worse situation that when more moderate wages compelled him to work.
> . . . No sight can be more pleasing to me, than . . . an industrious cottager returning from his daily labour, with a cheerful countenance . . .[58]

The verb 'compel' admitted the necessity of social control if the farmer was to exploit labour to the full. What labour could achieve uncontrolled was horribly illustrated by the French Revolution,[59] which concentrated conservative writers' minds to a prodigious extent. They and their public liked their workers to be uncomplainingly at work. Thus occupied they posed no threat as they did when idle, or, more particularly, when congregated in ale-houses.[60]

The Revolution had permitted the native poor to appear a real threat. Gilpin's 'loitering peasant' was an image with a powerful potential, for this was an independent member of the labouring classes, enjoying his liberty; not an

36

'industrious mechanic', an individual working hard for the benefit of a master and therefore under his control.[61] Gilpin meant to shock his readers into realising the scope of a picturesque way of seeing.

By divorcing the object from all associations, Gilpin destroyed its content. Therefore, objects which in reality were disturbing enough to be unpaintable[62] were rendered both fit and safe. The 'loitering peasant' now faded into the landscape, became a collection of hues and tints precisely as interesting as those of his surroundings. The picturesque allowed artistic acceptability to a mass of material which would not otherwise have had it. It was a process of aesthetic laundering.

And therefore, a picturesque painting should tend to have no significant subject-matter. In these quite remarkably depopulated 1802 studies, Constable's subjects were only the representations of particular views. The studies' virtues lie to a certain extent in their obvious picturesqueness, but more in their unique control and discipline. Their very objectivity denies content, the portrayal of matter giving the paintings meaning beyond representation.

In his letter to Dunthorne, the young and isolated Constable implied that he felt naturalism to be an end in itself, and that he had yet to be over-concerned either with what he painted, or where he painted it. And here there was potential for a conflict. As the automatic elevation of his thoughts from the anatomy lesson to God showed,

34. *Cattle near the edge of a Wood*
c. 1805 Pencil and watercolour $8 \times 9\frac{3}{4}$
(20.3 × 14.9). London, Victoria and Albert Museum (R.61)

Constable was in the habit of drawing conclusions, of interpreting what he saw. Likewise, the painted activity noted earlier in works like *Golding Constable's Kitchen Garden* (Fig. 130) implied a real concern (shared by local society) with subject.

In his 1802 objectivity Constable was partly adopting a position he was advised to take, and partly indulging an activity which justified itself. Through the 1800s he was to advance greatly in naturalism and proficiency, but the works which survive when contemplated *en masse* suggest inconsistency, almost aimlessness; and I hope to show that this was largely because Constable had yet to find a type of landscape which engaged his whole interest. The 1802 studies did not indicate that the painter also interpreted the objects of creation as signifiers of an intellectual structure, save that perhaps we are meant generally to see the hand of the Deity in His creation.

What survives from these years gives an overall impression of uncertainty. The oil studies must be balanced against a contemporary drawing of a windmill, in a style pastiching George Frost's (Fig. 35)[63] for instance. Constable exhibited four paintings at the 1803 Royal Academy. Two were entitled *A Study from Nature*, and two *A Landscape*, unhelpful titles for identifying actual paintings, although they were possibly a selection of the 1802 studies. In 1804 Constable did not exhibit, and for 1805 his one offering was *A Landscape: Moon-light*, the identity of which is, unsurprisingly, obscure.

However, he continued to study from nature around East Bergholt, seeming to have used watercolour in preference to oil. Work done between 1803 and 1806 shows him maintaining his interest in the picturesque: an instance is the totally conventional watercolour of Chalk Church, which had been done from a drawing squared for transfer (Figs. 36, 37). We know little of Constable's practice at this period. The watercolours generally agreed to date from it are fine and fluent, often concerning themselves with broad effects of light and shade, and mass and landscape-structure, rather than with the minutiae of a scene (Fig. 34). They are picturesque in their colour, which in general (assuming not too great a deterioration in pigment) ranges over browns, yellows, greens, and greys; and in subject. Constable chose, it seems, either vistas or woodland scenes, some of which show how real the example of Gainsborough still was. We can only guess at what he was intending with these watercolours. Certainly he continued studying appearance, perhaps reserving paint for general effects, and pencil for more detailed works. He was also learning the forms and structures of the Stour Valley.

In 1806, though, his attention was drawn from his native scenes to the Lake District; for his uncle David Pike Watts financed one of Constable's very rare picturesque tours to this region. He continued working in watercolour mainly, and was prolific in producing interesting paintings. Watts was one of those who brook no contradiction,[64] and it would have been characteristic of him to conclude that if his nephew must profess landscape, he might at least work in country worth painting. 'What delight! what felicity! ... What are men to rocks and mountains?'[65] exclaimed Elizabeth Bennett in *Pride and Prejudice*, on hearing of a proposed trip to the Lakes. The popularity of this region with both artists and tourists was by this period becoming a matter for parody,[66] so for once Constable was behaving like any less eccentric landscape painter. He went quite willingly, for he was not one to jib against convention, although the story is that in this case he did. Leslie's is the accepted opinion on Constable's Lake pictures in general:

> They abound in grand and solemn effects of light, shade, and colour, but from these studies he never painted any considerable picture, for his mind was formed for a different class of landscape. I have heard him say the solitude of mountains opressed his spirits. His nature was peculiarly social and could not feel satisfied with scenery, however grand in itself, that did not abound in

35. *Windmill near Cattawade* 1802
Black chalk, charcoal, traces of red
chalk 9½ × 11¾ (24.3 × 29.8). Inscr. '3
Octr. Noon 1802). London, Victoria
and Albert Museum (R.38)

36. *Chalk Church* 1803 Pencil 8 × 10
(20.3 × 25.4). Inscr. 'Nr. Gravesend
Chalk Kent April 18. noon 1803'.
Private Collection

37. *Chalk Church* 1803–4
Watercolour. Size and whereabouts
unknown

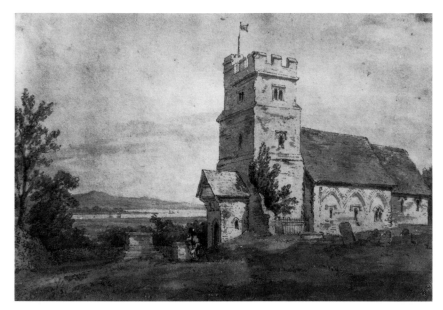

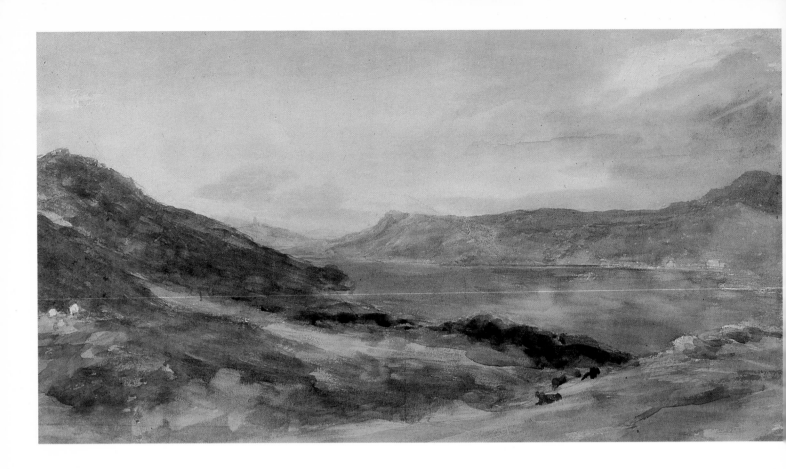

38. *Windermere* 1806 Watercolour and pencil on paper 8 × 14⅞ (20.2 × 37.8). Cambridge, Fitzwilliam Museum

human associations. He required villages, churches, farmhouses, and cottages; and I believe it was as much from natural temperament as from early impressions that his first love in landscape was also his latest love.[67]

Like most history this mixes truth, half-truth, and guesswork. There is a pleasing succinctness in the judgement of the studies. On the other hand nothing suggests any antipathy to mountains in 1806. Constable would hardly have taken such a long tour, or have been reported as an exceptionally keen sketcher,[68] if the mountains were then oppressing him. In 1814 he was still expressing genuine enthusiasm for mountainous scenery, writing to Maria Bicknell:

You tell me you have an opportunity of going into Wales—let me my beloved Child entreat you nay exhort you to embrace it . . . such a tour would be a real blessing to you in every point of view, the change, the air, and then the sublime scenery. I did hope we might have visited these delightfull places together for the first time . . .[69]

And later he thought that she would 'have been charmed with the affecting and sublime scenery of a mountainous country'.[70] So he was at least willing to come out with the proper sentiments (perhaps because he knew then that he was safe in Bergholt). And it is quite likely that, when Leslie knew Constable, this was no longer so. To give Leslie credit, the painter did generally prefer scenery in which humanity was less dwarfed.

Some of the work Constable had been thought to have done in oil while in the Lakes has now been attributed to his son, Lionel;[71] but there are fewer problems of attribution with the watercolours. Pictures in the latter medium show him to have responded acutely to the typically changeable Lake District weather, and fluctuating light conditions. The Lake works (Fig. 38) maintained the 'natural painture', but concentrated on the representation of fugitive effects: hence the use of watercolour, which was portable and speedily worked. That Constable was struck

most by the way the terrain's appearance changed with the weather is apparent too from the mnemonics he wrote on some watercolours. These range from simple meteorological observations,[72] to more detailed notations: 'Borrowdale 4 Oct 1806—Dark Autumnal day at noon—tone more blooming [?than] this . . . the effect exceeding ~~terrific~~ terrific—and much like the beautiful Gaspar I saw in Margaret St.'[73] The desire to check the masters against nature was persistent: thus the gratification in finding that the tone of a real landscape accorded with that of a painted one.

Like the 1802 studies, these 1806 ones concentrate on landscape, but not on its inhabitants. By exchanging the picturesque for the sublime or beautiful, Constable was continuing to regard landscape simply as motif, something allowing nothing but an objective appraisal. Unlike Wordsworth, Constable had not felt himself beset by superior forces in the Lake District; did not find that he heard a 'strange utterance' in the wind, nor felt 'Gleams like the flashing of a shield' as 'the earth/And common face of Nature' spoke to him.[74]

He called the landscape terrific, but almost comfortingly so, the association with Gaspard's landscapes familiarising the terror. Constable's engagement with this region was intellectual rather than emotional, and he took care to respond correctly to it. The Lake scenes are, nevertheless, extremely fine pieces of work, the concern with representation dictating style and palette still. Now, though, Constable was behaving as any other young landscape artist angling for success. He went off on his tour, made numerous studies from nature, and until 1809 (when Farington reported on a very large but unfinished *Borrowdale*)[75] exhibited Lake District landscapes in London. This was a calculated attempt to curry favour with a fickle public. It met with small success in the way of sales, although Constable had the consolation of a guardedly enthusiastic notice on his 1807 Royal Academy exhibits in the *St James's Chronicle*.[76]

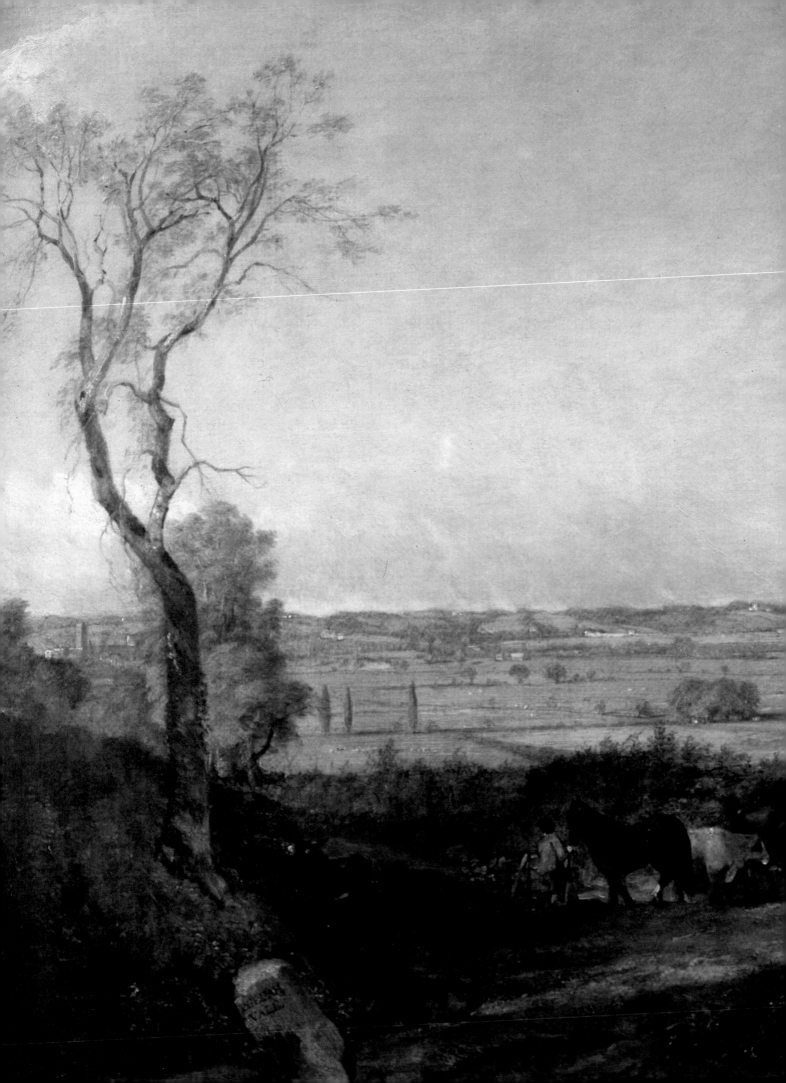

CHAPTER THREE
The Turn to the Stour Valley

39. Detail from *Dedham Vale, Morning* (Fig. 55)

Constable gave little impression of setting his sights too high after 1805. He began to earn a little money from art; Peter Firmin arranged that he copy portraits for Lord Dysart, and he produced cheap portraits around East Bergholt.[1] On 16 November 1807 Farington noted that Constable now appeared more settled in his profession, and was still attending life classes. He was now thirty-one, and had been eight years in London without achieving much. Significantly, in 1808 he began making oil sketches of Stour Valley landscapes, heralding the gradual focus of his attention on his native scenes, and the development of a distinctly unpicturesque idea of landscape.

One of these 1808 sketches is a view towards East Bergholt Rectory (Fig. 40). Painted on board (still visible through the cloudier part of the sky), Constable's method was to fix the lines bounding the main areas of landscape, fields, or masses of wood, and then to fill them in with local colour. He left a space for the tree to the left foreground, outlined its trunk and major boughs, and defined the main clumps of

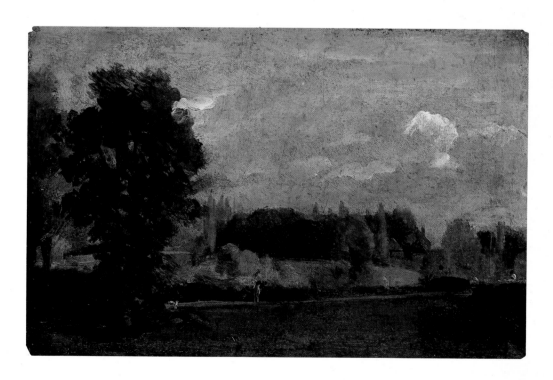

40. *East Bergholt Rectory* 1808 Oil on board 6⅜ × 9⅞ (16.2 × 25.1). Inscr. 'E.B.' and '1808' (twice). Cambridge, Fitzwilliam Museum

foliage. The general effect is rather flat and two-dimensional. A *View towards Dedham* (from the Stratford Road) (Fig. 42), dated 22 September 1808 is messier and less easy to read, although the technique was the same. Ian Fleming-Williams has suggested to me that Constable was so conservative simply because he was transferring his watercolour technique of laying in washes, to the different medium. Explanations for his having made this move from watercolour to oil can only be speculative.

Constable had probably already tried oil, with its different and wider expressive possibilities, in the Lake District. He would have known of the tradition of oil sketching amongst Wilson's pupils, notably Thomas Jones (it had recently been tried out by Turner). And he may simply have come to find watercolour too restrictive. Constable's proficiency was to develop with stunning speed. An oil sketch of 13 October 1809 (Fig. 41) surveys the Stour Valley from Fen Bridge Lane, East Bergholt. Although he continued to leave spaces for trees, which he then filled in, he otherwise showed far greater confidence, beginning to get varied effects of texture, and to use directional brushstrokes to describe things shown, particularly in that area of turf behind the recumbent traveller. He was persisting in the 'truth' to appearance of his 'natural painture', describing the topography accurately, and allowing both his choice of pigment and its positioning on the board's surface to be dictated by what he saw. Furthermore, as *Malvern Hall* (Fig. 9) reveals, he was beginning to base more ambitious work on this study. In a composition which demanded little detail, Constable captured a brilliantly natural approximation to the appearances of reflections in still water, or low sunlight raking lawns.

And then, around 1809 or 1810, circumstances played some part in directing Constable towards solitude, and a determination like that he showed in 1802 to be a landscape painter at all costs. His family began to put pressure on him. In 1809 his mother wrote, despairingly, '. . . dear John how much do I wish your profession proved more Lucrative when will the time come that you realize ! ! !'[2] To add to their exasperation, that year he fell in love with Maria Bicknell, going so far as to contemplate marriage, which, considering that in 1814 Maria was to state that 'people cannot now live upon four hundred a year'[3] may have been foolhardy. Certainly his family sometimes saw it this way. In January 1811 his mother reacted with a mild 'I should like to see & know you were Comfortable & *independent*',[4] in contrast to the previous March when she had warned her son to 'be wary of how you engage in uniting yourself with a House mate as well as in more serious & irrevocable yokes'.[5]

Before 1811 the courtship seems to have followed a steady course, although the opposition expressed thereafter by Dr Rhudde was enough eventually to have Constable forbidden the Bicknell household, and for Maria herself, in December 1811,[6] to urge that they terminate their correspondence. The unhappy state of their relationship was one reason for Constable's subsequent protracted stays in East Bergholt, but in 1810 the turn for the worse had yet to occur. What we see in his art, though, is greatly interesting. Firstly, his oil sketching technique attained spectacular maturity in 1810. Secondly, in 1811 Constable made a calculated attempt to establish himself as the painter of the Stour Valley. Charles Rhyne has suggested[7] that something of the impetus for Constable's artistic improvement derived from his emotional state, a theory made more attractive by virtue of Constable having been an artist who allowed his mood to affect his work.[8] And, to appear a feasible suitor, it would have been necessary to display himself as an original and important painter at the Royal Academy exhibition. His reaction to professional crisis in 1802 had been to return to Bergholt and paint laborious studies from nature. In 1810 and 1811 he exhibited the first two of a series of East Anglian landscapes, the deliberateness of this move retrospectively suggested by his writing in May 1812 'I have now very

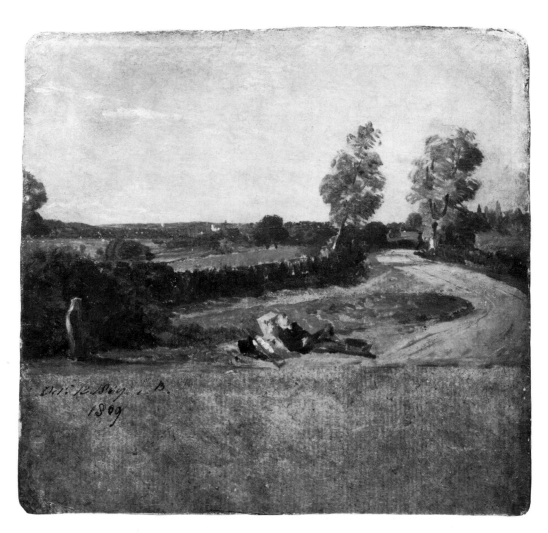

41. *Fen Bridge Lane and the Stour Valley* 1809 Oil 8½ × 12⅞ (21.6 × 32.7) on board 12¼ × 12⅞ (30.8 × 32.7). Inscr. 'Octr. 13 1809 EB'. Private Collection

distinctly marked out a path for myself, and I am desirous of pursuing it uninterruptedly.'[9]

His rapid technical advance in oil sketching is evident if an 1810 view of East Bergholt Rectory (Fig. 43) is compared with the 1808 one (Fig. 40). Constable was now working his paint on the picture surface, and had expanded his chromatic range to achieve a brilliant impression of the sun rising behind the Rectory. Furthermore, he had developed the confidence to attempt fine detail. An equally superb example of Constable's oil sketching is that shorthand but complete depiction of the Stour Valley from Flatford, yellowing under a lowering sky (Fig. 44), which is dated to *c.* 1810–12. Constable used brushes of varying sizes, and paint of varying dilutions: impasted in the left foreground, where it describes a spar and grasses, a very thin olive green strip to the left of Dedham Church. The red ground plays an important part, for example in establishing reflections in water; and the whole is not only astonishingly skilful, but produced, as it were, without effort. One has no impression of Constable's having puzzled over what colour to put where, as he had certainly had to do in 1808–9. The painting of the lock spars indicates his speed of working. A brush loaded with paint at first has lost most of it by the time the ones to the rear are being described. All is done in a series of fast slashes.

Although it is fair to assume that a number of oil sketches is now lost,[10] the remaining ones tell us much about Constable's way of seeing. He appears to have developed a capacity to perceive details of actual landscapes in terms of their rôles as features in the whole. The link between eye, mind, and hand was becoming highly tuned, and a chief difference between the oil sketches from 1810 and the 1802 studies is that while the latter appear intentionally laborious, the former are virtuoso

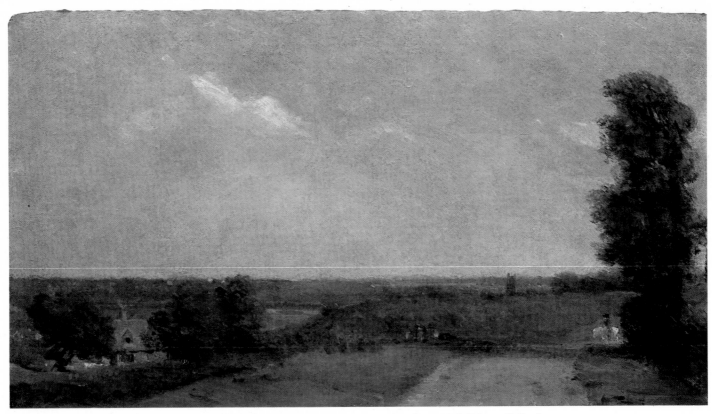

42. *View towards Dedham* 1808 Oil on board 5¾ × 10½ (14.6 × 26.7). Inscr. on recto '22. Sep. 1808'. Private Collection

43. *East Bergholt Rectory* 1810 Oil on canvas laid on panel 6 × 9⅝ (15.3 × 24.5). Inscr. '30. Sept. 1810 E. Bergholt Common'. Philadelphia Museum of Art, John G. Johnson Collection

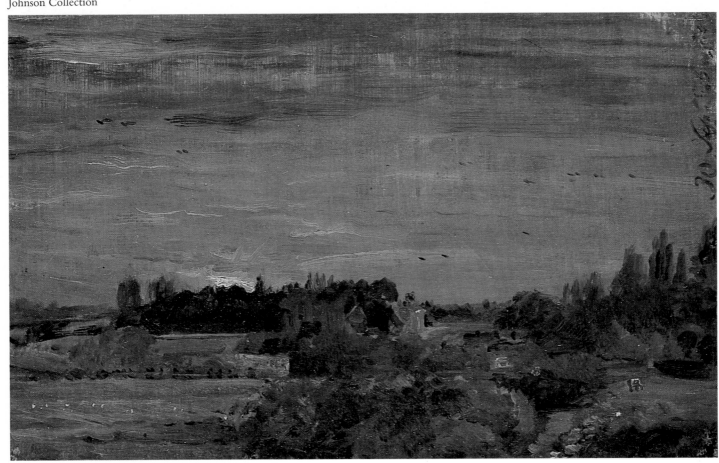

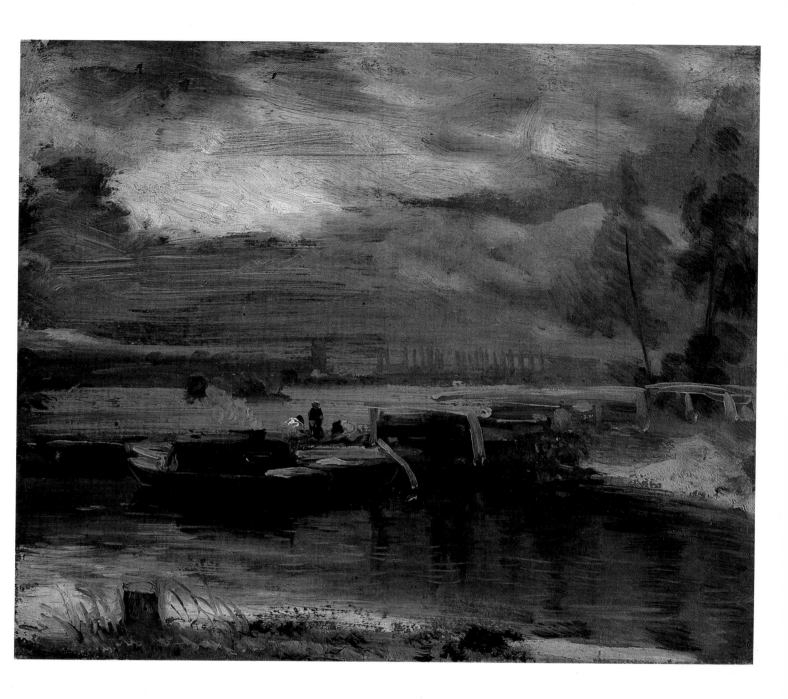

44. *Barges at Flatford Lock c.* 1810–12
Oil on paper laid on canvas 10¼ × 12¼
(26 × 31.1). London, Victoria and
Albert Museum (R.104)

45. *Barges on the Stour,*
twentieth century

performances. His expertise had advanced to the point where labour could best be displayed in a finished picture, rather than a study. By 1811 he seems to have evolved two sketching techniques, one where the paint was laid in fluidly, to create general effects (Figs. 44, 59), and another where he used less oily paint to achieve almost a 'mosaic' effect and transmit the impression of a landscape as a multiplicity of reflecting surfaces (Figs. 65, 164).

Having first shown it at the 1810 R.A., Constable re-exhibited *A Church Porch* (Fig. 47) at the 1811 British Institution;[11] while to the Academy that year he sent *Dedham Vale, Morning* (Figs. 39, 55), which developed the pretensions of the earlier picture. He had turned to the Stour Valley, and painted its scenery in such a way that, had cognoscenti noticed his pictures, they would have had to have taken his pretensions very seriously. Not only was the choice of terrain new, but so was the break away from the picturesque or sublime through the introduction of significant figures, providing subjects in harmony with the ethos of the landscapes themselves.

If *Dedham Vale, Morning* sets a precedent (see below), Constable worked the

47

46. *East Bergholt Churchyard c.* 1806
Pencil and wash $4\frac{7}{16} \times 3\frac{1}{8}$ (11.2 × 7.9).
Paris, Louvre (R.F.6110)

smaller *Church Porch* up from sketches, which explains why there is so fine a rendering of general effect at the cost of detail. Leslie described the composition as showing '. . . the stillness of a summer afternoon . . . broken only by the voice of an old man to whom a woman and girl sitting on one of the tombs are listening.'[12] And, as the subject certainly connects with Constable's illustrations to Gray's *Elegy* (Figs. 46, 48),[13] this means that we can relate his iconography to the poem.

A discussion of Constable's reading habits at this period will show how likely a thing this would have been, for although there is some evidence that, at this period, he liked Byron,[14] not only was his mind stored with eighteenth-century rather than modern poetic ideas, but he also found them to have real meaning in the conduct of life. In a parallel to the 1802 paraphrasing of Reynolds, Constable was able easily to adapt poetic sentiments to apply to his own condition. In Chapter One we mentioned Constable parading his literary knowledge in an 1812 letter to Maria, where his 'landscape which found me poor at first and keeps me so' paraphrased Goldsmith in *The Deserted Village*. What Goldsmith wrote in 1770 of poetry fitted Constable's own sentiments towards landscape, and his method of paraphrase reveals both his knowledge of the poem, and his deep sympathy with Goldsmith's sentiments. He appears to have been equally at ease with other writing.

It would have been surprising if Constable had not been a reader of Thomson's *Seasons*,[15] first published in 1730. Like most people of his time he knew the poem well. In 1812 he cited Thomson to Maria,[16] and in 1816 referred to *The Seasons* in an attempt to dispel her fears of the penury which would be her likely lot were she to marry him. Writing 'what is the world to us, "its pomps, its follies, & its nonsense all" '[17] Constable adapted

> What is the world to them,
> Its pomp, its pleasures, and its nonsense all (*Spring* 1137–8)

a witty paraphrase from a section about

> . . . the happiest of their kind!
> Whom gentler stars unite, and in one fate
> Their hearts, their fortunes, and their beings blend (1110–12)

And Thomson goes on to write of the life of this happy couple as comprising

> An elegant sufficiency, content,
> Retirement, rural quiet, friendship, books,
> Ease and alternate labour . . . (1161–3)

Constable knew Maria would recognise his source, and appreciate his compliment of equating their relationship with that poetic ideal. Indeed, by substituting 'follies' for 'pleasures' he unconsciously revealed a little of the priggish side of his nature. The way that the passage refers to a life of retirement in rural quiet, lived on an elegant sufficiency, displays not only a sophisticated understanding of poetry, but also the extent to which Constable could find its attitudes fitting reality. This is of particular interest with respect to the conceit of rural retirement.

The Horatian ideal of the quiet and simple country life informed much eighteenth-century writing.[18] Gray's *Elegy* describes a community living it, and Goldsmith's anguish in *The Deserted Village* at the immoral dislocation of a similar group points up the morally desirable character of life as it was. The idea also lay behind some of Constable's apparently more straightforward remarks during the early 1810s, when this unlucky love affair impelled him to the refuge of rustic isolation. In May 1813 his 'I hope to be as much as I can at Bergholt, for to that dear Spot I always turn as a safe and calm *retreat*'[19] (my italics) suggests he took poetic myth as factual advice, and found literary ideas of an earlier period harmonising

48

exactly with his own thinking. On 27 May 1812 he was anticipating the summer.

> I am still looking towards Suffolk where I hope to pass the greater part of the summer, as much for the sake of pursueing my favorite Study as for any other account. You know I have succeeded most with my native scenes they have always charmed me & I hope they always will—I wish not to forget early impressions.[20]

Again Constable was taking over poetic diction. Early in *The Task* (1785) Cowper wrote that

> . . . scenes that sooth'd
> or charm'd me young, no longer young, I find
> Still soothing and of pow'r to charm me still (*The Task* I 141–3)

If Constable's 'I wish not to forget early impressions' relates to this, it supports the idea that he was appropriating Cowper to his own use. This is probable, as in 1812 he complained to Maria about not being allowed to communicate with her ' "with Your Arm fast locked in mine" as Cowper says'[21] and had adapted lines from that same section of *The Task*:

> And witness, dear companion of my walks,
> Whose arm this twentieth winter I perceive
> Fast lock'd in mine . . . (144–6)

Constable clearly found Cowper's response to a familiar local landscape more than appropriate to his own circumstances. This is not surprising, as he preferred Cowper 'to almost any other' poet[22] (again in 1812), and seems to have identified strongly with him.

This points to the reality of a poem like *The Task* for such a reader as Constable. He would have taken Cowper's sentiments as truths, and this suggests that he would have read Goldsmith or Thomson in the same way. It seems, in particular with *The Task*, that Constable identified himself with Cowper to the extent that he could see himself in the rôle of the poem's subject; Cowper, to Maria Bicknell's Mary. And therefore he was able, too, to live out its morality.

Like the poets, Constable celebrated the simple country life. He found it morally preferable to what the poets saw as its natural opposite, urban dissoluteness, and like theirs his morality was broadly georgic—a word which, in a restricted sense, must refer to Virgil's poem, or those which in eighteenth-century Britain were written in imitation of it. Virgil advocated the harmonious establishment of a rural society ordered on a socially moral basis, which would generate the civil order and material wealth that would add even further to Rome's greatness and the glory of Octavian. The Augustans found the nearest parallel to eighteenth-century Britain to be Imperial Rome, and until about 1760–80 georgics were written for the simple enough reason that poets considered them appropriate to the description of contemporary society and landscape.[23]

In its British manifestation the georgic in this sense was a social poetry, founded in a rural society in which all worked for the common good, and which divided workers into those who laboured, and those who dictated, their common 'industry' directed to the shared end of national advancement and glory decided on by the latter. In the agricultural context, labour tended the landscape to produce wealth in the form of crops which, when traded, funded the cities, thriving with commerce and arts, which denoted the healthy civilisation. There was a chain of causation linking the ploughman with what his labour ultimately produced; thus to break the chain would jeopardise society. Consequently the georgic had also a moral aspect, exalting such social virtues as Industry or Honesty, and damning indolence or dishonesty. This

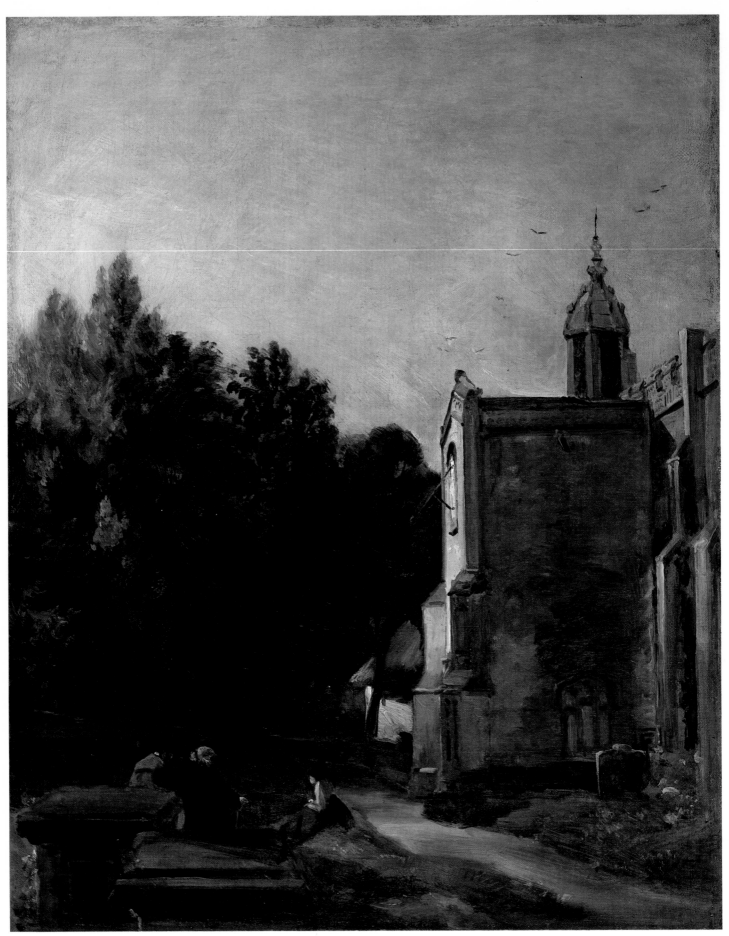

47. *A Church Porch* 1810 Oil on canvas $17\frac{1}{2} \times 14\frac{1}{8}$ (44.5 × 35.9). London, Tate Gallery

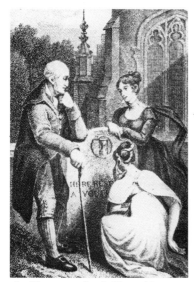

48. Chapman after J. Constable, Frontispiece to *A Select Collection of Epitaphs and Monumental Inscriptions*. Ipswich 1806

49. N. Poussin *Et in Arcadia Ego* 1639–40 or 1642–3 Oil on canvas 33¾ × 47⅝ (85.75 × 121). Paris, Louvre

50. N. Poussin *Et in Arcadia Ego* 1629–30 Oil on canvas 39¾ × 32¼ (101 × 81.9). Chatsworth, the Duke of Devonshire

morality underpinned much of Constable's reading of poems not in themselves georgics, and part of the broad appeal of, say, *The Task*, must have lain not only in its literary expression of everyday life, but also in the way its moral analysis of actions accorded with habits of thought Constable had learned from his mother.

One indication of the attraction that Cowper, for instance, held for a country readership is that the *Ipswich Journal* published excerpts from *The Task* throughout 1786,[24] perhaps confirming in the young Constable his deep admiration for 'the poet of Religion and of Nature'.[25] And it is interesting that Aikin's *Calendar of Nature*, a book of which Constable was in 1821 to say he was so fond that he was 'always giving it away'[26] has been serialised in the same newspaper between 1784–5.[27]

The rural professional class to which the Constables belonged found georgic sentiments particularly appropriate at this period. We have observed Thomas Ruggles liking to see the plough moving in summertime over a fallow field: he found that it enhanced the aesthetic *value* of the landscape. To describe an agricultural landscape as 'georgic' is to indicate something of the nature, profundity, and social complexity of its iconography; and recent writing on British landscape of this period has shown not only the usefulness of using the term in this way, but also the extent to which a 'georgic' way of thinking came naturally to this class.[28] Consequently, when using 'georgic' I shall be referring to this historical context; further reasons for which will become clear as the text proceeds.

If we return to *The Church Porch* and Gray's *Elegy* two things should now be plain. Firstly, Gray was the kind of poet Constable preferred. Secondly, the idea of making art out of the unsophisticated and unobtrusive cycle of rural birth and death would probably have appealed strongly to him. The pictorial reference of the figures in *A Church Porch* to his own illustration to Gray was deliberate. It also gave a key to his iconography.

In the local sense Constable equated East Bergholt with Stoke Poges, picturing the old man and tombstone to remind us that youth fades and death comes, the church suggesting the Christian context in which life must be lived and imbuing the painting with a moral air. Constable was sophisticated enough a painter to reinforce this iconography by making pictorial reference to Poussin's *Et in Arcadia Ego* (Figs. 49, 50) (he had seen the Chatsworth version in 1801). That 1806 drawing makes a direct connection with Poussin's shepherds, and if the figures in the painting link with the drawing, then so must they refer to Poussin. Constable may even have known the story of Reynolds and Dr Johnson, when the latter, puzzled by the inscription 'Et in Arcadia Ego' on a tombstone in the background of a double portrait, was told by Sir Joshua that George III had correctly understood it as 'death is even in Arcadia';[29] and Panofsky has shown how the theme had become assimilated into the cultural stock-in-trade of the eighteenth century.[30]

More immediately, Turner had also referred to this imagery, both in *Pope's Villa at Twickenham* (Fig. 51) and, more obliquely, in *Thompson's Aeolian Harp* (Fig. 52), exhibited in his own gallery in 1808 and 1809 respectively. Both compositions are 'Claudean', the latter connecting compositionally with the *Mill* (Fig. 104), to sharpen the poignancy of their elegy to the Augustans by arranging the terrain to recall what Gessner had found to be the quintessentially georgic landscape type. Constable shaded his landscape's mood differently to Turner, for his painting was about an unchanging East Bergholt, a place which his pictorial sophistication forces us to see as a species of Arcadia, an ideal landscape in the very form it presents itself He reflected his own affection for the place, and made clear something of its nature.

In this *A Church Porch* is one with *Dedham Vale, Morning*, although the point there is made more obviously, and the image can be decoded more easily. The composition derived from oil sketches (Figs. 41) and ended a process during

51. J. M. W. Turner *Pope's Villa at Twickenham* 1808 Oil on canvas 36 × 47½ (91.5 × 120.6). Trustees of the Walter Morrison Picture Settlement

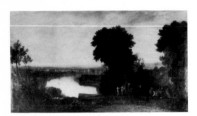

52. J. M. W. Turner *Thomson's Aeolian Harp* 1809 Oil on canvas 65⅝ × 120½ (166.7 × 306). City of Manchester Art Galleries

53. (facing page, above). *Dedham Vale* 1809–10 Oil on paper laid on panel 8½ × 12½ (21.5 × 31.8). Collection Stephen Raphael

54. (facing page, below). J. Constable(?), Compositional Study for *Dedham Vale, Morning* 1810–11 Oil on panel 6 × 10¾ (15.24 × 27.3). Whereabouts unknown

which the topography was subtly transformed. By making the landscape more expansive, emphasising a tree on the left, and opening up a subsidiary perspective on the right (Fig. 53), Constable, without falsifying the detail of the terrain, turned the sketch into a 'Claude'. The deliberate development of the composition is apparent from preparatory sketches on wood (Fig. 54) where he experimented with broadening the landscape. Moreover, while the Claudean composition refers it to an ideal, truth to place is enforced through the descriptive style, the attempt to refine a 'natural painture'. Perhaps the silver birch is too ornate to escape looking as though it had been transplanted from Wilson, and the main foliage masses of the trees to the right are not clearly distinguished, but in many other passages the naturalism is remarkable. The lighting of Dedham church tower, the restive cattle, the trees in the middle distance: all attest to Constable's capacity to translate specific observation onto the larger scale, working far from the motif. The western sky even indicates the imminent formation of cumulus cloud, which will betray the promise of the morning.

The 1802 studies had also included Claudean landscapes, but then Constable had recognised scenes as paintable because of his memory of Claude, and had performed a picturesque assessment of the terrain. With *Dedham Vale, Morning* he defined the scene's potential for himself, recognising the capacity of reality to fit a Claudean pattern, and by *imposing* this on his topography revealed that his attitude to landscape had changed and become more sophisticated.

By this relation to the Claudean format, modern works could become possessed of high pretensions, something which should be considered a little more closely, for to understand these pretensions in more detail (as we can, for example, with *Thomson's Aeolian Harp*, a painting connected directly to a descriptive passage in *The Seasons*) assists in a more precise appreciation of Constable's achievement in turning the Stour Valley into a Claudean landscape in *Dedham Vale, Morning*.

Eighteenth-century poetic descriptions of landscapes have important connections with pictorial models, as John Barrell has described.[31] There is an early example of this transposition in Pope's *Windsor-Forest*:

> Here waving groves a chequer'd scene display
> And part admit, and part exclude the day;
> As some coy nymph her lover's warm address
> Nor quite indulges, or can quite repress.
> There, interspers'd in lawns and op'ning glades,
> Thin trees arise that shun each other's shades.
> Here in full light the russet plains extend:
> There wrapt in clouds the blueish hills ascend. (17–24)

Pope arranged his description to direct attention via 'here' and 'there' from the foreground to the distance. The waving groves are close, hence four lines are devoted to them; but the thin trees are far enough away to be perceived along with lawns and glades in just two. Eventually the 'eye' moves to the plains and hills. To emphasise how pictorial an arrangement this is, Pope allows the scene light, shade, and colour. It is significant that it is initially linked with the 'Groves of Eden',[32] and summarised in 'hills and vales . . . woodland and . . . plain/earth and water',[33] for this allows an overview of the landscape in which

> . . . order in variety we see,
> And where, tho' all things differ, all agree. (15–16)

After this comes that pictorial landscape description, arranged in a way at least reminiscent of a Claude (Figs. 33, 104), for the perspective to the distance is articulated through tonal bands,[34] and 'blueish' may be a verbal approximation to the faded hue

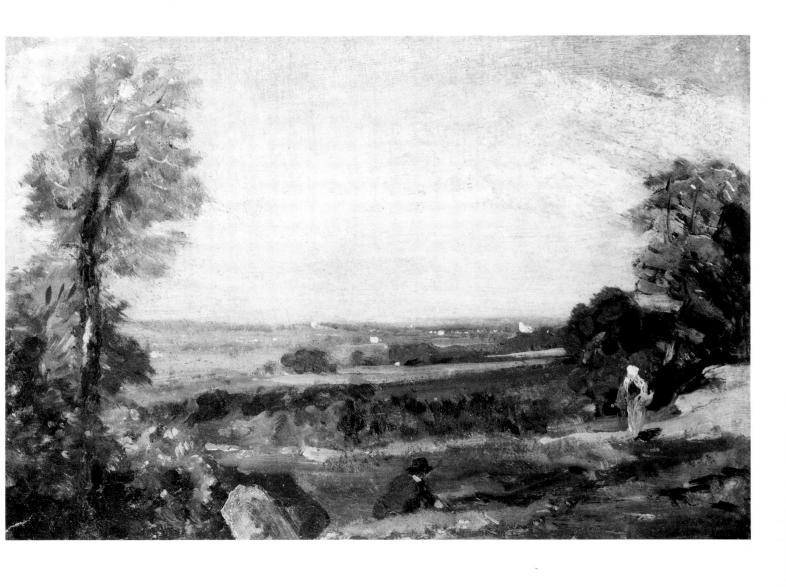

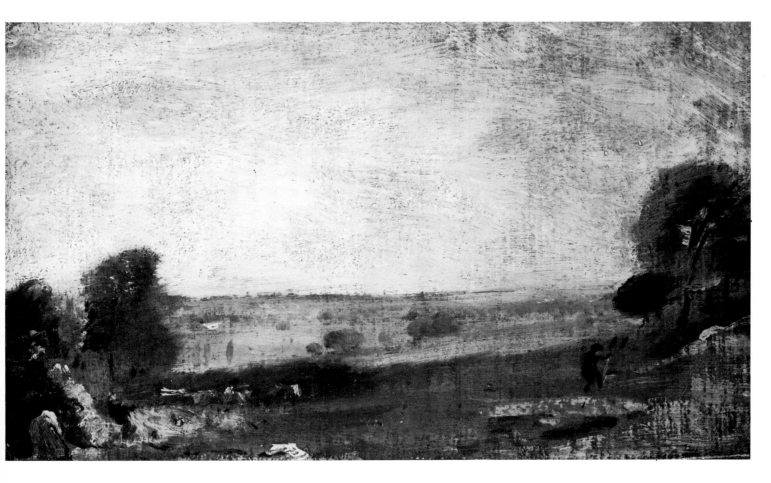

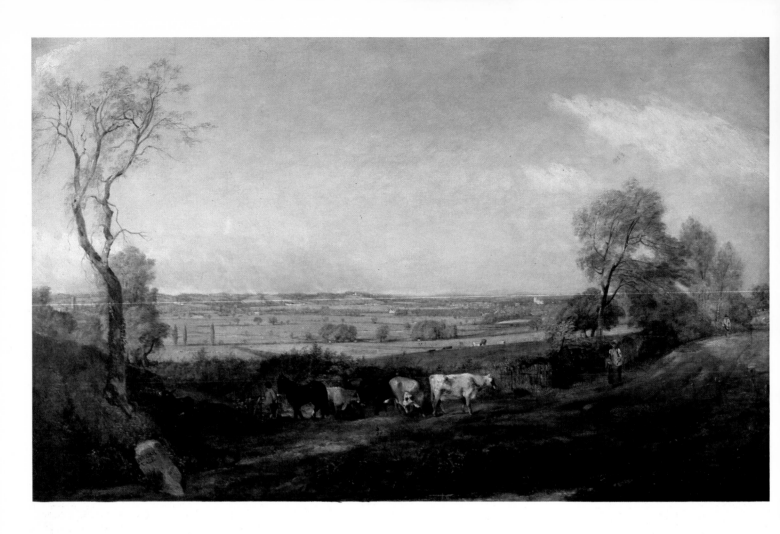

55. *Dedham Vale, Morning* 1811 Oil
on canvas 31 × 51 (78.8 × 129.5).
Major Sir Richard Proby Bart

the hills assume in the backgrounds of so many of Claude's paintings. And a
connection between Claude and *Windsor-Forest* might help our understanding of
what Pope exactly meant by 'harmonious' confusion[35] or 'order in variety'. Having
painted his scene, and linked it with Eden, one version of the landscape of the golden
age, Pope's conclusion

> Rich Industry sits smiling on the plains,
> And peace and plenty tell, a STUART reigns. (41–2)

firmly establishes its georgic nature.

This was the first of many such poetic landscapes which, until the nineteenth
century,[36] by being made the locations for thriving husbandry, bustling trade, and
busy communities, were defined as microcosms of that greater Paradise on Earth,
Britain. Turner's view from Richmond Hill was based on a passage from *The
Seasons* which opens by inviting us to 'sweep/The boundless landscape'.[37]
'Landscape' has a precise pictorial connotation. Turner automatically conceived this
influential passage as a Claude, and because of the direct connection between word
and image, his iconography is accessible.

It is important to note that Thomson made this view from Richmond Hill the
essential *British* landscape; and at the passage's opening, his tone is celebratory:

> Here let us sweep
> The boundless landscape; now the raptur'd eye,
> Exulting swift, to huge Augusta send;
> Now to the Sister-hills that skirt her plain;
> To lofty Harrow now; and now to where
> Majestic Windsor lifts his princely brow. (*Summer* 1408–13)

54

The prospect is vast. Thomson spans town and country, and his eye moves from Augusta up the Thames

> . . . to where the Muses haunt
> In Twit'nam's bowers; and for their Pope implore
> The healing God . . . (1426–8)

Finally, exulting, he closes his description.

> Inchanting vale! beyond whate'er the Muse
> Has of Achaia or Hesperia sung!
> O Vale of bliss! O softly swelling hills!
> On which the power of Cultivation lies,
> And joys to see the wonders of his toil. (1433–7)

Here the 'power of cultivation' links with Pope's 'rich Industry' to the same effect. Yet, continuing the passage, Thomson recapitulates the scene, and identifies it in a more general sense:

> Heavens! What a goodly prospect spreads around,
> Of hills, and dales, and woods, and lawns, and spires,

56. *Flatford Mill from the Lock* ?1811
Oil on canvas $9\frac{3}{4} \times 11\frac{3}{4}$ (24.8 × 29.8).
London, Victoria and Albert
Museum (R.103)

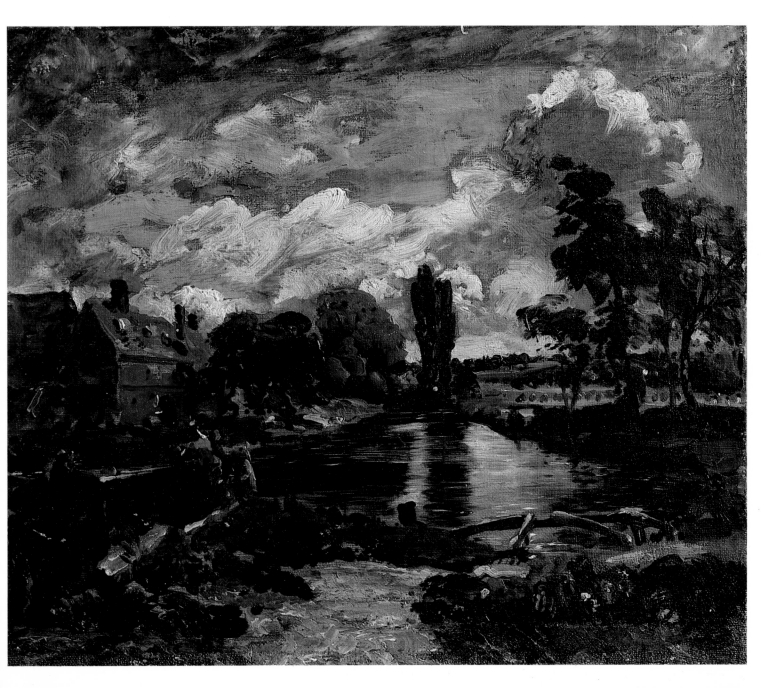

And glittering towns, and gilded streams, till all
The stretching landscape into smoke decays!
Happy Britannia! Where the Queen of Arts,
Inspiring vigour, Liberty abroad
Walks unconfin'd e'en to thy farthest cots,
And scatters plenty with unsparing hand. (1437–44)

In this brilliantly chauvinistic writing Thomson summarises the earlier lines with 'goodly prospect' (a Prospect being that type of landscape painting in which the country is surveyed from a high viewpoint) and identifies it as 'Happy Britannia'. For its detailed description we must return to the earlier passage, and recall the 'boundless landscape', 'huge Augusta', or 'Majestic Windsor'. Their enormous size contrasts with rural Thameside quiet, where the poets, living their soft, secure, inglorious lives, add, through their achievement, to the glories of the state. As all this is the 'wonders' of the toil of Cultivation, this forces the georgic equation. Thus the view of the Thames valley from Richmond Hill became the type of the landscapes of Happy Britannia.

Turner, who linked the passage with his own and Thomson's poetry on the Aeolian Harp,[38] would have been unusual had he not realised it in Claudean terms. In the foreground of his consummately boundless vista (where, nonetheless, flocks can be detected along the banks of a Thames down which vessels ply) the artist placed nymphs decking the Aeolian Harp (which makes the music of nature) with wreaths, and a classical ruin pointed to the Augustan equation. Turner demonstrated the timeless importance of Thomson's sentiments. He celebrated an England at war, the Happy Britannia which must triumph against the French.

It would be wrong to claim that, because it, too, is Claudean, *Dedham Vale, Morning* presents landscape on terms equivalent to *Thomson's Aeolian Harp*, for it is in a minor against Turner's major key. Yet something analogous to the Turnerian vision imbues the painting. It portrays an obscure patch of England, where people perform the mundane tasks of a summer's morning, much as in *The Church Porch* those figures typify the kind who might be found in a country churchyard. As Turner qualifies the Thames Valley as a species of Arcadia, so *Dedham Vale, Morning* infers that as it is with the Stour Valley, then so it is with Britain. From *Windsor-Forest* onwards, the Thames had been taken as the representative British river. Constable holds up the Stour for admiration beside it. The milkmaid may have been the one who collected those cows each morning, but she also represents the labourers who populate a georgic world.

Content like this makes the picture unpicturesque, and meshes it firmly into a web of contemporary attitudes and opinions. Constable linked his pictorial beauty with its cause, and in these two paintings presented rather a different idea of place to that in earlier Stour Valley landscapes. Moreover, its textual content allows *Dedham Vale, Morning* the morally-uplifting function Reynolds held to be the province of history painting. Constable had learned the techniques of a 'natural painture' both from the *Discourses*, and from the teaching of Beaumont and Farington; but he now discovered a means of investing the landscape with value-systems, and to an extent the acceptance or denial of these is essential to judging the image correctly. As a conservative solution to the problem of supplying the moral and serious art which, at that period, history painting had ceased to provide, *Dedham Vale, Morning* and *The Church Porch* were strikingly individual paintings.

This iconography underpins the larger painting's delicate beauty: Constable transmitting the peculiar amenity of an early summer's morning, and granting us, perhaps, appropriate associations of scents and sound. *Dedham Vale, Morning* broke new ground for him by reflecting something of his own feeling for place. As we

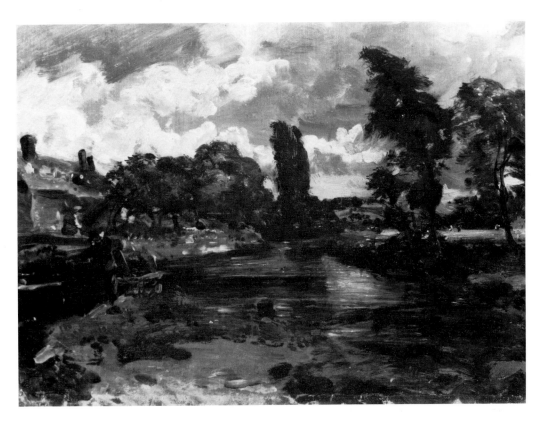

have seen, Constable's love for East Bergholt was a constant theme in his letters to Maria. He wrote in 1812 how he preferred 'Bergholt and the vicinity of our own house to almost any other',[39] or how he loved to be 'in this delightfull place . . . amongst my favourite Haunts',[40] while we have seen that in 1813 he was finding the village 'a safe and calm retreat'. His pictorial presentation of the landscape was a quite natural expression of what he, as an inhabitant, felt for it. He also self-consciously presented the canvas as an 'important' work.

Farington reported Constable's anxiety over the painting's fate. On 23 April 1811 he wrote that

> Constable called, in much uneasiness of mind, having heard that his picture—a landscape, 'a view near Dedham, Essex' was hung very low in the Anti-room of the Royal Academy. He apprehended that it was proof that he had fallen in the opinion of the members of the Academy.—I encouraged him & told him Lawrence had twice noticed his picture with approbation.

And Lucas added to this impression of Constable having staked a great deal on *Dedham Vale, Morning* by noting, 'He has often told me this picture cost him more anxiety than any work of His before or since that period in which it was painted. that he had even said his prayers before it.'[41]

In portraying the Stour Valley Constable was shifting from the safe ground of convention. In contrast to the Lake District this was a landscape which generally escaped notice. On the other hand, the scenery of the Orwell was recognisable to a larger part of his audience since it had, as Constable well knew, the aesthetic bonus of its association with Gainsborough. As early as 1764 the latter's friend Joshua Kirby wrote of the estuary as 'so to speak, cautiously . . . *one of the most beautiful Salt Rivers in the World*',[42] Arthur Young was entranced by it,[43] and Cobbett had found that you could go hardly a quarter of a mile from Ipswich 'without finding views that a painter might crave'. So had Constable remained true to type as the purveyor of popular landscapes, he would more logically have gone a few miles from East Bergholt, to paint along the banks of the Orwell. Those two donkeys may make the

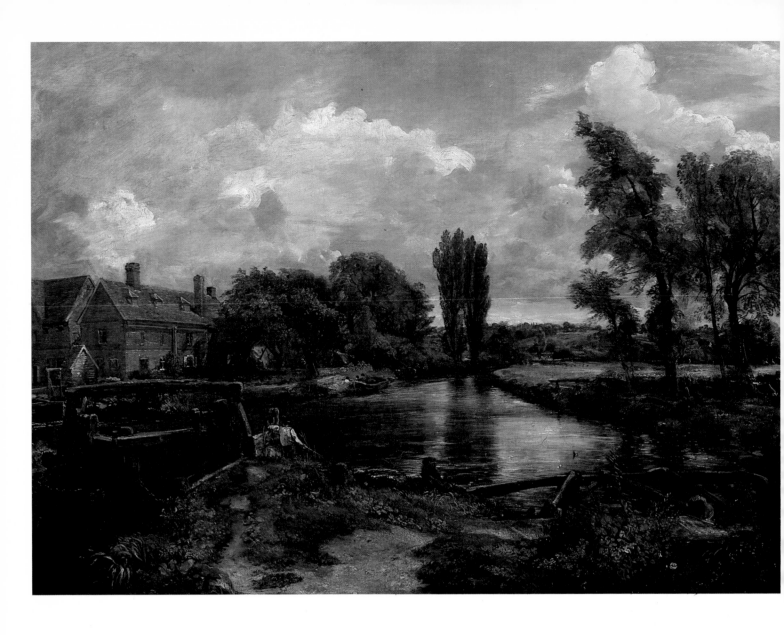

58. (left). *A Water-Mill* 1812 Oil on canvas 26 × 36½ (63.7 × 89.42). Washington D.C. Corcoran Collection (Anonymous Loan)

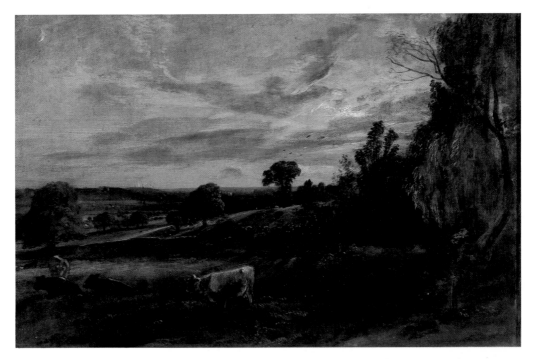

60. (right). *Landscape: Evening* ?1812 Oil on canvas 12½ × 19½ (31.7 × 49.5). London, Victoria and Albert Museum (R.98)

59. (left). *A Hayfield at East Bergholt* 1812, July 4. Oil on paper 6¼ × 12½ (16 × 31.8). London, Victoria and Albert Museum (R.115)

Gainsborough connection explicit, for these were beasts of which the earlier painter had been fond (Figs. 22, 232). Hence *Dedham Vale, Morning* is an assertive and challenging painting. Constable probably inscribed the title on a milestone as a deliberate pun. Unfortunately only he recognised the work for the milestone it was. Its fate is retailed by Leslie. 'Such pictures were . . . too unobtrusive for the exhibition, and Constable's art had made no impression whatever on the public.'[44] Indeed, *Dedham Vale, Morning* remained unsold.

One reason Constable had staked so much on it was that during 1811 he was seriously contemplating marrying. In October while his hopes for a 'future union' with Maria were flimsy[45] she was more optimistic,[46] but neither knew how to surmount the overriding problem of Constable's chronic poverty.[47] Eventually they resigned themselves to a prolonged courtship and their correspondence took on something of a clandestine character.

Constable himself described what he had been doing over 1811 in a letter of November 10: 'I can give but a poor account of myself. I have tried Flatford Mill again, from the Lock (whence you once made a drawing), and some smaller things. One of them (a view of Mrs Roberts's lawn—by the summer's evening)—has been quite a pet with me.'[48] This can be related to the canvases Constable exhibited at the 1812 Royal Academy as *A Water-Mill*, and *Landscape: Evening* (Figs. 58, 60), the one being a view of Flatford from the lock, and the other a view of Mrs Roberts's ground.[49] Fortunately Charles Rhyne has tracked the former canvas down, and has instigated its cleaning, besides introducing it to the public.[50] Consequently we are able to associate with it a number of oil sketches done between 1810–11 (hence Constable's 'again').

The various oil sketches (Figs. 56, 57) were made from the head of the lock, looking down the river, with a view to the left of the mill, and to the right of watermeadows. That in the Victoria and Albert Museum (Fig. 56) most closely relates to the final composition. Although the sketches vary in tonality, they tend to concentrate on dramatic effects of sky, and reflections on the river; both important to the exhibited painting, which likewise shows a clear attempt at handling the responses of various features to a slightly muted sunlight. It seems that Constable was keen to transfer the sketches' spontaneity on to the larger scale of 26 × 36½ inches, for his paint has been applied in spots and dabs, and the technique is rougher than with *Dedham Vale,*

Morning. Neither is it a painting with a great colour-range, although the *Landscape: Evening* has more.

In trying to marry the general effects of light, shade, and colour forced on him by looking into the light, Constable here attempted the detail he knew to be perceptible in the foreground and near distance, producing in consequence a visually discordant painting. Indeed, it may be an acknowledgement of this only partial success, that soon after the exhibition, in July 1812, he was back at Bergholt making oil sketches of comparable subjects (Figs. 59, 64). In these he worked his paint thickly, the intermixing of the paints being mimetic of the dissolution of form when looking into the sun, and impasting his own sun on a pink sky.

These 1812 Royal Academy exhibits reveal two things about Constable's practice and aspirations. The first is that he premeditated his exhibition paintings, and made deliberate series of oil sketches in preparation for them. The second is that he had for the moment abandoned the pretensions of *Dedham Vale, Morning*, returning to the picturesque, presumably in the hope of attracting the buyers who had missed the point in 1811. It may be no accident that the *Landscape: Evening* repeated a subject first attempted in the 1802 studies. It appears, nevertheless, that having turned to the Stour Valley landscape, Constable was determined to keep on painting it, for, as he wrote on 27 May 1812, 'I have now very distinctly marked out a path for myself, and am desirous of pursuing it uninterruptedly.'

Certainly, as oil sketches dated 1812 show (Figs. 59, 62, 64, 66), he was working brilliantly, and his pencil drawing was also steadily becoming more precise. There was virtually a nervousness to the exactness and care for which he strove in a detailed description of Flatford Lock (private collection), while a very beautiful and wide view of Dedham from Langham (Fig. 61) connects with oil sketches (Fig. 62, 63) and might have been part of the preparation for a projected exhibition canvas.[51] The pictorial evidence suggests a consistent development in a 'natural painture', for Constable was studying appearances with discipline and increasing confidence. His letters too show how he was keeping to the programme he had outlined in May 1802. Having made these superb oil sketches through July 1812, on the 22nd he was to write to Maria,

> How much real delight have I had with the study of Landscape this summer, either I am myself much improved in *'the Art of seeing Nature'* (which Sir Joshua Reynolds calls painting) or Nature has unveiled her beauties to me with a less fastidious hand . . . but I am writing this nonsense to You with a really sad heart, when I think what would be my happiness could I have this enjoyment with You—then indeed would my mind be calm to contemplate the endless beauties of this happy country—[52]

In the twelfth Discourse Reynolds had stated that '*The art of seeing Nature*, or in other words the art of using Models, is in reality the great object, the point to which all our studies are directed',[53] and had elsewhere written that, since 'The rules of Art are formed on the various works of those who have studied Nature the most successfully', 'all the rules which this theory, or any other, teaches, can be no more than learning the art of *seeing* Nature'.[54] By 'the art of seeing nature', then, Reynolds meant the art of using what was to be had from the masters when coming to nature oneself. Constable acknowledged the source of 'the art of seeing nature', but, by equating this with 'painting', implied, consistently with his thinking since 1802, that painting was 'the art of using models' to help in the original study of natural appearance.

While ploughing that same furrow, the artist was reacting to events with unusual determination. Clearly committed to landscape, he would continue to express his affection for 'my beloved Bergholt'[55] as he worked there,[56] and opposed those who

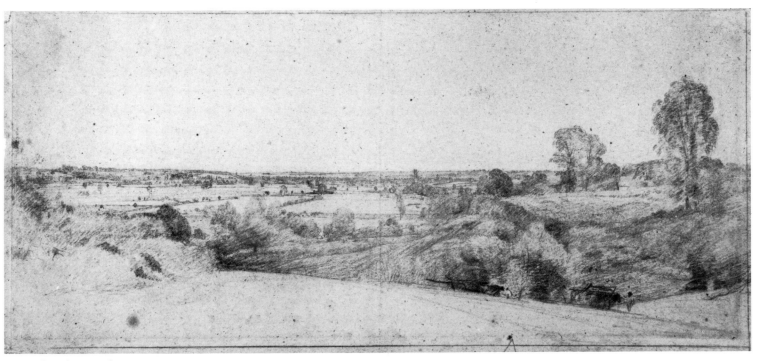

61. *Dedham from Langham c.* 1812,
Pencil with white heightening
$12\frac{5}{8} \times 26\frac{1}{4}$ (31.2 × 66.7). Dept. of
Prints and Drawings, The Royal
Museum of Fine Arts, Copenhagen

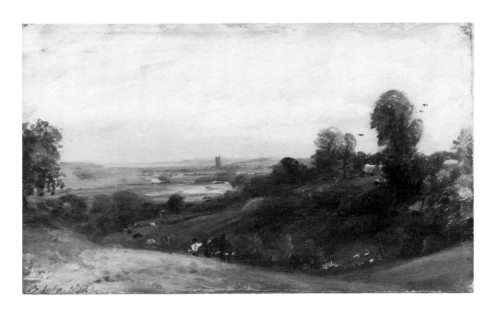

62. *Dedham from Langham* 1812, July
13 Oil on canvas $7\frac{1}{2} \times 12\frac{5}{8}$ (19 × 32).
Oxford, Ashmolean Museum

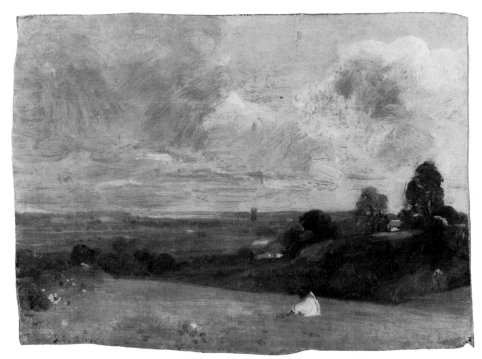

63. *Dedham from Langham c.* 1812, 24
Aug. Oil on canvas laid on board
$5\frac{3}{8} \times 7\frac{1}{2}$ (13.6 × 19). London, Tate
Gallery

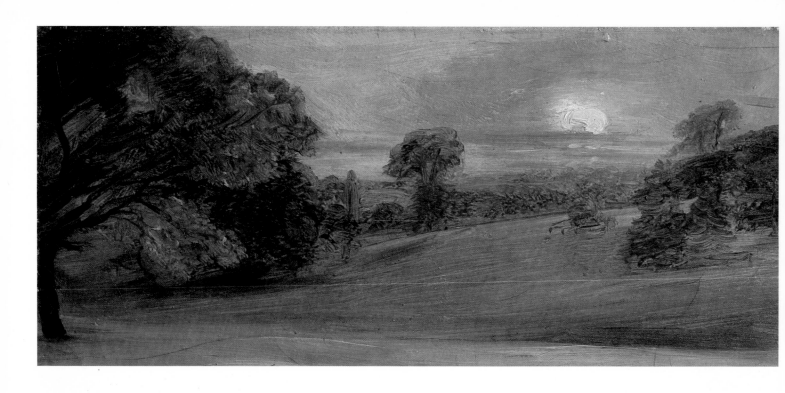

66. *Landscape with a Double Rainbow* 1812, July 28 Oil on paper laid on canvas 13¼ × 15⅛ (33.7 × 38.4). London, Victoria and Albert Museum (R.117)

64. (facing page, above). *Evening Landscape at East Bergholt* 1812 July 7 Oil on canvas 6½ × 13¼ (16.5 × 33.7). London, Victoria and Albert Museum (R.116)

65. (facing page, below). *Dedham from Langham c.* 1811–13 Oil on paper laid on canvas 9⅞ × 12 (25.1 × 30.5). London, Tate Gallery

urged him to leave 'a profession so unpropitious'.[57] Indeed he found that he loved painting 'more and more dayly'.[58]

Constable found problems in translating the naturalism of his sketches on to the larger scale. Indeed so great is the discrepancy in quality between oil sketches and the 1813 *Landscape, Boys Fishing* (Fig. 70) that doubts have been raised about its authenticity.[59] Conspicuously a bad painting, where obtrusively detailed work clashes with areas of matt green, it is hard to reconcile with the calibre of the oil sketches. I would, however, agree with those who think it genuine.[60] What appear to be preparatory oil sketches survive, and correspondingly finished parts of the painting, the lock gates, or the elms, agree closely with Constable drawings.[61] And, as Constable was an unpopular artist, and the Stour Valley exclusively his terrain, some identity for the *pasticheur* needs to be proposed. *Landscape, Boys Fishing* illustrates the problems he found in transferring the detail he apprehended in nature on to canvas in the studio, and also maintains the picturesque.

63

67. *East Bergholt Rectory* 1813 August
19 Oil on canvas on panel $4\frac{1}{4} \times 5\frac{5}{8}$
(10.75 × 14.25). New Haven, Yale
Center for British Art, Paul Mellon
Collection

68. 1813 sketchbook. Pencil $3\frac{1}{2} \times 4\frac{3}{4}$
(8.9 × 12). London, Victoria and
Albert Museum (R.121) p. 21

69. 1813 sketchbook. Pencil $3\frac{1}{2} \times 4\frac{3}{4}$
(8.9 × 12). London, Victoria and
Albert Museum (R.121) p. 46

Constable found it easiest to work out of doors. Oil sketches of 1813 are of familiar quality (Fig. 67), and even more is revealed of his capacities by the justly celebrated 1813 sketchbook (Figs. 68, 69, 71–6, 85–6, 150). This is filled with thumbnail drawings of incidents and landscapes, mainly in and around East Bergholt, but also as far away as Colchester. Constable was unnecessarily modest when he wrote of it to Maria Bicknell in 1814: 'You once talked to me about a journal. I have a little one that I made last summer that might amuse you could you see it—you will then see how I amused my leisure walks—picking up little scraps of trees—plants—ferns—

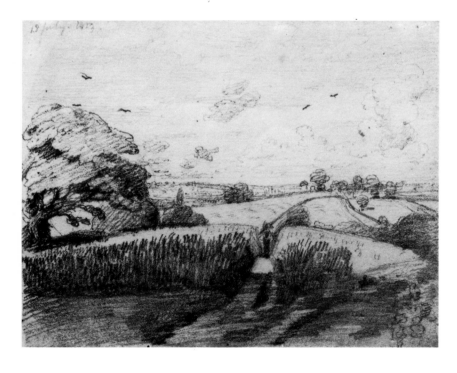

70. *Landscape, Boys Fishing* 1813 Oil
on canvas 40 × 49½ (101.6 × 125.8).
National Trust, Fairhaven Collection,
Anglesey Abbey

distances &c. &c. — '62 As it is a 'journal', and a product of Constable's 'leisure walks',
the sketchbook evidently records what caught the attention of that peripatetic villager
as he wandered at large through familar terrain.

Working on sheets of only 3½ × 4¾ inches, Constable displayed uncanny facility.
On page 21 (Fig. 68) is a scene at Bergholt, looking over fields of ripening corn towards
Stoke. A varied technique, going through hatching, to shading, to outline, created a
miniature precision in the placing of objects within the landscape, along with a
corresponding accuracy of depiction in this image of a cornfield with a path cut
through its heart. Elsewhere he worked on an even smaller scale. Page 46 (Fig. 69) has a
drawing of the scene upstream from Mrs Roberts's meadows, three studies of
labourers, and a view up a shady lane to a whitewashed cottage. Dedham from
Langham, a favourite vista, appears several times (Figs. 71, 72) along with near and far
views of the village fair (Figs. 75, 76), matchstick ploughmen (Fig. 74), or, on 11
August (Fig. 73), a barge and tow horse.

Constable's pencil and oil sketches reveal a by now astonishing capacity to
reproduce the appearances of nature, and thus to advance the 'natural painture'. He

65

71. (above left). 1813 sketchbook. Pencil $3\frac{1}{2} \times 4\frac{3}{4}$ (8.9 × 12). London, Victoria and Albert Museum (R.121) p. 36

72. (above centre). 1813 sketchbook. Pencil $3\frac{1}{2} \times 4\frac{3}{4}$ (8.9 × 12). London, Victoria and Albert Museum (R.121) p. 52

73. (above right). 1813 sketchbook. Pencil $3\frac{1}{2} \times 4\frac{3}{4}$ (8.9 × 12). London, Victoria and Albert Museum (R.121) p. 54

74. (right). 1813 sketchbook. Pencil $3\frac{1}{2} \times 4\frac{3}{4}$ (8.9 × 12). London, Victoria and Albert Museum (R.121) p. 72

75. (below left). 1813 sketchbook. Pencil $3\frac{1}{2} \times 4\frac{3}{4}$ (8.9 × 12). London, Victoria and Albert Museum (R.121) p. 85

76. (below right). 1813 sketchbook. Pencil $3\frac{1}{2} \times 4\frac{3}{4}$ (8.9 × 12). London, Victoria and Albert Museum (R.121) p. 87

77. *Willy Lott's Farm c.* 1812 Pencil
$7\frac{1}{8} \times 11\frac{3}{16}$ (20 × 28.4). London, Witt
Collection, Courtauld Institute of Art

78. *Willy Lott's Farm c.* 1813 Oil on
canvas $13\frac{3}{8} \times 11$ (34.0 × 28.0).
London, Victoria and Albert
Museum (R.373)

79. *The Mill Stream c.* 1810–13 Oil on board $8\frac{3}{16} \times 11\frac{1}{2}$ (20.8 × 29.2). London, Tate Gallery

was quietly determined to persevere with landscape, writing on 30 June 1813, 'I am quite delighted to find myself so well although I paint so many hours—perhaps too many but my mind is happy when so engaged—not only by being occupied with what I love—but I feel that I am performing a moral duty'.[63] This passage reveals not only that Constable found in his art a therapy for the spiritual turbulence created by personal circumstances (in 1815 he was to explain that his mind was 'never so calm and comfortable' as when working in the fields),[64] but also that he considered painting itself to be a form of work, as important a profession as any other.

Constable was advancing art, an index of civilisation. But work was itself intrinsically valuable, for it was essential for the progress of society towards perfection—

> . . . thy blessings, Industry! rough power!
> Whom labour still attends, and sweat, and pain;
> Yet the kind source of every gentle art,
> And all the soft civility of life:
> Raiser of human kind![65]

These self-explanatory lines suggest why Constable found painting a 'moral duty', his way of adding to the more general industry which lay at the base of national greatness. And, for Constable, opposed by Dr Rhudde, and the others who urged him to leave so unpropitious a profession, this was a vital defence against the charge that, because he did not appear to *do* anything, it followed that he was without employment.

The product of Constable's labour was the oil sketches and drawings made over the summer of 1813. As we saw, working from them on a studio canvas could create problems, and something of both their persistence, and Constable's awareness of them, is revealed in a letter he wrote to John Dunthorne, in February 1814, while he was preparing his exhibits for that year's Royal Academy exhibition.

> I am anxious about the large picture of Willy Lott's house, which Mr
> Nursey says promises uncommonly well in masses &c., and tones—but I am

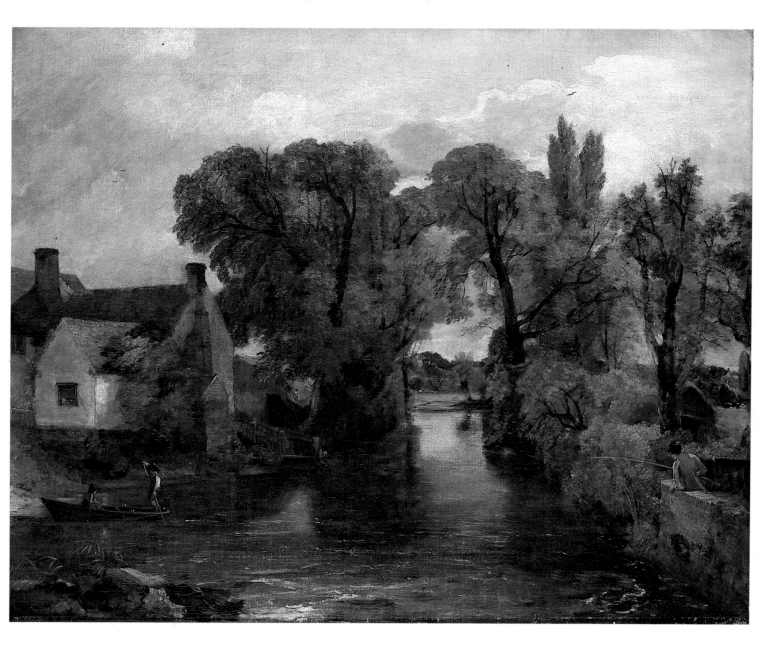

80. *The Mill Stream c.* 1814 Oil on canvas 28 × 36 (71.1 × 91.5). Ipswich Borough Council

determined to detail it but not retail it out. Mr Nursey is in Town to ship his son to the East Indies.

I have added some ploughmen to the landscape from the park pales which is a great help, but I must try and warm the picture a little more if I can. But it will be difficult as 'tis now all of a peice—it is bleak and looks as if there would be a shower of sleet, and that you know is too much the case with my things. I dread these feilds falling into Coleman's hands as I think he will clear them a good deal and cut the trees—but we cannot help these things.

I have much to say to you about finishing of my studies more in future—but I look to do a great deal better in future. I am determined to finish a small picture on the spot for every one I intend to make in future. But this I have always talked about but never yet done . . .[66]

The 'large picture of Willy Lott's house' was probably a version of *The Valley Farm* (Figs. 77, 78), rather than *The Mill Stream* (Figs. 79, 80) which is also of this period.[67] In either case Constable was working up his studio painting from oil sketches. For a picture to promise well in masses and tones would mean that while in general terms it cohered, Constable was frightened that the detail he wished to add would wreck it (as it had with *Landscape, Boys Fishing*). He appeared

69

to attribute these difficulties to working from sketches, for he meant 'to finish a small picture on the spot' in future, to provide a more detailed guide for studio work. He was aware that, working from nature, he achieved something of the 'completeness' which was evading him in the studio. He was genuinely bothered by this. He was scared to touch the landscape with the ploughmen because it was 'all of a peice', but still looked too wintry.

The way Constable wrote of his *Landscape, Ploughing Scene in Suffolk* (Figs. 81, 91) betrayed the force of his feeling for East Bergholt. From his canvas, his thoughts moved to the actual landscape he was in the act of painting: the kind of thing which could only happen with one who inhabited that countryside. As he worked, Constable worried about those fields falling into the wrong hands, exemplifying the way his ties with place meant that his artistic response to it was shaped by factors specific to his experience.

The addition of the ploughmen was to be of crucial importance, for Constable, having produced one agricultural landscape, went on to do others, the iconography of which is vital in increasing our knowledge of his attitudes to East Bergholt. Yet, although the *Ploughing Scene* did reflect what interested him in his native countryside, one can suspect that the initial impulse towards this kind of painting was the smart of a friend's preference for Turner's picture to his own in the 1813 Royal Academy (and perhaps a wish to do Gainsborough's farming landscapes over again from nature).

Turner had produced agricultural Thames scenes—*Ploughing up Turnips near Slough* (Fig. 84) is a good example[68]—from the early 1800s; and in 1813 exhibited the marvellous Yorkshire landscape, *Frosty Morning* (Fig. 85) at the Royal Academy. This has the seasonal subject of hedging and ditching, observed by a man and a girl, he with a gun, she with the hare he has shot serving as a scarf. John Fisher wrote to Constable of Turner's final agricultural landscape:

> I have just heard your great picture spoken of here by no inferior judge as one of the best in the exhibition . . . I only like one better & that is a picture of pictures—the Frost of Turner. But then you need not repine at this decision of mine; you are a great man like Bounaparte & are only beat by a frost—[69]

This struck Constable enough for him to transmit Fisher's opinion to Maria,[70] and it might be that now, as certainly was to be the case in the 1820s, he was taking an implied criticism badly. Generally he was sensitive to and appreciative of Turner's merits. In 1812 he found that although *Hannibal and his Army crossing the Alps* was 'so ambiguous as to be scarcely intelligible in many parts' it was nevertheless 'as a whole . . . novel and affecting'.[71] In 1814, though, Constable was more than usually conscious of Turner as a rival. He repeated to Farington criticism of Turner,[72] and to Maria Bicknell wrote this report on the exhibition:

> I have seen the Exhibition—'tis natural we should look first for our own children in a Crowd. I am much pleased with the look and situation of a small picture there of my own—I understand that many of the members consider it as genuine a peice of study as there is to be found in the room . . . a large Landscape of Turners seems to attract much attention—should we ever have the happiness to meet again it may afford us some conversation—my own opinion was decided the instant I saw it—which I find differs from that of Lawrence and many others entirely—but I may tell you (because you know that I am not a vain fool) that I would rather be the author of my landscape with the ploughmen than the picture in question.[73]

Turner's spectacular *Dido and Aeneas* was indeed large. Constable was comparing an exhibit $20\frac{1}{4} \times 30\frac{1}{4}$ inches with one $57\frac{1}{2} \times 93\frac{3}{8}$, and his conclusion opposed the general opinion. 'I am not a vain fool' rings hollow, and my impression is that, having

followed Turner's lead, Constable felt let down by the latter's move to academically acceptable historical landscape.

Constable may have assumed this tone because the *Ploughing Scene* was a picture to which he attached great importance in his struggle for recognition. Perhaps there was an element of chance in the addition of the ploughmen; nevertheless they gave the landscape an extra quality, for they allowed the composition to return to the type prefigured in 1810–11 and to reflect what the 1813 sketchbook tells us were his local interests. They did this directly, for the landscape came from page 12 (Fig. 85) and the ploughmen from page 71 (Fig. 86). And although this addition may seem arbitrary, I shall show that there was a strong likelihood that ploughmen would have been on that particular field at the season Constable painted; that, in thinking of his landscape, he mused about what actually would be happening there, in a way which fitted with his worrying about Coleman and the trees.

We must, furthermore, appreciate Constable's iconography, if we are to understand how precisely this painting reflected his local preoccupations. The subject of ploughing was firmly entrenched within a literary and pictorial tradition, as Constable himself emphasised, by including in the Royal Academy catalogue this couplet:

> But, unassisted through each toilsome day,
> With smiling brow the Plowman cleaves his way,

He carefully chose it from Robert Bloomfield's *Farmer's Boy*, a poem which pointed up the landscape's local singularity. An enormously popular work, which had already provided subjects for other artists,[74] it was a localised *Seasons*, centred on the annual round of the 'Boy', Giles, on a small farm near Bury St Edmunds. Although Bloomfield occasionally adopted a strain of lament for the past, this was infrequent; and because it linked with similar sentiments in *The Deserted Village*[75] to such a reader as Constable it would have appeared conventional, as a conceit designed to contrast with the poem's main concern of documenting the present.

The Farmer's Boy was sure to appeal to Constable. Under his kind master Giles's life was innocent, arduous, and pleasant. Despite occasional mawkishness, in general *The Farmer's Boy* is charged with a homespun version of the georgic which had more pretentiously informed earlier poems. Ripe cornfields, for instance, are introduced as

> A glorious sight, if glory dwells below,
> Where Heaven's munificence makes all the show,
> O'er every field and golden prospect found,
> That glads the Ploughman's Sunday morning's round,
> When on some eminence he takes his stand,
> To judge the smiling produce of the land.
> Here Vanity slinks back, her head to hide:
> What is there here to flatter human pride?
> The tow'ring fabric, or the dome's loud roar,
> And stedfast columns, may astonish more,
> Where the charm'd gazer long delighted stays,
> Yet trac'd but to the *architect* the praise;
> Whilst here, the veriest clown that treads the sod,
> Without one scruple gives the praise to GOD; (*Summer* 115–28)

Bloomfield's commonplaces are enlivened by his individualism. Repeating familiar ideas—God's gifts shaming human vanity—he nevertheless ties in the account with reality by describing the Suffolk ploughmen's habit of inspecting each others' work on Sunday mornings; something Constable would have liked. Bloomfield can also

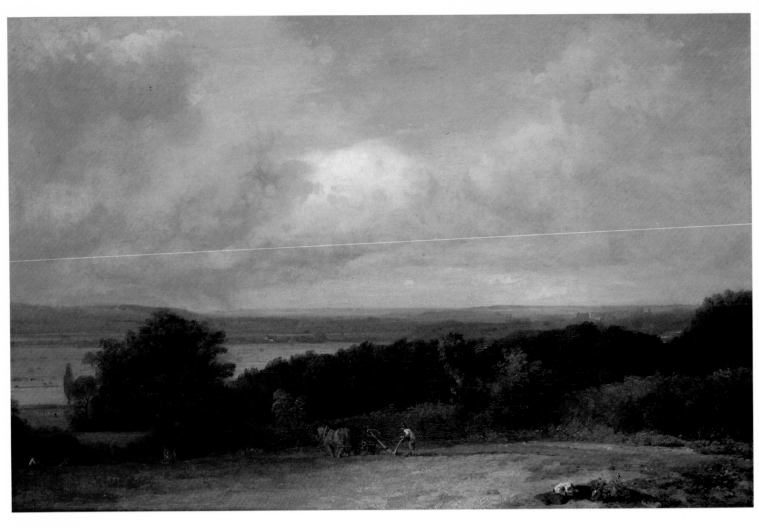

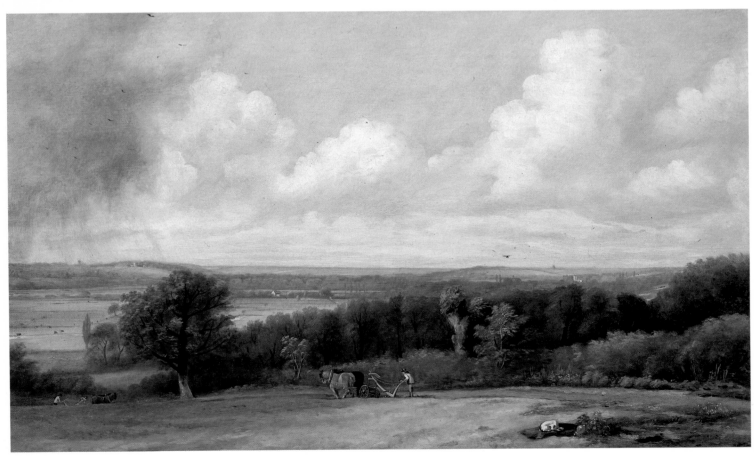

81. (facing page, above). *Landscape, Ploughing Scene in Suffolk* 1814 Oil on canvas $20\frac{1}{4} \times 30\frac{1}{4}$ (51.4×76.5). With Christies', July 1982

82. (facing page, below). Replica of *Landscape, Ploughing Scene in Suffolk* ?1826 Oil on canvas $16\frac{3}{4} \times 30$ (42.5×76). New Haven, Yale Center for British Art

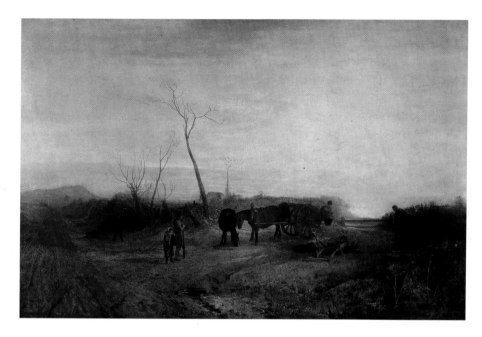

83. J. M. W. Turner *Frosty Morning* 1813 Oil on canvas $44\frac{3}{4} \times 68\frac{3}{4}$ (113.5×74.5). London, Tate Gallery

84. J. M. W. Turner *Ploughing up Turnips near Slough* Oil on canvas $40\frac{1}{8} \times 51\frac{1}{4}$ (102×130). London, Tate Gallery

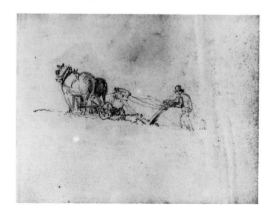

85. 1813 sketchbook. Pencil $3\frac{1}{2} \times 4\frac{3}{4}$ (8.9×12). London, Victoria and Albert Museum (R.121) p. 12

86. 1813 sketchbook. Pencil $3\frac{1}{2} \times 4\frac{3}{4}$ (8.9×12). London, Victoria and Albert Museum (R.121) p. 71

be witty. The punning 'golden prospect' is both a neat description and a reference to the wealth the harvest represents. And lastly, attributing it all to God is done with the same language Constable used; something relevant, for, later in 1814, the artist was to write

> I am delighted with Alison's book on the nature and principles of Taste—I prefer it much to Mr. Burke's as I think it more just and its conclusions more sublime . . . he considers us as endowed with minds capable of comprehending the 'beauty and sublimity of the material world' only as the means of leading us to *religious sentiment* . . .[76]

Constable had rather brutally précised the newly fashionable associationist aesthetic of the Reverend Archibald Alison,[77] and his language confirms that he had again broken away from the formalism of the picturesque to an art with a significant iconography. Furthermore, this iconography embodied value systems which conformed with those both of his East Bergholt neighbours, and of the poets whom he preferred to read.

Alison's arguments were subtler than Constable implied. He believed that beauty or sublimity were emotions experienced after the imagination was activated by what the eye perceived. Trains of thought had to be aroused, and an object's aesthetic potency lay in its capacity to suggest such trains. Alison wrote for example that Spring put one in mind of childhood, Autumn of decay and dissolution.[78] He added that such associations were confined to educated people;[79] the ideas had to be in the mind before the sight of some fitting object could activate them. Perhaps the crux of his thinking is to be found in this passage:

> It should seem, therefore, that a very simple and a very obvious principle is sufficient to guide our investigation into the source of the sublimity and beauty of the qualities of matter. If these qualities are in themselves fitted to produce the Emotions of Sublimity or Beauty, (or in other words, are in themselves beautiful or sublime), I think it is obvious that they must produce these Emotions, independently of any association. If, on the contrary, it is found that these qualities only produce such Emotions when they are associated with interesting or affecting qualities, and that when such Associations are destroyed, they no longer produce the same Emotions, I think it must be allowed that their Beauty or Sublimity is to be ascribed, not to the material, but to the associated qualities.[80]

It is vital to recognise the significance of Constable's preferring Alison to Burke. Alison opposed *On the Sublime and Beautiful* because he was unwilling to be persuaded by a purely objective aesthetic. For Burke, aesthetic emotions were aroused by particular characteristics—size, shape, colour—which *any* object might display. Therefore, for something to become 'beautiful' it needed only to be round, smooth, and lacking sharp tonal contrasts; and consequently the adjective qualified rounded hills at twilight, or an evil tyrant's candle-lit bald head equally. Alison considered such formalist theorising to be fallacious:

> But although the qualities of matter are in themselves incapable of producing emotion . . . yet it is obvious that they may produce this effect, from their association with other qualities; and as being the signs or expressions of such qualities as are fitted by the constitution of our nature to produce Emotion . . . In such cases, the constant connection we discover between the sign and the thing signified, between the material quality and the quality productive of Emotion, renders at last the one expressive to us of the other, and very often disposes us to attribute to the sign that effect which is produced only by the quality signified.[81]

87. W. Byrne after T. Hearne
Ploughing from *Rural Sports*
Engraving publ. 25 July 1810

88. Valentine Green *'Ye Gen'rous
Britons! Venerate the Plough!'* 1800
Engraving. Reading, Museum of
Rural Life

89. Ploughman from A. Fitzherbert
Boke of Hosbondrye 1523. Reading,
Museum of Rural Life

This recognises that the object, functioning as sign, does so through an incontrovertible linkage with systems of association, systems of historically defined ideas.

Alison was convinced that the sign always involved associated meanings, that 'oak tree' not only described the plant, but also had a dimension involving oak's qualities, its strength, its contemporary use in ship-building, and consequently its associations with trade and naval power, partly because much eighteenth-century writing was loaded with systems of association, and writers found it impossible to describe events or scenes except as constituents of a deliberate moral iconography. As this passage from Wordsworth and Coleridge shows, the habit was recognised:

> It is supposed, that by the act of writing in verse, an Author makes a formal engagement that he will gratify certain known habits of association; that he not only thus apprises the Reader that certain classes of ideas and expressions will be found in his book, but that others will be carefully excluded.[82]

While it is wrong to look for Alison's associated ideas only in literature, for Constable eighteenth-century poetry is a logical source of his iconography: hence his easy link of Alison's theories with the idea that we know God through his works, expressed both by Bloomfield, and by Constable himself after that anatomical demonstration in 1802.

'Habits of association' were common to the poetry Constable preferred. Bloomfield began Book II of *The Farmer's Boy* with 'The Farmer's life displays in every part/A moral lesson to the sensual heart'; and choosing a couplet from this poem to underline his *Ploughing Scene* was a conscious and deliberate step. One reason for taking a couplet from Bloomfield, rather than the more usual Thomson,[83] was that it insisted on the importance of place to the painting, while, at the same time, endorsing the georgic iconography, where the ploughmen assumed the hoary rôles both of indicator of season, and of type figure for Industry.

This first function had been described by Aikin in his *Essay on . . . Thomson's Seasons*: 'The most obvious and appropriated use of human figures in pictures of the seasons, is the introduction of them to assist in marking out the succession of annual changes by their various labours and amusements . . .'[84] Constable himself must surely have been aware of the mediaeval tradition of the Labours of the Months, which had persisted stubbornly in art. Contemporary manifestations were Hearne and Byrne's *Rural Sports* (Fig. 87), or many of the illustrated editions of *The Seasons*, which continued to mark spring by ploughing, summer by haymaking, autumn by harvest, and winter with a domestic incident like people sitting around the fire.

Besides indicating season, Constable's ploughmen did much more, for the ploughman usually represented the personified Industry at the base of all georgically interpreted progress. Mason neatly summarised this cliché:

> . . . in the Waste
> Place thou that man with his primaeval arms,
> His plough-share, and his spade, nor shalt thou long
> Impatient wait a change; the waste shall smile
> With yellow harvests; what was barren heath
> Shall soon be verdant mead.[85]

Thomson had followed a description of spring ploughing with an explanation of its fundamental value, and his concluding sentiments 'Ye gen'rous Britons! venerate the plough!'[86] were pertinent enough still in 1801 for Valentine Green to inscribe those lines under a print (Fig. 88) which, being dedicated to the Board of Agriculture, indicated the audience for this rustic iconography. As early as 1523 a

90. F. Wheatley *Ploughmen* 1795 Oil on canvas 61 × 85 (154.9 × 215.9). Whereabouts unknown

woodcut of a ploughman for Fitzherbert's *Boke of Hosbondrye* had itself been labelled 'Hosbondrye' (Fig. 89).

Constable's ploughmen qualified the landscape where they worked, and that John Allnutt purchased the *Landscape, Ploughing Scene in Suffolk* as a georgic pendant to a pastoral Callcott suggests some contemporary appreciation of their iconography.[87] The figures in Constable's paintings encourage us to consider the countryside he portrays as well-farmed, and therefore socially happy, stable, and peaceful. Moreover they transmit Constable's own feelings for a locale where everything was always 'calm—comfortable—and good'.[88] There was subtlety in quoting Bloomfield, for the lines end this description:

> No wheels support the diving pointed share;
> No groaning ox is doom'd to linger there;
> No helpmates teach the docile steed his road;
> (Alike unknown the plow-boy and the goad;) (*Spring* 67–70)

Constable would have recognised this as an accurate account of working the swing plough (Fig. 5) around Bury St Edmunds. He chose from Bloomfield's *Suffolk* poem to emphasise that his landscape was about the same region. And I suggest that his composition reinforces this concern with locale.

Compare this picture with, say, Wheatley's more conventional 1795 ploughmen (Fig. 90), and significant differences emerge. Wheatley's low viewpoint emphasised the figures' genre value, and landscape was used merely as a suitable setting. Constable, in contrast, took so high a viewpoint that we survey the countryside itself, before focusing on activity represented therein. This high viewpoint, accordingly, incorporated the ploughmen as natural elements of a landscape painted with a marked regard for topographical accuracy.

There is an interesting parallel to this scene in *The Task*, early in the first book, in that passage where Cowper and Mary are out walking, and which Constable in 1812 had been identifying with his own circumstances. Cowper's description (one of many comparable eighteenth-century accounts of scenery) is of the landscape of the upper Ouse valley. An eighteenth-century convention was to describe a view as it would appear from high ground, which gave a corresponding 'command' over it.[89] It has been shown how 'command' suggested actual control over landscape, without which it could realise a potential danger and revert to the 'desert' conventionally contrasted with scenes of cultivation. The eighteenth-century relationship between man and nature was conceived in terms of nature requiring regulation to be rendered intelligible, This control might come through science as much as pictorial description, for both helped make their subjects known. In its pristine form nature was little use. It grew too little to support man, and therefore required husbanding, which, by definition, also imposed order on the chaos. If you *command* a view, it is implied that government is exercised over it, and theorising like, for instance, Gilpin's was part of an attempt to extend this control to types of environment less susceptible to more normal conditioning.

Farming, selecting the forms and colours of particular landscapes, made them intelligible, much as Constable's repeated sketching helped expand and refine his knowledge of both landscape and place. In this *Ploughing Scene* the high viewpoint reflects the eminence which was selected by both poets and travellers for admiring views:

> How oft upon yon eminence our pace
> Has slacken'd to a pause, and we have borne
> The ruffling wind, scarce conscious that it blew,
> While admiration, feeding at the eye,

91. Detail from *Landscape, Ploughing Scene in Suffolk* (Fig. 81)

And still unsated, dwelt upon the scene.
Thence with what pleasure have we just discern'd
The distant plough slow moving, and beside
His lab'ring team, that swerv'd not from the track,
The sturdy swain diminish'd to a boy! (*The Task* I. 154–62)

The passage then moves from the ploughman in the near distance, to the Ouse winding through a herd-besprinkled valley, its distant sides meeting the clouds, and the whole embellished with villages or church towers. Cowper's detailed description reveals as intimate a knowledge of this landscape as Constable had of the Stour Valley, and he ends with the moral:

Scenes must be beautiful, which daily view'd,
Please daily, and whose novelty survives
Long knowledge and the scrutiny of years.
Praise justly due to those that I describe. (I. 177–80)

Constable knew these lines well. When, in 1814, William Craig illustrated them, he showed Cowper and Mary surveying a ploughman also in the near distance (Fig. 92): Craig, Constable's contemporary, visualising that passage, produced an image echoing Constable's in a painting of the Stour Valley from Mr Godfrey's park palings. If Constable's painting does connect with Cowper's poetry, it may well mean that with this view Constable was seeking to show that this was a landscape which gave continuing pleasure, and which was therefore beautiful, to impress on us the unassuming but powerful charm which he himself felt so forcibly.

The ploughman served as a moral qualifier. If an East Bergholt labourer was fit to assume Industry's mantle, this showed up the enviable qualities of the local proletariat, and, by implication, local society. In the same way Cobbett was to praise Suffolk ploughmen. And while certain of the painting's systems of signification connect with that literary ideology found intellectually relevant by Constable, conclusions about these are confirmed in the ways that the composition connects with the other pictures, besides that illustration to Cowper, or Valentine Green's print.

By adding ploughmen to his landscape Constable showed what he valued in the Stour Valley landscape and created an expressive pictorial vehicle for the development of his 'natural painture'. The high viewpoint, with its command over landscape, is a virtual metaphor for Constable's confidence and control. Furthermore, the iconography of the ploughman was one which was sympathetic to the farming interest. Green's plate was dedicated to the Board of Agriculture; Thomas Ruggles described how he liked to see the kind of scene Constable had painted, and went on to agree with Cowley that a plough is 'among the most respectable insignia of a family',[90] thus interpreting it as a georgic symbol. It is also notably unpicturesque. The picturesque was a 'painterly' aesthetic, not one which drew force from areas beyond the pictorial. As Gilpin said, it was a mistake to confuse cause and effect, and call a cornfield beautiful because it suggested ideas of wealth and fruition. This, however, is what Constable was beginning to do.

One of the majority who preferred to see industrious mechanics rather than loitering peasants, Constable showed his ploughmen working gratifyingly hard. The painting developed from the Royal Academy exhibits of 1811, and began a series of working Stour Valley landscapes culminating in 1821, with *The Hay Wain*. These works all share a concern with representing topography, a naturalistic style, and working subjects, and are pictured from a habitually high viewpoint. Later in 1814 Constable was to develop this idea of landscape with a *View of Dedham* (Figs. 95, 103) and *Boat Building* (Figs. 105, 107). Not only their subjects were

92. W. Cowper *Poems* London 1814. Titlepage to Vol. II (after W. Craig)

93. *View of Dedham* (sketch) 1814 Sept. 5 Oil on Canvas 15½ × 22 (39.4 × 55.9) Leeds City Art Galleries

94. Photograph of Dedham Vale

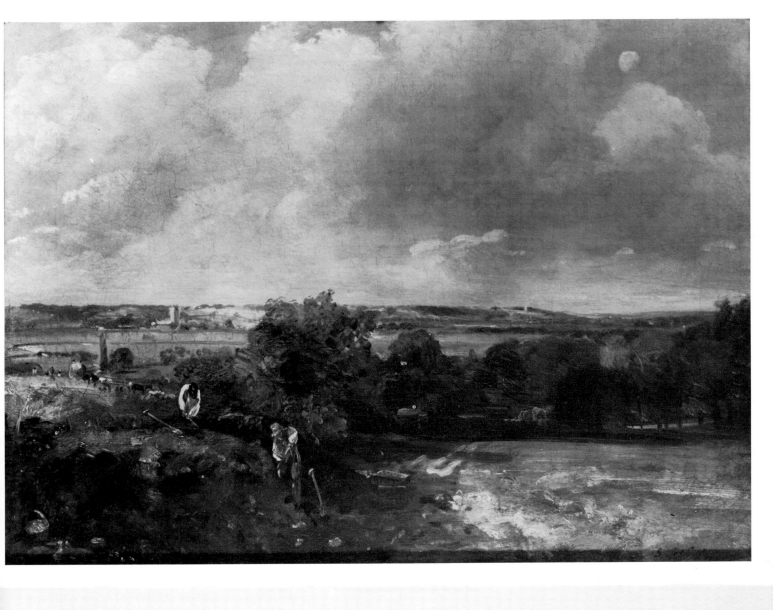

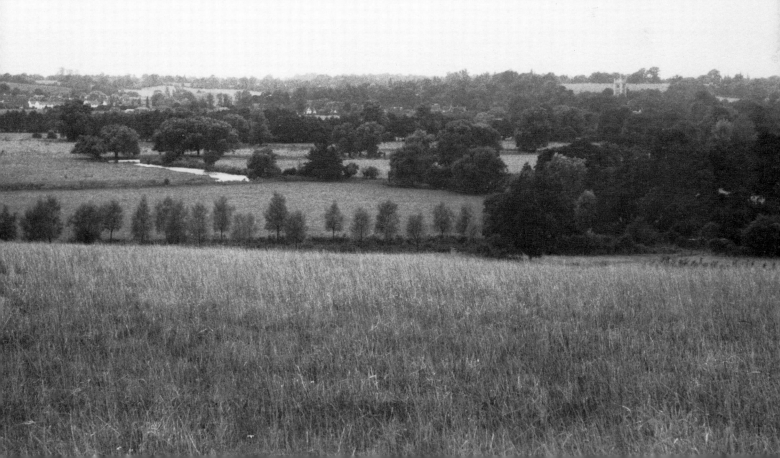

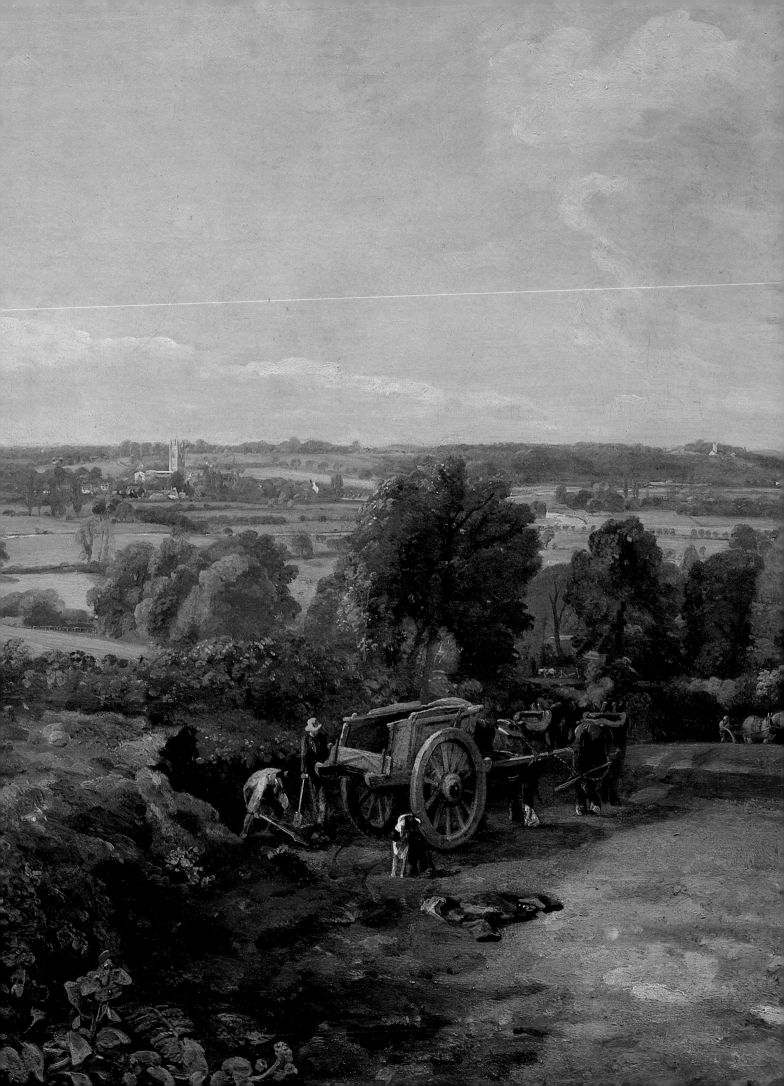

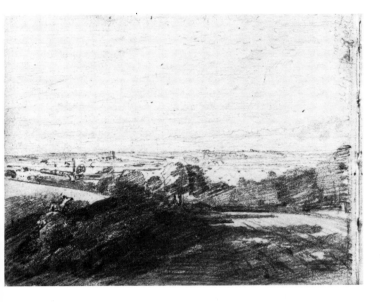

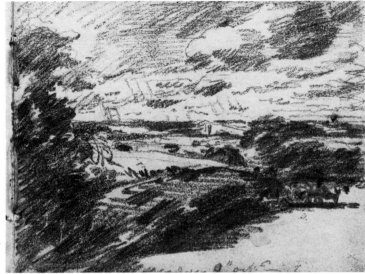

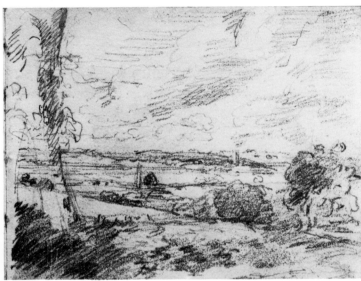

96. (top left). 1814 sketchbook. Pencil 3⅛ × 4¼ (8 × 10.8). London, Victoria and Albert Museum (R.132) p. 62 *View of Dedham*. Inscr. '26 Sepr. Morning ½8 o'cl.[?]'

97. (top right). 1814 sketchbook. Pencil 3⅛ × 4¼ (8 × 10.8). London, Victoria and Albert Museum (R.132) p. 81 *View of Dedham*. Inscr. '9th Octr—.'

98. (above left). 1814 sketchbook. Pencil 3⅛ × 4¼ (8 × 10.8). London, Victoria and Albert Museum (R.132) p. 65 Study for *View of Dedham*

99. (above right). 1814 sketchbook. Pencil 3⅛ × 4¼ (8 × 10.8). London, Victoria and Albert Museum (R.132) p. 60 Studies for *View of Dedham*

100. (right). *A Cart and Horses* 1814. 24 Octr. Oil on paper 6¼ × 10⅜ (15.9 × 26.4). London, Victoria and Albert Museum (R.134)

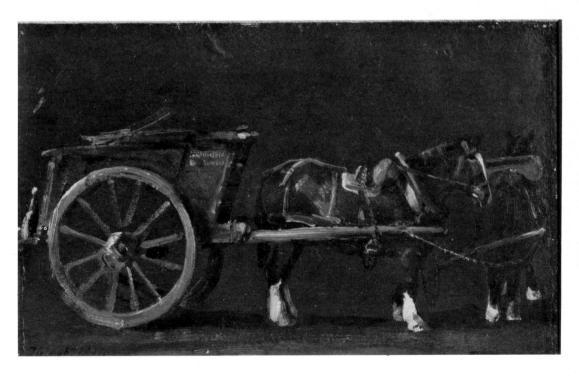

95. (facing page) Detail of *View of Dedham* (Fig. 103)

101. 1814 sketchbook. Pencil 3⅛ × 4¼ (8 × 10.8). London, Victoria and Albert Museum (R.132) p. 68 *A tumbrel and plough*. Inscr. '9th Octr. I 1814'

important. These pictures also showed Constable how to solve that problem of getting pictures both finished and detailed, which was continuing to bother him after the exhibition.

It was then that Farington reminded Constable of his failings:

I told him that the objection made to his pictures was their being unfinished; that Thomson gave him credit for the taste of his design in the larger picture just exhibited, & for the indication shown in the colouring, but he had not carried his finishing far enough.—I recommended him to look at some of the pictures of Claude before he returns to his country studies, & to attend to the admirable manner in which all parts of his pictures are completed . . .[91]

Constable obeyed by studying Angerstein's Claudes[92] and then, in July, left London for Bergholt. When Farington next saw him on 5 November., Constable said he had 'been occupied in painting Landscapes from nature'. 'Landscapes' implies something with more pretensions than the studies Farington was normally shown, and here we must mention that Leslie reported Constable saying of *Boat Building* (produced that autumn) that it was painted 'entirely in the open air'.[93] I mean to show that this was very probably the case, not only with this painting, but also the *View of Dedham*, which he also painted that autumn.

It would have been a practical step to go from preparing the exhibition picture from series of sketches to painting the picture itself from nature. His intention to do a small picture on the spot for every large one planned showed Constable aware of his gifts as a *plein-airiste*, and it could have dawned on him that this suggested procedure could be rationalised by working directly from nature. Hence in late October (when *Boat Building* and the *View of Dedham* were probably completed) Constable wrote that he had been 'wishing to make the most of the fine weather by working out of doors',[94] and either painting is small enough to fit on the easel comfortably.

Some of Constable's letters to Maria Bicknell reveal the contentment he felt and the deep affection he had for East Bergholt.[95] Others record his artistic progress. This illuminating passage dates from 2 October:

We have had a most charming season—and I hope I have endeavoured to avail myself of it—it is many years since I have pursued my studies so uninterruptedly and so calmly—or worked with so much steadiness & confidence I hope you will see me an artist one time or other—but my Ideas of excellence are of that nature that I feel myself yet at a frightfull distance from perfection.[96]

Although he still saw himself the student, his modesty here was remarkable, for what he had achieved by 2 October showed him close to mastery of the 'natural painture'. Significantly this happened at Bergholt, where the calm and comfort he felt there lent itself to his work.

Drawings and paintings of this campaign comprise a sketchbook (Figs. 96–99, 101, 102, 108–10, 122, 134, 149, 179, 180), a large and finished drawing of the family farm (Fig. 121), some oil sketches of farm tools (Figs. 5, 100), *Boat Building*, the *View of Dedham*, and work preparatory to them, much of this being in the 1814 sketchbook (Figs. 96–99, 101, 102, 108–10). Using mainly drawings rather than a series of oil sketches for this was new. Constable had happened to find his ploughmen and landscape in the 1813 sketchbook, but they had probably not been drawn with a picture in mind. Otherwise the 1814 sketchbook reveals Constable again to have concentrated on incidents and scenery around East Bergholt, although he also seems quite often to have gone the seven miles to Stoke-by-Nayland.

The *View of Dedham* was commissioned as a wedding present for Philadelphia Godfrey, the squire's daughter. On 28 August Constable wrote of a 'very grand match' being 'nearly ready at Old Hall',[97] the prospective groom, a Thomas

102. 1814 sketchbook. Pencil 3⅛ × 4¼ (8 × 10.8). London, Victoria and Albert Museum (R.132) p. 54 *Studies for View of Dedham*

Fitzhugh, making up in wealth what he lacked in youth. The landscape Constable painted for Miss Godfrey was once more from their park palings, or at the most a yard or so from them. It surveys the valley across to Dedham and the Langham hills from the entry to a field (Fig. 94). It was indicative of local taste that Constable's patrons picked (possibly in consultation with him) this view, rather than a portrait of the house, or some familiar nook in its park.

Once he had the commission Constable's first move was, on 5 September, to make an oil sketch (Fig. 93). It is both larger and more finished than many other sketches. The actual painting was 'almost done' by 25 October,[98] and was to be exhibited as a *View of Dedham* in 1815.[99] Both the 5 September sketch and painting show stages in the preparation of a field for wheat drilling: therefore the *Landscape, Ploughing Scene in Suffolk*, depicting the same field, illustrated what would have been happening, ploughing a clover ley for fallow, earlier that year, to show that in adding the ploughmen Constable was remembering that they would probably have been there in fact. The sketch features a large dunghill, and a harvest on the adjoining field. In the painting the dunghill is smaller and muck is being ploughed in. Rather than harvest we now see stubble.[100]

Sketch and painting reflect the sequence of events, then, and we may watch the dunghill diminishing in dated pencil drawings of 26 September (Fig. 96) and 9 October (Fig. 97). That the painting fits neatly into documentary sequence argues for its having been done with at least close reference to the motif. Compared with the viewpoint of the sketch Constable was looking more to his left, fitting in both that 'ox-bow' on the river, and the Langham hills, which makes the painting appear correspondingly more composed. The 26 September drawing was done at 8.30 a.m., and a correspondence will be observed between the shadows here, the 9 October drawing, and both the sketch and painting. This means they were *all* done early in the morning, which, as we learn from one of Lucas's anecdotes of Constable and Dunthorne, provides further evidence for suspecting *plein-air* work on this canvas. 'Both were very methodical in their practice taking with them into the fields their easels and painted one view only for a certain time each day when the shadows from objects changed their position the sketching was postponed untill the same hour the following day.'[101]

Added to this we have the fact that, as the *View of Dedham* was painted in the early morning, both *Boat Building* and the drawing for it have lighting which would accord with middle to late afternoon. In July 1812 Constable had explained to Maria, 'I do not study much abroad in the middle of these very hot bright days . . . last Year I almost put my eyes out by that pastime',[102] so we may have a demonstration here of his working from nature either side of mid-day, and in 1815 *Golding Constable's Kitchen Garden* and *Flower Garden* respectively show the landscape in the morning and evening. And the case for arguing that *Boat Building* and the *View of Dedham* were done from nature can be strengthened. First, Leslie stated that this was so with the former canvas. Second, there are no known oil studies for it; and only the Leeds sketch and two oil studies of tumbrels survive for the *View of Dedham*. Otherwise preparation was in pencil in the 1814 sketchbook[103] on pages close enough to suggest that both paintings were under way at the same period. This pattern of preparation rather contrasts with the earlier one.

Constable's procedure, having worked on his scene, might have been to draw it carefully onto the canvas, before painting it in the open, having already studied the foreground bustle enough (Figs. 99, 101, 102) to show a typical rather than precise moment of activity. The quality of the actual pictures provides a final reason for thinking that Constable had turned to *plein-air* work. The *View of Dedham* has a washed and autumnal look, one or two trees beginning to show yellow, and with minute detail married to this general effect. Constable painted with almost uncanny

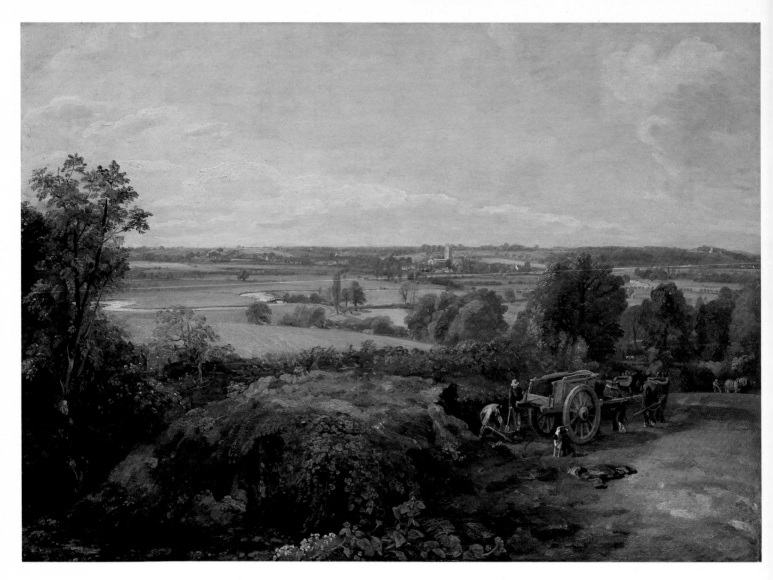

103. *View of Dedham* 1814 Oil on canvas 21¾ × 30¾ (55.3 × 78.1). Boston, Museum of Fine Arts

104. Claude Lorrain *Landscape. Marriage of Isaac and Rebekah* 1648 Oil on canvas 58¾ × 77½ (149 × 197). London, National Gallery

105. Detail from *Boat Building* (Fig. 107)

precision of touch, and looked at closely the painting shows many striking passages: the tender brushing in of the dunghill surface, or the delineation of Dedham. Furthermore he abandoned convention for observation: there is little tonal perspective; on the Essex side of the valley he alternated bleached green meadows with darker woods, or described the individual rooftops of the Dedham houses. This landscape marks a triumphal step towards the 'natural painture', and with *Boat Building* shows why Constable was so pleased with his progress in 1814. The preparation for *Boat Building* was probably similar to that for the *View of Dedham*. Having drawn his composition (Fig. 108) and studied the workmen (Figs. 109, 110), Constable eventually simplified the scene by reducing the number of figures. It is perhaps less successful than the *View of Dedham*, although certain passages are brilliantly painted.

Were we to see the history of art simply as a history of stylistic development, both paintings would deserve notice. However, their handling of subject and presentation of landscape were also significant. Consider the composition eventually achieved in the *View of Dedham*. A pencil drawing (Fig. 98) suggests that this was a rearrangement of motifs for the sake of a particular harmony and balance, for this design shows experimentation with the composition, Dedham church appearing to the right, and a broader extent of valley landscape shown than in the other drawings. A tree was placed rather obviously in the left foreground, to create a *repoussoir* for the view to Dedham. Constable also tried to articulate the perspective through deliberate vertical accents: the tree to the left, a poplar near Fen Bridge, and Dedham

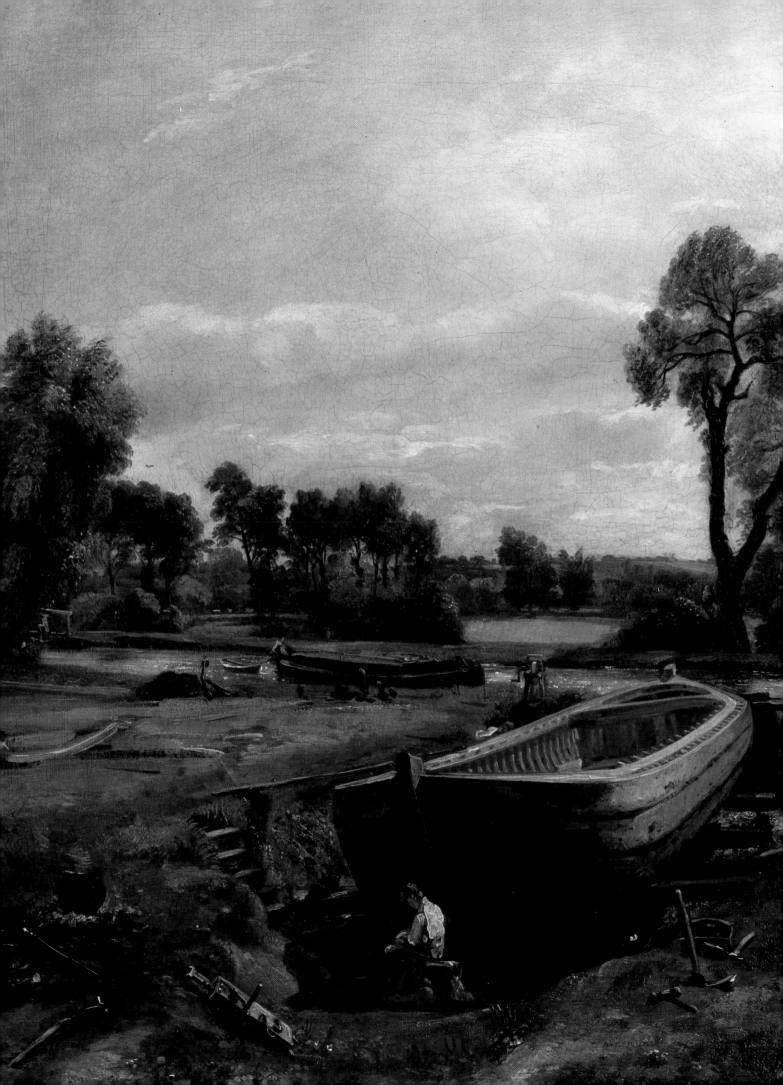

church tower lining up neatly; and in the painting the distance was compressed. The composition appears a subtle reversal of Claude's in *The Mill* (Fig. 104), which Constable had been studying at Angerstein's before departing for Suffolk. Where Claude's peasantry dances, picnics, and lazily herds its cattle, Constable's gets on with sowing the wheat. Instead of an expanse of water backed by soft blue hills, we look over stubble to the broad and light meadows of the Stour Valley. Rather than paint a picturesque mill, Constable introduced Dedham church. He did not overstate the link with Claude, but it was nevertheless strong and deliberate.

The canvas was thus related to Claude's visualisations of the Golden Age. For Claude's relaxed figures who need only inhabit the landscape to enjoy its fruits, we have working East Anglian labourers: modern reality is pitted against imagined ideal. All they share is a georgic end. Constable's iconography was resolutely contemporary, and the last thing you would associate with Claude would be a dunghill. However, the georgic did justify so low a subject. Advance towards social and cultural perfection depended on the progress of agriculture. So its smallest details warranted attention, and manure, essential for heavier crops, indicated that these farmers knew their business. Bigger yields increased profits, which was not only to the advantage of the farmer, but also the nation. Hence the dunghill, the obscure origin of this, takes pride of place in the painting.

Manure also has a precise iconographic meaning. In *The Sugar Cane* Grainger produced a laboured justification for writing of such things: 'The sacred Muse/ Nought sordid deems but what is base',[104] and from time to time other poets wrote of muck heaps.[105] Bloomfield, for example, had described virtually what Constable painted. First, the dunghill was built up:

> Thence from its chalky bed behold convey'd
> The rich manure that drenching Winter made,
> Which pil'd near home, grows green with many a weed,
> A promis'd nutriment for Autumn's seed.
>
> (*The Farmer's Boy, Spring* 187–90)

Eventually the muck was spread and ploughed in:

> The plough moves heavily, and strong the soil,
> And clogging harrows with augmented toil
> Dive deep: and clinging, mixes with the mould
> A fat'ning treasure from the nightly fold,
> And all the cow-yard's highly valu'd store,
> That late bestrew'd the blacken'd surface oe'r.
>
> (*Autumn* 61–6)

That first passage helps us understand Constable's iconography, particularly through its expression of the anticipation so much a part of farming. And, of course, one's thoughts should go from sowing to its consequences, much as Thomson's did when, having described Spring ploughing, he continued

> And o'er your hills, and long withdrawing vales,
> Let Autumn spread his treasures to the sun.
>
> (*Spring* 67–8)

Bloomfield, with a nice sense of the reality of farming, expanded this idea. He wrote how, after sowing

> The grateful Farmer trusts the rest to Heaven.
> Yet oft with anxious heart he looks around,
> And marks the first green blade that breaks the ground;
> In fancy sees his trembling oats uprun,
> His tufted barley yellow with the sun;
>
> (*Spring* 96–100)

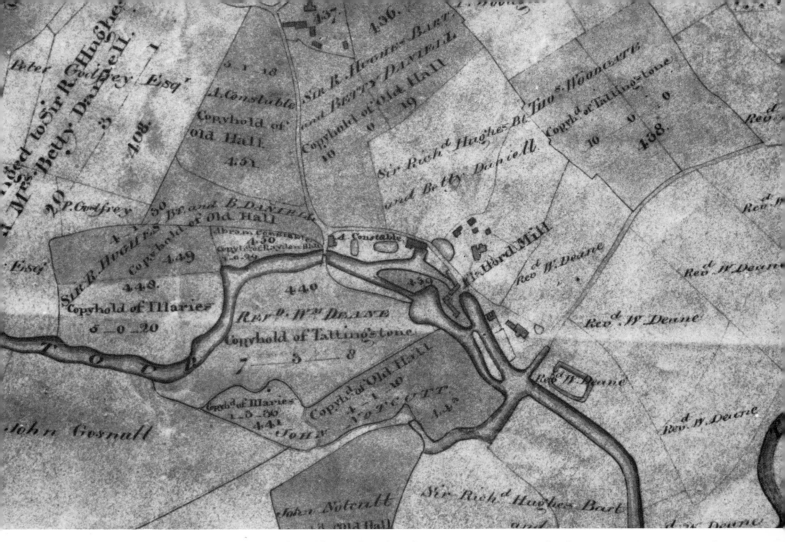

106. Map of Flatford Mill. Detail
from 1817 East Bergholt Enclosure
Map. Suffolk Record Office

His sense of working for the future was common both to georgic poets and
agricultural writers: we have seen how Arthur Young wrote of 'the prophetic eye of
taste' gaining a like pleasure from anticipating what was to come.

This gives a not unexpected pointer to the significance of Constable's imagery.
His iconography in the *View of Dedham* was of a piece with that of the *Ploughing
Scene*. Labourers by their industry admitted a tacit agreement with the farmer that
their work benefited all, and Constable, by painting this view of the squire's behest,
demonstrated how far he agreed in this point of view. And because his subject,
wheat sowing, suggests thoughts of wheat harvest, the landscape takes on a religious
connotation, in exactly the way Constable's mother constantly saw spiritual
significance in the slightest action—'This Morning began to Mow the Town
Meadow; & Harvest will then be thought of—Man was not intended for idleness—
or at least incurd the punishment of Labour for disobediece—God bless you.'[106]
Constable had liked Alison for his belief that religious sentiment was the chief end of
aesthetic pleasure. In the *View of Dedham* we must understand the subject, and then
see that even in the melancholy of Autumn there is the seed of new life. To someone
with Constable's upbringing, the development of such thoughts on to meditations on
the Resurrection of Christ and the promise of eternal life must have virtually been
inevitable. The painting, while being georgic, has, too a spiritual aspect, accessible to
those who believe in and approve of the God who has disposed that particular
social landscape in that particular way.

Boat Building (Figs. 105, 107) is more mundane. It gives a pictorial account of how
to construct a barge. Reading the foreground from left to right, we see first a figure
engaged on a baulk, then, next to him, but closer, a second working on shaped timber.
The viewpoint is so high as to let the eye prospect the interior of the barge under

87

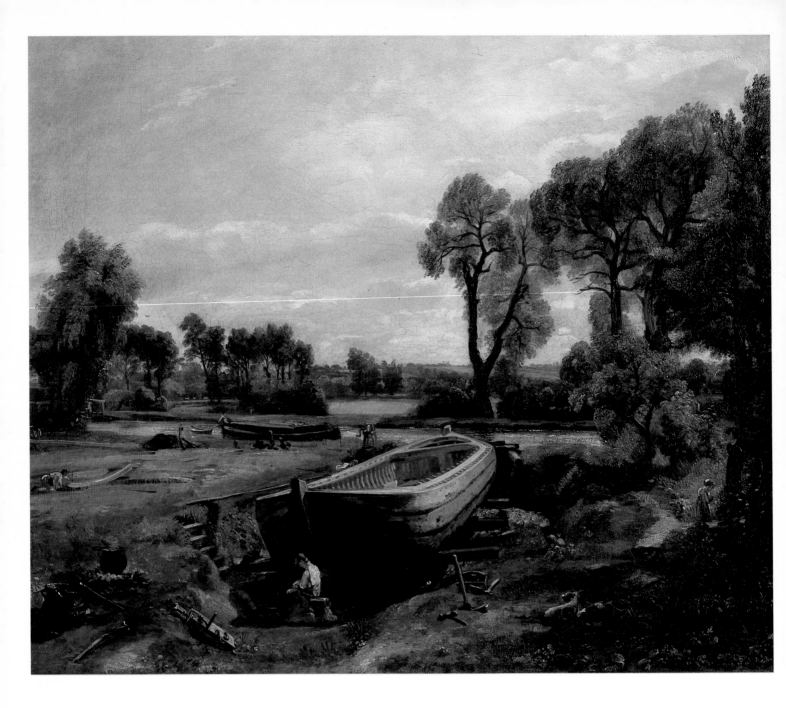

107. *Boat Building* 1814 Oil on canvas
20 × 24½ (50.8 × 61.6). London,
Victoria and Albert Museum (R.137)

108. 1814 sketchbook. Pencil 3⅛ × 4¼
(8 × 10.8). London, Victoria and
Albert Museum (R.132) p. 57 Study
for *Boat Building* Inscr. 'Sepr. 7 1814
Wednesday'

construction, and understand how it is made. Adjacent ground is littered with a figure, a cauldron of pitch, and various adzes, pitch being used to caulk the hulk. The barge on the river completes the sequence by showing us the eventual appearance and function of these vessels, with a dry dock explaining how the one under construction will eventually reach the river. Constable was concerned to simplify the scene for the purposes of explaining it: this much is clear from the differences between the painting and the equivalent sketchbook drawing. The result is a local georgic about how barges were built at Golding Constable's Flatford dry dock.

As the composition practically amounts to a source of instruction, this places it within the georgic ethos. Virgil's poem itself served as an instruction-book of husbandry, and besides explaining how to go about agriculture or viticulture, demonstrated too their importance in the wider political context—hinted at here by Constable via the cultivated landscape in which his scene is set. And, as he had with the *View of Dedham*, Constable reinforced his iconography by referring to one of Angerstein's Claudes. Charles Rhyne has shown how Claude's disposition of his figures in the *Embarcation of St Ursula* (Fig. 111) connects with Constable's landscape.[107] Presumably a seaport was most suitable to a scene of boat building.

While its didacticism was unprecedented, *Boat Building*'s other characteristics occurred in other work. As in the *View of Dedham* a remarkably high viewpoint dictates our perception, and, as the whole is invariably perceived before its details, this introduces a context, the entire scene, before its constituents. The latter must thus be considered in relation to the former. We have to suppose that barges and the little industry of barge building have something, at least the carriage of goods, to do with the agricultural landscape in which they are situated. Realising this will lead the observer's thoughts on to wider ideas of Trade, and its importance to Britain; the management of detail via the high viewpoint permitting this train of thought, and, incidentally, allowing us to see the composition as structured in a 'poetic' way, imitating the kinds of literary patterns discussed above. Once the poet had reached his eminence, he would take a quick overview of the landscape, enumerate its details, and draw a conclusion or moral: this closely parallels the way Constable's composition now functions. We see first the landscape, then its parts, and draw a conclusion by thinking about their interrelation. Having developed this sophisticated idea of landscape, Constable was to maintain and develop it over the next two years, a period when he was increasingly resident at Bergholt.

CHAPTER FOUR
The 'Natural Painture'

During 1815 Constable, now spending almost all his time at East Bergholt, developed the achievements of the previous year. His continuing absence from London sometimes upset Maria Bicknell. On 18 October she complained: 'How very strange it is you do not write to me, I should have thought in a fortnight, you might have answered my letter, particularly as you mentioned leaving Suffolk about that time . . .'[1] The following day, a contrite Constable replied: 'I am truly sorry my dearest Maria that you should have been disappointed not having heard from me—I have really been every day intending to write to you but I have been so much out endeavouring to catch the last of this beautifull year that I have neglected almost every other duty.'[2] This was one of many such statements: during that August Constable said he was 'living in the feilds' and seeing no-one but the harvest men.[3] Maria began to feel neglected. On 18 January 1816 she complained of his wintering in the country, not London, but concluded: 'Believe me I would have everything give place to your profession, and if it succeeds best in the country, pray do not let my impatience bring you to town.'[4]

Constable himself had become almost obsessed with painting around Bergholt. None of the canvases thought to have been painted in 1815 is dated, and certain paintings we know to have been done then are lost; however, work in the first category, the *Brightwell*[5] (Fig. 113), the two paintings of his father's gardens (Figs. 112, 128, 130, 132), and, probably, one version of *A Cottage in Cornfield*[6] (Fig. 119, 120) (see below), is superb. All these pictures are small, and the last four show a concern with harvest, something evident, too, in drawings of this year (Fig. 114).[7] In fact, bearing in mind that, stylistically, these paintings follow on from the works of 1814 (which had a powerful documentary element), 1815 is the most logical year for Constable to have produced harvest pictures. On 8 August the *Ipswich Journal's* agricultural column remarked that 'very few preceding seasons have been so blessed as this', and on 2 September that it had been 'dry, abundant, a good harvest'. In 1814 Constable's time was accounted for with other projects, as it would be too in 1816. That year saw a 'disastrous' harvest, while in 1817 it was late, cold and wet.[8]

Nevertheless, various paintings do pose problems. Apart from those mentioned above is an upright harvest scene in a narrow valley (perhaps that of the Riber, which ran across Constable ground and below East Bergholt Rectory) (Fig. 118), closely related to a drawing (Fig. 115), possibly from an 1815 sketchbook.[9] However, we cannot know if the drawing precedes the painting, or whether this is a project Constable abandoned, although the unfinished painting of reapers under a beautiful

112. Detail from *Golding Constable's Flower Garden* (Fig. 130)

evening light probably dates from 1815. Equally there are, as Ian Fleming-Williams has suggested, questions raised by both versions of *Cottage in a Cornfield* (Figs. 19, 120). The smaller (Fig. 120) was exhibited in 1817, and was on a canvas of 12 × 20 inches (a size Constable preferred for outdoor work).[10] In its right foreground is a donkey with foal, and on 3 December 1815 Constable had been sketching 'a donkey that I wanted to introduce in a little picture',[11] in other words, to add to a completed work. However a donkey also appears in the larger version (Fig. 119), which is also mostly in the style of 1815, although only exhibited in 1833, when Constable finished off the right-hand trees (possibly adapting them from his 1802 *Dedham from Langham* (Fig. 31). This tallies very closely with an 1815 drawing (Fig. 114) (whereas the smaller painting corresponds less exactly) and is also on a canvas of the size used both for *Boat Building*, and a variant of *The Valley Farm* (also dated to 1815).[12] It might be that Constable had begun the painting, but failed to complete it before a brief visit to Brightwell in early August—hence the necessity to add the trees in 1833. And as the corn is correspondingly higher in the small version, it is appealing to imagine that, after his visit, he produced that painting. However, the appearance of the trees, the weeds in the corn, and distant fields, tell against this; and the corn itself actually looks less ripe. Might Constable, then, have returned to the site (perhaps in the valley near Fen Bridge, and looking upstream) in 1816 when, as we shall see, the weather was bad (hence the tall but uncut corn) and painted the smaller landscape?

If the larger painting was done in 1815 it would be contemporary with *Golding Constable's Kitchen Garden* (Figs. 130, 132), a morning picture, and *Golding Constable's Flower Garden* (Figs. 112, 128), an evening one, and may have been painted around the middle of the day. If so, Constable was not exaggerating when he wrote to Maria of living in the fields, and seeing only the harvest men.

1815 would be a likely date for the *Gardens* on stylistic grounds, while also being supported by documentary features.[13] The chief is that ripe wheat covers the field backing on to the gardens, a drawing of which (Fig. 122), dated 22 September 1814,

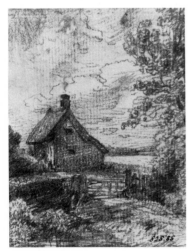

shows it half-ploughed, that is, being prepared for wheat-sowing. Therefore the paintings probably date from the following year, 1815. It is indicative of Constable's acceptance of and pleasure in the reality of East Bergholt that, as his painting concerned itself with mastering natural appearance, so too did his subjects have a significant documentary aspect. Remembering the relation between paintings and drawings, these were probably prepared from a large drawing (Fig. 121) of the panorama, also dating from 1814, for it corresponds with the sketchbook sheet too closely for coincidence.

I shall discuss both paintings more fully below, but must first mention works which are documented but, for the moment, unidentified. In mid-October 1815 Constable described one ambitious project as 'a rather larger landscape . . . than ever I did before, and this it is my wish to secure in great measure before I leave this place as I here find many aids',[14] and was still hoping to get it 'in some sort of forwardness'[15] on 3 November, continuing to work on it on 15 November.[16] If

115. *Reapers* ?1815 Pencil $7\frac{1}{4} \times 4\frac{5}{16}$ (18.4 × 10.9). Paris, Louvre (R.F.6100)

116. *Gleaners* ?1815 Pencil $4 \times 3\frac{1}{16}$ (10.2 × 7.8). Paris, Louvre (R.F.6101)

117. *Gleaners* ?1815 Pencil $2\frac{15}{16} \times 3\frac{11}{16}$ (7.5 × 9.4). Paris, Louvre (R.F.6099)

118. (right). *Reapers* ?1815 Oil on canvas $17\frac{1}{2} \times 14\frac{1}{2}$ (44.5 × 36.8). Private Collection

119. *Cottage in a Cornfield* ?1815 & 1833 Oil on canvas 24½ × 20¼ (62 × 51.5). London, Victoria and Albert Museum (R.352)

120. *A Cottage in a Cornfield*
?1815/1816 Oil on canvas 12 × 20
(31.4 × 26.5). Cardiff, National
Museum of Wales

Constable really was painting a larger canvas than he had tried before, it would have been over five foot wide.[17] If he completed it, he may have exhibited it in the 1816 Royal Academy for neither *The wheat-field*, nor *A Wood: Autumn* is now known. Thus either might have been Constable's first 'six-foot' canvas. Neither can we tell if *The wheat-field* was re-exhibited as *A Harvest Field: Reapers, Gleaners* in the 1817 British Institution, nor what connection this piece might have had with that vertical harvest scene (Fig. 118) discussed above. It would seem, though, that the *Harvest Field*, and perhaps its exhibition companion, *A Cottage*, had been painted in 1815. First, there was the subject, and drawings of reapers, gleaners, and so on (Figs. 116, 117) were probably made for this picture. One can guess that it showed an East Bergholt landscape, and is likely to have been painted out of doors. Both the drawings, and the likely dimensions of the exhibited canvas suggest this. Its framed measurements were 33 × 42 inches. If, like the *View of Dedham*, its frame was 5 inches wide,[18] then so would the canvas have been a similar size, 23 × 32, against $21\frac{3}{4} \times 30\frac{3}{4}$

95

121. *View over the Constable Farm*
1814 Pencil $11\frac{7}{8} \times 17\frac{3}{4}$ (30.2 × 44.9).
London, Victoria and Albert
Museum (R.176)

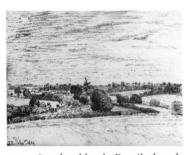

122. 1814 sketchbook. Pencil $3\frac{1}{8} \times 4\frac{1}{4}$
(8 × 10.8). London, Victoria and
Albert Museum (R.132) p. 38 View
over the Constable farm. Inscr. '22
Sepr. 1814'

123. Map of the Constable Farm
from the 1817 East Bergholt
Enclosure Map. Suffolk Record
Office

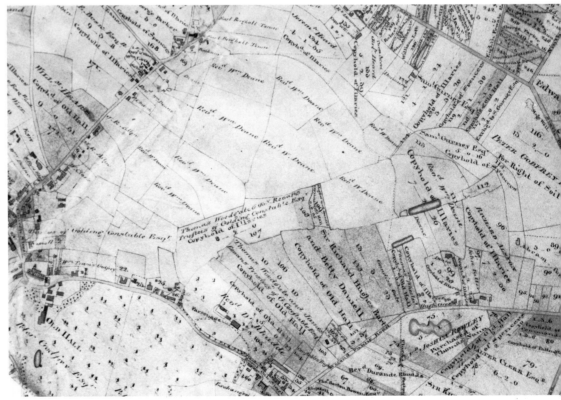

124. W. Byrne after T. Hearne *Threshing* from *Rural Sports* Engraving publ. 23 July 1810

125. W. Cowper *Poems* London 1814 Frontispiece to Vol. II (after W. Craig)

126. G. Stubbs *Reapers* 1784 Oil on panel 35½ × 54 (90.17 × 137.16). London, Tate Gallery

127. G. Lewis *Hereford from the Haywood* 1815 Oil on canvas 16⅜ × 23½ (41.6 × 59.7). London, Tate Gallery

inches, indicating Constable taking up the largest of his 'outdoor' canvas sizes. It is, however, more fruitful to discuss surviving paintings.

The Brightwell, the larger *Cottage in a Cornfield*, and the *Gardens* show how tragic is the disappearance of these other works. In 1815 Constable's technique had advanced, with his acuity of vision, to a point where he had come near to realising his 'natural painture'. Leslie called Constable's art of this period 'perfect',[19] and harmony and balance characterised his work until at least 1817. Works of the 1810s form a distinct and distinguished group. During his spell of virtual residence at East Bergholt, Constable produced some of the finest of all British landscape painting, and a discussion of the *Gardens* will show how the unique synthesis in his person of the interests of artist and inhabitant created such extraordinary, if eccentric canvases.

Although the *Gardens* are small they display an uncanny amount of detailed work. Not a touch of the brush was wrong. In the *Kitchen Garden*, an area of a few square inches (Fig. 132) shows a gate leading into a triangular meadow, with a track running down one side, and a brown cow grazing in the blue-green shade of some oaks. Equally superb is the still-life of the village, to the composition's right. In the *Flower Garden* (Figs. 112, 128) Constable achieved comparative clarity and balance. It is hard to conceive how they could not have been done on the spot as the only preparatory work (if preparatory it is) is those drawings, and the handling is so very precise. Constable probably painted either from an upstairs window or from the roof of East Bergholt House.

These are agricultural landscapes, and connections between figures, fields, and the village constantly suggest themselves. A corn field near the windmill (Fig. 132) has around a dozen figures harvesting it; there is a thresher in the Constable barn; the mill indicates the destination of the threshed grain; and the village gives a reason for these activities. Agriculture serves the community, which displays its own virtues through neat houses and gardens. Golding Constable took a pride in both farm and garden: his son painted the evidence.

Like the 1814 ploughmen, details in these pictures have iconographical forerunners. Threshers are found both in Hearne and Byrne's *Rural Sports* (Fig. 124), and in Craig's illustrations to that 1814 edition of Cowper (Fig. 125). And painted cornfields and harvests abound: obviously Stubbs's (Fig. 126), but also two pictures actually of 1815, a De Wint of the open fields in Lincolnshire (Fig. 129), and Lewis's, showing harvesting in Herefordshire (Fig. 127). In these pictures, though, interest is focused differently. Attention is directed more to harvesting than to the landscape, whereas Constable buried harvest so deeply in the landscape that it can take time before we discern it. Harvest functions as one element in a complex, to qualify the painted landscape. There is also a more personal iconography to these landscapes, for Constable associated the view to the Rectory (seen in the *Kitchen Garden*) with happier times with Maria,[20] although at this period he was busier painting than being in love.

Constable's 1815 work not only recorded that year's bumper harvest, but also concentrated on subjects as georgic and literary as ploughing or muck spreading. Painted harvests had an interesting history in eighteenth-century British landscape.[21] Thomson's treatment of harvest in *The Seasons* was, as the century progressed, repeated by hosts of lesser poets. And through poetry we acquire an understanding of the subject's detailed iconography.

Thomson began *Autumn* by describing cornfields awaiting the sickle—

> Extensive harvests hang the heavy head.
> Rich, silent, deep, they stand; for not a gale
> Rolls its light billows o'er the bending plain:
> A calm of plenty! (31–4)

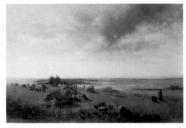

128. *Golding Constable's Flower Garden* 1815 Oil on canvas 13 × 20 (33 × 50.8). Ipswich Borough Council

129. P. De Wint *A Cornfield* exh. 1815 Oil on canvas 41¼ × 64½ (104.8 × 163.8). London, Victoria and Albert Museum

The last phrase revealed how the scene gave more than merely visual pleasure; Thomson was equally glad to anticipate the wealth these cornfields would produce. He saw the appearances of nature as a series of effects, and with cornfields and harvesting he explained the cause early on:

> These are thy blessings, Industry! rough power!
> Whom labour still attends, and sweat, and pain;
> Yet the kind source of every gentle art,
> And all the soft civility of life:
> Raiser of human kind! (43–7)

This opens an 110-line apostrophe to Industry, which stated the value of work in terms still to be found material by the farming community in Constable's day.

Thomson's argument was that Industry alone raised (and differentiated) man from the beasts. It taught him to exploit natural resources; to live in houses rather than caves. Eventually it inspired the creation of government, with the few speaking for the many in an ordered society. Hence, Thomson wrote, cultivated life developed, the cities grew, and trade boomed. As good conclusions should, Thomson's summarised and confirmed the drift of the entire passage—

> All is the gift of Industry; whate'er
> Exalts, embellishes, and renders life
> Delightful. (141–3)

Only after this does he move on to the harvest itself, describing reaping, and

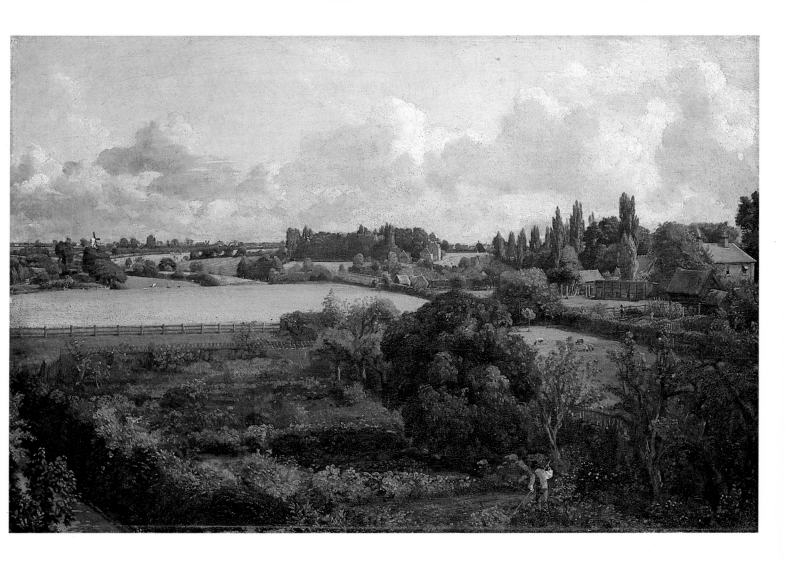

130. *Golding Constable's Kitchen Garden* 1815 Oil on canvas 13 × 20 (33 × 50.8). Ipswich Borough Council

introducing what became a conventional injunction to be generous to the gleaners, to display some Christian charity, and to remember the fickleness of fortune.[22]

It is worth considering what this very influential passage entailed. Much of it was standard. Harvest crowned the farming year with wealth. As it was the consequence of hard work, this was itself infinitely valuable, as being what raised mankind to some state of civilisation. Tension set in, however, in linking industry with labour. Industry is presented as a personification not, as far as we can tell, much related to muscle-power, except that Labour attended her, presumably as a horny-handed maiden. Industry, then, included *any* form of work. What made this usage so convenient was, that by attributing all this prospective wealth to a personification, everyone accordingly had a share in the boons of civilisation, in reality the province of the few.

Thomson's description had a political facet, a concern with promoting the status quo by arguing for it in generalisations and abstractions, rather than by giving particular instances. While it ignored the possibility that the individual labourer might (as Stephen Duck indeed did[23]) interpret affairs differently, it provided a useful ideology for those who would benefit materially from the labour which the poor performed as their contribution to that general Industry. Were the latter to deny their muscle, nothing would be grown, and society would revert to the primitive horrors from which Industry had engineered its escape: thus the moral necessity of labour was self-evident. Furthermore, as Thomson indicated in his instructions to be charitable, the social system did look after its poor. It appreciated their value, and took care to preserve them. In invoking Fortune, Thomson even

asked us to believe that fluctuation in status was inevitable, that the strong must fall, while, if the weak worked hard enough, they might replace them.

The myth of self-advancement through hard work had a strong hold on bourgeois ideology. Hogarth's Industrious 'Prentice became Lord Mayor, we are led to understand, as a consequence of applying himself to his work, and Constable had himself written that when painting, making his own contribution to that all-embracing Industry in which all classes had an interest, he was 'performing a moral duty'. As we shall see, Thomson's ideas continued to be attractive to certain other poets, and to particular social classes, even though the georgic had become after the 1760s an eccentric genre. Writing of harvest in his *Calendar of Nature*, Aikin stated that the 'farmer now sees the principal object of his culture, and the chief source of his riches, waiting for the hand of the gatherer'. He went on to describe cornfields and harvesters:

> This pleasing harvest-scene is beheld in its perfection only in the open-field countries, where the sight can take in at once an uninterrupted extent of land waving with corn, and a multitude of people engaged in the various parts of the labour. It is a prospect equally delightful to the eye and the heart, and which ought to inspire every sentiment of benevolence to our fellow-creatures and gratitude to our Creator.

The disinterestedness of Aikin's phrasing slipped only when he advocated harvest-home as a treat for the poor labourer, which 'chears his heart, and prepares him to begin without murmuring the labours of another year'.[24] Cheerful Industry should normally settle uncomplainingly to work, but Aikin's 'murmuring' suggests that this complaisance was not universal. Even this late, though, his sentiments tallied with Thomson's. Material wealth, in the form of corn, was the gift of a kind God, and God therefore acquiesced in the society which farmed for that corn. In 1799, Robert Bloomfield expressed similar sentiments, painting his scene with so much local detail that one can concentrate on this at the cost of the whole.[25] For thinking farmers the georgic was a natural and pleasing way of evaluating the landscapes they farmed. Moreover, it was one with practical meaning. Consider this passage from Constable's uncle's diary, dating from a time when the painter was actually his guest: '. . . in 17 days the finest Harvest ever known—wthout rain & fine crops: for His Providential goodness at this *Critical* time God be prais'd—Gave a Supper to all our harvest People . . .'[26] The relief at a good harvest, the thanking of God for the wealth it provided, and the discharging of an obligation to the labourers who had done the work are the clichés of English georgic poetry. As one might expect, they evidently had a strong base in the attitudes of the farming interest.

And when Constable exhibited *A Harvest Field; Reapers, Gleaners* at the 1817 British Institution, he included in the Catalogue

> No rake takes here what Heaven to all bestows—
> Children of want, for you the bounty flows!

and directed his audience to 'Bloomfield's Poem', *The Farmer's Boy*, again. Thus we can identify the traditional iconography of this lost painting. Bloomfield (whom Constable respected enough to inscribe lines he had written under a drawing of some clouds (Fig. 131) was possibly here again preferred to Thomson because he was a Suffolk poet.

In the *Harvest Field* the figures were, presumably, important in the same sense as in other works, for example the *Gardens*, where they are buried in landscape, factors in a more complex whole. I have already mentioned how these two paintings survey and interrelate the Constable farm and East Bergholt, and how harvest is an insistent if unostentatious feature. There is a passage in Thomas Ruggles's *Picturesque Farming*

131. *Cloud Study* 1825–37 Ink
$13\frac{3}{16} \times 8\frac{5}{16}$ (33.5 × 21.1). London, Tate Gallery

which serves as a commentary on them. Ruggles, himself a farmer at Clare, further up the Stour, described thus the sentiments aroused by the sight of such ripening landscapes:

> It must give the farmer pleasure to walk around his fields and see the growing and ripening products of his industry, and . . . thoughts of a more elevated nature may break upon his mind; he reflects on the moral certainty of reaping the produce of his labour; he feels his heart filled with gratitude to the great disposer of events for having blessed his honest industry with the fruits of the soil; and for having cast his lot in a country, whose government insures him liberty of person and security of possession.[27]

Like Thomson (who urged the Husbandman 'Think, oh! grateful think/How good the God of Harvest is to you'[28]) Ruggles embraced all work under Industry. Ruggles directed his labourers, secure in the eventual outcome of work he performed by proxy. Intriguingly, Ruggles used the abstracted 'industry' and more concrete 'labour' to mean the same thing, revealing a habit of thinking in terms of what was done, but not of those who did it. Neither was his complacency disturbed by doubts. Ruggles saw his as a moral attitude: 'as ye sow, so shall ye reap', one calculated to fill one with a sentiment both religious and intimately political. The constitution of England gave the security of tenure which permitted the farmer's morally exemplary behaviour. Therefore it was a sacred institution.

Here is that sense of reality which saw the georgic as an idiom of fitting modernity. As Constable seems to have shared the farmers' attitudes, so it came naturally to subscribe to a point of view which gave everything seen in the landscape a place in the great scheme of things. Constable was in a position to take it over. Not only was his social position one which had (as the *Gardens* revealed) the right to direct labour, it was also what allowed the painter to position himself in the family mansion and do a couple of landscapes recording all this.

The results are superb paintings. Perhaps some modern spectators might be hard put to symphathise with their rural moral iconography, but it is still possible to enjoy the pleasurable sensations afforded by the sight of a sunlit agricultural landscape as its crops reach fruition. One of the most crucial elements of the appearance of the farmed landscape is the variety afforded through the year by the shifting patterns of the fields. Constable holds this for a moment, and transmits the deep satisfaction such scenes can give. When we consider how aimless his procedure, and how slow his development had been before around 1808–9, this obvious progress must have been encouraging to Constable himself. By the autumn of 1815 he was not only very difficult to prise away from East Bergholt, but also appears to have become bent on painting almost to the exclusion of everything else.

In mid-May 1816, Golding Constable died. As this made his son John financially independent, the idea of marriage to Maria Bicknell became practicable at last, and they had decided by late July to marry. Nevertheless, Constable managed to keep working in East Anglia until 28 September.[29] Naturally, he and Maria corresponded much on the subject, and passages show Constable balking at marriage; not only because of his understandable panic (he was by now forty), but also because of the extent to which this would interfere with his work. The letters of this period reveal Constable's amazing single-mindedness, his selfishness, and his insensitivity to the feelings of other people. We are generally told that this was one of those legendary love-affairs, the couple kept apart by a malevolent Dr Rhudde, which is in fact a little unfair on the Rector. In the end Constable seems to have been in two minds about whether to commit himself to art or to matrimony.

After visiting two old friends of his father's, the Reverend Driffield, and Major-General Rebow, Constable was at Bergholt by late July 1816. On 13 August he

132. (over page). Detail from *Golding Constable's Kitchen Garden* (Fig. 128)

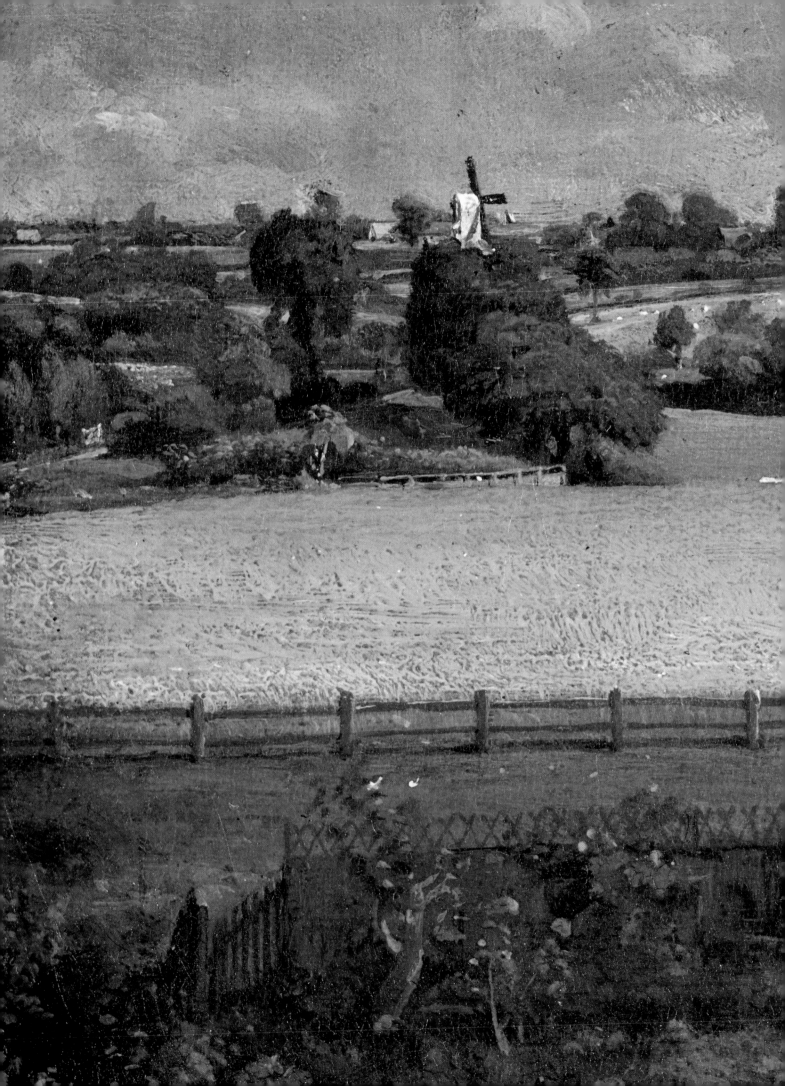

was excusing himself from writing a long letter because he had been working all day: this would be on *Flatford Mill* (Figs. 135, 136). Shortly afterwards he received two commissions from Rebow, for paintings of *Wivenhoe Park* (Figs. 12, 16), and *The Quarters, Alresford Hall* (Figs. 8, 10), something he viewed with mixed feelings:

> I am getting on as well as I can with my own pictures, but these little things of the generals will rather interrupt them—and I am afraid will detain [me] here a week or two longer than I could have hoped—and it would be a pity not to do as well as I can with what I have going on here for a few days longer more or less.[30]

His problems with *Wivenhoe Park* were mentioned above. Any strain there was stemmed from Constable's wish to avoid being hurried, for he also had paintings under way at Flatford. He needed time, and a firm commitment like a wedding day created pressure. It is almost as though, by accepting these commissions, he were trying to buy further time to keep painting.

So on 30 August Constable wrote 'If I should delayed longer in the country than I first expected I shall run up for a day or so to see you', followed, a few paragraphs on, by 'I shall be here a week at least longer'.[31] Maria's 'You must not talk of settling in London before the end of October'[32] revealed a saintly patience. Now a letter from Fisher sent Constable into near panic. It contained an offer to marry them, and this, as Maria herself assumed,[33] seemed to make the wedding inevitable. And, on 12 September, with his future being planned for him, Constable revealed just how obsessive about painting he had become.

> I am now in the midst of a large picture here which I had contemplated for the next Exhibition—it would have made my mind easier had it been forwarder—I cannot help it—we must not expect to have all our wishes complete. But a visit to our good friend John Fisher must be so very respectable, that I know not if it could be bought so dear—only that the visit to them later in the season would have done as well . . . The most of loss to me however will [be] my time (& reputation in future) at this delightfull season. But do not think my dear that I wish any alteration in our plan—every other concern of mine is second to yours.[34]

This tactless letter provokes some sympathy for Maria. As her reply to this astonishing plea to be allowed to stay on at Bergholt to get on with *Flatford Mill* is one of the very few of her letters not to have survived, it must have been blistering enough for Constable to have destroyed it. Its tone may be inferred from his reply, which began 'How sorry I am my dearest Love that anything should have escaped me that could have caused you one moment's uneasiness at such a time as this'.[35] The conviction of this shabby apology wavered as he went on to explain that he had wanted the time for painting, was taking commissions (which he was willing to sacrifice) for money, and then to express total lack of interest in Maria's trousseau, suggesting that as he was in mourning for his father, she might as well be married in black, too. Her last resorts were sarcasm—'your landscape too gives me some uneasiness, is there a chance of its being sufficiently forward to do without *your copy*?'—and to play his own game by musing on the foolishness of rashly entering into a penurious marriage.[36] This did the trick. Constable became resigned to his fate, and from his correspondence it appears that he almost began to consider Maria's feelings.

Constable may have been so on edge because he suspected it might be his final chance of sustained study around Bergholt. He was probable worried about *Flatford Mill*: the weather was bad that summer, and the painting was large enough to require plenty of labour. But I think that Constable's intense desire to keep painting

133. 1814 sketchbook. Pencil $3\frac{1}{8} \times 4\frac{1}{4}$ (8 × 10.8). London, Victoria and Albert Museum (R.132) p. 61 *Flatford Mill*. Inscr. '14 Augst 1814'

134. *Flatford Mill* 1814–17 Oil on canvas $9\frac{1}{2} \times 7\frac{1}{2}$ (24.1 × 19). Private Collection

also stemmed from his awareness of the extraordinary quality of his work. If he could be recognised for what he knew he was, one of the most original contemporary landscape painters, then success must come, just as it had done, far more easily, to less talented artists. The later *White Horse* was on a six-foot canvas mainly to attract exhibition-goers' attention. *Flatford Mill* was probably large for the same reason.

Although there are drawings of the view to the mill from the bridge in the 1814 sketchbook (Fig. 134), it is wrong to speak of *Flatford Mill* (Figs. 135, 136) having originated here, for it was a convenient motif, and one which Constable, wandering around a confined area, would have been hard put to avoid.[37] Equally, it is hard to know which, if any, oil sketches of this scene (Fig. 134) were done in preparation

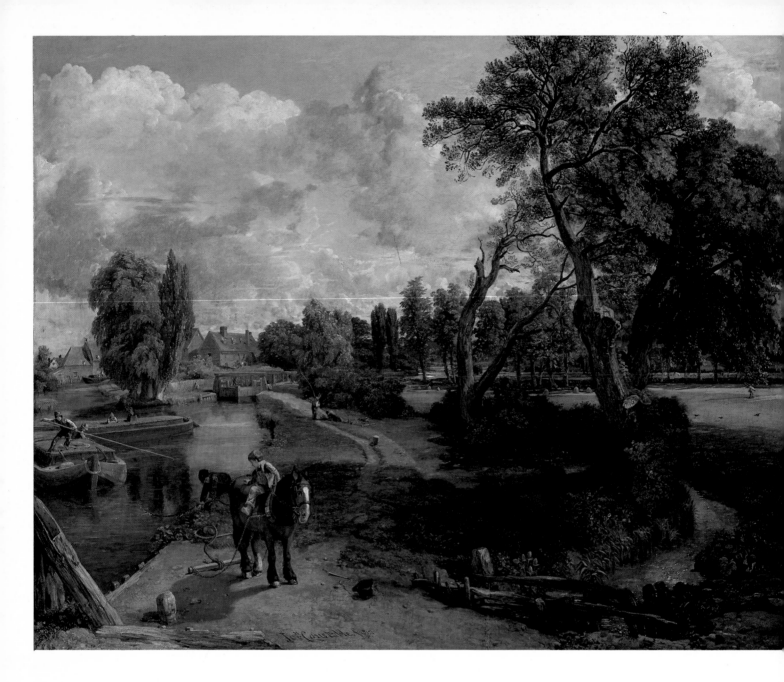

135. *Flatford Mill* 1816–17 Oil on canvas 40 × 50 (101.7 × 127). London, Tate Gallery

136. Detail from *Flatford Mill* (Fig. 135)

for *Flatford Mill*, save for a small one (now untraced) which records the whole scene. This might show Constable worried (as we know) about moving on to so large a canvas, and keen to try the effect of his planned composition before committing himself to it. Certainly some parts of the eventual painting were at one stage unsatisfactory, for a tow-horse was replaced by some young anglers, and the elms reworked from a detailed drawing of 17 October 1817 (Fig. 137). Nevertheless, so late an alteration presupposes a painting which Constable had liked enough to exhibit in the Royal Academy that year. One would guess that he painted it at least partly in the open. It displays the same uncanny verisimilitude as smaller *plein-air* works in passages like the clear water of the slip stream running over a muddy bottom, or the grazing cattle in the near distance (Fig. 136). And like smaller works, this painting has a significant documentary element indicated by the mower in the middle distance. On 16 August Constable wrote that they could not get their hay up,[38] and on the 21st grumbled, on returning from Wivenhoe Park, that Rebow's commissions interrupted progress with his 'own' pictures;[39] the coincidence of either making it likely that *Flatford Mill* recorded the dreadful summer of 1816.

By painting on a larger scale Constable reinforced the pretensions of his landscape.

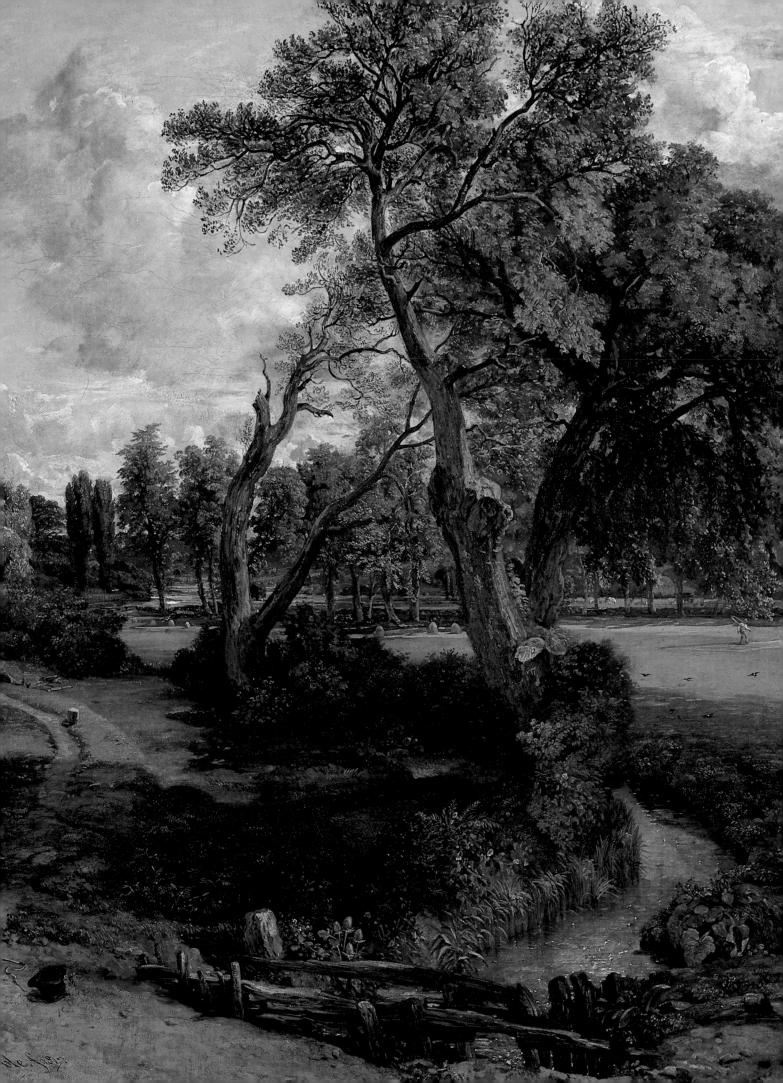

Like the earlier work, *Flatford Mill* has a high viewpoint and realistic style, and is topographically accurate. Constable's title, *Scene on a Navigable River*, explains what is happening. The buildings must be a mill, therefore the barges probably transport corn or flour (produce of the cultivated landscape). The sun's height, along with shadow-lengths, suggest a time close to mid-day, which puts south to the right and shows the river to flow west to east. Every feature is mutually explanatory in a landscape where man plays an unobtrusive but important part in directing its appearance through buildings, straightenings of the river, and husbandry. The high viewpoint, with its survey of the whole, enhances that sense of harmony between man and nature, because it makes all details significant in terms of the landscape itself. Constable's sentiments about Bergholt being calm, comfortable, and good are confirmed by such paintings as this. All is placid, all is natural. There is no sense of unease.

Neither did *Wivenhoe Park* present insurmountable problems. It is fairly certain that Constable painted it outside. First mentioning Rebow's commission for two paintings on 21 August,[40] Constable reported on 19 September, 'I have compleated my view of the Park for General Rebow & am just returned to this place'.[41] His interim 'I live in the park and Mrs Rebow says I am very unsociable'[42] implies that he worked mostly out of doors and the detail of *Wivenhoe Park* tends to favour that conclusion. Between the trunks of the clump to the house's right can be spied a fence, with farm buildings beyond it; this is close study like that in the *Gardens*. *Wivenhoe Park* is a wonderfully adept marriage of such precision with compositional completeness. The colouring is just, predominantly blues and greens, offset by white clouds and their reflections, and the handling of paint is absolutely confident. Although the descriptive painting is minute, it never obtrudes in terms of the whole. The canvas, at $22\frac{3}{8} \times 39\frac{7}{8}$ inches, was wider than the largest of the sizes Constable favoured for outdoor work, because he literally 'added' his deerhouse on a $3\frac{1}{8}$ strip to the right, attaching another, $3\frac{7}{8}$ to the left, the canvas having originally been a 'standard' $22\frac{3}{8} \times 32\frac{7}{8}$,[43] around the size used for the *View of Dedham*.

Rebow also commissioned a painting of *The Quarters, Alresford Hall* (Figs. 10, 8), at $13\frac{1}{4} \times 20\frac{3}{8}$ inches on the smaller of Constable's *plein-air* canvas sizes. As there is a very careful preparatory drawing for this painting, Constable may again have prepared for work out of doors by establishing the subject in masses and tones in monochrome, working on detail and colour before nature. *The Quarters* was expressly a souvenir of the summer house where Rebow's daughter went fishing, and, with trees beginning to yellow with the season, shares the naturalism if not the pretensions of *Wivenhoe Park*.

The easy combination in that painting of a revolutionary naturalism with a time-worn composition supports the theory that both Constable and Rebow took automatically to this way of portraying a country house. Iconographically, *Wivenhoe Park* was equally traditional. A reason for noticing country houses at all was the particular worth of their inhabitants, and picturing one implied this compliment to its owner, even though here the latter was paying to be flattered. Eighteenth-century poets created this tradition of compliment to patrons, as those under whose influence estates benefited in real terms of peace and prosperity, and few writers of local poems passed by the chance to lavish praise on the owners of the places described. Indeed, if the attack that Uvedale Price made on prospect-hunters is anything to go by,[44] the point had been reached where the aesthetic qualities of any landscape depended on the numbers of mansions it contained, for it was these which made it interesting.

In *Wivenhoe Park*, Constable's iconography was close to Turner's in *Ploughing up Turnips near Slough* (Fig. 84), where Windsor Castle played the part of the country

137. *Elms at Flatford* 1817 October 17 Pencil $21\frac{3}{4} \times 15\frac{1}{8}$ (55.2 × 38.5). London, Victoria and Albert Museum (R.161)

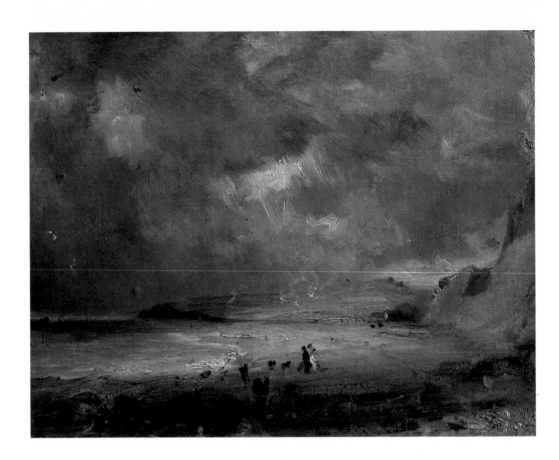

house. Although Rebow's effect on his domains was less unremittingly georgic,
georgic it was. Anyone with a modicum of taste would appreciate the estate's
beauty, and be inclined to praise its cause. They would approve of the combination
of beauty with utility (thus the juxtaposition of ornamental swan with toiling
fishermen, or the cattle dotted around and about).

By now, it might be argued, Constable had developed his 'natural painture' to its
full extent. A retrospect of his work over the next few years shows little real
development, until he began working on the large scale in the studio. One of the
touchstones of the ideal of the 'natural painture' was that it never could be achieved.
Reynolds wrote of improving the art, but never of attaining perfection. Constable
surmounted the problem of maintaining this development of his artistic ideal by
continuing to study nature *wherever* he found himself. Between 1815 and 1817 he
exhibited landscapes painted between 1815 and 1816. 1817 saw his last long
sojourn at East Bergholt, and possibly the 1818 Royal Academy contained work
done then, although Constable's catalogue entries are no help. Of the two drawings
exhibited, one was probably an 1817 one of East Bergholt church (Fig. 264),[45] and
another certainly of some elms in Old Hall Park (Fig. 1). However, after 1818

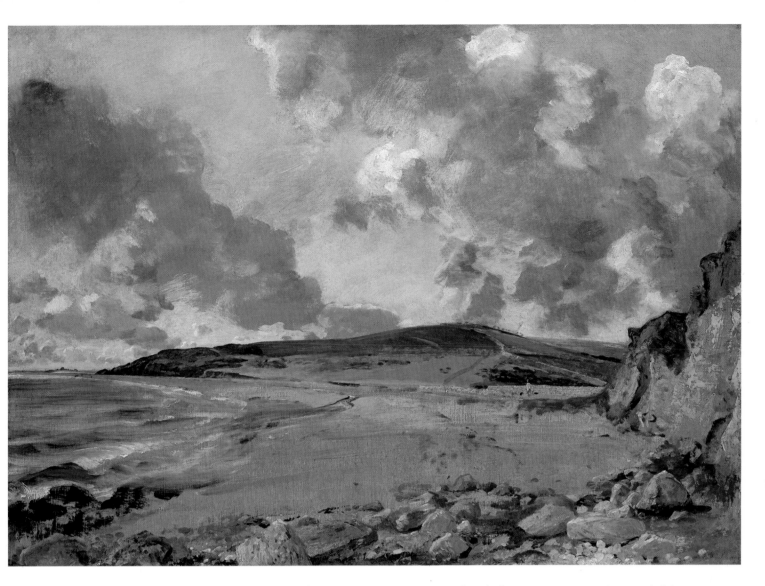

141. *Weymouth Bay* ?1816 Oil on canvas 20¾ × 29½ (52.7 × 74.9). London, National Gallery

Constable's Stour Valley landscapes were by definition retrospective, and this may well have something to do with the ways his art can be seen to change towards 1820.

Constable had been painting virtually only the Stour Valley for four years (he had sketched at Salisbury in 1811), a campaign of sustained study of the one landscape only to be equalled by Cézanne in Provence. Marriage meant a sharp removal from these familiar scenes. The work he did on his honeymoon, however, does not suggest too much of a shock for Constable, and when he returned for ten weeks in East Anglia in 1817, he may have been assuming that this would be a regular occurrence, and that his habits would not be too much disrupted: hence, perhaps, the attempts both he and his family made to conciliate Dr Rhudde.[46]

On his honeymoon in Dorset and Wiltshire, Constable was sketching unfamiliar sites, not studying well-known scenery. However, he met few artistic problems. Perhaps his emphasis on line rather than mass in certain drawings (Figs. 139, 140) reveals the necessity to delineate a novel landscape, yet he was easily rendering complex effects of light and shade, and some of the oil sketches are brilliant. *Weymouth Bay* (Fig. 138) is a bold and supremely successful rendering of a stormy effect. And neither is there any reason to assume that the larger picture (Fig. 141) should not have been done on this stay; the canvas is near the '20¼ × 30¼' outdoor size, and the technique used for the clouds is a coarser version of that seen in *Wivenhoe Park*, while the simple but consummately clever device of leaving the canvas ground to serve as the beach may have been as much due to the artist having wished to save time,

142. *Wivenhoe Park* 1817 Pencil
$4\frac{1}{2} \times 7\frac{3}{8}$ (11.5 × 18.7). Inscr.
'Wivenhoe Park Augst. 29. 1817'.
London, Victoria and Albert
Museum (R.159)

143. *Churn Wood and Greenstead
Church* 1817 Pencil $4\frac{1}{2} \times 7\frac{3}{8}$
(11.5 × 18.7). Inscr. '29 Augst. 1817.
Wivenhoe Park. Churn Wood'.
London, Victoria and Albert
Museum (R.160)

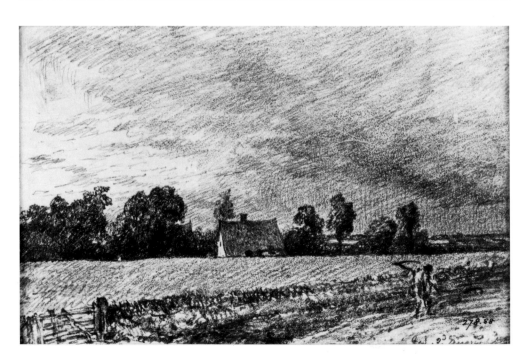

144. *Cottage and Road at East Bergholt*
1817 Pencil $4\frac{1}{2} \times 7\frac{3}{8}$ (11.5 × 18.7).
Inscr. 'E.B. 3d. August'. London,
Victoria and Albert Museum (R.157)

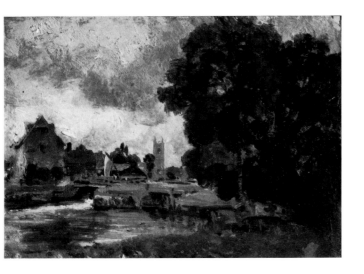

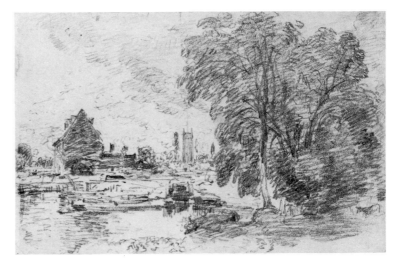

145. *Dedham Mill c.* 1810–17 Oil on
paper 7⅛×9¾ (18.1×24.8). London,
Victoria and Albert Museum (R.113)

146. *Dedham Mill c.* 1814–15 Pencil
4½×7¼ (11.5×18.4). San Marino,
Henry E. Huntington Art Gallery

147. *Dedham Mill* 1820 Oil on canvas
21⅛×30 (53.7×76.2). London,
Victoria and Albert Museum (R.184)

as to his having left the painting unfinished. It also serves to emphasise the clarity with
which the distance (painted more thickly) can appear in a very bright atmosphere.
And as no substantial painting emerged from the honeymoon, one may attribute
Constable's assiduity to work having become a habit, and to his wishing to keep his
eye in.

Since his marriage Constable had done little other than sketch, and he therefore
sent canvases lying readily to hand to the 1817 exhibitions. *A Cottage, Flatford Mill*,
and *Wivenhoe Park*, done in 1815 and 1816 went to the Royal Academy, while *A
Harvest Field: Reapers, Gleaners*, shown at the British Institution, may have been the
Wheatfield of the previous year's Royal Academy. And, as these exhibited works

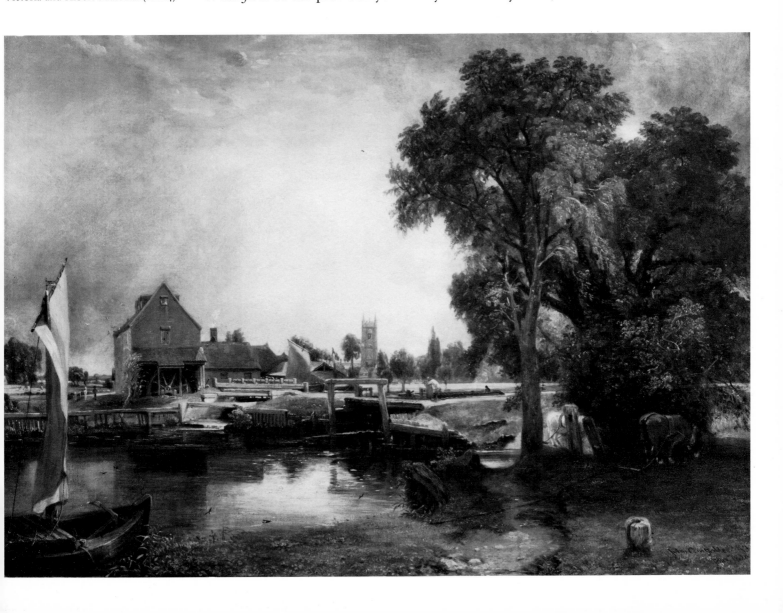

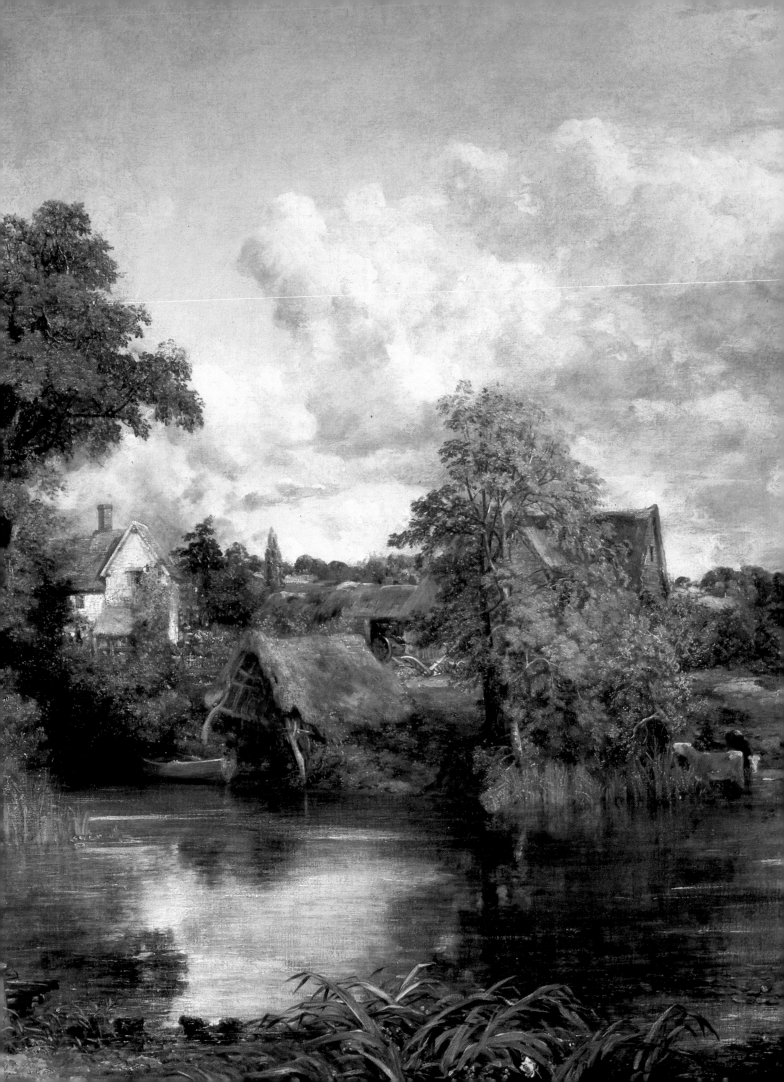

suggest, Constable's 1817 studies around East Anglia confirm that neither his idea of landscape nor his sense of place had changed. Indeed, an 1817 drawing of Mistley has already been mentioned to illustrate the conformity of taste between Constable and East Anglian society. Other drawings also show this consistency.

A prospect of reapers of 15 August (private collection) has its centre taken up by a view of the field, the corn in various stages of being cut, working figures engrossed in their labour. Then there are vignettes, like the one of 29 August, cattle taking cover from the sun under the trees of Wivenhoe Park (Fig. 142), done the same day as the neighbouring landscape towards Churn Wood and Greenstead Church (Fig. 143), where, in the foreground, figures reaped the cornfield which stretched some way into the distance. Another figure, this time trudging along and bent under a scythe, almost like one of Gainsborough's woodcutters, was drawn one evening at Bergholt (Fig. 144). Behind him was a view across a cornfield to a thatched cottage, backed by a line of wood, and with the further reaches of the Stour Valley showing beyond.

If nothing else these drawings show that Constable kept busy. He was also working in oil. On 11 November Farington reported on 'many studies' painted at Bergholt, and on the 24th recorded that Bigg spoke 'favourably of Constable's oil sketches done during the summer'. Constable wrote on the back of one 'made this sketch, Oct. 1817. Old Joseph King, my father's huntsman, came to me at this time—there was a barn on the right in which he had thrashed that time 70 years',[47] seeming to connect himself with an aged representative of the figures which populated his painting, and perhaps to celebrate an element of human continuity as well. In reverting to sketching in oil Constable had bowed to the inevitable in not trying to finish work on the spot, but rather to build up a store of studies for reference in the London studio. This implies that he meant to maintain his output of East Anglian landscapes.

With exhibition paintings, the only real departure was a gradual concentration on canal scenes. While in 1818 *Flatford Mill* was put into the British Institution, Constable's Royal Academy exhibits are uncertain. One, *Landscape; Breaking up of a Shower*, might be the *Dedham Mill* (private collection) which in 1819 went to the British Institution, for this painting does show a shower moving off. A drawing of this scene (Fig. 146) dates on stylistic grounds to *c*.1814–15, although its dimensions do not fit any known sketchbook.[48] There is also an oil sketch (Fig. 145), which relates to another *Dedham Mill* (Fig. 147), and which, being a similar size to both another version (in the U.S.), and an unfinished painting in the Tate,[49] suggests that all three are replicas of a successful composition; early instances of a practice Constable was to follow in the 1820s, In Fig. 147 Constable introduced a man opening the lock, and to the left added a barge, its horse released to graze while it waits for another vessel to shoot the locks. As usual, nature serves as a stage for and response to the actions of men, and an increase in the number of people might have been because Constable felt that what incident there had been in the first version was too sunk in landscape to attract notice. In these paintings he played on the bustle incident to a scene where boats load and pass through docks by a mill on a navigable river.

Also exhibited in 1819, at the Royal Academy, was one of Constable's most important paintings. He called it *A Scene on the river Stour*; we know it as *The White Horse* (Figs. 156, 148). At $51\frac{3}{4} \times 74\frac{1}{8}$ inches it may have been larger than anything he had previously tried, and this time, as Leslie wrote, it 'was too large to remain unnoticed'.[50] The critic of the *Literary Chronicle*, for one, was enthusiastic: 'What a grasp of everything beautiful in rural scenery! This young [sic] artist is rising very fast in reputation, and we predict that he soon will be at the very top of that line of art of which the present picture forms so beautiful an ornament.'[51] This large and expensive canvas was a gamble which came off in every aspect. Constable not only received good notices in the press, he managed to sell the painting for 100 guineas

149. 1814 sketchbook. Pencil $3\frac{1}{8} \times 4\frac{1}{4}$ (8 × 10.8). London, Victoria and Albert Museum (R.132) p. 66, *Willy Lott's Farm*

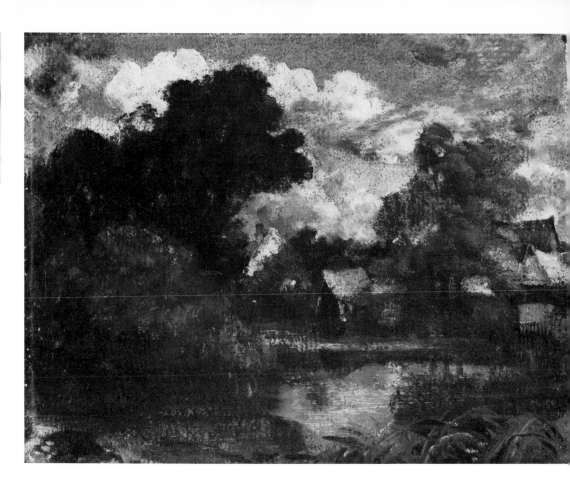

150. 1813 sketchbook. Pencil $3\frac{1}{2} \times 4\frac{3}{4}$ (8.9 × 12). London, Victoria and Albert Museum (R.121) p. 76 *Mooring post*

151. (right). Study for *The White Horse* c. 1818–19 Oil on canvas $9\frac{1}{4} \times 11\frac{7}{8}$ (23.5 × 30.2). Private Collection

152. Full-scale study for *The White Horse* c. 1818–19 Oil on canvas 50 × 72 (127 × 183). Washington D.C., National Gallery of Art

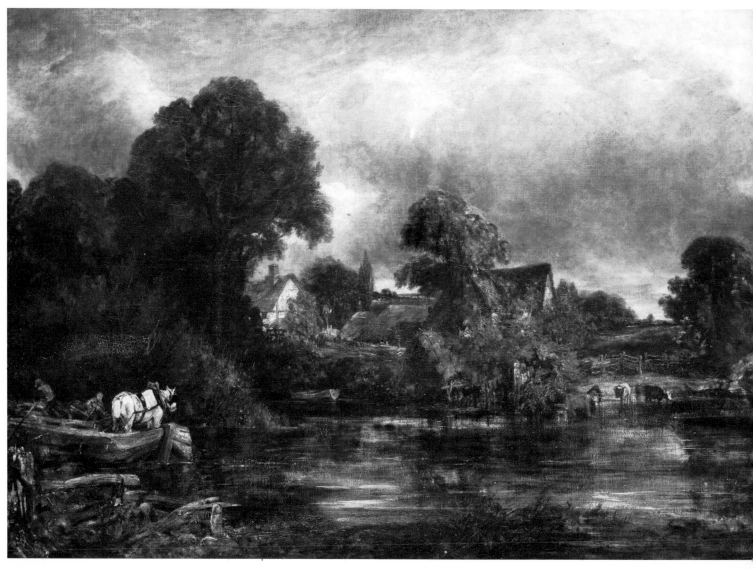

153. T. Gainsborough *The Watering Place* exh. 1777 Oil on canvas 58 × 71 (147.3 × 180.3). London, National Gallery

SUMMER.

II.

THE FARMER's life displays in every part
A moral lesson to the sensual heart.
Though in the lap of Plenty, thoughtful still,
He looks beyond the present good or ill;
Nor estimates alone one blessing's worth,
From changeful seasons, or capricious earth;
But views the future with the present hours,
And looks for failures as he looks for show'ers;
For casual as for certain want prepares,
And round his yard the reeking haystack rears;

154. R. Bloomfield *The Farmer's Boy* 5th ed. London 1801 Titlepage to *Summer* (J. Nesbit)

155. J. M. W. Turner *Walton Bridges* exh. 1806? Oil on canvas 36¼ × 48¾ (92.7 × 123.8). Private Collection

(albeit to his friend John Fisher), and on the strength of it was at last elected an Associate of the Royal Academy. Constable must have puzzled as to where he had been going wrong before.

Little 'preparatory work' survives for *The White Horse*. An 1814 sketchbook drawing (Fig. 149) shows the area from the boathouse to the left, and an oil sketch (Fig. 151) follows the composition fairly closely (although there is nothing to say either if it was done on the motif, or worked up from the drawings). This sketch was broadly worked to establish masses and tones, and extends the view to the right. Finally there is the large version of the subject (Fig. 152), the authenticity of which has been doubted,[52] although one needs to know who, other than Constable, would have painted it. It may be a rough sketch, both to try out the composition on the large scale, and to provide a model for reference during painting. If so, this would anticipate what I shall suggest was Constable's procedure in 1821, with *The Hay Wain*.

Presumably *The White Horse* was compiled from sketches of its parts, to which, as well as larger paintings like the unsold *Flatford Mill*, Constable referred to get something like the 'natural painture' on to this larger scale. One may debate whether he entirely managed it. Impasto varies, so while canvas ground appears between the trees by Willy Lott's house, pigment to the right-hand side of the barn gable is thick and opaque. Precision of handling fluctuates. The trees by the boat house are as accurate as any previously painted, but those to the far right, and the track, have a curious indistinctness, reminiscent of far earlier work. Seen close to, such stylistic variations can distract the view of the painting, but at about four yards the parts cohere, and it appears a complete and satisfying rendering of the Stour on a hazy summer's day, water reflecting its surrounds with a dull glassiness.

Placing the ferrying of the horse off-centre not only emphasised how this was but part of the landscape, but also diffuses attention: it takes some time to work out the painting's details in terms of their whole. The only activity is on the barge, but signs of it are littered elsewhere—the farmhouse, the moored rowing boat, the ploughs and other tackle in the barn, and the cattle. By signing the canvas from London, Constable intimated an element of retrospect in his vision, although by the very act translating it onto the large scale, he insisted on its vitality.

Constable suggested the georgic most obviously through the farming tools in the barn, and confirmed it elsewhere in the composition. Contemporaries would have found the cattle a telling detail, for in *Summer* this vignette characterised the country on a blazing summer's noon:

A various groupe the herds and flocks compose;
Rural confusion! On the grassy bank
Some ruminating lie; while others stand
Half in the flood, and, often bending, sip
The circling surface.

(*The Seasons: Summer* 485–9)

Gilbert White, who had observed similar scenes at Selborne, was delighted with this observation;[53] and paddling cattle were not uncommon in painting. Gainsborough may have bragged of his illiteracy: he nevertheless showed cows up to their hocks in a pool, while labourers, indolent with heat, laze by them in *The Watering Place* (Fig. 153), thus emphasising the torpor of a summer's noon. And while many of the illustrated editions of *The Seasons*[54] featured this image,[55] it was a little surprising to find Nesbit employing it for Bloomfield's *Summer* (Fig. 154), in which it did not occur (although were one to go in for source-hunting, this group of cattle is similar to Constable's). It shows how strong the associations with this motif were. Likewise

156. *The White Horse* 1819 Oil on canvas 51¾ × 74⅛ (131.4 × 188.3). New York, Frick Collection

157. (right). J. M. W. Turner *Dorchester Mead* 1810 Oil on canvas 40 × 51¼ (101.5 × 130). London, Tate Gallery

158. (facing page). Detail, study for *The Hay Wain* (Fig. 171)

Turner incorporated it as a significant detail in such of his Thames 'pastorals' as *Walton Bridges* (Fig. 155) or *Dorchester Mead* (Fig. 157).

These cows showed that over a hot noon the labourer could be permitted some respite. If he was idle it was because the heat had made him drowsy, and this somnolence was unexceptionable: a rare instance where convention allowed the figure to be shown inactive. Nothing is happening for the moment, but as this is only a temporary intermission, no threat to the social balance is posed.

Constable, though, while implying respite, nevertheless still showed figures working. With his background it might have been surprising had he done otherwise. Hence the landscape is at rest, save for the barge, also there of course to provide a modicum of 'subject'. It functions as does the boat with fishermen in *Wivenhoe Park*, and the choice of viewpoint for the glimpse of Willy Lott's farm over a wide expanse of the Stour might have been deliberate, to connect with the country house composition, and reflect approval of the social hierarchy by inferring that on his level Lott displayed the same laudable characteristics as Rebow did on his.

The barge was emblematic of trade, and the very contrast of its movement with the depopulated quiescence pervading the rest of the landscape enhances the idea that trade never ceases. On a purely anecdotal level, it was ferrying the horse because the towpath ran out, but it also helps to create a subdued georgic mood, in harmony with the season and time of day. It is an exactly judged moment of appropriate action.

Constable seems to have found few problems working in the studio. He evidently considered the painting ready for exhibition by 2 April, when Farington saw it, and recommended a number of alterations.[56] And the ease with which Constable was able to paint the Stour from London seems to reflect a tranquillity of mind, which perhaps helped the generally successful translation of the 'natural painture' from the smaller to the larger scale.

While this applied to his studio work, in 1819 Constable's painting habits took a significant change in direction. That July the Constables took a cottage at Hampstead and John began to sketch the Heath and its surrounds. Within two years he was exhibiting Hampstead landscapes at the Royal Academy exhibitions. In view of his extraordinary devotion to the Stour Valley, this was a major step for Constable to take. Iconographically Hampstead Heath, an uncultivated 'desert', was the kind of landscape to which it was feared the cultivated one might revert, although, significantly, in his 1819 sketchbook Constable focused as much on activities like earth-shifting as the landscape itself, and in a finished landscape of c.1820 (Fig. 161) such an incident was placed in the foreground, contrasting with the population of strolling figures. However, an oil sketch of 1819 (Fig. 162) has few figures, and concentrates on dramatic effects of weather, and the reaction of the broken and picturesque textures of the Heath to light. Almost structured in paint, Constable has worked browns and reds; and greens around the horizon, impasting white in the sky. This is the artist studying a terrain which in familiarity and character opposed that of the Stour Valley. And subsequent drawings of the opening of Waterloo Bridge, a celebration of national achievement in an urban setting, which are the basis of a painting eventually exhibited in 1832, contrast strongly with his Stour Valley.

Nevertheless, the East Anglian landscape continued to be the basis for Constable's Royal Academy exhibits. In 1820 he showed the first of what proved to be a popular composition, *Harwich Lighthouse* (Figs. 159, 160), and the second six-footer, *Stratford Mill* (Figs. 163, 164). Once again, this latter work had little incident. There is subject in the young anglers and a barge opposite them. But in general, the landscape is uncluttered and peaceful: the sun coming through one of those slightly turbulent skies that can develop in summer. The central part of the composition was

161. *Hampstead Heath c.* 1820 Oil on
canvas $21\frac{1}{4} \times 30\frac{1}{4}$ (54 × 76.9).
Cambridge, Fitzwilliam Museum

162. *Branch Hill Pond, Hampstead*
1819 Oil on canvas $10 \times 11\frac{7}{8}$
(25.4 × 30). Inscr. 'End of Octr.
1819'. London, Victoria and Albert
Museum (R.171)

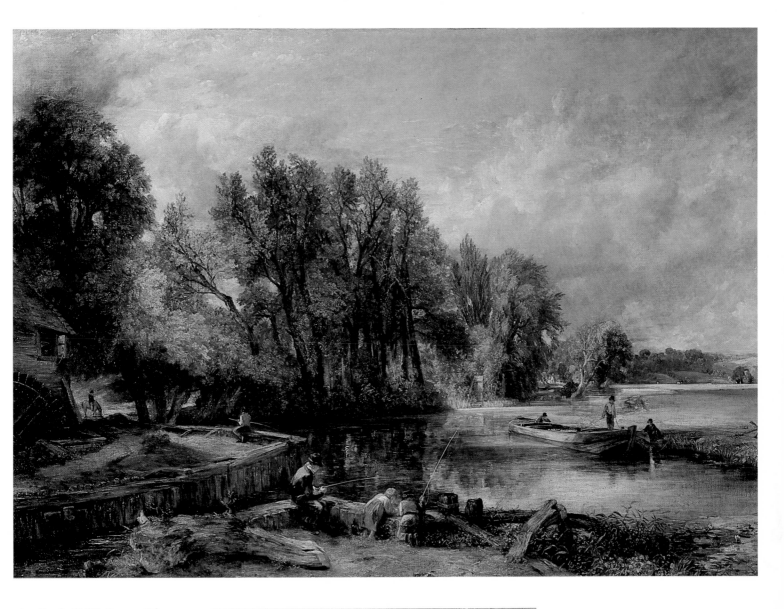

163. *Stratford Mill* 1819–20 Oil on canvas 50 × 72 (127 × 182.9). Private Collection

164. *Stratford Mill* 1811 August 17 Oil on panel $7\frac{1}{4} \times 5\frac{5}{8}$ (18.3 × 14.5). With Christies', November 1982

substantially based on an 1811 oil sketch (Fig. 164). Although less obviously busy, it conforms with earlier work, in the usual ways. It has a similar combination of barges, mill, and anglers, to that which in *Flatford Mill* qualified the terrain, and all is controlled by a high viewpoint; the style is largely aimed at representing nature.

Constable possibly conceived the idea for the painting in May 1819. On a rare visit to Bergholt he had walked up the Langham hills, and across some watermeadows, a route which could have taken in Stratford. Afterwards he wrote home 'in my life I never saw Nature more lovely',[57] but we cannot know if he attempted to convey some of his feelings through this canvas. Whatever its inspiration, Constable again had no problems in completing it in time for the exhibition, and was pleased enough about it to tell Farington he was unconcerned about its reception.[58] His confidence was surely boosted by a favourable press,[59] and, remembering his success in 1819, he must have felt that transferring his image of East Anglia on to the larger scale had paid off handsomely. As yet Constable was showing none of the neurotic uncertainty which, from around 1822–3, was to be the symptom of his painting the exhibition picture. It was to develop soon after *The Hay Wain* (Figs. 171, 175) in 1821, the painting which culminated that series of Stour Valley landscapes which had begun in 1811 with *Dedham Vale, Morning*.

Constable had ceased to draw much direct inspiration from the actual terrain that he painted on so large a scale. After the 1820 exhibition he and his family went off to Salisbury for much of July and August. Constable himself went up to Malvern Hall in September, and by October they were once again at Hampstead. On these journeys he sketched in oil and pencil, generally working with fluency and confidence. Dated Hampstead oil sketches impart a sense of dislocation, Constable having pictured ground, trees, and sky in combinations which suggest no topographical concern, but rather an interest in textures and effects. Indeed this may signal a change in his concern with place, for by November he was planning a picture of Waterloo Bridge for the 1821 exhibition. Farington advised that he 'complete . . . a subject more corresponding to his successful picture exhibited last May',[60] that is, he suggested *The Hay Wain* as the continuation of a line.

While Constable may, after confronting different landscapes, have been wishing to expand his repertoire, he appears to have found this no hindrance to painting what was to be the last georgic Stour Valley landscape. Constable reported on *The Hay Wain*'s progress in January 1821[61] and had it framed by 9 April.[62] Yet there is an impression that things were more rushed than usual, and on 25 February Constable's brother held out small hope for it:

> . . . I shall take the opportunity of sending you John Dunthorne's outlines of a scrave or harvest waggon. I hope it will answer the desired end; he had a very cold job but the old Gentleman urged him forward saying he was sure you must want it as the time drew near fast. I hope you will have your picture ready but from what I saw I have faint hopes of it, there appear'd everything to do.[63]

John Dunthorne who was drawing the harvest wagon was the son of Constable's old friend, and the letter describes Dunthorne senior egging him on to provide Constable with an accurate pattern of the Suffolk wagon—in this instance a timber trolley adapted to hay carting. Either the latter had no suitable sketch of his own, or he had forgotten how such a cart looked. The canvas still needed work on 1 April,[64] so to get the painting framed a week later he must have worked very hard at it.

For the last time, we survey an agricultural Stour Valley landscape. On 1 April Constable had complained to Fisher that the 'Londoners with all their ingenuity as artists know nothing of the feeling of a country life (the essence of Landscape)—any more than a hackney coach horse knows of pasture.' And he had gone on to express

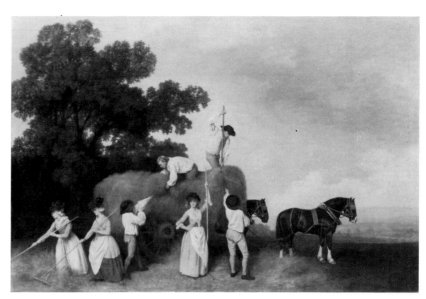

169. *Willy Lott's Farm* 1816 Oil on paper on canvas $7\frac{5}{8} \times 9\frac{3}{8}$ (19.4 × 23.8). Ipswich Borough Council

170. Study for *The Hay Wain* 1820–21 Oil on canvas 54 × 74 (137 × 188). London, Victoria and Albert Museum (R.209)

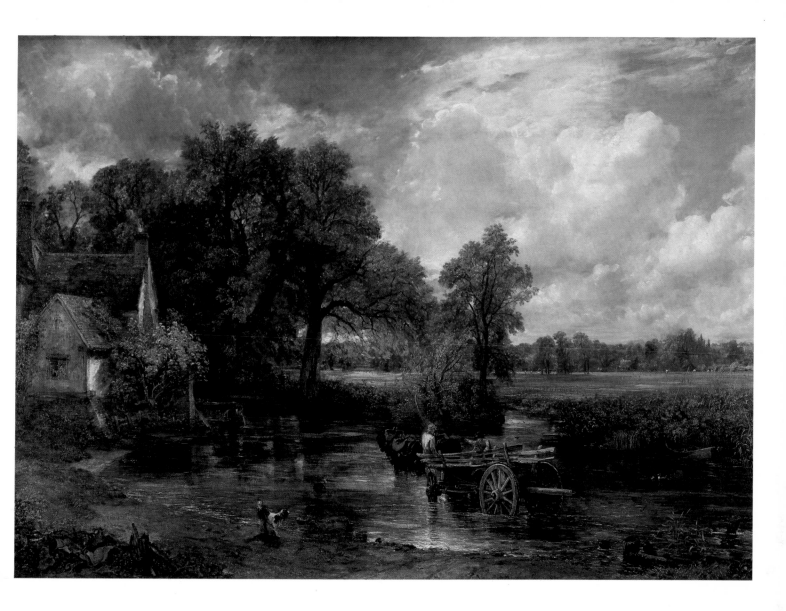

171. *The Hay Wain* 1821 Oil on canvas 51¼ × 73 (130.5 × 185.5). London, National Gallery

his pleasure at White's *Selborne*: '. . . it only shows what a real love for nature will do—surely the serene and blameless life of Mr White, so different from the folly & quackery of the world, must have fitted him for such a clear & intimate view of nature.' Constable's philosophy was little changed. He liked White for his moral and retired life, for 'the feeling of a country life', the sense of localised rural routine, which was what gave landscape its soul. Since Constable's attitude to landscape depended on his sense of place, it is hardly surprising that *The Hay Wain* conforms, in most important respects, with its predecessors.

Haymaking, which provides a narrative element, had traditional aspects. But rather than emphasise any of them Constable preferred to make his point via allusion. We see an extensive landscape, stretching from Willy Lott's house on the left to a watermeadow on the right. Within these meadows is a line of mowers, the figure at the end sharpening his scythe and surveying his companions. This recalls a character in a lost painting of which an account is given by Leslie. He retails how Sam Strowger, a Suffolk man who modelled at the Royal Academy, was entranced by the accuracy of, probably, *The Wheatfield*, and after its poor reception comforted Constable by saying 'Our gentlemen are all great artists, sir, but they none of them know anything about the *lord*', the 'lord' in Suffolk being the leading man in the line;[65] it is he who sharpens the scythe. Behind and to the left of the mowers is a laden wagon, men pitchforking hay on to it, which is replaced by the cart crossing the river at what was called Flatford precisely because the Stour there offered this

172. *Willy Lott's Farm c.* 1810–17 Oil
on paper 9½ × 7⅛ (24.1 × 18.1).
London, Victoria and Albert
Museum (R.110)

facility. As usual, the incident was shown as unremarkable. The white dots which
indicate the mowers' shirts are just several visual emphases in that area. Neither the
washerwoman, nor the angler (occupying the boat from *The White Horse*) notice
the wagon. Only the spaniel looks up to see what is going on. Though
inconspicuous, the subject is not unimportant. Incorporated by the high viewpoint
into the landscape, the haymakers transfer their genre qualities to the place itself.

Haymaking and sheepshearing traditionally indicated that summer had arrived.
Thomson emphasised the social relaxation of the occasion with villagers swarming
(a verb which, being associated with bees and the fourth *Georgic*, emphasised the
social harmony) over the 'jovial' mead, and when from dale to dale 'resounds the

173. P. P. Rubens *Landscape with the Château de Steen* after 1635 Oil on panel 51¾ × 90½ (131.8 × 229.9) London, National Gallery

174. Claude Lorrain *Coast Scene with Aeneas at Delos* 1672 Oil on canvas 39¼ × 52¾ (89.53 × 139.9) London, National Gallery

blended voice/Of happy labour, love, and social glee',[66] he reflected a real cheerfulness. Even Stephen Duck was to view haymaking with initial optimism:

> Before the door our welcome Master stands;
> Tells us the rip'ning grass requires our Hands.
> We wish the happy season may be Fair;
> And joyful, long to breathe in op'ner Air.[67]

And despite this blithe anticipation succumbing to labour and heat, it must have been a common enough reaction which, being noticed gratefully by the farmer, would have made it easier to believe that all had common stake in making the hay, and by implication, the other operations of husbandry.

For example, lightheartedness permeates Gainsborough's green and golden *Peasant with Two Horses and a Haycart* (Fig. 166), where, while two men load the wagon, a companion, leaning on his rake, makes small talk with a wench, and a fourth tumbles lazily from a horse in some welcome shade. The figures virtually represent Thomson's happy labour and love, the theme picked out also by Kirk for his charming 1794 illustration to *Summer* (Fig. 165). This was designed ten years after a painting by Stubbs (Fig. 167) where work appears as laborious as dancing, and the atmosphere is one of grave elegance.

Constable may have found a haymaking scene suggested by some lines in *The Task*:

> There from the sun-burnt hay-field, homeward creeps
> The loaded wain; while, lighten'd of its charge,
> The wain that meets it passes swiftly by;
> The boorish driver leaning o'er his team
> Vocif'rous, and impatient of delay. (I. 295–99)

This is perhaps the closest poetic equivalent to *The Hay Wain*, although literary and pictorial haymakings were common enough. Constable concentrated on the working scene, giving no hint that the iconography offered more, save for the paired ducks near the boat. As with *The White Horse*, work, in conformity with the ideas of the farming interest, does not cease, and we are meant to ponder on the social harmony it signifies.

Not only did this treatment of subject follow the development begun with *Dedham Vale, Morning*, so did a real concern with topographical accuracy. In this instance some of the oil sketches of Willy Lott's house to which Constable had recourse for his details (Figs. 169, 172) survive. One of late July 1816 (Fig. 169), also on the horizontal format, is the probable source of the left-hand side of *The Hay Wain* (in particular the detail of the Lott farm), Constable apparently taking whatever

175 (over page). Detail from *The Hay Wain* (Fig. 171)

attracted him from whichever sketches lay to hand. He also made a full-scale sketch for *The Hay Wain* (Fig. 170). He painted it at speed, and laid in the main areas of the composition. Although it is remarkable colouristically for the deep blues and rich pinks in the distance, and dabs of turquoise above the punt, these features do not obtrude at a distance of six or so feet, from where the use of the palette knife or the contrast between lumps of paint and canvas ground also resolve pictorially into a version of what in the final paintings is more carefully finished. Indeed, the sketch's general tendency to monochrome may reflect the way that Constable's drawings had earlier defined masses and tones prior to working *en plein air*. Perhaps this painting was to remind the artist of the whole, while he used oil sketches for the parts.

The Hay Wain did not much deviate from this sketch. A tow horse was removed and a fisherman added. The wagon appears from a different viewpoint, perhaps because it was designed from Dunthorne's drawing. Considering that Constable worked at some speed, his technique was highly disciplined. This was still the 'natural painture', and style was still bent on representing appearance. Brush strokes vary according to the surfaces they are to describe—sharp and fine for the grass blades in the right foreground, but a thick overlay of white in the distance to give the effect of sunlight on meadows. At other points, for example near the angler, the red-brown canvas ground has served as shade, while the small tree above the wagon is reminiscent of earlier work done on the motif. Considering that translating the accuracy and discipline of the 'natural painture' onto this kind of scale must have presented technical problems, it is a real measure of Constable's facility that he left no clues as to what they were. *The Hay Wain* will always be most striking for its recreation of the look of nature.

Like other works, *The Hay Wain* acknowledges the masters. Claims that the composition 'derives' from Rubens's *Château de Steen* (Fig. 173)[68] are not completely convincing, although if Constable did make a deliberate reference, then here is a rather more prosaic version of that laden market cart, and Willy Lott's farm would again receive pictorial reference to rather grander country houses. Constable was easily capable of such sophistication; and he would have been able, as John Barrell has suggested, to invert the composition of Claude's *Coast Scene with Aeneas at Delos* (Fig. 174),[69] and again boost his iconography via pictorial allusion. In this respect then, as with the naturalism of appearance, high viewpoint, topographical verisimilitude, and georgic subject, *The Hay Wain* was consistent with the work of the previous ten years. But it was the last in the sequence.

Furthermore, it has been pointed out how, in certain respects, it stands intermediary between the earlier and later canal scenes.[70] Farington suggested *The Hay Wain* to maintain a selling line, and like *Stratford Mill* the composition has one side blocked by trees, while the other is a view across meadows. It was this format which Constable was to develop and maintain over the first half of the 1820s.

CHAPTER FIVE
The Later Canal Scenes

In 1819–20 Constable was combining study and 'finished' painting less easily than before his marriage. While he mostly worked from nature at Hampstead, he still painted Stour Valley scenes for exhibition. The 1820s saw an increase in this diversification, so that, by around 1825, the artist was using different styles for different subjects, allowing us to single out the development of East Anglian landscape from the rest, and, by contrast, to understand its particular features. And in tracing the development of this divergence in artistic practice, we are fortunate in having some guidance to its nature from the artist himself, in the letters he sent to John Fisher in Salisbury. These are extremely informative, which is particularly helpful when the inaccessibility of these later paintings to other forms of historical analysis is taken into account.

As early as August 1821[1] we can begin to sense a change in Constable's attitudes, for when he wrote to tell Fisher that he had fitted up a room in his London house for exhibiting his own pictures, he thought that the latter would be 'still more' surprised at being told that his friend was going to pay his 'court to the world'. He meant that he was bringing his pictures to public attention, by opening his house: but implied that, despite those earlier attempts at attracting notice, this was a completely fresh move. Consequently it becomes as though all the previous years' work had only been a preparation for what was to happen in the 1820s, an idea supported by various of Constable's statements at this time:

> I have . . . made many *skies* and effects—for I wish it could be said of me as Fuselli says of Rembrandt, 'he followed nature in her calmest abodes and could pluck a flower on every hedge—yet he was born to cast a stedfast eye on the bolder phenomena of nature.' We have had noble clouds & effects of light & dark & color—as is always the case in such seasons as the present.[2]

He inferred that somehow previous skies had not been altogether successful. This, though, was not true. We remarked of *Dedham Vale, Morning* (Fig. 55) that it shows such a day as will, in summer, becomes increasingly cloudy; while a meteorologist wrote of the larger *Cottage in a Cornfield* (Fig. 119) that '. . . we find a scene of fierce noonday heat in July or August and get a powerful impression of fast growing cumulus clouds. That lonely cottage by the ripening corn will hardly escape a crashing storm that afternoon!'[3] Yet this landscape had probably been painted in 1815; and we have noted brilliant realisations of the 'bolder phenomena of

176. *Study of Clouds and Trees* 1821
Oil 10 × 12 (25.4 × 30.5). Inscr. on
recto 'Hampstead. Sept. 11, 1821. 10
to 11 morning under the sun—
Clouds silvery grey on warm ground
sultry—Light wind to the S.W., fine
all day, but rain in the night
following'. London, Royal Academy
of Arts

177. *Cloud Study* 1821 Oil on paper
on panel 8⅜ × 11½ (21.25 × 29). Inscr.
on verso '25th Septr. 1821, about 2 to
3 afternoon looking to the north—
strong Wind at west, bright light
coming through the Clouds which
are laying one on the other'. New
Haven, Yale Center for British Art,
Paul Mellon Collection

178 (facing page). Detail from
A View on the Stour near Dedham
(Fig. 181)

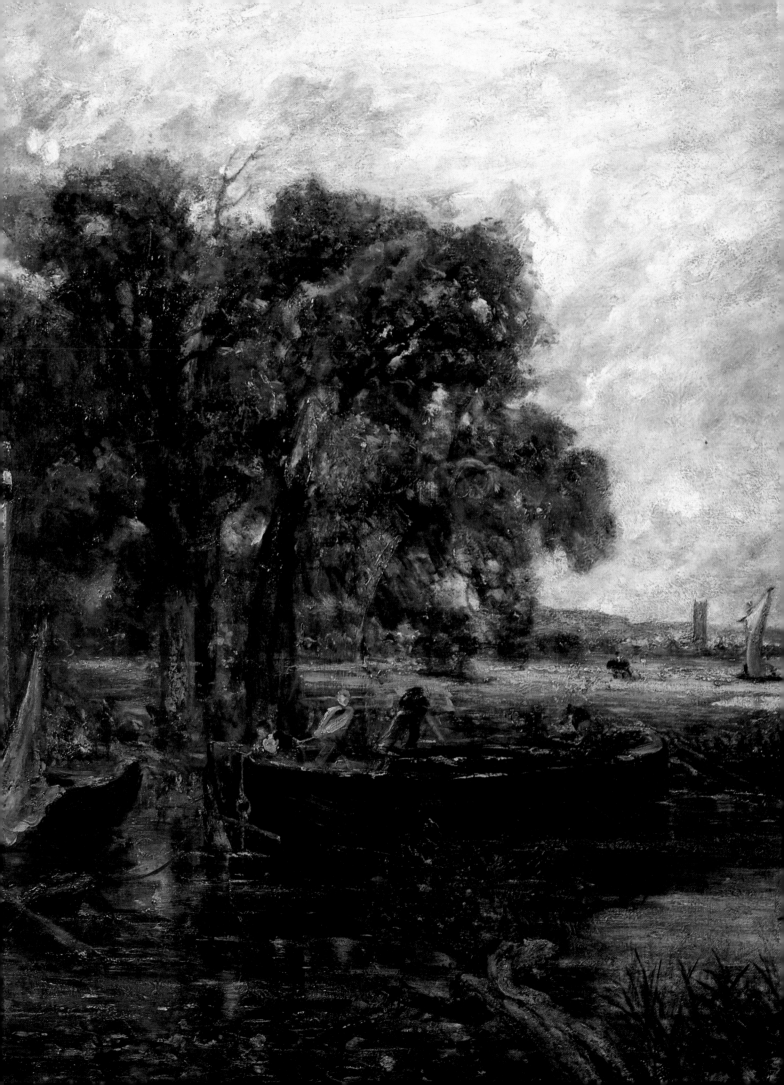

nature' in oil sketches of 1810–13 : a particular instance is the 1812 *Landscape with a Double Rainbow* (Fig. 66). One explanation for Constable's writing in this way may well be to do with developments in his own studies, and the growing complexity of the relation between studio and field work. While, for instance, in 1822 he was to show three Hampstead pictures at the Royal Academy, his main exhibit was again a six-foot canal scene, *A View on the Stour near Dedham*, over which painting he experienced problems not apparently posed by the other canvases.

It has been remarked how working on Hampstead Heath familiarised Constable with scenery very different to that of the Stour Valley. His response seems to have been gradually to concentrate on the skies, and the 1821 sky studies fall into two types: those with a small fringe of trees or landscape at the base (Fig. 176), and those with no indication of landscape at all (Fig. 177). Furthermore, Constable began to write very detailed descriptions of these skies on the paintings' backs. One such (Fig. 176) reads: 'Hampstead. Sept. 11, 1821. 10 to 11 morning under the sun—Clouds silvery grey on warm ground sultry—Light wind to the S.W., fine all day, but rain in the night following.' Typical of these legends, which identify the sky studies as having virtually scientific pretensions, it records one moment in flux, and, by giving a natural history, the development and consequences of that moment are detailed. This moves the 'natural painture' down a particularly arcane avenue, for the logical thing to do would be, by building up a bank of such studies (along with their legends), to tell by referring to them what any particular configuration of clouds would mean. And yet one might have expected Constable to have already had that knowledge which is the countryman's by experience, to have known from a glance at the general disposition of the sky what the most likely developments would be. Furthermore, as the main reason for our appreciation of these sky studies is their beauty as paintings, for many are quite extraordinarily successful virtually as abstracted compositions, it would be naive to imagine that Constable achieved in them an objective and instantaneous record. They took (as their legends indicate) about an hour to paint; possibly they were composed.

However, it is noteworthy that the last time Constable had needed mnemonics with landscape studies had been in the Lake District; like Hampstead, it was an unfamiliar region, and its landscapes had not engaged him so fully as those of the Stour Valley would come to do. Equally, Hampstead Heath was strange, and Constable's studies concentrated on shifting and dislocated effects of light and shade, themselves governed by wind and cloud movement. It is interesting that, as the sky studies achieve the status of independent works of art, they appear to have had little part in dictating the skies of exhibited pictures. The three paintings of *Hampstead Heath* possibly exhibited in 1821 and 1822[4] are pleasing enough, but do not have skies strikingly more skilfully painted than earlier work in the Stour Valley, Constable stated that he was determined to conquer the bolder phenomena of nature, perhaps to allow him a way of continuing to advance the 'natural painture' in circumstances which meant that he did most of his sketching at Hampstead.

If this reads as an over-complication of circumstances, Constable's letters show that his attitudes were less straightforward than they previously had been. For instance, shortly before that passage on skies, Constable had moaned about commissions, and how, independent of them, he had done some studies. It appears that now, although he needed them, and although they were probably given in consequence of an appreciation of his painting, Constable did not welcome commissions, and that working from nature was an antidote to them.

His attitude to painting was becoming altogether more complex, for, after writing of the sky studies, he went on, '. . . I am so much behind hand with the Bridge, which I have great hinderances in. I cannot do it here—& I must leave my family and work in London . . .' In other words, the Bridge, which was to become *A View on*

the Stour near Dedham, had to be painted in London, away from direct contact with nature at Hampstead. While the Stour Valley landscapes were inevitably done away from the place, it seems as though they now actually benefited from being painted in the city. This might have partly been through a concern to maintain a successful format, yet in a letter Constable wrote Fisher on 23 October 1821,[5] he followed the news that he had 'made more particular and general study than I have ever done in one summer' with 'but I am most anxious to get into my London painting room for I do not consider myself at work without I am before a six-foot canvas'. There was a shift from the attitudes of the 1810s, when study had itself been work, and a further hint of that separation in practice between sketching on the motif, and painting on the large scale in the studio.

It was this same letter which contained Constable's sentiments on skies as the chief '*Organ of sentiment*' in a painting, presumably the prime means of transmitting mood, before going on to pick up on an account Fisher had given[6] of angling in a New Forest river:

> . . . what River can it be. But the sound of water escaping from Mill dams, so do Willows—Old rotten Banks, slimy posts, & brickwork. I love such things . . . as long as I do paint I shall never cease to paint such Places . . . I should indeed have delighted in seeing what you describe . . . 'in the company of a man to whom nature does not spread her volume or utter her voice in vain'.
>
> But I should paint my own places best—Painting is but another word for feeling. I associate my 'careless boyhood' to all that lies on the banks of the *Stour*. They made me a painter (& I am gratefull) that is I had often thought of pictures of them before I had ever touched a pencil.

Constable's outpouring was less spontaneous than it might seem. If taken as literally applying to his own art, it would fit only the canal scenes; and Constable had taken up Fisher's 'careless boy' to refer it to Gray's 'careless childhood',[7] and establish a literary reference. Equally Dr Johnson had written to Bennet Langton of his anticipated delight in hearing the ocean, or seeing the stars 'in the company of men to whom Nature does not spread her volume nor utter her voice in vain'.[8] Here Constable played Johnson, but his having 'thought of pictures of them before I had ever touched a pencil' may expand the reference to the legend of Gainsborough having been so familiar with everything around Sudbury 'that he had not so perfectly in his *mind's eye*, that had he *known he could use a pencil*, he could have perfectly delineated'.[9] If the connection exists it certainly points to Suffolk as the target for Constable's nostalgia, but a Suffolk in which he associates himself with Gainsborough; something which would be quite feasible in a passage of such extraordinary literacy.

Later in his letter, Constable revealed more of his sentiments towards his work, for, writing of the way the 'weather has blown & washed the *powder off*' his 'last year's work', he added, 'I do not know what I shall do with it—but I love my children to well to expose them to the taunts of the Ignorant . . .' In 1814, pleased with *Landscape, Ploughing Scene in Suffolk* at the Royal Academy, Constable had joked to Maria Bicknell about always seeking one's own children in a crowd. The emphasis here had changed subtly. In calling his paintings 'children' Constable exposed a deep emotional commitment to his work, one touched with a new nervousness; something which was to become pronounced. That it was actually a change in attitude is confirmed by what Constable wrote to Fisher after the 1822 Royal Academy exhibition had opened.

On 13 April 1822[10] he expressed misgivings about *A View on the Stour near*

Dedham (Figs. 178, 181, 182, 184): 'I never worked so hard before & now time was so short for me—it wanted much—but still I hope the work in it is better than any I have yet done . . .' Considering that he had been engaged on it for seven months it is surprising that Constable should have felt that the canvas wanted finishing. This hurry to complete the exhibition work was to become habitual. Four days later Constable was to enlarge on his feeling towards this picture: '. . . there is no end to giving way to fancies—occupation is my sheet anchor—my mind would soon devour me without it. I felt as if I had lost my arms after my picture was gone to the Exhibition—'.[11] Constable stressed the importance he attached to the *act* of painting, something he linked to a state of mental hyperactivity, by describing painting itself as a kind of therapy, a means of helping him stay calm. This is in complete contrast to his earlier experiences at East Bergholt, where sometimes he had been unable to maintain the mental stability he needed to make successful pictures.[12] The idiom Constable evidently had in mind with his extraordinary 'I felt as if I had lost my arms' was the one whereby we say that to part with a friend or relative would be like cutting off an arm or a leg. His paintings were so much a part of him that, when they left the studio, his body was somehow maimed, and he became less than a whole man. And that it was his *arms* that he seemed to lose suggests that he was unable to recover from this disability, for he was left unable to hold the palette or wield the brush. The painter could not exist without his painting, and vice versa; this emphasises the psychological complexity of Constable's approach to his six-foot canvases, the children he loved too well to expose to the taunts of the ignorant, and which, from this time on, he would habitually attempt to rescue from their purchasers.

If the correspondence with Fisher is a true guide, Constable's approach to painting was gaining this complexity only from the summer of 1821. Possibly symptomatic of this was his being unable to finish satisfactorily *A View on the Stour near Dedham* in time for the 1822 exhibition. Here we can say something about how the problem arose. There are two versions of this composition (Figs. 181, 182), and Constable appears to have been dissatisfied enough with the first to work up a second for exhibition. Version one had been on the easel since before 20 September 1821. If we take earlier practice into account this should have allowed him ample time for finishing, but difficulties arose. In January Fisher had seen the first version of the painting, so that the alterations Constable subsequently enumerated to him must have been made after this visit.

> The composition is almost totally changed from what you saw. I have taken away the sail, and added another barge in the middle of the picture, with a principal figure, altered the group of trees, and made the bridge entire. The picture now has a rich centre, and the right-hand side becomes only an accessory. I have endeavoured to paint with more delicacy but hardly anyone has seen it.[13]

Beckett suggests that this passage dates to 14 April.[14] If this is so, at some time between January and then Constable laid by the first version, and began and finished a second attempt at *A View on the Stour near Dedham*.

The changes of which Constable wrote may be seen by comparing the Holloway painting, the 'sketch' (Figs. 178, 181), with the Huntington one, the 'painting' (Figs. 182, 184). The scene itself was adapted from drawings of 1814 (Figs. 179, 180) (and perhaps some lost oil sketches) which demonstrate how, to include the bridge, the river had to be turned a few degrees to the south. The drawings also raise doubts about the precise formation of those painted elms, the same trees which were viewed from different angles in both *Boat Building*, and *Flatford Mill*. Although the rough surface of the sketch does not allow one to read the style as completely representational, the same adjacent trees, divided from one another by a hedge, are shown, with a view across

water meadows to the Essex hills. The painting, however, fills this gap, and although the foremost tree is painted carefully the ones behind it are blurred, with the distance (save for a glimpse over meadows) closed off by a mass of foliage and boughs. Although the only sail which was 'taken away' is in the sketch, the other changes Constable detailed fit the painting. The trees have been altered, a barge has been added in the middle of the picture, and the greater extent of bridge now shown accords with its being made 'entire'. A hint of a closer relation between sketch and painting is given by the painted-out rowing boat in the latter. Therefore we have two versions of the composition. It might be that Constable had been working on both canvases, and had painted up the sketch as a first version, which was now translated to the second canvas, after he had tried out the effect of painting out that sail. It has been pointed out how both develop the lay-out of river, trees, and meadow seen first in *Stratford Mill* and developed in *The Hay Wain*.[15]

The sketch, however, was far more worked up than the large study for *The Hay Wain* (Fig. 170), and therefore far more independent as a work of art. For the first time Constable took enthusiastically to the palette knife, laying on paint, particularly along the river, in wide streaks. We can also discern 'whitewash', splashings of white running over surfaces described almost three-dimensionally in paint. Certainly the picture is solidly structured, but its style would have been unacceptably free. On 13 April Constable was to describe this as an habitual problem: 'Collins told Manning, on his asking if it was not better than Constable had yet done, Collins said it was—that the sky was very beautiful and there were parts in which it could not be better ... Some of the parts were very nicely finished ...' This remark suits his having 'endeavoured to paint with more delicacy'. Therefore one of the motives behind the painting of a second canvas was to create something more controlled. Yet, at a time when painters' use of white could cause controversy,[16] Constable did not eschew it, and it defines surfaces in both the foreground and distance, while the paint in general is more richly textured than it had been in any previous canal scene. This new control gave apparently greater truth to appearance, at the cost of images becoming ambiguous. A lily pad with a bud emerging at the bottom right actually looks like a tobacco pipe, and there is some representational ambiguity about the spar where the rake is.

There were other alterations. From left to right, along the river bank, a willow stump became a spar, some juvenile anglers were replaced by a rake, a rowing boat was introduced, along with a washerwoman (like the one from *The Hay Wain*) near the bridge. A cow became a lady, a sail was shortened, a tow-horse taken out, and Dedham church tower lowered. The two main effects were to remove figures from the foreground, and greatly to increase the apparent extent of the right-hand side. Constable created several vanishing points, and destabilised the

179. 1814 sketchbook Pencil 3⅛ × 4¼ (8 × 10.8). London, Victoria and Albert Museum (R.132) p. 27 *A View on the Stour at Flatford*

180. 1814 sketchbook Pencil 3⅛ × 4¼ (8 × 10.8). London, Victoria and Albert Museum (R.132) p. 52 *A View on the Stour at Flatford*

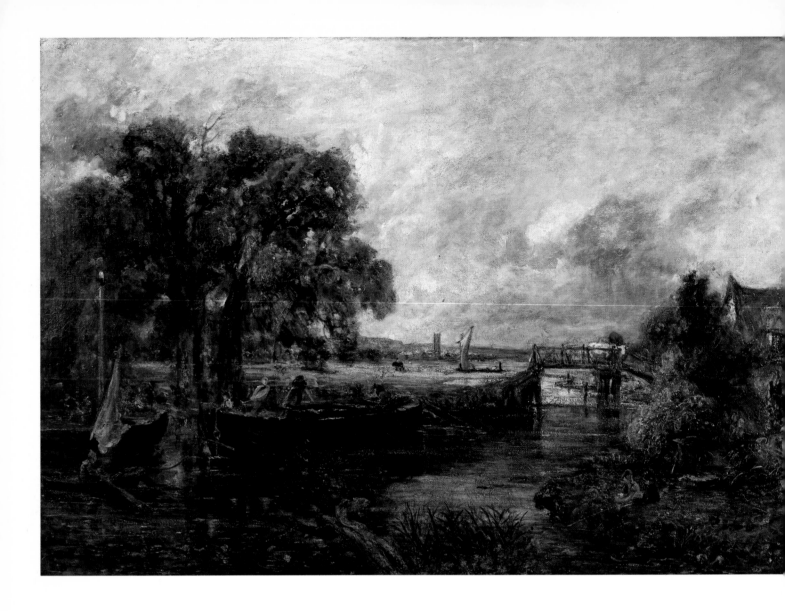

181. *A View on the Stour near Dedham* 1821–2 Oil on canvas 51 × 73 (129.5 × 185.4). University of London, Royal Holloway College

perspectival superstructure. Incident was shown differently, too. The sketch had treated subject in the manner of earlier work: a barge, not unreminiscent of the one from *The White Horse*, is in the act of lining itself up with the help of a tow to shoot the lock through which the barge to the right, raising its sail, has just passed. This narrative logic is not so apparent in the painting. Nothing tells one that the left-hand barge has ever been anything but moored, and there is no way of explaining why those other barges should have become the stages for men of vastly differing sizes to carry out such violent action.

Constable had moved towards an attitude to subject as more self-contained. It worked on the terms it defined for itself, but linked with other aspects of the picture far less than it had in the sketch. Even the removal of the horse towing the barge in the distance reduced the narrative element, so important to previous Stour Valley work, paintings in which we have noted the mutual interdependence and harmonious interrelation of figures in their landscape. Yet, in the painting, the incident was emphasised. It took up a greater area of the canvas, and attention is guided to it by pointers like the handle of the rake. The viewpoint dropped, to fix attention on those barges: almost paradoxically, for while the subject had increased in emphasis, it had decreased in meaning. It had become distanced. No figures link it with the foreground, and water now bars the spectator from the picture space. Subject is no longer involved in a georgic narrative, but is just one point of visual emphasis. Constable himself had recognised and approved of this when he wrote that 'the

140

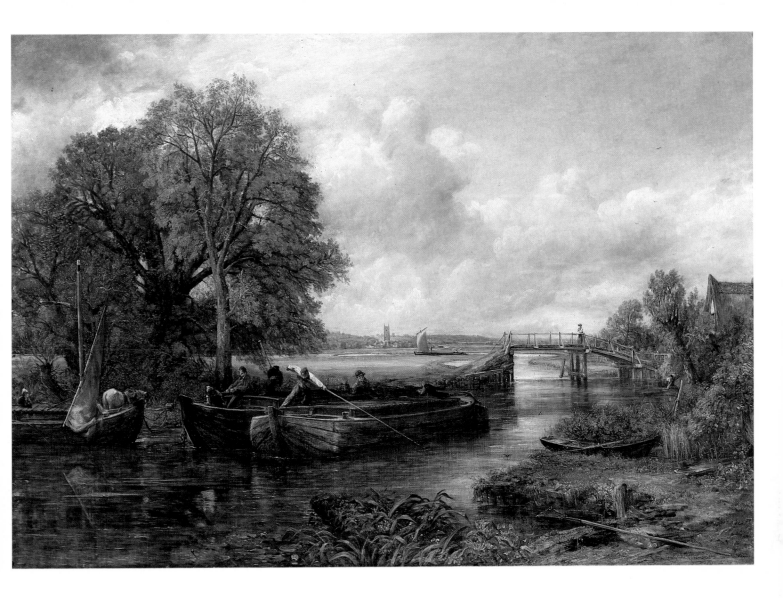

picture now has a rich centre, and the right-hand side becomes only an accessory'.

This indicated an important shift in his attitude to place, for the right-hand side was what located the composition, and showed it to be at Flatford. But then the title, *A View on the Stour near Dedham*, was topographically loose, particularly as, by making Dedham church tower smaller, Constable created the illusion of the village being at some distance. Treating place as 'only an accessory' matters precisely because it had previously been of such importance. And with respect to the title, when Constable's mother wrote of the 'Langham, Dedham & Bergholt Vales'[17] she differentiated areas of terrain as exactly as her son did when he called a landscape *Dedham Vale, Morning*. Constable's concern with locale had changed.

A View on the Stour near Dedham displays signs that, in seeking to continue this line of canal scenes, the artist was finding inspiration in his own work. It developed one composition and, by reorientating the motifs, Constable disguised the borrowings of the barge from *The White Horse*, and the punt and washerwoman from *The Hay Wain*. These earlier paintings were becoming a dictionary of incidents, and in the very arbitrariness of their deployment we have something which, along with the decreasing relevance of topography, stylistic developments, and the lowering of the viewpoint, builds up to force the conclusion that, even in comparison with the sketch, this picture marked a major break in Constable's East Anglian landscape.

The way Constable's notion of the Stour Valley had changed can be followed and defined through both the paintings and correspondence of the 1820s. As early as

1821–2, Constable had to curb his style to make a canvas fit for exhibition, and this was itself a symptom of that new attitude to the actual business of painting. It was becoming a therapeutic act of creation, and Constable's attitudes to nature had altered, and not only because the relation between study from nature and studio canvas was far less direct than once it had been. In his own words, through concentrating on skies, he was sketching the bolder phenomena of nature, unattached to any experience of place, and not necessarily seen as illuminating any particular landscape. And, at the same time, there was a change in the conception of the canal scenes to something from which the next few years' work was to develop.

By the summer of 1822 Constable must have been sanguine, for the Salisbury lawyer Tinney had guaranteed him 100 guineas for his next six-foot canvas,[18] but leaving Constable free to take more, should it be offered. Curiously, it was an offer Constable never took up. Indeed, later in the year he began to show a new brittleness. In early October he was fidgety. Things, he wrote to Fisher, were going less smoothly than he might have liked.[19] He complained about the burden of commissions, then mentioned fifty sky studies 'tolerably large to be carefull'.

His habits were developing from the previous year. He mentioned that he had been extracting himself from that arrangement with Tinney; thus signalling a marked change in his response to patrons, which, in his next letter, he defined more clearly.[20] As Constable grumbled about a commission from a Mr Savile for a large picture, he blamed this for keeping him from painting 'an excellent subject for a six-foot canvas'. From now on Constable made it increasingly plain that commissions were a shackle, although he nevertheless complained endlessly about his work not selling. The painter who would not expose his 'children' to the taunts of the ignorant was adopting a position of independence amounting to isolation; something in strong contrast with that easy agreement between him and his patrons during the East Bergholt days. Indeed, his subsequent dealings with Tinney were to show him in the worst possible light.

And, in that letter of early October 1822, we can begin to trace a change in aesthetic outlook. Complaining about a bad book, Constable wrote

> The world is full enough of what has been already done, and in the art there is plenty of fine painting—but very few good pictures. I am told his [Millman's] is fine writing and as you say gorgeous—but it can be compared—Shakespeare cannot, not Burns, nor Claude nor Ruisdael, *and it took me 20 years to find this simple idea out*—or at least to act upon it. [my italics]

In one respect this rejected the 1802 philosophy, the doctrine that the way art developed was by building on the example of the works of the masters. It plumped for individuality and isolation. Yet Constable would contradict these views elsewhere. In May 1823, he wrote of Wilson that 'He is now walking arm in arm with Milton—& Linnaeus. He was one of the great appointments to shew to the world the hidden stores and beauties of Nature. One of the great men who shew to the world what exists in nature but which was not known till his time.'[21] He associated painter, scientific classifier, and poet, and inferred a similar end to their endeavours. The idea of the artist being concerned in investigating physical appearance was similar to sentiments expressed in 1802. But then the notion of art evolving, building on the work of the past, had been crucial. Now it was not: neither Ruisdael nor Claude could be compared. Their work, like that, we imagine, of Constable too, existed in isolation. This contrast in outlook reflects that between the ostensible development of the 'natural painture' in the Hampstead sky studies, and the very different criteria governing studio work.

Constable maintained his irritation throughout that October. Before moaning about Savile's commission he had mentioned that, back in London, he had yet to do

any painting. And, having worked himself up into a state of ripe annoyance, Constable launched into his well-known attack on contemporary painting: 'The art will go out—there will be no genuine painting in England in 30 years. This is owing to *'pictures'*—driven into the empty heads of the junior artists by their *owners*—the Governors of the Institution &c &c.' He was angry at the degree to which non-practising connoisseurs, not the artists, were apparently beginning to dictate public taste: 'W. Vandeveld—& Gaspar Poussin—& Titian—are made to spawn millions of abortions . . . Hofland has sold his shadow of Gaspar Poussin—for 80 Gns—it is nothing more like Gaspar than the shadow of a man is like himself on a muddy road. It is a beastly [thing]. It is a shocking scene of folly & ruin . . .' Until we are presented with a comprehensive study of organisations like the British Institution and thus gain a clearer account of the influence they held over the market in modern painting, we can only observe that Constable was one amongst other artists who considered it to be pernicious.[22] With respect to the current discussion, however, he was again claiming that the great artist stands alone, beyond imitation, again in contrast to his earlier ideas, when learning from, rivalling, and exceeding previous landscape-painters had been central to Constable's ethos. He had seen himself then as continuing a tradition, the validity of which he now appeared to deny.

In a letter of December 1822,[23] Constable wrote, 'I have nothing to help me but my stark naked merit, and although that (as I am told) exceeds all the other candidates—it is not heavy enough,' which further illustrates how much his position had changed from the humility of the 1810s, the view of himself as always the student. He railed against paintings being made the standard of art, and admitted to a depression. This was to endure at least until late February 1823, and kept him from painting over this time.[24] Constable's mood was not lightened by his obligation to fulfill the Bishop of Salisbury's commission for a painting of the cathedral, ordered under the impression that such a thing would be doing Constable a favour.

At this period, Constable's capacity for work depended on his frame of mind, and in late February 1823 he announced both his increased tranquillity, and that *Salisbury Cathedral from the Bishop's Grounds* (Fig. 183) would be certain for the exhibition, along with the possibility that he might have completed that 'large upright landscape' too. If this was the six-foot canvas from which Savile's commission had been keeping him in October 1822, then the failure to produce the painting in time for the 1823 exhibition was an extension of the indecision which led to two versions of *A View on the Stour*. And, as *A Boat passing a Lock*, exhibited in 1824, was just a 'large upright landscape', the evidence favours the conclusion that, in 1823, Constable for, it seems, psychological reasons, had found himself incapable of painting another canal scene. This is in strong contrast to 1816, say, when he had managed to paint *Wivenhoe Park* and *The Quarters*, and to get *Flatford Mill* into a reasonable state of completion. Not only had the nature of Constable's East Anglian landscapes begun changing, but also it seems, his own artistic relation to them.

However, he managed *Salisbury Cathedral* (Fig. 183) in time for the 1823 Royal Academy, and reported triumphantly on this to Fisher:[25]

> I got through that job uncommonly well considering how much I dreaded it. It is much approved at the Academy and moreover in Seymour St though I was at one time fearfull it would not be a favourite there owing to a *dark cloud*—but we got over the difficulty, and I think you will say when you see it that I have fought a better battle with the Church than old Hume, Brogham and their coadjutors have done. It was the most difficult subject in landscape I ever had upon my easil.

The quip about the dark cloud referred to the Bishop's objecting to so foreboding a sky in a wedding picture. More to the point, it is interesting that the commission

was something which Constable had dreaded. Increasingly in the early 1820s, again in contrast with the 1810s, Constable found it terribly difficult to produce work to order, even though he needed to do this for money. Not only was it something he had to get through but his canvas was a battlefield, and its object the portrayal of a large Church, a term Constable fastened on to display his skill as a punster.

Constable used 'church' to include the sense of church as institution; hence his digs at reformers. Constable liked radicals as little as Fisher, who, in February 1823 had been so put out as to direct an attack at the 'vulture of reform'[26] which he feared was preparing to feed off the body of the church. Constable had only begun to show his political colours in 1820 when he had described Queen Caroline, whom George IV was trying to divorce for reasons of political expediency, as 'the Royal Strumpet', and 'the rallying point (and a very fit one) for all evil minded persons'.[27] However, as the 1820s was a period of political and constitutional uncertainty, it is to be expected that Constable would have reacted to events. Indeed, he and Fisher can be classed as ultra-tory rather than just conservative: by coupling Brougham, who despised radicals, with Hume, who was one, Constable revealed that for him to advocate political reform was as good as calling for revolution.[28]

It was possibly Archdeacon Fisher who, in 1822, signing himself a 'Deacon of the Church of England'[29] had a contribution published in *John Bull*, Constable having received from him a piece for that paper a day or so earlier.[30] This Deacon had also been concerned for the preservation of the Church, remembered with reverence 'our wise forefathers (whom upstart Whigs and Radicals would fain have us regard as fools)' and went on to argue that 'by protecting and supporting a particular Church we avail ourselves of all the advantages which a civil government must acquire from religion'.

183. *Salisbury Cathedral from the Bishop's Grounds* 1823 Oil on canvas 34½ × 44 (87.6 × 111.8). London, Victoria and Albert Museum (R.254)

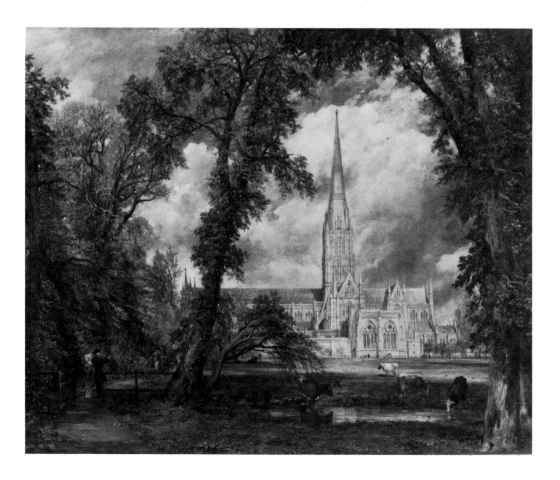

184 (facing page). Detail from *A View on the Stour near Dedham* (Fig. 182)

These were hoary sentiments, their object the protection of the interests of a ruling class which occupied allied positions of power in church and state. To Constable or Fisher, 'Church' symbolised the tried values and spiritual half of that composite, Church and Constitution, which many believed perfect, and therefore not requiring reform. Both men used 'Church' in this way, although the less directly involved Constable was more sanguine than Fisher about its capacity to survive the radical onslaught.[31] At this point, it is simply worth remembering that a painting of Salisbury Cathedral is more than just a portrayal of architecture.

Constable was pleased with his picture, and, as he wrote this letter, exuded bonhomie: 'This nonsense may amuse you when contemplating this busy, but distant scene. However though I am here in the midst of the world I am out of it— and am happy—and endeavour to keep myself unspoiled. I have a kingdom of my own both fertile & populous—my landscape and my children.' So rather than, say, finding it at Bergholt, Constable now took retreat in painting. We need no more succinct illustration of the substitution for an aesthetic with a direct and objective relation with the world, by one derived from his own personality, the psychological complexity of which is encapsulated in 'I have a kingdom of my own both fertile & populous—my landscape and my children.'

Art had become a retreat from the world, not the result of a confrontation with it; and there was, too, an element of ambiguity in Constable's phrasing. In 1821 he had meant his pictures when he said 'I love my children too well to expose them to the taunts of the Ignorant.' His language suggests the very personal nature of his creativity, allowing us to measure the intensity of his relation with the six-foot canvases he was always trying to paint. Equally, he might have been forced into his own kingdom through his isolation in the London artworld. A comparatively straightforward analysis of the relationship between painter and paintings, like that which we can carry out with the pre-1821 work, is now impossible. To guess what Constable thought his art was doing, we must approach it through the medium of his correspondence.

Over the next few months, while Constable continued to paint and draw, what work there is does not allow much to be added to what we have so far seen of his working from nature. In Suffolk in April, he made some fine drawings of motifs which, as far as we can tell, had not previously featured in his repertoire. The Hampstead work was attaining a degree of objectivity which anticipates Boudin, and the artist was to be busy on autumn visits both to Salisbury and to Sir George Beaumont at Coleorton.

His letters display increasing signs of that new complexity of outlook. Ideas were repeated. Constable reiterated the importance of the studio for his work.[32] Then he exposed something of his relation to his own painting when he requested the return of *Stratford Mill* from Tinney,[33] in terms which implied that his paintings were only loaned to their possessors. As a commission was a shackle, and as Constable had to paint for himself, then at the same time did his paintings become increasingly private. It was in this letter that he condemned the Diorama: 'it is without the pale of art because its object is deception—Claude's never was—or any great landscape painter's.' If by 'deception' Constable meant a style concerned with illusion or representation (opposed to one which alluded to the objects it represented), evidence of a change in outlook accrues. The earlier paintings' spectacular realism had shown how nature needed little intellectual processing to be transformed to art of the highest pretensions. But this idea seemed to have gone by the board, and Constable himself, perhaps because of the emotional basis of his theorising, tended at this period to become brittle and argumentative if challenged, needing to prop up his paintings, particularly *The Lock* (Fig. 190) and *The Leaping Horse* (Figs. 202, 203, 205), with elaborate written explanations.

An example of the vehemence with which Constable could react to criticism occurred in October 1823. Fisher had transmitted an opinion expressed by Constable's fellow landscape painter F. C. Lewis that he had taken to repeating himself.[34] He should have known better. As, at first Constable declined to reply, Fisher sent another, teasing letter,[35] which in the end was answered,[36] but in such a manner as to lay bare its author's personality with startling clarity. Having made a brief attempt to take this criticism on the chin, Constable's tone moved quickly to shrill self-defence.

> Thank you for both your kind—amusing—and instructive letters. I shall always be glad to hear anything that is said of me and my pictures. My object is the improvement of both.
>
> When Nat. Hone's malignant picture, 'The Conjuror' (meant to ruin Sir Joshua Reynolds 'fair fame') came to the Exhibition, the members were for rejecting it. 'No' said Sir Joshua—'if I deserve this censure it is proper that I should be exposed.'
>
> Lewis like most men living in the atmosphere of the Art . . . are always great talkers of what *should be*—and this is not always done without malignity—they stroll about the foot of Parnassus only to pull down by the legs those who are laboriously climbing its sides.

This is a paranoic reaction to a mild and justified criticism. To compare this charge of repetition with Hone's clever exposure of Reynolds's sources points to an extremely sensitive ego. But evidently, as the reference to Parnassus indicates, Constable's painting was so serious a matter as not to brook criticism.

This was not the only interesting passage in a letter which went on to show that Constable was still attempting to retrieve *Stratford Mill* from Tinney by promising 'not to meddle with it', and when he did, to let Tinney know in advance. And Constable's penultimate paragraph is worth consideration: 'I want to get my easil in Town—& not witness rotting melancholy dissolution of the trees &c—which two months ago were so beautifull—& lovely.' This was mid-October, in which season Constable had previously been hard at work out of doors. There was a retreat to art from nature. And the gap became more noticeable that autumn when, between 21 October and 28 November the artist was the guest of Sir George Beaumont at Coleorton, where, on arrival, he found himself enraptured by the carefully picturesqued grounds.[37]

As he had previously been three weeks in Salisbury, Maria's patience at her husband's long absences began to wear thin; understandably, in view of the sacrifices she had made by marrying him. While his letters failed to stay her annoyance, they do reveal his state of mind over this holiday. In one of 27 October[38] he made his one critical remark on Wordsworth (although in the 1820s he sometimes quoted his verse). As was their wont, the Beaumonts had introduced their guest to Wordsworth's poetry, in this instance *The Excursion* (new to Constable, although in print since August 1814). He found that '. . . it is beautifull but has some sad melancholy stories, and as I think only serve to harrow you up without a purpose— it is bad taste—but some of the descriptions of Landscape are beautifull . . .' This is not a sympathetic reaction to a writer to whom, on the grounds that they were both interested in landscape, Constable has often been deemed the pictorial counterpart. Otherwise, the letter is interesting as a paean to life at Coleorton, and for showing how much Constable enjoyed being amongst Beaumont's Claudes (Figs. 28, 29, 33).

Writing on 2 November, both to Fisher[39] and Maria,[40] he mentioned having begun a careful copy of Claude's *Landscape with a Goatherd* (Fig. 28), which in 1802 he had used to help form a style for his own careful studies of the Stour Valley. But now Constable copied what he considered another's work from nature,[41] and

186. *Landscape with Trees* (after Claude) 1825 Pen and brown wash $11\frac{5}{16} \times 7\frac{7}{8}$ (28.8 × 20). New Haven, Yale Center for British Art, Paul Mellon Collection

through studying nature through art, turned the 'natural painture' on its head. By 5 November he felt that this particular Claude 'contains almost all that I wish to do in Landscape'.[42] This amazing statement flatly contradicted the earlier philosophy, simply by admitting that a painter's aims could be realised in the work of an earlier master.

Constable then went on to write of Claude's paintings—

> You would laugh to see my bed room, I have dragged so many things into it . . . and I have slept with one of the Claudes every night. You may well indeed be jealous, and wonder I do not come home—but not even Claude Lorraine can make me forget my darling dear Fish—I dream of her continually & wake cold and disappointed.

He was joking that his love for landscape was getting to vie with his love for his wife, although to sleep with Claude only left him 'cold and disappointed'. The conflict intimated between art and wife reinforces the idea that Constable's creativity had, over the 1820s, developed a basis of deep emotional complexity. Again this contrasts with what appears to have been a comfortable relationship between Constable, landscape, and local society during his East Bergholt days. And indeed the point can be demonstrated more fully if one illustrates the ambivalence of Constable's attitudes to Claude during the mid-1820s.

At Coleorton he was enraptured. *Narcissus* (Fig. 33) was 'enchanting and

185. Study for *The Lock c.* 1825 Pen, sepia, wash, pencil, traces of white heightening $11\frac{5}{16} \times 14\frac{1}{2}$ (28.7 × 36.4). Centre sheet $10\frac{1}{16} \times 12\frac{1}{16}$ (25.7 × 31.1). Cambridge, Fitzwilliam Museum

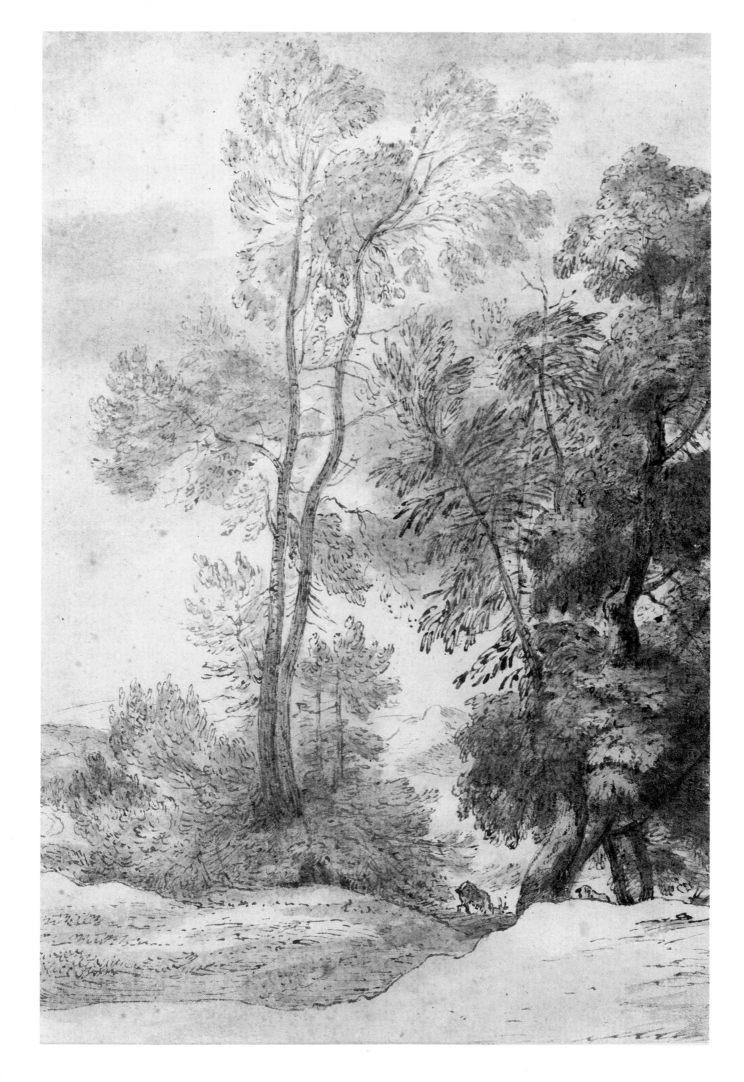

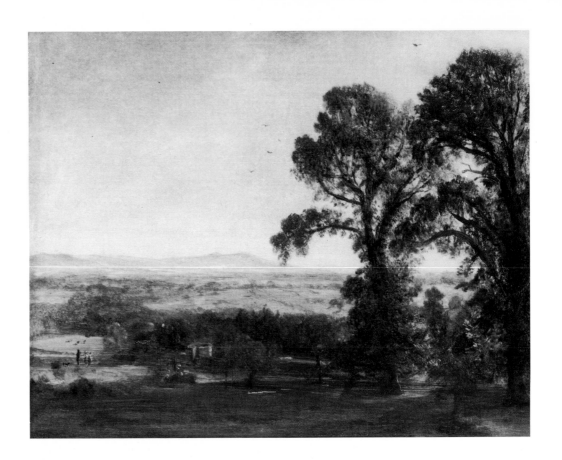

187. *Bardon Hill* 1823 Oil on board
8 × 10 (20.2 × 22.5). New Haven,
Yale Center for British Art, Paul
Mellon Collection

lovely . . . very far surpassing any other landscape I ever yet beheld';[43] and he found being surrounded by Claude's landscapes an experience of almost hallucinatory intensity. It even affected him artistically, strongly influencing the colouring and tree painting of the small contemporary oil sketch of *Bardon Hill* (Fig. 187).

But, by 17 January 1824,[44] apparently the affair had soured. This was Constable on the Claude drawings which Payne Knight had just bought: '. . . they looked like papers used and otherwise mauled, & purloined from a Water Closet—but they were certainly old, & much rent, & dissolved, &c. but their meer charm was their age.' This was clearly inspired by anger towards Payne Knight, bastion of the British Institution, and champion of the Old Masters, steadfastly selective in his patronage of modern art, and who, that very morning, had been in Constable's studio without buying anything. To compare Claude's pen and wash drawings with used lavatory paper was obviously an intemperate simile: yet Constable meant it at the time.

That outburst was one swing of the pendulum. The other is represented by an 1825 facsimile of just such a Claude drawing (Fig. 186), or a later compositional drawing for a version of *The Lock* (Fig. 185). Constable understood and respected Claude's greatness. Yet he could be driven to vitriolic abuse by the insistence of the powerful figures in the commercial and political factions of the London art-world, on favouring the masters and second-rate practitioners of their manners, rather than supporting more experimental modern painting. At Coleorton Constable had once asked Beaumont 'if there was likely to be a society of noblemen and gentlemen to regulate the offices of the Church—the Horse Guards—the medical world &c.—and award prizes to the aspirants'.[45] The irony was directed at the disproportionate sway he felt that connoisseurs could, via the British Institution, exercise over the careers of first-rate painters who had the temerity to stray from the path of what they considered to be true taste. Constable felt that amateurs would never understand art in the same way as painters did, and, as his own work was becoming individualistic and 'difficult',

150

his awareness of what was to remain a problem throughout this decade would have boosted his already exaggerated tendency to nervous anxiety: hence the reaction to Payne Knight and the Claude drawings.

Thanks to the correspondence with Fisher we may trace the development of the final canal scenes, *The Lock* and *The Leaping Horse*, in detail. The only change in the letters' tenor was (as we have seen above) the hint of an increasing mutual concern with politics, manifesting itself as an underlying sense of unease. In December Fisher was in connected sentences to write 'The saints will lose us the West Indian islands' and mention Angerstein's pictures.[46] His worry was minor but genuine. The terminology was outmoded: Wilberforce and the Clapham sect were the 'Saints' who had moved for the abolition of the slave trade in 1807: nevertheless, the ultra-tory John Bull was still using the term in the 1820s.[47] In his reply[48] Constable was rational, informative, and in good spirits enough to be 'settled' for the exhibition. He followed news of his painting with an anti-radical anecdote. The former was concerned with an offer the ever-generous Tinney had made for Constable to paint a couple of fifty-guinea landscapes which at the time he had thought would make 'a nice winter employment',[49] the latter with the tale of his friend Roberson, a schoolmaster who

188. *'Landscape—a Barge passing a Lock on the Stour'* 1825 Oil on canvas 55 × 48 (139.7 × 122). Private Collection

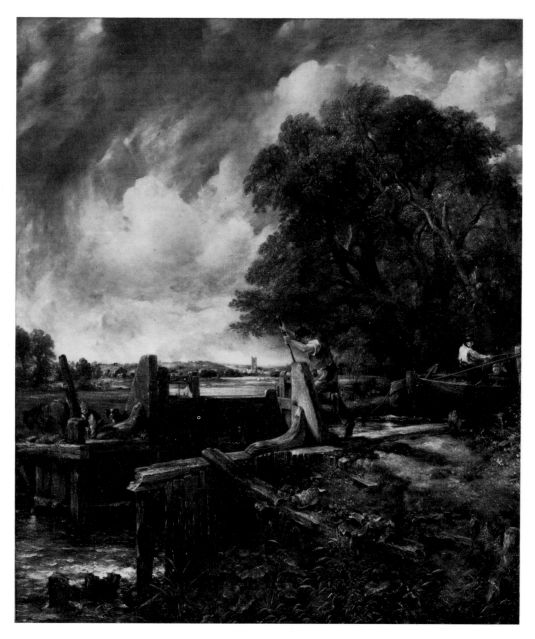

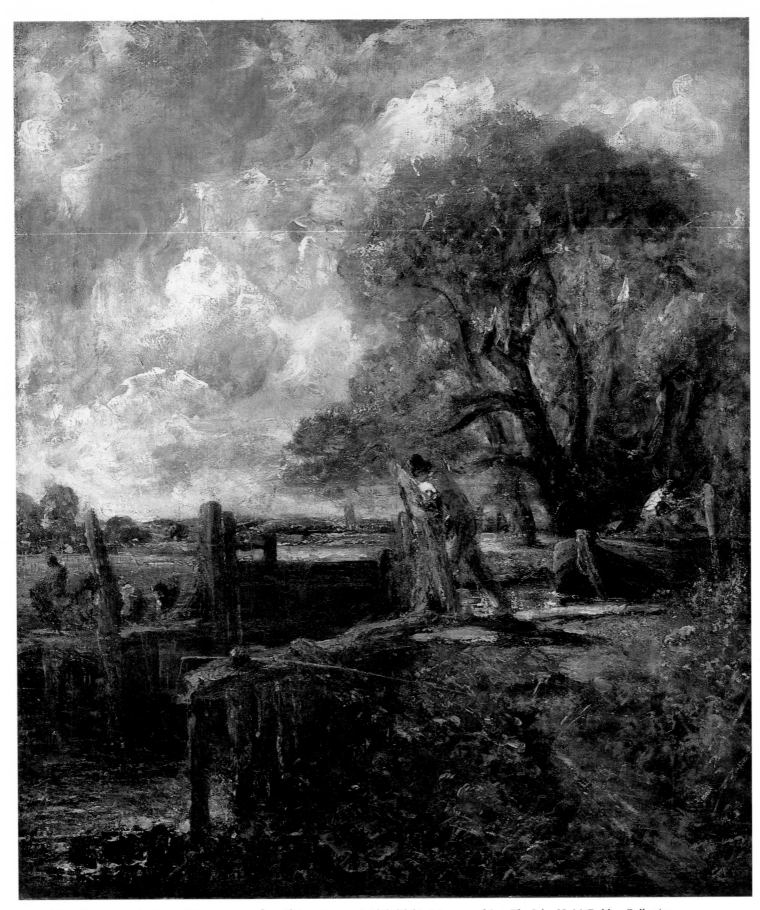

189. *A Boat Passing a Lock* 1822–4 Oil on canvas $55\frac{3}{4} \times 48\frac{1}{4}$ (141.6 × 122.5). Philadelphia Museum of Art, The John H. McFadden Collection

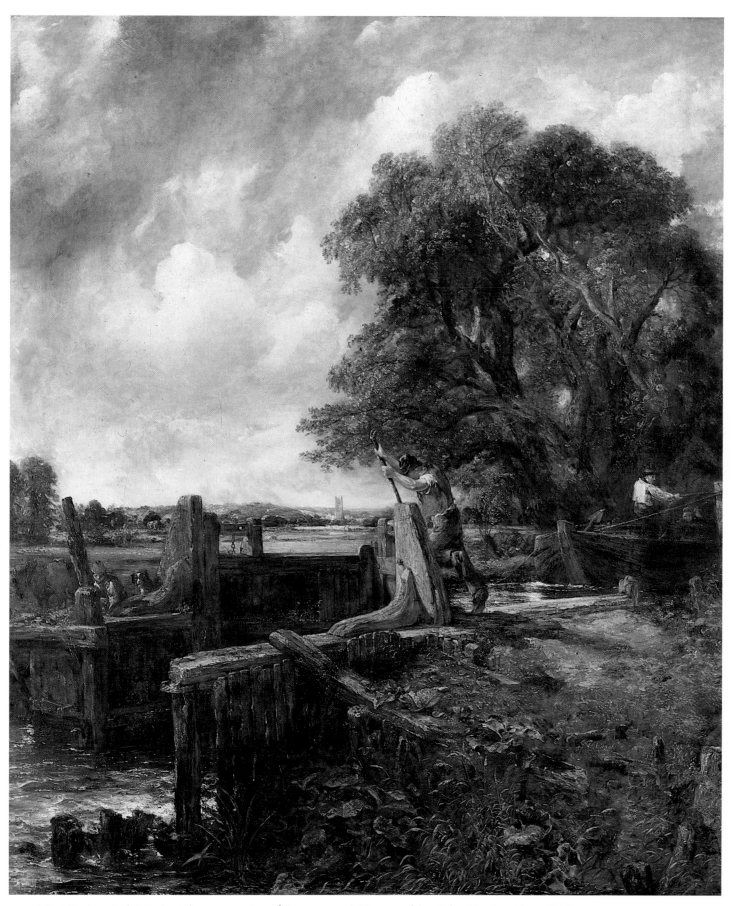

190. *A Boat Passing a Lock* ?1823–5 Oil on canvas 56 × 47½ (142.2 × 120.7). Trustees of the Walter Morrison Picture Settlement

had beaten a boy who subsequently claimed paralysis. This turned out to be untrue, but not before Roberson had become ill from criticism levelled at him, something Constable had described as part of a general attack on the clergy by 'the diabolical prints'.

For Constable, however, any distant threat of radicalism was pushed into relative insignificance by the upward swing his fortunes took in 1824. At the same time as grumbling about Payne Knight, Constable had mentioned Arrowsmith, a French picture dealer, trying for a second time to buy *The Hay Wain* for exhibition at Paris—'perhaps', wrote Constable, 'to my advantage, for a prophet is not known in his own country' ('I feel myself yet at a frightfull distance from perfection,' he had written in 1814). Taking this opposing position goes with that self-assertiveness which accompanied his nervous brittleness, as he developed his new theories. For the moment these appear only as a denial of the 'natural painture', and their own nature cannot be defined. It becomes clearer after a discussion of *The Lock* (Fig. 190).

If consistency of endeavour indicated mental stability, Constable was probably easier than usual to live with during the early part of 1824. He was so busy on *The Lock* that it was not until 15 April that he wrote to Fisher, '. . . I was never more fully bent on any picture than that on which you left me engaged upon. It is going to its audit with all its deficiencies in hand—my *friends* tell me that it is my best. It is a good subject and an admirable instance of the picturesque.'[50] That the painting needed more work, and that it was his best so far, are familiar themes. *The Lock* is in a style so personal that Constable may have needed to reassure himself as to its calibre.

However, as it was an 'admirable instance of the picturesque', this intimates a return to an aesthetic which had apparently been abandoned in 1814. To Constable's delight he sold it for 150 guineas off the walls of the Academy, the first time this had happened with a canal scene, and some encouragement that he was following the right path. As he had also sold paintings for France, Constable was ebullient as he wrote of *The Lock*'s reception:

> My picture is liked at the Academy. Indeed it forms a decided feature and its light cannot be put out, because it is the light of nature—the Mother of all that is valuable in poetry, painting or anything else—where an appeal to the soul is required. The language of the heart is the only one that is universal—and Sterne says that he disregards all rules—but makes his way to the heart as he can. My execution annoys most of them and all the scholastic ones—perhaps the sacrifices I make for *lightness* and *brightness* is too much, but these things are the essence of landscape.[51]

Later that year Sterne's disregard of rules was itself made into a rule—'never mind the dogmas and rules of the schools but get to the heart as you can'.[52] In *Tristram Shandy* Sterne had satirised criticism rigidly based on outmoded rules, which, in Constable's case surely provided a defence against attacks from the artistic world, and was more directly a dart aimed at the connoisseurs who judged a modern painting only according to how reminiscent of some accepted master it was: it was only four months earlier that Constable had produced that tirade against Payne Knight and his Claude drawings.

As Constable said, he annoyed all the scholastic critics with his execution, and this is only one of the important points in that passage. If *The Lock* was the 'admirable subject for a six-foot canvas' mentioned in late October 1822, and the project laid by in 1823 in favour of *Salisbury Cathedral from the Bishop's Grounds*, then it had taken over eighteen months to get to the Royal Academy, and then as a single exhibit. It is important to note the contrast with the trouble-free 1810s. There is always the possibility that Constable had made some preparatory studies for it at Flatford in

April 1823 (an undated drawing in the British Museum connects with the horizontal variant of the composition). Nevertheless, although the terrain is recognisable, with Flatford Lock shown in a considerably simplified way, there are important general connections between this composition and *A View on the Stour* (Fig. 182), connections which suggest some development of the one from the other.[53]

A large study for *The Lock* (Fig. 189) is almost exactly the size of the exhibited painting, and rather than being a preparatory sketch, is a splendid first version in which style is far freer than would be practicable in a picture meant for exhibition. And even the execution of the latter was found irritating. The first version reveals the liberal use of the palette knife, forms suggested though not defined through paint, so that the clouds (which for some time had been Constable's principal area of study) are basically sculpted areas of white paint, made clouds only through their positioning.

The composition was handled the same way in each, and developed out of *A View on the Stour*, to the extent that one can think of *The Lock* as an upright improvisation on the earlier painting. The elms are sited to make a mass of wood and foliage to the right, and the emphasis is continued on this side of the canvas via the restless and energetic act of opening the lock to let through the barge; a view across 'snowy' meadows to Dedham filling up the rest of the landscape, just as it had in the earlier painting. Place was pretty much irrelevant. Constable assembled certain features local to Flatford as the compositional skeleton for his expressionistically manipulated paint. His writing in 1821 of painting his own places best comes increasingly to look as if he were judging in retrospect, and it is always useful to recall the work up to *The Hay Wain* where, through the mutual interaction of place depicted and subject shown, was created an idea of place with notable pretensions. In *The Lock*, the subject is there only for pictorial emphasis.

This painting has so low a viewpoint that there is a threatening sense that its contents could tip out. It forces attention on the genre element more violently than similar low viewpoints in, say, the agricultural paintings of Stubbs (Figs. 126, 167). But whereas the imagery of the latter makes connections outside itself, this was not so here. *The Lock*'s subject can be understood only in the limited context of Constable's own work. It transposes the boy opening the lock from *Dedham Mill* (Fig. 147), or the bargemen from *A View on the Stour* (Fig. 182), to give the painting a limited and hermetic signification. This is the antithesis of the scope available in decoding earlier images, where a horse being ferried on a barge was not solely figural, but also significant of an historically retrievable ideology of the value of trade and work, which, in turn, transmitted the notions of value it embodied to the terrain pictured. Ignoring for the moment Constable's representationally ambiguous style, the lad and barge in *The Lock* are only what the paint represents, the imagery has been purged of any content. The juxtaposed pigments apparently present a barge, but not one which signifies beyond either representation, or the physical nature of the paint surface.

Part of this composition's extraordinary calibre depends on its being painting concerned with painting, not only in its relation to *A View on the Stour*, but also in the way that the canvas provided a field on which the work of handling oil paint is a conspicuous and crucial feature. Constable acknowledged something of this when he called *The Lock* an 'admirable instance of the picturesque'. Previously Constable had abandoned the picturesque because of its incapacity to embody other than formal qualities, and I described it above as a species of aesthetic laundering, capable of defusing the threat from objects which, on non-objective grounds, might be found disgusting. It mattered little *what* was painted, far more how it was done. Developing this idiosyncratic and personal variant of the picturesque allowed Constable to paint anything, safe in the knowledge that it would have only pictorial signification. Hence both topography and subject are irrelevant to *The Lock*.

191. *Coast Scene at Brighton, Evening* ?1828 May 22 Oil on paper $7\frac{7}{8} \times 9\frac{3}{4}$ (20 × 24.8). London, Victoria and Albert Museum (R.303)

192. *The Devil's Dyke c.* 1824 Pencil $13\frac{1}{8} \times 16\frac{1}{2}$ (33.3 × 42). London, Victoria and Albert Museum (R.279a)

In the remainder of his description Constable claimed that a concern with '*lightness* and *brightness*' necessitated his stylistic extremism. The copious application of white (again something to which connoisseurs might have objected) was presumably to achieve an effect of the painting surface comprising a multiplicity of reflecting surfaces, their effect mimicking that of the 'light of nature' which 'cannot be put out'. Constable probably intended to recreate something like the impression of broken sunlight on *any* landscape, hence the abstracted character of his style. This, however, depends on our having understood the letter correctly. The only certain thing about *The Lock* is that it bids a final farewell to the 'natural painture', for Constable stated that he had at last mastered the light of nature.

And, by beginning to speak of some universal language, the 'language of the heart', Constable implied that he had abandoned his rationalist theories of art. He probably meant that his paintings should provoke some instinctive response, yet, even with Constable's guidance, we can never be certain that our response to *The Lock* will be the one he meant.

However, it is undeniable that this painting, and the next variant on the theme, *The Leaping Horse*, confirm the demise of the artistic philosophy crucial until 1821. The high viewpoint allowed the spectator to 'penetrate' the painted space, and to discern in detail those aspects of landscape's appearance which Constable felt were susceptible to pictorial transmission. Furthermore, the image withstood historical elucidation, in contrast to *The Lock*, where the low viewpoint bars one from the picture-space, where the character of images is ambiguous, and where it is essential to burden the painting with language, to create some verbal approximation, rather than to *understand* it. Hence Constable writes of this 'universal' language, the 'language of the heart'. Later that year Constable was delighted that the French should liken his paintings to 'the full harmonious warblings of the Aeolian lyre, which *mean* nothing'.[54]

193. *Shoreham Bay* 1824 Oil $5\frac{7}{8} \times 9\frac{3}{4}$ (14.9 × 24.8). Inscr. 'Shoreham Bay. The Walk to Chalybeate Wells Brighton. Tuesday 20th July 1824'. Cambridge, Fitzwilliam Museum

194. *Brighton Beach with Colliers* 1824 Oil on paper $5\frac{7}{8} \times 9\frac{3}{4}$ (14.9 × 24.8). London, Victoria and Albert Museum (R.266)

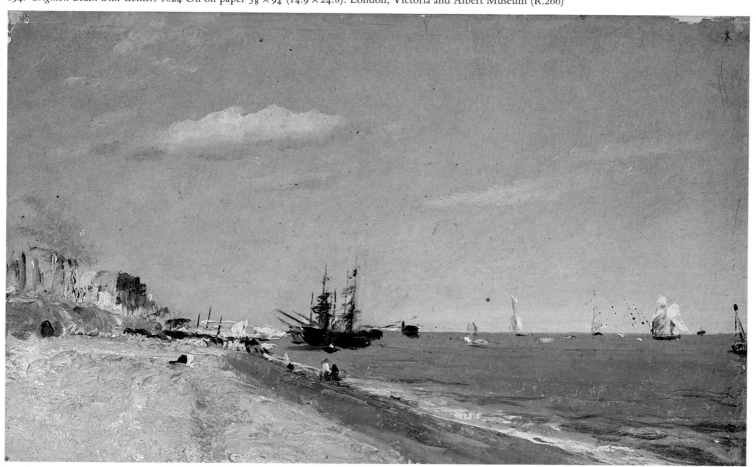

For the moment this temporary success must have reassured the artist. He enjoyed that sad reflection on British taste, his French triumph, and was boosted by the easy sale of *The Lock*. In addition compliments from, for instance, the engraver Reynolds, were couched in terms which showed that at least one or two understood what he was trying to do in painting.[55] Arrowsmith was providing commissions, and even though the radicals were making dangerous inroads with such measures as the repeal of the Combination Acts, there were also more encouraging events, like the death of Byron. Constable thought the world 'well rid' of him, though the 'deadly slime of his touch' remained.[56]

By July his mood was darkening. Small commissions were harrassing him. They 'cut into my time & consequently into my reputation';[57] yet he had to accept them; he needed the money. One reason for this was that Maria's health had declined to the point where it was necessary for them to rent a house at Brighton for the benefit of the sea air. Constable found the town 'the receptacle of the fashion and offscouring of London';[58] he nevertheless soon began studying coastal scenery in oil, pencil, and watercolour. And we are reminded, in particular by the works in oil, of the variety in Constable's practice at this period. Works like *Shoreham Bay* (Fig. 193), or *Brighton Beach with Colliers* (Fig. 194), done within two days of one another in July 1824, are both of a calibre equal to the Suffolk sketches. The only departure was the use of a small palette knife instead of a brush, to lay in parts of the middle distance in the former, and the beach in the latter. Perhaps because he was painting without distraction, as a tourist viewing unfamiliar sights, these sketches still have a concern with appearance, and seem to maintain the 'natural painture' in the old sense. *Shoreham Bay* stretches from a green foreground, with a clouding sky imposing a blond tonality over all. In *Brighton Beach*, the tonal contrast between the lightness of the shingle, and the blues of sky and sea is, by silhouetting vessels in black, used to portray the glare of the coastal light. At Brighton, Constable appeared consistent in his objectivity. Painted on paper, which allowed a reduced expressive range to his oil, there is a very beautiful green, grey and yellow coast scene which Graham Reynolds thinks may have been painted in 1828 (Fig. 191). This variety is important, as the canal scenes show that the 'natural painture' had been abandoned for a type of picturesque. The reactionary concerns of the Brighton oil sketches serve to emphasise the uniqueness of the East Anglian work, and the necessity to understand it on its own terms.

And even as Constable maintained his 'natural painture' in South Coast oil sketches, his response to a visit from Brighton to the Devil's Dyke in Sussex in August 1824 (Fig. 192), revealed how restricted his adherence to the ideal now was. He described the landscape he had seen as

> ... perhaps the most grand & affecting natural landscape in the world—and consequently a scene the most unfit for a picture. It is the business of a painter not to contend with nature & put this scene (a valley filled with imagery 50 miles long) on a canvas of a few inches, but to make something out of nothing, in attempting which he must almost of necessity become poetical ...[59]

The 'natural painture' had been to do with contending with nature, and had often featured the 'valleys filled with imagery' which were now rejected. Likewise, the high viewpoint, with its control over the ground pictured, and assumption that not only could the artist contend with nature, but stand some chance of doing so successfully, had long vanished. The low viewpoint preferred now denied this dialectic, and made the relationship of spectator to painting uncomfortable. The alternative, to make something out of nothing, is perhaps with *The Lock* illustrated through the transformation of a landscape decorated with motifs from earlier work

into a vehicle for striking pictorial effects, imbuing unpretentious subjects with tremendous grandeur. He may also have meant to associate his work with that of Turner by referring to Hazlitt's famous remark that the latter were *'pictures of nothing and very like'*. The creation of a whole from the germ of an idea would also take place between autumn 1824 and spring 1825, as Constable set about *The Leaping Horse* (Figs. 195–197, 201–3, 205).

Writing on 2 November 1824[60] Constable admitted to a depression—'All my indispositions have their source in the mind ... I have not been well for many weeks', he wrote, which on his recent record, meant that he would not have been painting. And, as he does not mention *The Leaping Horse*, he possibly began it after then. One symptom of his state of mind was an attempt to shrug off those generous commissions from Tinney: 'Tinney's pictures I see no prospect of my being able to afford the time from the publick to—and after a time they become a burthen—dead weight—and even a reproach to my own conscience . . .' He wrote to Tinney, to excuse himself. Tinney's dignified reply[61] reveals that Constable had again been trying to lay his hands on *Stratford Mill*, this time for an exhibition at the British Institution. We sense that though they had been bought, Constable still considered himself the owner of his pictures. A Mr Morrison had purchased *The Lock*, but it was 'My Lock'[62] back on Constable's easel in April 1825. It was not yet finished, and the notion of the composition being in flux, needing continual work, links with his repeated versions of it (Fig. 188) as one way of allowing him to work the theme out.

This time Tinney was willing to release *Stratford Mill*, and to forget the commissions. Not surprisingly, though, he felt wounded: 'I know my good friend that acts of kindness ought to be expected from no professional person in the line of his profession', he wrote, adding wryly that his only reasons for offering the commissions in the first place had been to alleviate Constable's need to be certain of remuneration for his pictures.

Fisher had surmised that Constable wanted *Stratford Mill* as a model against which to 'whip up' other paintings;[63] but his friend denied this:

> You are both mistaken as to my motives for desiring it so soon as I at first requested to have [it]—I wished for it not to *'whip up any other pictures by'*—my Lock which now hangs in my painting room being far beyond it in that respect—but my anxiety was to have it in readiness and by me as an inducement for the Wise Men of the Institution to receive it . . .

This is from an informative letter of 17 November.[64] It strengthens the suspicion that Constable felt himself at war against the connoisseurs of the British Institution, and therefore having to present them with a landscape in a style he thought they would find more acceptable. Yet although it does appear that the Institution had an almost pernicious power over modern art at this period, in theory at any rate Constable should have been able to survive without it: he could offer works for sale at the Royal Academy, and he did admit visitors to his London rooms. Indeed, the way he was anxious not to submit one of his more recent works to this exhibition might point to an uncertainty about what he had been doing.

More definitely, he did admit here that he now used his own painting as a standard to set against any new works; his art was feeding off his art. Hence he could use *The Lock* to 'whip up' other pictures. At the same time he announced plans for a new picture, making as he did so one or two interesting reflections:

> I regard all you say but I do not enter into that notion of varying ones plans to keep the Publick in good humour—subject and change of weather & effect will afford variety in landscape. What if Van de Velde had quitted his sea pieces—or Ruisdael his waterfalls—or Hobbema his native woods—would not the world have lost so many features in art? I know that you wish for no

195. Detail from *The Leaping Horse* (unexhibited) (Fig. 201)

material alterations—but I have to combat from high quarters, even Lawrence, the seeming plausible argument that subject makes the picture . . .

. . . I must go on. I imagine myself driving a nail. I have driven it some way—by persevering with this nail I may drive it home—by quitting it to attack others, though I amuse myself, I do not advance them beyond the first—but the particular nail stands still the while . . . No man who can do anything well, will ever be able to do another different as well . . .

This can be read as an apologia for the repetition of subject most apparent in *A View on the Stour* and *The Lock*. In 1825 it was continued with *The Leaping Horse*, on which Constable worked with *The Lock* hanging in his studio, and available for reference. 'Driving a nail' suggests working that one theme, but in a sense very different now to before 1821, when Constable had varied subject, season, and topography.

196 (facing page, above). *The Leaping Horse: preparatory drawing* 1824–5 Pencil, pen(?), and wash 8 × 11⅞ (20.3 × 30.2). London, British Museum (L.B.10A)

197 (facing page, below). *The Leaping Horse: preparatory drawing* 1824–5 Pencil and wash 8 × 11⅞ (20.3 × 30.2). London, British Museum (L.B.10B)

In this context we may be able to relate a series of small works in oil (Figs. 199, 200), which features a barge coming up through a lock with Dedham Church in the background, to this set of canal scenes. Their relation to the terrain at Dedham lock is ambivalent. However, the way Constable has taken a low viewpoint to view landscape features which appear both in *The Lock* and *The Leaping Horse* might indicate that these were *esquisses* done while he was 'driving his nail' between

160

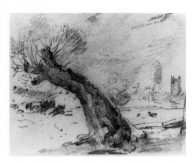

198. *A Willow* ?1816 Pencil $3\frac{1}{2} \times 4\frac{1}{2}$ (8.9 × 11.4). London, Courtauld Institute of Art, Witt Collection

1822–6. If so, this is further evidence for the dedicated single-mindedness with which he pursued this theme. He was concerned to impress on Fisher the small importance subject now had, and it was in this context that he expressed delight that the French had compared *The Hay Wain* and *A View on the Stour* (exhibited in the 1824 Salon) with 'the rich preludes in musick, and the full harmonious warblings of the Aeolian lyre, which *mean* nothing'—save perhaps that the music of the Aeolian lyre is the music of the wind, of nature untrammelled, abstracted, and unlocated.

This particular letter displayed Constable's range of mind, as he moved from topic to topic. Having unburdened himself of matter pertinent to his painting, he told a tale of the evil way of Calvinists, and indulged some gossip which led him to Brighton, where his wife had been. From this developed reflections on the work he had done while there, drawings of boats and coastal scenes, '. . . more fit for *execution* than sentiment. I hold the genuine—pastoral—feel of landscape to be very rare & difficult of attainment—& by far the most lovely department of painting as well as of poetry. I looked into Angersteins the other day—how paramount is Claude.' This is one of those deceptive statements, which actually has little to do with Constable's painting. It is more of a retrospect, for he had effectively banished the pastoral from his own painting.

Lastly, this letter indicated the starting date for *The Leaping Horse*, one sufficiently late to put him behind on work nearer Christmas.[65] Constable stayed in London, therefore, and on 5 January 1825 wrote, 'I am writing this hasty scrawl [in the] dark before a six foot canvas which I have just launched with all my usual anxieties. It is a canal scene . . .'[66] The verb 'launched' suggests that the process of making these paintings was like setting off on a voyage into the unknown. One started the picture with little idea of how it would finish. Constable needed only 'canal scene' to identify his subject, because subject was not of the first importance to his conception.

He was to work well and fast on *The Leaping Horse*, and as early as 23 January was pleased with his progress:

> The large subject now on my easil is most promising and if time allows I shall far excell my other large pictures in it. It is a canal and full of the bustle incident to such a scene where four or five boats are passing with dogs, horses, boys, & men & women & children, and best of all old timber-props, water plants, willow stumps, sedges, old nets, &c & &c.[67]

This would as well fit *a View on the Stour*. But, regarding *The Leaping Horse*, the passage suggests that Constable was working on the V & A version (Fig. 201), which at least has two (not 'four or five') barges in its left foreground. Constable had listed objects typical to any canal scene, no matter that it is hard to find many of them in the eventual painting. Fisher made the proper response. His wife, he wrote, had observed that Constable's 'enumeration of objects "carried her down to the river side"'.[68]

Then this good start faltered. When, on 8 April, Constable next wrote to Fisher,[69] the picture was at the Academy, he had worked very hard, but he had to admit that '. . . no one picture ever departed from my easil with more anxiety on my part with it. It is a lovely subject, of the canal kind, lively—& soothing—calm and exhilarating, fresh—& blowing, but it should have been on my easil a few weeks longer.' That last was an understatement. This was a new canvas, and Constable must have worked incredibly hard in the short time he had allowed himself. *The Leaping Horse* went to the exhibition along with a couple of stylistically more restrained Heath scenes.[70] Indeed, not only has the disposition of paint in the Heath pictures more to do with observed reality, but their concern with topography also contrasts (as we shall see) with *The Leaping Horse*; and consequently, as they stand

199 (facing page, above). *Canal Study* ?1822–6 Oil on canvas laid on panel $4\frac{1}{2} \times 6\frac{1}{2}$ (11.5 × 16.5) New Haven, Yale Center for British Art, Paul Mellon Collection

200 (facing page, below). *Canal Study* ?1822–6 Oil on paper $6\frac{1}{2} \times 10$ (16.5 × 25.4) laid on panel. London, Tate Gallery

202. *The Leaping Horse* 1825 Oil on canvas 56 × 73¾ (142.2 × 187.3). London, Royal Academy of Arts

203. Detail from *The Leaping Horse* (Fig. 202)

201. *The Leaping Horse* (unexhibited) 1824–5 Oil on canvas 51 × 74 (129.4 × 188). London, Victoria and Albert Museum (R.286)

apart from landscapes of other regions, the East Anglian scenes must be considered on their own terms.

In attempting to trace the genesis of *The Leaping Horse* we gain some insight into the way Constable set about inventing a landscape, for although the sluice might have been based on a memory of an actual one,[71] the scenery itself was closer to that of the horizontal *Lock* (Fig. 185), but reversed. The preparatory work that certainly is for this painting comprises two sepia drawings, and the large 'sketch'. In his *Memoirs* Leslie wrote that Constable had originally dithered over whether to send this or the 'finished' canvas:[72] thus they possibly represent parallel workings of the same theme. To guess the chronological order of these works, or even to know if they can be called 'preparatory' in the conventional sense, is difficult.

They divide into types: those with two barges (Figs. 196, 201), and those with one (Fig. 197, 202). In the painting the willow stump was only later shifted to the left, on 7 September 1825.[73] The surfaces of *all* versions are worked (the Victoria and Albert Museum oil having a particularly caked *facture*) and Constable, working at speed, came close to a non-figurative art. The sepia drawings are as much about tonal marks on paper as about landscapes with recognisable elements. Consider the area around the sluice in Fig. 197. It breaks into a tonal patchwork in which patterns of contrast predominate. In so far as it matters, the landscape is recognisably the same in all versions. It has a view up to a sluice over which a horse is jumping, and to the left the customary rich mass of barge and trees, with a more open landscape to the right. This was wrought through stages into a more 'acceptable' form, until in the exhibited picture we can discern a plausible show of wooden posts, or weeds. As Turner was doing also in the 1820s, Constable was coming close to an abstracted art, and part of

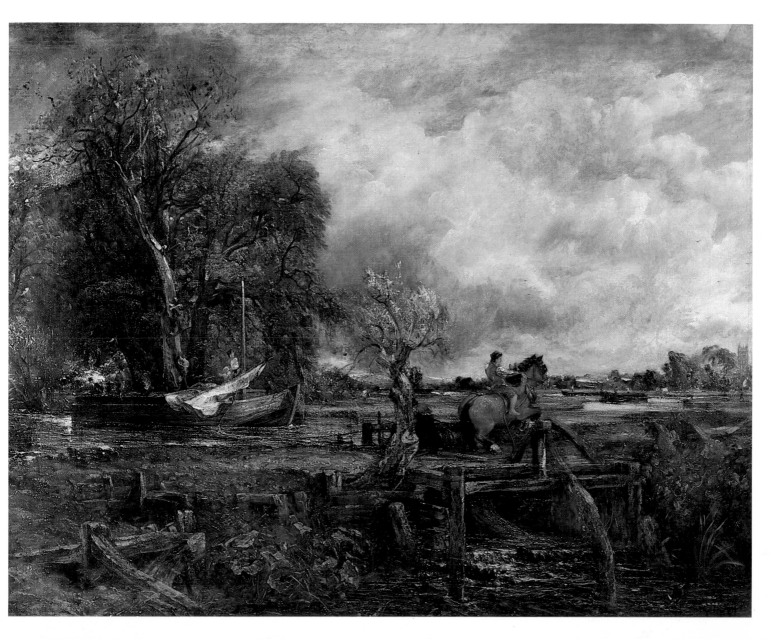

the brilliance of his effect is in the tension created through his efforts to force this into a figurative one, in order to make the scene acceptable to contemporary taste.

In the exhibited painting topography is irrelevant. Constable used either *Flatford Mill* (Fig. 135), or his drawing of the elms (Fig. 137) as a basis for those behind the sluice, but without worrying about transferring their surrounds as well.[74] Dedham Church, a landmark, achieved definition, probably to close off the right with a vertical, but possibly because it had previously appeared in both *A View on the Stour* and *The Lock*, and was integral to this conception. Here it was adapted fairly obviously from *Dedham Mill* (Fig. 147), but minus the village. And this is notwithstanding an attractive suggestion that the composition's prototype was a drawing of a willow stump, some cattle, a mark (which could be a moorhen) and a church tower (perhaps too squat for Dedham) (Fig. 198)[75] the dimensions of which could fit a dismembered sketchbook of 1816.[76]

As before, Constable attempted to exhibit something the public might tolerate. The 'sketch' is expressionist to a degree, and that tendency to abstraction shown in the sepias is equally pronounced. As we have noted, the painting had to be more disciplined; yet there are areas of representational ambiguity, for instance those spars around the sluice; and other passages, the white around the near barge, or that slash with a white-and-ochre-loaded palette knife above the barge to the left of the church, remain unchecked in their expressionism (Figs. 202, 203). Indeed, the sky and horse itself were alone painted with more regard for 'reality'.

And only the sky is naturalistic in the terms Constable defined in his own earlier work. Otherwise the colours have a pervasive, almost sickly gloom to them, and the hills appear to be covered in ancient snow. Sometimes there is no concession to the third dimension, particularly with the elm trunk, which appears to explode as two-dimensional bands out of the barge. The palette knife was copiously used, and here gave the tree a greater degree of definition than it had in the 'sketch'. This is a landscape of almost overpowering presence, but to understand rather than intuit it we have to turn for guidance to the artist himself.

Constable wrote that he meant *The Leaping Horse* to be 'lively—& soothing—calm and exhilarating, fresh—& blowing', and a day or so later was to call *The Lock* 'silvery, windy, & delicious'.[77] This is interesting terminology, for only 'silvery' has any objective relation to painting. Writing of *The Leaping Horse*, Constable attempted a run of antitheses. We cannot know exactly what meaning he intended, but it is possible that the landscape was the physical embodiment of what he found integral to a total (not just visual) experience of nature, the breeze and freshness one associated with being outdoors in places like Brighton or Hampstead Heath. He gave a verbal impression of flickering lights and shadows, as his style was probably meant to recreate such effects, and suggest an association of flickering light with windy days, which seems to have fed his own verbal description of his pictures. The style moved towards abstraction to cope with abstracted nature, seen in terms of essences, wind and light. Because they fluctuate constantly, this may be connected with Constable's inability to stop work on a canvas, and partly explains why we can see such a change in the character of his naturalism, from one concerned with fixing appearances, to one to do with recreating sensation.

Guided by Constable himself, then, we can guess that the rugged, almost savage style, and brilliance of effect in such a painting as *The Leaping Horse* is partly created through his attempt to transmit pictorially the sensations, the flux of shifting lights, the feel of the wind, the shifts in perception caused by actual bodily movement, of being outdoors. Nature becomes a general phenomenon, not something fixed, to be studied in one locale. These 1820s canal scenes, in contrast to the East Anglian landscapes of 1810–21, are removed from significant concern with literary, topographical, political, social or other elements.

204. *Branch Hill Pond, Hampstead*
exh. 1825 Oil on canvas 24½ × 30¾
(62.2 × 78.1). Richmond, Virginia,
Museum of Fine Arts

We could understand *The Hay Wain*'s iconography through the poetry we know
Constable enjoyed. No similar exercise is rewarding for *The Leaping Horse*. It might
be, for instance, that in concluding that lightness and brightness were the essence of
landscape, Constable may have been expressing ideas analogous to Wordsworth's:

> The unfettered clouds and region of the Heavens,
> Tumult and peace, the darkness and the light—
> Were all like workings of one mind, the features
> Of the same face, blossoms upon one tree;
> Characters of the great Apocalypse,
> The types and symbols of Eternity. (*Prelude* VI 634–39)

And yet we cannot *know* either if there is a connection, or if a reading of
Wordsworth's poetry is helpful to a comprehension of Constable's art. Possibly there
is a shared concern with defining the flux, and yet the sense of particular nature
which in Wordsworth is so strong seems by Constable in the 1820s to have been
abandoned for almost its opposite. In historical terms, Constable was far less
enthusiastic about Wordsworth, than he was, say, about Cowper or Bloomfield,[78]
which increases that sense of Constable's isolation at this period.

205. (over page). Detail from *The
Leaping Horse* (Fig. 202)

Constable's abstracted and picturesque art of 1822–5 had little to do with place. This new and alternative aesthetic was, if the letters are to be believed, maintained over the later 1820s, although the landscapes changed in formal respects. Possibly this was because Constable himself appreciated the sense of a comment John Fisher had made in November 1824: 'I hope that you will a little diversify your subject this year as to *time of day*. Thompson you know wrote, not four Summers but *four Seasons*. People are tired of mutton on top mutton at bottom mutton at the side dishes, though of the best flavour and smallest size.'[79] While Constable nevertheless continued developing the one theme with his repetitions of *The Lock* (although this was one composition he thought saleable[80]) after *The Leaping Horse* had failed to sell, *The Cornfield* (exhibited in 1826) shifted away from the river, and presented the public with a more conventionally picturesque version of landscape. This may also have been because Constable realised that he had to come half-way to meet the art establishment if he was to stand any chance of popular recognition.

CHAPTER SIX
Constable's Picturesque

From 1826 Constable began to diversify his landscape, a process which accelerated after Maria's death in 1828. Although he had turned, in the first half of the 1820s, to a picturesque vision of the canal landscape, he seems in 1826 to have heeded Fisher's advice about varying his output, for *The Cornfield* (Figs. 206, 208) showed a valley scene, not one on the river, and was picturesque in far more conventional a sense. Indeed, in the later 1820s Constable went through a picturesque phase, culminating with the great 1828 *Dedham Vale* (Figs. 213, 214, 219), and it is the pictures of this period that I shall discuss in this chapter.

Although in 1825–6 Constable consciously moved from the intense individualism of the canal scenes, there was little drastic change in his actual working habits. For instance, when he wrote to Fisher in September 1825 he had just left *The Leaping Horse*, having been trying to calm its style enough to attract a buyer[1]—

> I am now thank God quietly at my easil again. I find it a cure for all ills beside its being the source of 'all my joy and all my woe'. My income is derived from it, and now that after 20 years hard uphill work—now that I have disappointed the hopes of many—and realized the hopes of a few (you best can apply this)—now that I have got the publick into my hands—and want not a patron—now that my ambition is on fire—to be kept from my easil is death to me. My commissions press in upon my hands.[2]

In this excited state, Constable saw life as it suited him. Yet, while he wrote his spirits seemed to deflate, and he went on to say that his brother Abram would be sending funds, and so contradicted that claim about receiving his income from painting. Although he welcomed his commissions here, by 1 October they had become 'dead horses', paintings he had to do because they were pre-paid, and which he was getting off his hands with all speed.[3] Once more we are reminded of how crucial it had become for Constable to be before the easel, in the act of creating, yet he went on to say that he had been too depressed to paint much, and of having sent Fisher a 'disagreeable' letter (which has not survived).

Constable could not paint when his spirits were low: something fitting the emotionally-fueled art of one who called his landscapes his children, and who felt he had lost his arms after *A View on the Stour* had gone to exhibition. A clue to the development of his thinking is found in the way he used 'vision', and some of its derivatives, on 9 November 1825:[4]

I should fear that my vision of happiness in making you a visit at Salisbury—like most of my dreams of bliss—will be but a vision—I am hard run in every way that I know [not] which canvas to go to first.

My Waterloo like a blister begins to stick closer & closer—& to disturb my nights . . .

I am in trouble about Tinney . . . but if artists (creatures of feeling, visionaries) are to be judged of by every day usage—like pound of butter men—they must always be in scrapes and on the wrong side.

An intervening letter from Fisher[5] and Constable's reply[6] show him clearer in his motives, and less accessible in his thinking.

The Tinney problem had recurred because Constable wanted *Stratford Mill* for an exhibition in Edinburgh, and Tinney had refused to lend it. Fisher pointed out that this was from the not unnatural motive of wishing to have his picture back on his own walls, and added that Constable appeared 'devilish odd' in his behaviour towards commissions. The reply was along the lines that Tinney was unfit to own a Constable, 'but as pictures cannot choose their possessors, or the painters of them for them, we must let the subject rest'—except that Constable then went on to accuse Tinney of wrecking his chances of showing in Edinburgh. Against this we must remember that there were numbers of unsold paintings (*Flatford Mill* or *The Leaping Horse* for instance) which lay readily to hand. Once again, there is a suspicion of a nervousness in Constable's dealings with his 'publick', hence his desire to show himself with an acceptable and proven exhibition piece, *Stratford Mill*. Railing against Tinney, he ascended heights of paranoia—'It is easy for a bye stander like you to watch one struggling in the water and then say your difficulties are only imaginary . . . My master the publick is hard, cruel & unrelenting.' Here he was again referring Fisher to Samuel Johnson, for the latter had described a patron as one 'who looks with unconcern on a man struggling for life in the water, and, when he has reached ground, encumbers him with help'.[7] In one way this increases a sense of vacillation in Constable's thinking. He defines the public as his collective patron. Earlier he had not wanted a patron; now like Johnson he was cursed by the lack. And yet, when a patron did appear, Constable's principal desire was to rid himself of the encumbrance.

As Constable continued his letter, he revealed more of his psychological condition: 'I have related no imaginary ills to you—to one so deeply involved in active life as I am they are realities, and so you would find them. I live by shadows, to me shadows are realities.' He was involved in a task of lonely and intuitive artistic search, beyond even that earlier conception of artist as creative intelligence. When Constable called artists 'creatures of feeling, visionaries', his mind ran from visions as 'dreams of bliss' immediately to his paintings. Constable's landscapes, those glimpses into a 'Kingdom' of his own, were becoming the visions of a creature of feeling, something characters like Tinney could hardly be expected to understand.

Yet, because the meaning of 'I live by shadows, to me shadows are realities' is obscure, that sense of Constable's being engaged in interpreting elusive and intensely personal ideas is enhanced. Maybe the ever-changing appearances he perceived were the 'shadows' thrown by some greater intellectual reality. Earlier Constable had abused Hofland for selling a 'shadow' of a Gaspard, no nearer the model than a man's shadow to the real man: conceivably he was coming to consider perceptible appearance merely the trace of that more perfect entity it was the painter's task to intuit. And as shadows occur where light is blocked, to find shadows realities means extraordinary artistic vision (which discussion will be seen later to have some bearing on *Hadleigh Castle* (Fig. 245)). It might be for this reason that Constable's style had developed as it had.

206. *The Cornfield* 1826 Oil on canvas 56¼ × 48 (143 × 122). London, National Gallery

172

This was theory. In the practical world of financial survival he did nothing to relieve his problems by reacting to Arrowsmith as to any other patron, and wrecking the relationship after a quarrel. He had sold more in France than in Britain.[8] As the winter drew on, Constable became, as usual, a bad correspondent as he worked up the landscape intended for the 1826 Royal Academy, *The Cornfield* (Figs. 206, 208). On 8 April 1826 he sent Fisher an account of the picture:[9]

> I have dispatched a large landscape to the Academy—upright, the size of my Lock—but a subject of a very different nature—inland—cornfields—a close lane, kind of thing—but it is not neglected in any part. The trees are more than usually studied and the extremities well defined—as well as their species—they are shaken by a pleasant and healthfull breeze—'*at noon*'—'while now a fresher gale, *sweeping with shadowy gust the feilds of corn*' &c, &c. I am not without my anxieties—but they are not such as I have too often really deserved—I have not neglected my work or been sparing of my pains . . .
> My picture occupied me wholly—I could think of and speak to no one . . .

This interesting passage reveals first how little interest Constable had in the actual subject—'a close lane, kind of thing'—and second that he was deliberately trying to control his technique, and therefore not neglect his work. However, he was unable to stop himself being enthusiastic about the general windiness of the whole scene. He continued his letter, 'I am much worn, having worked very hard—& have now the consolation of knowing I must work a great deal harder, or go to the workhouse. I have however work to do—& I do hope to sell this present picture—as it has certainly got more eye-salve than I usually condescend to give them.' Leslie found 'eye-salve' offensive enough to censor it,[10] but Constable was merely admitting that his usual style tried the public's tolerance. Those lines from *The Seasons* stuck in his mind as appropriate to this painting (while his joke about noon was aimed at Fisher's complaint about his lack of diversity). In the 1827 British Institution Constable exhibited *The Cornfield*, using Thomson's verses as a tag:

> A fresher gale
> Begins to wave the woods and stir the stream,
> *Sweeping with shadowy gust the fields of corn.* (*Summer* 1654–6. Constable's italics)

What is interesting is the context, for the passage in the edition Constable used[11] began:

> Confess'd from yonder slow extinguish'd clouds,
> All aether soft'ning, sober *Evening* takes
> Her wonted station in the middle air,
> A thousand shadows at her beck. (*Summer* 1646–9, my italics)

These lines described a day's end, when, after stillness, a breeze springs up. Yet according to Constable *The Cornfield* featured a landscape at noon. When Constable had cited Bloomfield in 1814 and 1817 this had been both precise and significant. He knew *The Seasons* as well as *The Farmer's Boy*, yet the way he related Thomson's lines to *The Cornfield* was of a piece with the relation of that picture to earlier work, was as formalistic as the picturesqueness of his style.

The poetry referred only to the importance of cornfield and wind in this painting, guiding attention to the same message transmitted visually by the slight bend of the wheat, and by the upturn of leaves on certain boughs. As the passage in *The Seasons* is just part of a general exegesis on the significance of harvest and its politically symbolic rôle, the way Constable, by extracting these lines and insisting only on their illustrative function, divests them of that significance he was only too aware

207. *A Lane c.* 1810–17 Oil on paper laid on canvas 8 × 11$\frac{5}{16}$ (20.3 × 30.3). London, Tate Gallery

they had, is precisely analogous to the formal emphasis of his work at this period. When previously he had inserted a catalogue tag, for instance a couplet from Bloomfield with the *Landscape, Ploughing Scene in Suffolk*, this was to insist that there was more than met the eye to the image of the ploughman: he represented a type of Industry, and pointed to the season. In turn he qualified the actual scenery which Constable painted. We have seen that poetry from Thomson could serve the same purpose: but not with *The Cornfield*. Constable's tag blocks the possibility of this corn signifying a georgic landscape, and this, as we shall see, supports the formal picturesque of the painting itself.

With *The Cornfield* Constable deliberately moved away from his immediately preceding work. It was not a canal scene (although the combination of pool and old wood is a reminder of them), perhaps in acknowledgement that continuing to drive that particular nail brought diminishing returns. Indeed it was almost ostentatiously picturesque, not only in subject and composition, but also in the texture of the paint surface. This was generally subdued (save for areas like the right foreground, where Constable's expressionist marks reappear). The sky is more controlled, and less overwhelmingly gloomy than in the canal scenes, and in general the painting has a rich, not a violent surface, exposed canvas-ground in areas like the bank to the right contrasting with the worked texture of paint (perhaps to suggest the indistinctness of form in shade, against its three-dimensionality in light). Constable intended this subdued style, and his 'eye-salve' may refer to this. But in a brilliant account of *The Cornfield*[12] Graham Reynolds has noted various artistic borrowings, such as the exhibition-going public would probably also have spotted, so having its sense of vision salved.

Reynolds convincingly suggests a compositional connection with Claude's *Hagar* (Fig. 29), proposes that the sheep originated in Gaspard's *Landscape near Albano* (Fig. 210), and is amazed at the dead tree in the left foreground relatively soon after Constable had replied to Sir George Beaumont's innocent enquiry as to where he put his brown tree, by placing a violin on the lawn to contrast with nature's predominant greenness. Constable did not confine his borrowings to these instances alone, and it is possible to subject the composition to what amounts to a pictorial dissection.

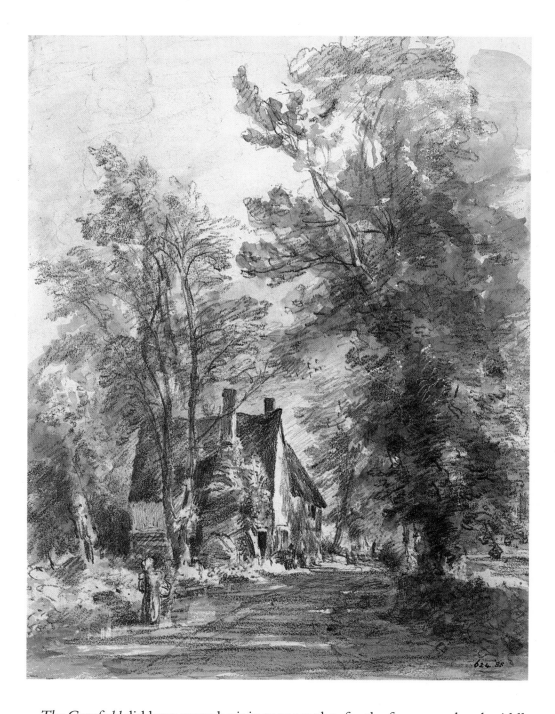

208 (facing page). Detail from *The Cornfield* (Fig. 206)

209. *Water Lane, Stratford St. Mary* 1827 Pen and grey wash 13 × 8⅞ (33 × 22.5) Inscr. 'Stratford Water Lane. Oct 1827'. London, Victoria and Albert Museum (R.291)

The Cornfield did have some basis in topography, for the foreground and middle distance came from an oil sketch (private collection), with a tree killed off, and a distant village added. The drinking boy was another East Anglian memory; he had appeared in another earlier sketch (Fig. 207), although the figure might also refer obliquely to Claude's *Narcissus* (Fig. 33). Constable was also, almost humorously, paying his respects to Gainsborough.

Both the view down a shady lane across fields to a village, and the dead tree, were Gainsborough trademarks (Figs. 22, 211). Gainsborough was fond of donkeys (although this beast is a cousin to the one first seen in *Dedham Vale, Morning* (Fig. 55)), and in one landscape, probably of the early 1760s, had a flock of sheep moving down a rutted lane.[13] Constable's mallow leaves have numerous precedents in Gainsborough's landscapes. Such cross-referencing made *The Cornfield* picturesque in the exact sense; much of what it showed was adapted from pictures. Nevertheless, the artful Constable ensured his picturesque in plenty of other ways besides. Payne

177

210. G. Poussin *Landscape near Albano* Oil on canvas. London, National Gallery

Knight, for instance, wrote, 'The usual features of a cultivated country are the accidental mixtures of meadows, woods, pastures, and cornfields, interspersed with farm houses, cottages, mills, &c. and I do not know in this country that better materials for middle grounds and distances can be obtained, or are to be wished for . . .'[14] Constable's middle ground and distance incorporated just such a mix, one which blurs pleasingly, rather than intruding itself on the sensibility for non-pictorial reasons.

The picturesque allowed one to paint anything. Consequently *The Cornfield* deals in paradox, for it takes elements which in the 1810s had functioned as fully-charged signs, and discharges them of signification. Constable has portrayed his own variant of Gilpin's loitering peasant in the drinking boy, a figure not only improbable, but potentially disastrous. Constable knew enough about border collies to know that this one would not continue driving its flock towards a cornfield. Yet it was precisely this group which he added to the drinking boy, and if, as Graham Reynolds suggests, that boy is a figure for the young Constable, then, like Narcissus, he has turned away from reality to study reflections. This picturesque condemns the georgic of the 1810s, for it allows Constable to include the motif regardless of its *actual* potential. This fits well with the sort of objections raised against Payne Knight by practically-minded writers, like the agriculturist William Marshall.

> Briars, brambles and wild tangled thickets, with the poaching effects of cattle, and even cart ruts (by way of the work of art) may be had gratis, or at very low cost . . . The most offensive of Mr Brown's beautiful disfigurements may readily be *picturesqued* in this way: it is only transferring the care of them from the gardener to the herdsman, and the business in a very short time will be completely done! This is . . . drawn from actual observation . . . by mere *dint of neglect*, places, heretofore beautiful, have been rendered picturesk and highly irritating, both to the minds and bodies of those who explored them.[15]

These sentiments would have been shared by Constable in the 1810s: but, despite apparent attempts at horticultural accuracy,[16] *The Cornfield* is picturesque in opposition to the georgic. If the small boy *does* represent Constable, the georgic is something on which he has turned his back.

And in many respects this is a curious picture for the countryman Constable to have painted. Were this illusory countryside real, that dead tree would be down; wheat would not grow to the edge of the field as the crop to the left does; the donkeys would be tied up; neither, at harvest-time, would the sheep look unshorn, nor be heading towards a field where the gate is not just open, but off its hinges. The plough is an invented composite, based on both types sketched in 1814 (Fig. 5). The abnormal behaviour of the sheepdog has been noted above. And that large cornfield appears to have a totally inadequate workforce, one man departing with a stick (not sickle), leaving just two to cut the corn, when one would expect a scene of crowded confusion of the kind pictured in *Golding Constable's Kitchen Garden*. J.T. Smith had told Constable not to invent figures for a scene, but to paint those that came naturally to it,[17] while W.H. Pyne had propounded the following picturesque axiom:

> It is highly essential to sketch figures, animals, or other objects, to embellish the design, upon the spot: the groups then assume the air of nature; their occupations are mostly accordant with the scene; and they are consequently appropriate in action, character, and every essential that constitutes fitness or propriety.[18]

Together with his mention of eye-salve, and deployment of figures and motifs as cyphers for a chimerical pastoral, it seems possible that in certain respects *The Cornfield* was an ironic landscape, one which the connoisseurs should like, because it contained so many references to other pictures. Constable had been showing a

211. T. Gainsborough *'View of Dedham' (View of Cornard)* c. 1747 Oil on canvas 24⅝ × 30¾ (62.5 × 78.1). London, Tate Gallery

growing concern with his public, and if, as I shall suggest below, he associated its tastes with those of the Directors of the British Institution, then it would have been practical to produce something it would be more likely to appreciate.

The Cornfield also infers that Constable had come to have little concern with which landscape he painted. Apparently reverting to pre-1822 subjects and style, they were used in a landscape in every respect the opposite of earlier paintings. It is more a piece of the work of 1822–5, where motifs had a limited charge, and denoted no underlying extra-pictorial philosophy, save that the work was meant to embody those qualities of nature (wind or light) which Constable himself found cardinal. In *The Cornfield*'s illusory georgic and obvious picturesqueness, Constable evolved a more publicly tolerable vehicle for his experimentation with those abstracted concerns with breezes and bloom, light and shade.

Further evidence that Constable had turned to a more conventional picturesque was *The Cornfield*'s co-exhibition piece, a version of the rather unsatisfactory *Parham Mill* (Fig. 212): an anglicised variant of a subject any admirer of Hobbema would appreciate. When Fisher wrote to tell Constable in 1825 that this old mill had been replaced by a 'new, bright, brick, modern, improved patent monster', such a building as the Constable of the 1810s would have approved, the artist mused that there 'will soon be an end to the picturesque in the kingdom';[19] thereby intimating

212. *A Mill at Gillingham in Dorset* 1826 Oil on canvas 19¾ × 23¾ (50.2 × 60.4). New Haven, Yale Center for British Art, Paul Mellon Collection

not only that he was turning to the picturesque consciously, but also that he had come to associate it with an old England. It was in part a nostalgic vision of a world fatally threatened by the one developing in the 1820s.

From 1826 the correspondence with Fisher declined, and as letters to Leslie only began proliferating in 1828–9, we have less from Constable on his own art for these years. The voluminous correspondence begun in 1829 with David Lucas was geared to problems with the mezzotints the latter was doing after Constable's landscapes, which subject has had extended and distinguished coverage.[20] In a letter to Fisher of 9 September 1826, Constable confessed to the increasingly rare achievement of having finished a painting, *The Glebe Farm* (Figs. 215, 216, 218) (which he was to exhibit in the British Institution in 1827): 'My last landscape [is] a cottage scene—with the Church of Langham—the poor bishops first living—& which he held while at Exeter in comendamus. It is one of my best—very rich in color—& fresh and bright—and I have "pacified it"—so that it gains much by that in tone and solemnity.'[21] The picture was therefore intended as elegiac, and may have been under way for some time, as Bishop Fisher had died on 8 May 1825. Of the several variants of the painting, it is likely that the Detroit version was the one which was produced for 1827 (Fig. 215).[22]

Improvising his composition on an oil sketch (Fig. 216), Constable introduced Langham church tower (in allusion to Bishop Fisher), and moulded his terrain. He moved the farm, and defined a track down the left centre. *The Glebe Farm* is a picturesque composition in the same formal sense as *The Cornfield*, in that not only the richly-worked paint surface and the textures have to be so categorised, but also the compositional format itself.

While Hobbema invented the genre of cottage landscape in woodland, Gainsborough anglicised the tradition, and repeated the pattern of a slightly off-centre path let out through woody and tummocky ground (first seen in *Cornard Wood* (Fig. 22)) in numerous landscapes of the early 1760s. Indeed, in the later Tate *Glebe Farm* (Fig. 218), the small girl with the pitcher behind her may refer obliquely to Gainsborough's famous *Cottage Girl with Dog and Pitcher* (Fig. 217). If so, this would reinforce the picturesqueness of the composition, in the sense of referring to pictures. Moreover, in calling it a 'cottage scene' Constable may have been recalling J. T. Smith's cottage picturesque, by which he had been so impressed in the 1790s.

Had not Constable told us that the composition commemorated an early mentor, in contrast with, say, *The Church Porch*, we would not have been able to tell that *The Glebe Farm* was elegiac through formal analysis. It is likely that, recalling the lead he himself gave in writing of *Parham's Mill*, the picturesque had now gained for him a nostalgic element, an association with the irretrievable past; hence his choosing so picturesque a memorial to Bishop Fisher. Yet this reading of the picturesque was an individual one, not one propounded by the movement's theoreticians.

The subdued and more conventional style of *The Glebe Farm* would have made it more suitable for exhibition at the British Institution, and at the same time more attractive to buyers. Indeed, the 1827 version was bought by a George Morant. Yet the 'ferocious' *Chain Pier, Brighton* (Fig. 220), exhibited at the apparently more liberal Royal Academy, reveals that the strain of demoniacal energy pulsating through the canal scenes remained close to the surface.[23] This great grey and threatening reply to the seaside picturesque of Collins or Callcott alluded to their sentiment via the foreground nautical litter, but far more, impresses through the savagery of the ocean and the grandeur of the sky. It is no small pity that Constable was relatively silent on this picture. It seems he picked his subject because he often went to Brighton to visit his wife. While he seems not to have liked the place, this did not stop him painting there. Yet he had gone on to write (in that letter where he had recorded his visit to the Devil's Dyke) of beach scenes that:

213. Detail from *Dedham Vale* (Fig. 219)

214. Detail from *Dedham Vale* (Fig. 219)

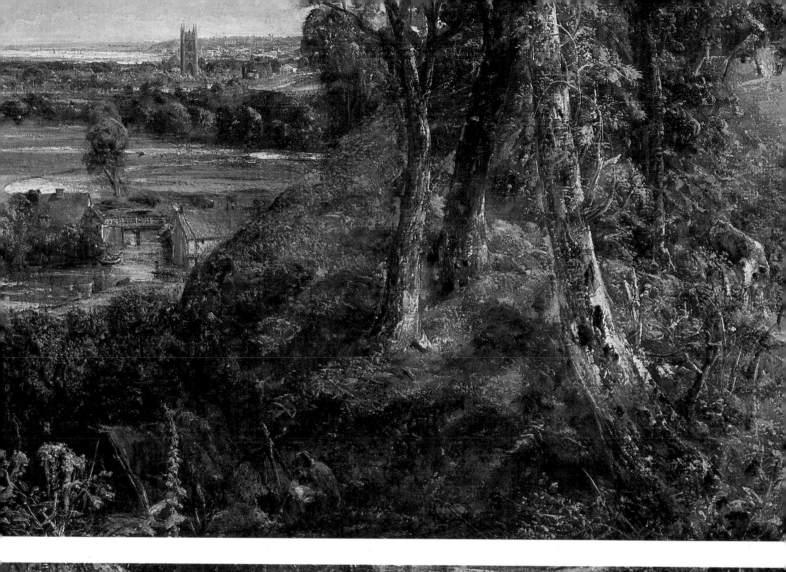

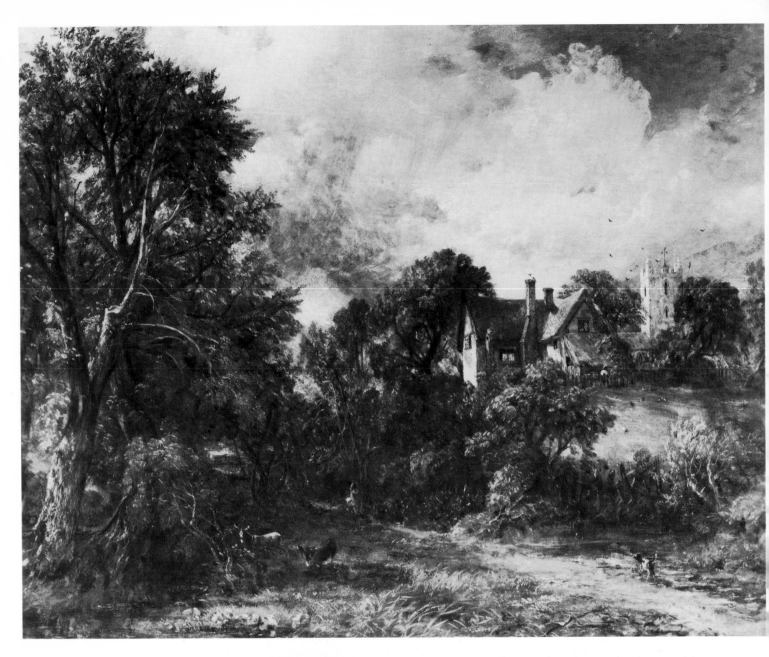

215. *The Glebe Farm* ?1827 Oil on
canvas 18¼ × 23½ (46.4 × 59.7).
Detroit Institute of Arts

216. *A Cottage and Lane at Langham*
c. 1810–17 Oil on canvas 7¾ × 11
(19.7 × 28). London, Victoria and
Albert Museum (R.111)

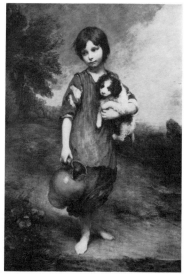

217. T. Gainsborough *Cottage Girl with Dog and Pitcher* 1785 Oil on canvas 68½ × 49 (174 × 124.5). Sir Alfred Beit Bart.

218. *The Glebe Farm c.* 1830 Oil on canvas 25¼ × 37⅝ (64.8 × 95.6). London, Tate Gallery

. . . there is nothing here for a painter but the breakers—& sky—. . . But these subjects . . . are in fact so little capable of that beautifull sentiment that landscape is capable of . . . But I am not complaining—I only meant to call to your recollection that we have Callcott & Collins—but not Wilson or Gainsborough.

He may have meant to demonstrate the dramatic potential of coast subjects, where the sea and sky in their magnificence make the kind of genre features on which Callcott or Collins concentrated look trite. Fisher backed this up in a later report: 'It is most beautifully executed & in a greater stage of finish and forwardness than you can ever before recollect. Turner, Callcott and Collins will not like it.'[24] We are again reminded how far Constable's range and interests had expanded. The Stour Valley was now but one amongst many possible subjects.

And yet, in October 1827, for the first time in ten years, Constable took a long holiday at Flatford. He had obviously spoken of Suffolk to his children, but they seemed to have missed the point. The eight-year-old Maria remarked, on passing over Stratford Bridge, and being told that they had arrived, 'O no, this is only feilds', something which so tickled her father that he repeated her remark.[25] To his wife he wrote the letters of a stranger in a familiar landscape:

Golding has bought . . . a sad tumble down place & very old—but I am perswading him to repair it . . . It is situate opposite the Windmill. I was over his woods with him. All goes on well . . .

Yesterday a wedding at Dedham, a Miss Bell & a Mr. Spink a horse surgeon—God knows who they are—but the bells rang all day Mr.

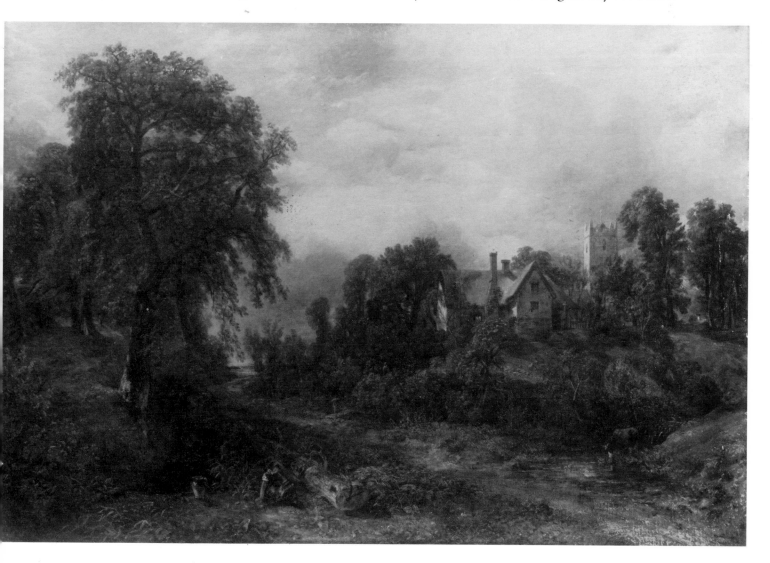

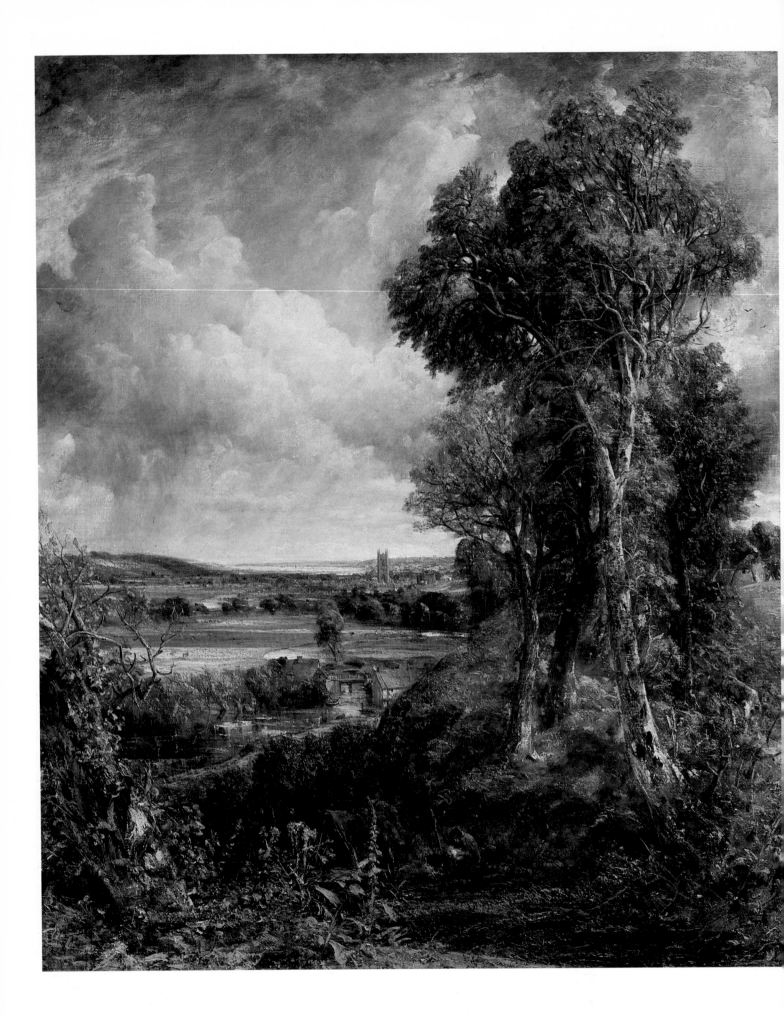

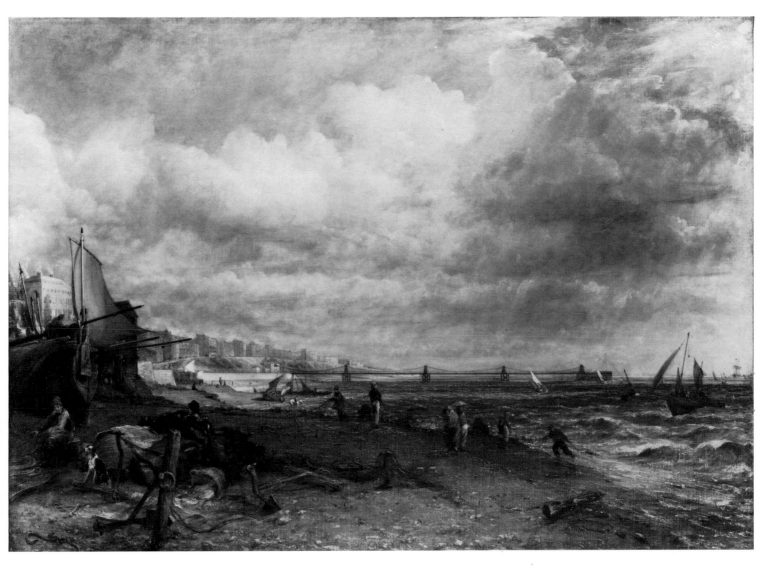

220. *The Chain Pier, Brighton* 1827
Oil on canvas 50 × 72 (127 × 183).
London, Tate Gallery

219 (facing page). *Dedham Vale* 1828
Oil on canvas 57⅛ × 48 (145 × 122).
Edinburgh, National Gallery of
Scotland

221. *The Marine Parade and Chain
Pier, Brighton c.* 1826–7 Pencil, with
pen additions 4⅜ × 16¾ (11.1 × 42.5).
London, Victoria and Albert
Museum (R.289)

Tuffnell's little meeting house has not answered, as it is to be sold. The pulpit
is bought by Harcourt Firmin for a dog kennell. Mr Tuffnell preaches now
cheifly in his boat.[26]

The short, data-packed sentences, betray the extent to which Constable had lost
touch with his native scenes. He no longer knew who people were. His mind was so
full of amusing gossip that it dashed from bit to bit. He wrote as someone
experiencing a long but confusing moment of *déjà vu*.

At Flatford, Constable made a number of drawings, using a large sketchbook
(Figs. 209, 222–5). In comparison with earlier work, however, these drawings
manifest stylistic uncertainty, fluctuation in the way Constable used the medium, and
rather less concern with reproducing the masses and tones of his subjects. Some are
competent and pleasing, like the fine pencil and watercolour *Water Lane, Stratford*
(Fig. 209), where pencil hatching combines with washes to recreate effects of broken

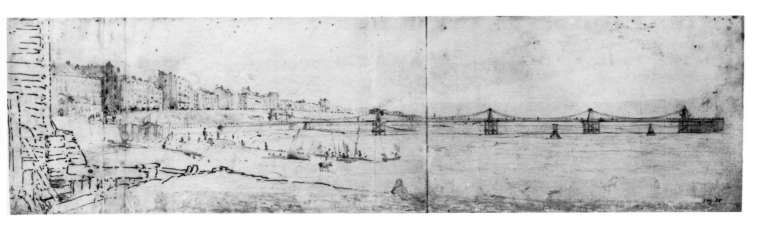

sunlight on a picturesque motif. Others reveal the appearance of such compositions before finishing: it looks almost as though Constable's hand was shaking while he drew *A Village Street* (Fig. 223), for the paper is scarred with broken marks and jagged lines. And rather than observed appearances dictating style, he resorted to schemata, outlining and then filling in the shapes of trees, with almost a sense of the pencil having moved involuntarily. Other drawings attempted a more disciplined portrayal of the motif. Yet, even though there is greater differentiation of, say, bridge timbers in the view of the dry dock and bridge at Flatford (Fig. 224), those systems of suggestive marks remain, in the grass by the edge of the dock, or in the twigs and foliage of the polled willows. It is worth contrasting these drawings with those of 1817 (Figs. 1, 137, 142–4, 264). Although the latter were not free of schemata, these had been subordinated to a fluent rendering of the appearances of actual landscape: suggesting that in 1827 Constable had more complicated a relation with nature.

Problems in avoiding expressionism seem to have occurred in particular around Flatford. The drawing done either in 1825 or 1826 for *The Chain Pier Brighton* (Fig. 221) was controlled and precise, objective in comparison with these. Likewise, some of the 1829 Wiltshire drawings (Fig. 227) recall in their care and attempt at precision the earlier Stour Valley work, rather than these 1827 drawings. And in the same way as, while painting *The Leaping Horse*, Constable's Brighton sketches were formally similar to the kind of Stour Valley work the canal scenes opposed, this contrast highlights the extent to which the East Anglian landscapes now formed a concern unique in the artist's range. It indicates the necessity to formulate an approach exclusive to them, and which will possibly not apply to landscapes of other places. The manufacture of *The Chain Pier, Brighton* was far more straightforward a process than the depiction of these 1827 East Anglian landscapes.

Once, in a drawing of the dry dock at Flatford (Fig. 224), Constable repeated a motif earlier important, for this in *A View on the Stour near Dedham*, drawn on the site. There are telling reminiscences of the earlier work: the low viewpoint, or the behatted woman; although we may speculate whether Constable drew someone who was actually present, or whether she was included because she was essential to the composition. And did the barge feature because this conception *required* a barge, or because it was passing by at the time? It is impossible to know how far memory was dictating Constable's perception, but it is undeniable that it did, so that what we see amalgamates observation and preconception, with a style that is jerky, perhaps because observation of place, and the intellectually-derived idea of the picturesque, were irreconcilable.

Sometimes Constable found it hard to get anything down at all. There is a drawing of two children on a barge,[27] where there are both startling shifts of scale, and almost a failure to confront reality. Throughout these drawings there is a feeling of ambivalence towards these motifs, the raw material of the post-1821 canal scenes. There was little of their energy or vividness. Certain drawings are bad, others show ambiguous motifs. Studies of polled willows (Fig. 222) appear to record trees of direct significance for such canal landscapes as *The Leaping Horse*. These paintings had emerged as creations of Constable, working in the environment of the studio: great landscapes, but with increasingly little direct relation with place. In 1827 Constable seems to have been most at ease in subjects unrelated to previous work, subjects he could come to completely fresh.

This apparent artistic conflict between the past and the present could suit his sense of confusion around East Bergholt. The church bells rang, but Constable had no idea for whom. He saw his brothers and sisters inhabiting a world natural to them, but strange to him. Yet in 1828 Constable did paint for the Royal Academy a subject which might have been inspired by this visit. This was a superb and grand version of a scene which had occupied him throughout his Suffolk days, from the Hurlock

222. *A Polled Willow* 1827 Pencil $8\frac{7}{8} \times 13$ (22.4 × 33.1). Inscr. 'Flatford Meadows Oct 13 1827.' London, Victoria and Albert Museum (R.294)

186

223. *A Village Street* 1827 Pencil
$8\frac{7}{8} \times 13$ (22.4 × 33.1). London,
Victoria and Albert Museum (R.299)

224. *A View on the Stour at Flatford*
1827 Pencil $8\frac{11}{16} \times 12\frac{13}{16}$ (22.1 × 32.9).
Inscr. 'Flatford Octr 5 1827'. Dublin,
National Gallery of Ireland

225. *A Barge on the Stour* 1827 Pencil
and grey sepia wash $8\frac{7}{8} \times 13$
(22.4 × 33.1). London, Victoria and
Albert Museum (R.298)

226. J. M. W. Turner *Crossing the Brook* 1815 Oil on canvas 76 × 65 (193 × 165). London, Tate Gallery

watercolour (Fig. 20), through the 1802 oil study (Fig. 31) and onwards (Figs. 61–3, 65, 71, 72, 228), *Dedham Vale* (Figs. 219, 213, 214).

The painting relies heavily on that early essay in the 'natural painture'. But it increases the picturesque through being in a style closer to that of *The Leaping Horse* than Constable had risked for a few years. It would be attractive to have this canvas completing a development begun with that 1802 study, and closing this part of his career with elegance and symmetry. Yet, although after 1822 Constable's East Anglian landscapes did sink increasingly into being just one part of his artistic output, he continued to paint them, and deliberate interconnections between the variants of this composition are hard to prove.

In June 1828 Constable briefly mentioned *Dedham Vale* to Fisher as 'a large upright landscape (perhaps my best)':[28] he repeated news of the annual improvement in his work almost as a litany. This is in fact one of Constable's greatest paintings. Picturesque, both in its riposte to Turner's tribute to *Hagar* (Fig. 29) in *Crossing the Brook* (Fig. 226), and through its reference to Claude (and perhaps commemorating Sir George Beaumont—who had died in 1827—in a way analogous to *The Glebe Farm* and Bishop Fisher) it is far more than a source-hunter's dream. We do not know the detailed history of the painting.[29] Constable of course was completely familiar with this view, and had plenty of reference material to hand, but it seems he relied mostly on the 1802 study (Fig. 31), altering the foreground a little so that a wrecked tree stump developed on the left-hand side, while the lighting of the terrain seems to have been adapted from a later oil sketch (Fig. 65).

Constable composed so that the eye looks down to the river and bridge, before reaching the distance. The bridge is probably so prominent as a reference to *Crossing the Brook*, a relation further emphasised through the placing of figures, and the opening of a subsidiary perspective to one side. This artifice was probably to satisfy his public that Constable was fit to be an R.A. A popular objection to his pictures was that they lacked subject, in contrast to Etty, who produced pornography, called it History Painting, and therefore made himself a fit Academician. By referring to Turner, and through him to Claude, Constable had applied another dose of eye-salve, to counter prejudices normally expressed against his work.

227. *Old Sarum* 1829 Pencil 9$\frac{1}{16}$ × 13$\frac{1}{16}$ (23 × 33.2). Inscr. 'Evening July 20 1829'. Victoria Art Gallery, City of Bath

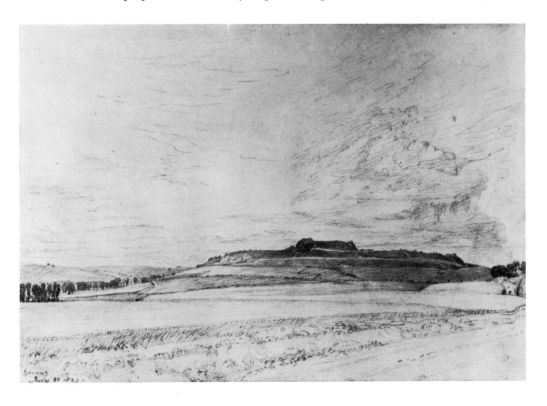

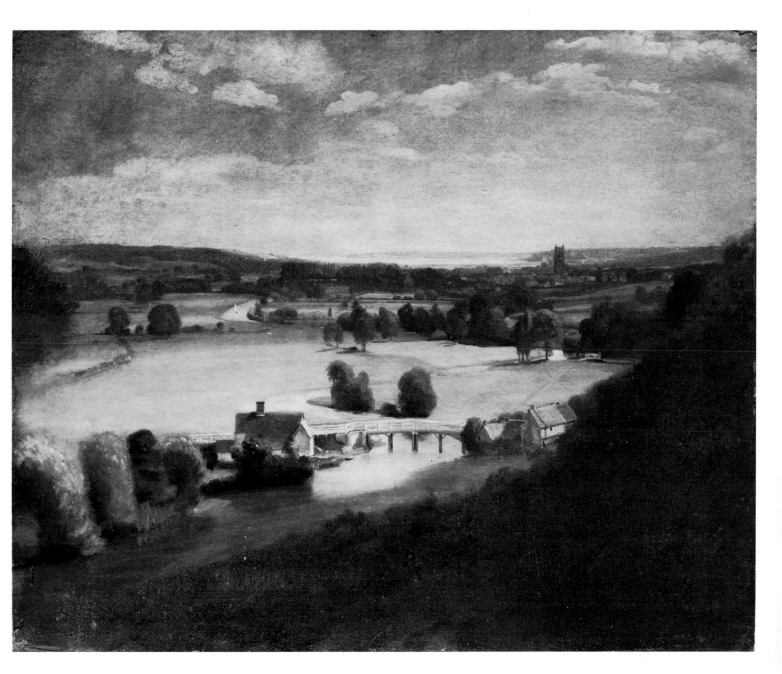

228. *Dedham from Langham c.* 1805? Oil on paper laid on canvas 19⅝ × 23¾ (49.8 × 60). London, Victoria and Albert Museum (R.63)

Having disciplined the composition, however, Constable indulged in greater freedoms in other ways, particularly stylistic. While he defined the bridge and its surrounds with care, noticeable areas of representational ambiguity were also created. In the foreground, or in the distance about Dedham, the laboriously built-up paint surface creates its own logic of ridges and furrows, over which further paint has been dragged. Its traces have been left so randomly as to tell against representation. And, as with some earlier works, we find 'fugitive images', by which term I mean those areas of paint which resolve themselves into images only if the spectator wills them to do so. The artist has appeared to balance his need to paint abstractly with the requirement of making some concession to the observable world. This is very apparent with that cow trapped in the undergrowth a little way up on the right. While interpreting that paint as a cow, it is equally patches of white among others, which, blending with the paint surface, lose representational distinctness. The palette, furthermore, suggests a schematic application of colour. Water and sky were shown white, grey, and blue, foliage dark green, and meadows, yellow. The familiar trails of white are noticeable here and there, but now this job was also being done by yellow. Consequently an independent colouristic unity

emphasises the abstracted qualities of the picture, and also the tension between these and the efforts at representation.

Constable did not state what he intended with this picture. We may guess at a continuing concern with lightness, breezes, and freshness, which had been important before 1828, and continued to preoccupy him after then. He was probably still hoping to evoke abstracted sensations through pictorial suggestion, and in attempting this Constable had developed this emotively expressive style.

After the exhibition Constable entered a period of sanguine temper. His beloved *John Bull* noticed the picture, he wrote to Fisher, '*as a redeemer*'[30] although any praise from that source, which in 1827 had reacted to Turner's exhibits with jokes about cooks and curry,[31] was of dubious worth. Constable was also more cheerful because his father-in-law's death had benefited him by some £20,000, enough to secure the family finances for the foreseeable future. Things must at last have seemed promising. Then, on 23 November 1828, Maria Constable died from consumption. It is surprising that she had survived so long, for, constitutionally weak, she had, despite pleas to her husband,[32] been almost continually pregnant since marrying him. Her death shattered Constable. Afterwards he would wear nothing but mourning, and his mood tended more and more to the bitterly pessimistic. *Dedham Vale* earned him his R.A. (in February 1829), but Maria was not alive to share his triumph.

After this Constable's work developed variously: *Dedham Vale* was the last in that series of East Anglian landscapes begun in 1811 with *Dedham Vale, Morning*. Although their development had been steady until 1821, after 1822 we have seen to how great an extent they had become an idiosyncratic and distinct line in Constable's *oeuvre*. Between 1822 and 1826 the canal scenes evolved in new directions. Topography and narrative incident ceased to have importance, style was no longer bent to a 'natural painture' in any representational way, but more in the sense of the paintings evoking the sensations associated with the experience of nature itself. Where the viewpoint had been high, commanding the landscape, it had now dropped, and with this went any psychological control over the painting's contents. From being comfortable in society Constable retreated into isolation, assumed the mantle of visionary, and felt plagued by patrons. The requirement that a spectator should make a verbal response to the canal scenes follows the way Constable himself wrote of their abstracted qualities: the very style insisted that the 'spectator's share' had become crucial. Without its being offered, Constable could have no conviction of the value of his work.

This shift was dramatic enough, and because of the irony of *The Cornfield* we can surmise that Constable had rejected the value of a georgic idea of place. By turning instead to an ostentatiously picturesque vehicle for his paintings of Stour Valley subjects—a conception, moreover, which he appears to have associated with a vanishing England, the world he had known—he might have been offering a sop to the connoisseurs. He was also denying the validity of the working landscapes he had so easily painted during the 1810s.

As these were the vision of a member of the rural professional class, artist or not, it seems likely that Constable's unique relation with East Bergholt and the Stour Valley may have had some bearing on the direction his painting took in the 1820s: in comparison with Stour Valley landscapes Constable's paintings and drawings of other terrains followed far less troubled a course. It might be helpful, then, to describe something of the background to the artistic departures and developments we have been detailing.

CHAPTER SEVEN
The Background to the 1820s

We have seen how Constable's East Anglian landscapes followed their own development, and we must ask why, over the winter of 1821-2, Constable underwent a period of crisis during which they changed drastically in type, before becoming picturesque with *The Cornfield* in 1826. It is easiest to propose reasons for these developments if we work backwards through the chronology. As Constable admitted, *The Cornfield* assumed the appearance it did because he wanted it to sell. Towards 1823 Constable had begun to hint at some tension between the artist and his public. Reading his letters to Fisher, a concern with pleasing his 'cruel and unrelenting master' was voiced often enough to rouse a suspicion that the fragility of the relationship between practitioner and purchaser was a constant, underlying worry. Furthermore, there are hints that we can begin to suspect some connection (in the artist's mind at any rate) between the demands of this public, and the opinions of the connoisseurs.

We can guess that the numbers of potential buyers of paintings had, by 1800 or so, increased to an extent that not only presupposed a developing interest in art, but also created a need for some intermediary, the critic, to inform them of the merits or otherwise of what painters had on offer. Some indication of the changing status of artists is shown, for instance, by the popularity of watercolour exhibitions in the 1800s,[1] or the way that Turner and Constable displayed their wares in specially fitted-up rooms.[2] A bad press could hurt sales. By the middle of the 1820s Constable was uttering the hoary complaint of the British artist against the blind adherence to and imitation of the example of the respected old masters. Because their works were tried and familiar, painters working in a recognisably similar manner allowed connoisseurs a standard against which they could judge these modern works. Consequently this could implicitly censure the modernity of such as Turner or Constable.

There is a possibility that Constable directed his anxiety at an unholy alliance of the public and the connoisseurs who ran the British Institution. When he complained in October 1822 that 'there will be no genuine painting in England in 30 years' this would be 'owing to "*pictures*"—driven into the empty heads of the junior artists by their *owners*—the Governors of the Institution &c. &c.'.[3] He was almost frantic to have *Stratford Mill* represent him at an exhibition the latter had organised, for not only was there a striking contrast in appearance between this painting and his most recent work, but also there is some evidence that Sir George Beaumont at least liked it.[4] He sent it along with *The White Horse*, which was equally unexceptionable,

and which he had far less trouble extracting from Fisher. It is interesting that, although Beaumont had known Constable for years, he never patronised him, in striking contrast to his promotion of Wilkie. In the 1820s he employed Constable and Johnny Dunthorne mostly as picture-menders,[5] and in September 1825 Constable mentioned that Beaumont 'liked what I was about, but wanted me to imitate pictures'.[6] Even Leslie notes that the two were in basic disagreement about how painting should be conducted.[7] In addition to this there are Constable's remarks on Payne Knight and his Claude drawings in 1824.

Those who prefer the old masters are liable to be put out by paintings which are as experimental as Constable's canal scenes. The artist might have felt that pursuing this line brought small returns from the public, and that therefore he should bow to the inevitable and produce a picturesque landscape, one which could be compared with other paintings. It is arguable that subject, in terms either of terrain or incident, had become unimportant; that he found this change an easy one to effect. Part of the irony of *The Cornfield* lies in its virtual parody of Gainsborough at the expense of the connoisseurs, for Constable knew that Gainsborough's landscapes were as personal and as profound as his own. And this more conventional picturesque could allay disquiet about Constable's subjects, while continuing to allow him to experiment with the abstracted preoccupations evolving since 1822. One can only speculate over the degree to which the opinions of the connoisseurs of the British Institution affected the failure or success of contemporary painters; or even whether it operated a veto over certain kinds of painting, for the information is not available. Nevertheless, their distaste for Turner and the 'white' painters is well known, and David Brown has shown the extent to which Callcott was damaged by British Institution disapproval in the 1810s.[8]

We can call Constable's shift to the picturesque partly the result of his compromising with public taste, but no straightforward explanation can be given for the crisis in his East Anglian landscapes in 1822. And one cannot stress too much how drastic a change was occurring at this time, for Constable's East Anglian landscape altered in practically every respect. In the 1810s his style had been concerned with recreating the appearances of nature in a particular place. There was a strong element of 'realism'—extending from a concern with describing topography to documenting agricultural events. Constable became increasingly concerned about working if not on, at least near to the motif. He habitually used a high viewpoint to survey his scenes in which an element of georgic narrative (itself to be defined partly through knowing the habits of thought of the rural professional class, partly through the poetry Constable read) was crucial in imparting social, political, and artistic value to the paintings. Constable worked easily and quickly, and was in general in agreement with his patrons.

After 1822, to be at work in the studio came to be of prime importance: thus the large canvases were produced at some removes from nature. Painting itself became a compulsive and emotional activity. Rather than agree with his patrons, Constable found them an encumbrance, so personal were his paintings to himself. His style soon ceased to have much to do with a naturalism of appearance, which was abandoned for a naturalism of sensation, consequently becoming far more abstracted in character. It followed that elements like topographical verisimilitude or agricultural narrative were no longer important in Constable's conception. The low viewpoint gave the spectator none of the command over landscape that the high one had done, and consequently allowed it to become threatening through lack of control. We have to rely on Constable himself for clues to his intentions, otherwise simply to enjoy his painting. Constable developed an idea of the artist as creative intelligence revealing truths about the world to a generally unappreciative audience.

If we hope to account for this sudden shift, we have to consider extra-artistic

factors for the simple reason that an account of Constable's stylistic development must fail to explain the crisis of 1822. It might be argued that, as one would expect, Constable was moving away from his concern with East Anglian landscape anyway. In 1821 he had intended to exhibit an *Opening of Waterloo Bridge*, but Farington suggested *The Hay Wain*. Yet, after this, it was, at least superficially, the East Anglian landscape to which Constable stayed loyal. And, after removing to London, and enjoying the '5 happiest & most interesting years of my life',[9] Constable persisted in painting East Anglian landscapes in the old way. Neither did his experience in painting from nature at Hampstead seem to affect the canal scenes. Therefore, although there are reasons for thinking it likely that, in the 1820s, Constable might have been changing direction anyway, they are hardly enough to account for the break. And, as this was in paintings of a region with which Constable had deep personal and emotional ties, a 'happy country', in which he had been able to enjoy 'endless beauties', paintings of which followed a development independent of that exhibited by other works, then we have to look elsewhere if we are to account for it.

One clue is provided if what is essentially a negative factor is taken into account. As Constable himself admitted, after 1822 subject was of no importance to him, and what the paintings of this time are not is georgic. Yet, before then Constable had presented the modern agricultural landscape as being vitally so, as being a *topos* where the ploughman was as crucial a factor in explaining its beauty as the farmer in deciding to extract that beauty from the essentially intractable material of nature. *The Cornfield* actually denied the practicality of such a way of seeing. Indeed, if Constable's picturesque was connected to ideas of a vanishing England, and thus had a nostalgic element, the picturesque landscape of 1826 onward took a farewell of an East Anglia in which Constable's earlier values might never have mattered at all.

The rejection of subject was of prime importance in this sudden change in direction in Constable's East Anglian landscape, and several things need to be borne in mind in attempting to account for this. One is that it appears to be true that georgic landscape was a fragile species of British painting anyway. Turner produced compositions analogous to those Constable painted before 1821, until *Frosty Morning* of 1813 (Fig. 83). He then abandoned this kind of landscape, and when wishing to impart value to his compositions resorted either to allegory, as in *Dido building*

231. J. M. W. Turner *The Decline of the Carthaginian Empire* 1817 Oil on canvas 67 × 94 (170 × 238.5). London, Tate Gallery

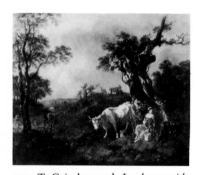

232. T. Gainsborough *Landscape with a Woodcutter and Milkmaid* 1755 Oil on canvas 43¾ × 51 (108.6 × 129.5). Woburn Abbey, the Duke of Bedford

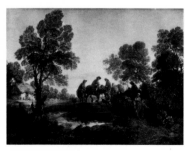

233. T. Gainsborough *Peasants going to Market c.* 1769–70 Oil on canvas 47 × 57½ (119.4 × 146). Kenwood, Iveagh Bequest

Carthage (Fig. 230) and *The Decline of the Carthaginian Empire* (Fig. 231),[10] or to the picturesque, exemplified in *Crossing the Brook* (Fig. 226).

Gainsborough's landscape had undergone a parallel development. During his Suffolk days they had presented as easy a georgic as, in his own way, Constable was to do sixty years on. The 1755 *Landscape with a Woodcutter and Milkmaid* (Fig. 232) sites its subject in front of a view of Ipswich. The lad in the middle distance plods behind his plough, separated by the fence from the two yokels, who, as so often with Gainsborough, enjoy their rustic dalliance. We see two areas, one where work goes on, and one where it has occasional remittance. It may be that the latter is common land—that is, ground belonging to the poor—in contradistinction to the fenced part.[11] The artist passes no comment on the relative desirability of either, but implies a view of rural life where the independent peasantry, and a subservient wage-labouring class, coexist. In these landscapes everything is in its place.

After Gainsborough went to Bath, in 1759, this harmonious vision of landscape (along with any concern for topography) disappeared, while his style rapidly became mannered. His landscapes betrayed an instant response to the terrain, by appearing hillier and more wooded, but within a very few years, his figures had ceased to exist so easily within the environment he painted for them. Images of migration began to preponderate (Fig. 233): there was little pleasing dalliance. By the late 1760s, Gainsborough's figures had become dislocated, and were always travelling. There appears to be in this at least a parallel to Goldsmith's response to contemporary events in *The Deserted Village* (1770) where he wrote of a *nouveau-riche* landlord upsetting a fine social balance, and enforcing the migration of a village's inhabitants:

> Even now, methinks, as pondering here I stand,
> I see the rural virtues leave the land.[12]

In Bath Ralph Allen had diverted the rural economy to stone quarrying, with, presumably, a correspondent disruption of agriculture. Gainsborough, seeing the poor going to and returning from work, may have found himself responding like Goldsmith, and the painting of a constantly moving poor may have been his response to the introduction of a capitalistically rationalised economy.

In Suffolk Gainsborough always showed his rustics as individuals, rather than as conventional clowns. This implies at least a readiness to consider them as people, and reports from his Bath days evidence a real sympathy for the poor.[13] It is significant that, despite his exclamations of being sick of portraits and wishing to retire to some sweet village, Gainsborough nevertheless stayed well within the urban or metropolitan environment. He knew that country life had its harrowing aspects, as we can see from those late 'Fancy Pictures' (Figs. 217, 234), where he so neatly inverted the relationship between figures and landscape. The 1787 *Wood Gatherers* (Fig. 234) presents a cruel image of mute and motherless urchins gathering twigs to scratch a living. The contemporary critic Sir Henry Bate Dudley saw it differently, however. He wrote that the painting contains 'a rustic history that cannot fail to impart delight to every beholder', and that 'these charming little objects . . . cannot be viewed without sensations of tenderness and pleasure, and an interest in their humble fate'.[14] There was no need to ask what society it was which allowed its children to become such 'charming little objects', for, as Bate later wrote, 'the law of man is composed for the equal distribution of rights, and the impartial preservation of them'.[15] It was unavoidable that a gulf should open between rich and poor, but as these children so clearly had learned habits of industry, then so was it in their own power to better their lot.

Yet Gainsborough's imagery suggests a different view. The 'Fancy Pictures' were portraits of models whom the artist paid, not invented figures. Moreover, the facial

234. T. Gainsborough *The Woodgatherers* 1787 Oil on canvas 57½ × 46½ (146 × 118.1). New York, Metropolitan Museum

differentiation in these portraits of the poor, compared with the pasty masks he turned out for money, makes one suspect some sympathy with them. Gainsborough's peasantry moved from being comfortably at home in a Suffolk where they and everything else had a place, to being lost in a strange region. It is clear from the contradiction between Bate's and my analyses of the *Wood Gatherers* that the way an image is seen depends on who sees it, and that Bate was able to view these figures with a complacent sympathy. The way that historical circumstances affect ways of seeing will be seen to be particularly important in relation to Constable. Gainsborough's development was contemporary with a literary move away from georgic poetry, which, before around 1770 had been an acceptable and popular vehicle for describing the contemporary British countryside. Because of its insistence on the value of the mundane, turning life directly into art, I have suggested that the incompatibility of the Bath countryside with this myth inspired the change in Gainsborough's landscapes. And because georgic poems always do have this purportedly documentary character, the way they are or are not used reveals a great deal of the attitudes of individuals to circumstances.

It has been convincingly argued that the Britain which was emerging under the impetus of capitalist agricultural economics was not one which could easily accommodate the georgic.[16] It did not totally lose its viability: John Scott published his *Amoeban Eclogues* in 1782, but a poem like Goldsmith's *The Deserted Village*, with its sentimental radicalism,[17] in part at least commemorated the demise of a rural society akin to that which Gainsborough had portrayed around Ipswich. In *The Village* (1783) George Crabbe evolved a more rational and hard-headed kind of writing. The poem argued powerfully and brilliantly against the myth Goldsmith had defined, denying the possibility of a rural life which allowed pleasure to all. Like Goldsmith, Crabbe was for the rich realising their obligations to the poor, but to improve their lot, not return it to a condition from which they had allowed it to decline through their neglect. In this way, then, he could use landscape description as a metaphor for the bad government exercised over a community—

> Lo! where the heath, with withering brake grown o'er,
> Lends the light turf that warms the neighbouring poor;
> From thence a length of burning sand appears,
> Where the thin harvest waves its wither'd ears; (I. 63–66)

Crabbe only admitted his openly political intentions in the line where, by rhetorically enquiring the whereabouts of the swains, who

> . . . daily labour done,
> With rural games play'd down the setting sun;
> Who struck with matchless force the bounding ball,
> Or made the pond'rous quoit obliquely fall; (I.93–6)

he referred to that passage early in *The Deserted Village*, where '. . . all the village train from labour free / Led up their sports beneath the spreading tree'.[18] However, Goldsmith's games were played over a holiday, which Crabbe could not countenance, letting us know that they are right and proper only after the daily grind is over.

But when he explained that even this had vanished, because the poor had all taken to smuggling, he admitted too his credence in a 'hard' philosophy, one changed subtly in tone from Thomson's 'happy labour'. There was a new sense of the necessity of regulation, so that the well-governed poor might play, but only when not at work. Their resorting to smuggling testifies to their masters' dereliction of duty. Crabbe admitted to some humane feeling,[19] and wished there to be time for leisure.

He berated the bad landowner for neglecting his own interest, and in his apostrophe to Manners[20] revealed not only how the georgic may be achieved, but also that *The Village* is another poem on the use of riches. These poor are the same that theorists had begun to write about in the 1780s, the ones whom Ruggles felt should be educated to a degree fit for their station. What liberty they had was granted them, and was not theirs by right.

One of the best social histories of the period 1795–1835 has given this summary of the changes in country life:

> What happened between say 1750 and 1850 was . . . that a rural society which was in some senses traditional, hierarchical, paternalist, and in many respects resistant to the full logic of the market, was transformed under the impetus of the extraordinary agricultural boom (and the subsequent, though temporary recessions) into one in which the cash-nexus prevailed, at least between farmer and labourer. The worker was simultaneously proletarianised—by the loss of land, by the transformation of his contract and in other ways—and deprived of those modest customary rights as a man (though a subordinate one) to which he felt himself to have a claim.[21]

Encouraged by the price inflation and huge profits of the Napoleonic Wars, the relation between master and man became a wage one. And the increase in mechanisation meant that the amount of manual labour actually necessary on the farm declined, at the same time as there came the realisation that it was more economic only to employ men when they were needed.

The nature of the change in relationship between employers and employed was succinctly described in 1824 by Anthony Collett, Rector of Heveningham in Suffolk, in *A Letter to Thomas Sherlock Gooch Esq., M.P.*

> The present system of relieving in money, without providing labour, has produced a lamentable series of evil consequences. It has broken the bond of union which formerly existed between the labourer and his employer, who both, within a period to which my memory extends, considered their interests as one and the same. The husbandman then worked for years, perhaps for life, on the same farm. He was considered as part of the establishment; rejoiced in his master's prosperity, and sympathised with him in misfortune. These mutual feelings no longer exist. The labourer is now, in general, the mere servant of the day, or of the season; and is cast off, when the task is done, to seek a precarious subsistence from other work, if he can find it; if not from the parish rates. It has most rapidly effected the total demoralisation of the lower orders . . .[22]

Here a contemporary analysed his own society in terms which accord with the judgements of modern historians. Collett showed an astonishing accuracy of judgement. Even when Arthur Young doubted, in a famous passage, whether wholesale enclosure was entirely a good thing for rural society, his argument was not that the move towards enclosing should be halted, but rather that while it continued some heed should be taken of the interests of the poor, for it was sensible policy to avoid as far as possible creating any disaffection.[23] Collett saw and understood what had happened. He even suggested that men should be kept on in times of depression, because in the long run this would be cheaper.[24]

We might consequently wonder, if this was the true state of affairs, how an artist like Constable could produce georgic landscapes at all, reality being so unaccommodating to that way of seeing. The problem can be answered if two things are taken into account. As Bate Dudley's description of *The Wood Gatherers* showed, contemporaries could see things very differently to present-day historians,

and we are all selective in what we choose to notice. Secondly, Constable's attitude was partly that of the agriculturist. And one can argue that during the period of the Napoleonic Wars, conditions prevailed which encouraged so confident an iconography of landscape.

Just two couplets from Thomas Batchelor's *Village Scenes* of 1804 reveal how strong the belief in traditional ideals still was:

> Sweet village! loveliest of the rural plain,
> Abode of Love and Virtue's seraph train,
> Where, crown'd with olives Peace serenely smiles
> Each labour lightens, and each care beguiles. (163–7)

That first line identifies this village as an Auburn preserved. Batchelor was easy with the clichés; as another of his publications was *A General View of the Agriculture of the County of Bedfordshire* (1808) for the Board of Agriculture, this was probably because of his close involvement with the farming interest. It was among these people that the Constables moved, and it appears clear that men like Golding Constable, while never being activists, had an identity of interest with this group. Indeed we may begin to tie in those references to agriculturists, their ideas, and their aesthetics, made elsewhere in this text.[25]

The lines below are from *Cultivation*, a poem dedicated to Sir John Sinclair, President of the Board of Agriculture, in 1797. The poetry requires no commentary.

> Lo! From the desert springs the golden grain;
> Thick ranks of corn o'erspread the barren plain,
> The swains who late survey'd a joyless waste,
> With grateful raptures their new harvest taste.
> The hoary cottager delights to hear
> The jocund ploughboy whistling in his ear.[26]

The evidence of such sentiments as these, or indeed the iconography of Constable's post-1810 landscapes, is that so apparently reactionary an optimism came naturally to the farming community. We shall see that it was shared by other painters during the Napoleonic Wars, and I shall discuss how the inflation of corn prices, and the full employment associated with this over *c.* 1800–15, presented a bustling countryside, which would have easily allowed this georgic interpretation, although there were tensions implicit in making it. I should like to begin by explaining how this happened, and why, for example, Crabbe should have come to write in terms of the most desirable behaviour being submission to regulation.

Arthur Young and others claimed benevolent motives in their writing, but their chief interest was the increase of agricultural efficiency to the benefit of the farmer's pocket. A key factor in improving farming was the relationship with the labouring poor. We have already quoted Billingsley as having been little bothered with their welfare. But individuals like Thomas Ruggles would sometimes advise readers to be 'steady friends to the poor', encouraging them to work hard, rewarding the extra-industrious ones, and educating them to a degree appropriate to their status. It is noteworthy that Ruggles expressed these sentiments in an essay on aesthetics, ostensibly dealing with the beauties of the cultivated landscape. It realised that workmen were important to the formation of that landscape, and should therefore get good treatment.

A fascinating thing about much of the agriculturists' sociological theorising was its lack of any sense of these ideas having consequences. Ruggles, in another essay, would advocate the prohibition of gleaning.[27] He argued that the custom was not founded in right, and had a tendency to encourage the poor to rely on charity, as well as fuelling their inclinations to theft: therefore, as gleaning countered the

honesty and industry so desirable in the poor, it was better that it should be stopped. If asked to whom the poor could then turn in need, Ruggles would have pointed out the sense of obligation he wished to see amongst farmers, and which, elsewhere, he himself described in these terms: '. . . there is a tacit contract between men when societies, states, and kingdoms are in their infancy; that to him whose only patrimony is his strength, and ability to labour, that patrimony should be equal to his comfortable existence in society . . .'[28]

Ruggles had obviously not taken into consideration both the fact that the poor regarded gleaning as a right and that its abolition would be a socially destructive act. Better farming, where all the corn went into the barn, would benefit all through greater profits allowing higher wages. He was assuming that farmers and labourers shared the same materialistic outlook. Opposition to Ruggles's views on the gleaning question was soon expressed: 'The spirit of *Christianity* favours it, as it favours the diffusion of all social good, and cherishes a community of interest—a fraternal equality . . .'[29] These however were the sentiments of Capel Lloft, a notorious radical (and incidentally the person who saw *The Farmer's Boy* into print). His were not the views of the majority of the farming interest.

Ruggles and others saw no reason for doubting the justice of their theorising, and were convinced, too, that as their ideas must tend to the increase of material wealth, then so would they enhance the social good. The occasional failure of the poor to comply with these desirable norms was attributable to their boorish stupidity: 'it appears to be a truth plainly proved, that the wretched situation of the poor, and the expense of their maintenance, are, in a great degree, increased, if not occasioned, by their laziness, their want of œconomy, their habitual fondness of strong liquors, and . . . apathy',[30] wrote Ruggles in 1793. Two years on, Arthur Young, in a paper occasioned by bread riots (wheat having almost doubled in price) mused that 'while the poor will be blind enough to oppose inclosures, let them complain of dear provisions'.[31]

By the 1790s the French Revolution and its consequences were concentrating the minds of the theorists wonderfully.[32] The Reverend William Clubbe of Brandeston in Suffolk signed his 1793 *A Few Words to the Labourers of Great Britain* as 'A Yeoman', although it is ironic that his audience was largely illiterate. Clubbe's panic at thoughts of Revolution in England was not disguised:

> One of the greatest Blessings enjoyed under the present Constitution of this Country, is security in our Liberties and Property. Observe then how *equally* the poor are protected in these with the rich, and of course, how *equally* interested in the preservation of them . . . This equal protection of rich and poor, and the equal Justice of the Laws . . . are only to be found in the *English* Constitution . . .[33]

Clubbe was serious. He went on to argue that destitution was not the lot of the honest, the sober, or the industrious, and that, were 'The Levellers' to triumph, then the labouring classes would lose everything, and 'soon sink into a State of Society, not to be preferred to that of SAVAGES'.[34] Clubbe's wonderful sophistry reveals just how much self-interest motivated all those apparently benevolent instructions to the poor. He also shows that the voices of conservative opinion seldom expressed themselves with the sophistication of a Burke.

However, along with reports of burnings of Tom Paine's effigy, writing like this reveals the extent and depth of the concern that events in France had engendered. Indeed, in one such report of effigy-burning[35] we read that the poor of Layham in Suffolk were rewarded for their reassuring performance with 'an ox . . . roasted whole, together with a sufficient quantity of bread, and a hogshead of strong beer'. Yet in general it was felt that the moral fibre of the poor was insufficient to allow them

to drink even in moderation. Arthur Young contrasted parishes with and without ale-houses in terms of

> . . . industry, of moral conduct, sobriety, attendance of divine service; above all in point of family comfort, and eventually of population; and as a consequence of the whole, in point of habitual contentment, submission, and attachment to the government under which they live . . . multiplied ale-houses are multiplied temptations . . .[36]

The poor, gathered together without supervision, might not only get drunk, but also become exposed to Jacobin propaganda.[37] Here there was an intriguing double standard. William Marshall reported that reapers in the Midlands had at least a gallon of beer per day,[38] and in Gloucestershire he was amazed at the capacity for cider of both masters and men.[39] Many farmworkers must have spent some of their working day in a state of mild stupefaction, but this was no departure from sobriety, as it was under the control of their masters.

The extent to which writers like Young were concerned with the poor's propensity to anti-social behaviour suggests not only that they were felt to present a threat, but also that there was an unarticulated awareness that they might not themselves see quite how much they were benefitting under the economic rationalisation of agriculture. Hence there was a necessity for regulation, but this was for the good of all, for its value was self-evident in improved agriculture.

An awareness of this kind of thinking can help us understand Stubbs's farming scenes (Figs. 126, 167), where the uncanny cleanliness of the workers has a little bothered recent commentators.[40] These paintings, produced from 1784 on, have a standard format. The figures are arranged in a frieze, occasionally with a wagon being piled high. With the various *Haymakers* there is usually a pert nymph, hand on hip, who gazes directly out of the picture. It has been suggested that this puts us in the same position occupied by the mounted farmer in the reaping scenes, permitting us an extra engagement with the subject.[41]

Although the landscapes are painted with Stubbs's typical precision, there is nothing to indicate a specific location, although that precision suggests (as with so much of his work) some model. And there is a virtual sense of unreality in the way the various actions of agriculture have been represented. For the sake of clarity, Stubbs tidies up the confusion normal to haymaking and harvest. His figures are viewed from a relatively low viewpoint, and therefore dominate the landscape. The whole could be called georgic; but this was very different to Gainsborough's version, where work was something you either took or left. Stubbs only gives his labourers leave to cease their toil when they are being addressed by their master. This supports the suggestion that in the *Haymaking* it is we who assume the position of mounted overseer.

We have to approve of the scene, as if we shared the views of the late eighteenth century farming interest. There is no impression that labour is arduous. It makes performers neither dirty nor sweaty. In the *Haymaking* one man has remained so cool that he has kept on his waistcoat. And the labourers are strikingly well-dressed. However, as Neil McKendrick has shown, their clothing is what contemporary farmworkers would have worn, and Stubbs has documented their attire. The image is gratifying to the onlooker in general as much as to the mounted man in the *Reapers*. These scenes reflect well on the farming interest; for these well-clad, sober, and industrious labourers are getting on with their work with a remarkable degree of complaisance. The image is one of which Ruggles or other members of the farming interest would have approved.

Stubbs's horse-portraits are enough to remind us of his close contact with the

landed gentry. And here it is salient that in the print *Ye Gen'rous Britons Venerate the Plough* (Fig. 88), dedicated to the Board of Agriculture, the labourer in the foreground has an expression of sober gravity, and is dressed as well as any of Stubbs's figures. The farming interest took pleasure in the sight of neat cleanliness. The contemporaneity of these paintings with the first volumes of Young's *Annals of Agriculture* and Crabbe's *Village* might even point to their serving as pictorial exemplars of that same rationalistic view of farming and improvement.

Indeed, around 1800 it would have been easy to see the picture as a true one. The peculiar conditions created by the Napoleonic blockade, combined with continuing high corn prices, induced many farmers to cultivate land which, without inflated returns, would not have repaid the expense.[42] The intensity of farming at this period can be seen for instance when Constable's *View of Dedham* (Fig. 103) is compared with a recent photograph of that landscape (Fig. 94). In 1814 there were far fewer trees than today, the river was navigable, and a significantly greater extent of the landscape was put down to cultivation. Mrs Constable reflected this boom in reporting on her brother and the Hertfordshire farmer (see above, p. 11).

Agricultural landscape in general enjoyed something of a revival in the 1790s.[43] It appears that one reason for this was closely tied in with the national paranoia induced by the French Revolution and War. Farming scenes, with all their implications of peace and plenty, presented a comforting sight: they portrayed the Happy Britannia which invasion, or popular revolution would have destroyed. And, after hostilities had broken out with France, attention was focused even more closely on native scenes and their virtues. Exhibition statistics point up the interrelation between such paintings and current events.

In 1791, such paintings had comprised 1.48 per cent of all subjects exhibited at the Royal Academy. After Paine, and the dramatic turn of events in France, the percentage in 1792 rose to 4.23. In 1802, only 0.81 per cent of works shown were either agricultural or rustic. In 1803 this rose to 2.43 per cent, the Peace of Amiens having intervened. Throughout the 1800s and early 1810s, the percentage hovered between 2 and 3.5, dropping significantly only in 1818.

The paintings revealed something of ruling-class ideology, if only because they were aimed at customers from that class, and not at the labourers who comprised their subjects. Interestingly, the mediocre artist William Redmore Bigg, exhibitor in 1794 of *The Husbandman's Enjoyment* or, in 1800, of *The Harvestman's Farewell* (and the perpetrator of many similar works), was elected R.A. suspiciously quickly, almost as a mark of official approval for the maudlin cottage scenes in which he specialised. The Napoleonic Wars saw an increase in rustic subjects at the main London exhibitions. Their quality was not always of the highest. Something like Wheatley's 1790 *Ploughmen* (Fig. 90) presents the subject as a genre-piece out of Stubbs, and Bigg's pictures are proto-Victorian in their sentimentality. However, in turning to agricultural subjects around 1814, Constable's paintings did relate to those of other landscapists, as well as, in a general sense, to those of genre painters.

This was not only with respect to subject-matter. In general the war kept artists at home, and encouraged them to study, and consequently aggrandise native scenes in their exhibition pictures. The important exhibition *A Decade of English Naturalism* (*1810–20*) conclusively demonstrated that while we may choose to concentrate on Constable or Turner, other artists also painted superb oil sketches. Linnell's work in oil or watercolour was recognisably produced with an intention like theirs, and shows an earnest attempt to lay down paint with a regard for the visual facts of the subject (Fig. 235). In *Kensington Gravel Pits* (Fig. 236), he realised his naturalistic study in terms of a working scene stylistically close to the pragmatic realism achieved by Constable around 1814.

We noted above that 1815 saw the completion of some distinguished harvest

235. J. Linnell *Paddington* 1811 Watercolour 4⅛ × 5¾ (10.5 × 14.6). Prof. Lawrence Gowing

236. J. Linnell *Kensington Gravel Pit* 1811/12 Oil on canvas 28 × 42 (71.1 × 106.7). London, Tate Gallery

237. G. Morland *The Ale-House Door*
1792 Oil on canvas 13¾ × 10¾
(35 × 27). London, Tate Gallery

scenes, particularly those by De Wint and Lewis (Figs. 129, 127). Style and conception equated with Constable's contemporary vision of the Stour Valley, and at just this period he was painting his own various harvest scenes. Was this coincidence, or was it indicative of a common response to circumstances? If the latter, it could be that picturing harvest, the archetype of the peace and plenty at which the georgic aimed, was a response to what had seemed Napoleon's final defeat in 1814. It was premature, but the idea that art can respond to history is lent some weight by Wilkie's subsequent celebration of Waterloo, *Chelsea Pensioners reading the Gazette.*

Although artists provided reassurance that in Britain the workforce used its scythes to cut corn rather than aristocratic throats, rustic genre and agricultural landscape both remained fragile ways of seeing. This emerges in the contemporary critical response to George Morland, which has been well chronicled by John Barrell.[44] Unlike Bigg, who as a painter was equally interesting, but as an individual rather less so, Morland's life was (we are told) of such spectacular and degenerate profligacy as to make instantly saleable matter for a spate of posthumous biographies.[45] Mostly these were sanctimonious about Morland's life-style, and there was a general sense of offence that, given the chance to make money and rise socially, Morland had preferred a life of drunkenness and squalor. Yet, the biographers had to acknowledge that he was a born painter, and, in Dawe's words, they had to allow him 'considerable merit for truth and simplicity of character in the objects which he represents . . . he is free from the affectation of a refinement which he does not possess'.[46] Where Morland taxed his commentators' critical liberality was in the presentation of his subjects.

As these were generally rustic genre pieces, the discomfort they could create infers that such paintings proliferated after 1790 precisely because of the *reassurance* they afforded the ruling class. Something of this is transmitted by Collins's remark on *The Ale-House Door* (Fig. 237). He described the composition as 'A group of English figures regaling themselves, which, like true sons of liberty, they seem determined on in spite of all opposition.'[47] The key correlation here is 'English figures' with 'true sons of liberty'. Only this allowed the subject acceptability. The peculiar merit of the British Constitution in this view was that it promoted liberty irrespective of class, and therefore one could not, in theory, reasonably advocate that the labourer be denied this liberty, even if he ended up in the ale-house. Collins could accept the composition only because these were English figures. Had they been Irish, or, worse, French, he would have considered the picture dangerously subversive.

Collins's comments reveal the deceptiveness of the apparently bland sentimentality of these rustic scenes. Labourers at their lunch were 'so boorish as to regard not the dumb eloquence of a poor dog, who is begging a share in vain'.[48] In the *Return from Market* the 'girls in the cart are rather too brazen for rural nymphs'.[49] His first statement confirms that in Collins's eyes the labourer was a type of lower humanity, the second that rural should mean innocent, that girls from the country were never 'brazen'.

This reaction demonstrates how, by the 1800s, there were both acceptable and unacceptable ways of portraying rustic subjects. Consequently, it was always possible that the observable reality of country life might not accommodate itself to a georgic way of seeing. Certainly, very few artists persisted in this vision of landscape. Turner's final agricultural scene, *Frosty Morning* (Fig. 83), exhibited in 1813, hardly marked the mid-point of his career. After then his painting took new directions. Perhaps, as a town dweller, Turner had been enchanted with the Thames below Oxford, until he came to feel that reality could not accept the interpretation he had imposed on it. I have suggested that this ideology had to adapt to the fact its subject might deny it, and it was possibly this which inspired Turner's alternative renderings of the British landscape. The tension in the relation between myth and reality could,

however, be ignored via a studious selection of what was seen, and this is an aspect of Constable's work I should like now to discuss.

It might begin to appear surprising that Constable managed to present the Stour Valley in this way at all. However, as we can show in various ways, he was completely unaware of a conflict between reality and his interpretation of it; something revealed, for instance, by the way he seems to have read *The Farmer's Boy*. While in certain respects Bloomfield's poem provided reassurance on the survival and continuing relevance of the old ways and ideas, in others it was a critique of modern agricultural developments. Constable appears to have read the poem as the local farmer would have, and to have found it a Suffolk rendering of tried and trusted georgic sentiments. The farmer whom Giles toiled, was described as:

> Serv'd from affection, for his worth rever'd;
> A happy Offspring blest his plenteous board,
> His fields were fruitful and his barns well stor'd,
> Unceasing industry he kept in view;
> And he never lack'd a job for Giles to do. (*Spring* 50–2, 55–6)

This was a farmer of whom the reader is intended to approve. He was playing the rôle society allotted him. He had laudable qualities, being revered for his worth and inspiring affection, and so, it would seem, the myth was sustained. This was a descendant of the yeomen who had run the farms which fed Thomson's Happy Britannia.

Yet, at times, Bloomfield's diction could jar the platitudinous tenor of his writing. A case occurs with the very couplet Constable chose in 1814 to accompany his *Ploughing Scene*:

> But, unassisted through each toilsome day,
> With smiling brow the Plowman cleaves his way.

Although, on the face of it, a conventional image, the pictorial equivalent would actually be one of Millet's labourers, rather than one of Constable's. Bloomfield made no secret of agricultural work being backbreaking: this ploughman has no help and is therefore kept daily in a solitary condition. That he might not enjoy this emerges through Bloomfield's slightly quirky 'smiling brow', for this translates literally as furrowed brow, a forehead which has become creased with toil, perhaps in ironic allusion to the work having the same effect on both field and ploughman. Now this could be a combination of literary ineptness and a desire to make a witty rhyme within the line, but I think not. 'Smiling brow' supports only too well the sense of the words 'unassisted' and 'toilsome', but it does not do this in any way blatantly. Such are the pleasing associations of 'smiling' particularly in the context of describing the particular labourer, the sort of person who had been 'happy' in Thomson's hayfields, that there is a sense in which it disguises the meaning of that couplet, and in so doing establishes an element of ambiguity.

Neither is the context of the other couplet—

> No rake takes here what Heaven to all bestows—
> Children of want, for you the bounty flows!

—the one Constable chose from Bloomfield for his *Harvest Field; Reapers, Gleaners*, without its problematic aspect. As we saw, Constable took naturally to such sentiments, for they expressed the usual response to the sight of harvest's end. Yet, in this section of the poem Bloomfield went on to show real disquiet. Having described reaping, and the sights and sounds typical to the season, he concluded on what ought to have been a high note—

> The bustling day and jovial night must come,
> The long accustom'd feast of HARVEST-HOME. (*Summer* 289–90)

This 'long-accustom'd' tradition reveals that, in the country, things do not change. The annual round involves the same worries, the same obligations, and the same rewards. The poet was keen to press the traditional character of this feast, the one Constable's uncle had been laying on for his own men. Bloomfield stressed the social consequences of all this:

> Here once a year Distinction low'rs its crest,
> The master, servant, and the merry guest,
> Are equal all . . . (*Summer* 322–4)

In terms of the tradition in which Bloomfield appeared to write, this was all conventional enough; but, calculating his effect, Bloomfield then dropped a bombshell:

> Such were the days, . . . of days long past I sing,
> When Pride gave place to mirth without a sting;
> Ere tyrant customs strength sufficient bore
> To violate the feelings of the poor;
> To leave them distanc'd in the mad'ning race,
> Where'er Refinement shows its hated face:
> Nor causeless hated;—'tis the peasant's curse,
> That hourly makes his wretched station worse;
> Destroys life's intercourse; the social plan
> That rank to rank cements, as man to man: (*Summer* 333–42)

This entire passage is a fascinating contemporary response to agrarian capitalism. Bloomfield cursed wealth as the chief cause of social disruption, and wrote of the pauperisation of the peasant, who might once have contemplated a small farm, but was now condemned to labour. This is fine writing, although Bloomfield rather defuses it later in the passage, blaming the misuse of wealth on fashion, and implying that farmers sensitive to the needs of the poor would soon rectify matters, making it all sound a little like the complaint Arthur Young made about small farmers living above their station and displaying unnecessary ostentation.[50]

The lament also lost force by acknowledging the context (defined in *The Deserted Village*) of how the misuse of wealth created social discord. And I would imagine that these factors could help a reader like Constable not to find the passage radical. He shared that same conservative distrust of fashion, for example. But despite it all, Bloomfield did state that the cash nexus had broken up a long-standing and harmonious rural social system.

His protest may have referred specifically to a move among forward-thinking agriculturists to do away with harvest-home altogether. Around 1805 Young wrote that he now gave men cash 'in lieu of earnest, dinner, gloves, and *hawky*, or harvest-home supper'.[51] So blithe a rationalisation of tradition betrayed a fatal ignorance of the sentiments of the working man. And it was Bloomfield, who had a real streak of reactionary sentimentality, who published in his *Wild Flowers* (1809) a dialect ballad, *The Horkey*, about the Suffolk harvest-home, in the preamble to which he wrote that 'These customs, I believe, are going fast out of use; which is one great reason for me trying to tell the rising race of mankind that such were the the customs when I was a boy.'[52]

Capitalistic rationalisation had subtly changed the relation between masters and men. It made more economic sense to pay cash in lieu of various customs because it both saved valuable time, and made keeping the books that much easier. It also

promoted a social distancing, which the poor resented, and of which their masters were not aware. To the farming interest, greater efficiency must benefit all.

Constable's Stour Valley landscapes, done on the site during the years that this relation with the poor was changing, reveal no awareness of any tension in country life. Yet the apparent conflict between image and reality suggests one or two questions. How did Constable conceive and maintain his idea of place? Why did he keep it beyond Bergholt, and as late as 1821? Why was its rejection so sudden? And how much did his unique ties with place affect his conception of it?

The modern historian might suggest that the reality of the labourers' lot was summarised by Bloomfield's pithy 'smiling brow'. But Constable was hardly concerned individually with the figures which peopled his landscapes. His detachment even comes over in the systems of composition which he used. Stubbs's low viewpoint forces our concentration on the genre motif, distinct from the landscape it occupies. Constable, with that almost ostentatious high viewpoint, incorporated his human subjects as integral to the landscape, with the same importance as a tree or cloud, cohering within and contributing to the aesthetic and intellectual complex of the completed painting.

Amongst agriculturists there was sometimes even a sense in which, although the farmworker was important, his work was as nothing to the intellectual effort of the farmer who directed the labour. The unavoidable Arthur Young exhibited some revealing habits of speech in his essay *On the Pleasures of Agriculture*. Amongst these pleasures were the sight of 'every object budding into life at the genial summons of returning spring; while all the colours of nature glow with a lustre excited by the efforts of his industry', or to 'assist with incessant attention the progress of vegetation towards the maturity of harvest'.[53] This was the farmer as creative artist. To write of 'his industry', or 'to assist . . . the progress of vegetation' suggests that the work of the farmhand was taken for granted, and suborned to the more abstracted 'industry' of his master: precisely Constable's outlook.

In village life there is still today, and has always been a social and cultural gulf between the lower, and middle and upper classes. The letters which have been preserved show that things were no different with the Constables. When a John Stollery was 'got into' Ipswich gaol by squire Godfrey this was for stealing a pig, valued at £1. 5s,[54] and in 1812 he was sentenced to seven years' transportation.[55] When Mrs Constable had written that her husband thought that Stollery was 'no doubt linked in with a very notorious set—perhaps John Goodrich among the number'[56] she may have meant the same John Goodrich who paid £4 per annum rent to Golding in 1800,[57] and therefore, probably, an employee (Joe Cook, who definitely was,[58] also paid Golding rent). We may suspect that there existed in the minds of the Constable family that same distrust towards the motives of the poor as was expressed by contemporary writers. That John Goodrich might be linked in with so notorious a member of the undeserving poor as Stollery shows again the necessity of regulation to keep them from going wrong. Then, as now, there was a variable degree of alienation between the labouring classes and their employers.

Conservative opinion felt that, as the laws protected all, then so it was right that such as Stollery be removed from circulation, not stopping to consider why his family poached and he stole pigs. As long as the poor lived with due propriety, families like the Constables carried out their side of Ruggles's 'tacit contract' by employing and housing members of the labouring classes, and by performing charitable and paternal acts. For instance, in 1814 Golding gave generously to a dinner for the East Bergholt poor, and in 1822 the surviving members of the family contributed to a find for the 'distressed and starving Irish'.[59] So deeply was this habit of charity ingrained in John that he continued to relieve selected individuals at Bergholt, and had carried out charitable acts the day he died.

Lucas retails Golding's paternalism.[60] He was 'kind and considerate with his servants', and, on his deathbed, his clerk was unable to recall an instance of his having 'dealt unfairly or taken advantage of the necessities of the poor, the widow or the fatherless'. He would not have distressed his dying master by saying otherwise; nonetheless the anecdote demonstrates the real obligation such individuals felt towards those less fortunate than themselves, and with such reassurances about their own behaviour, the rural professional classes could ignore the developing realities of country society.

When in late 1814 or early 1815 the Ipswich brewer John Cobbold, expanding the family mansion, invoked his legal right as Lord of the manor to appropriate soil from a causeway on the property of a Robert Small, the latter considered that he had been robbed, and expressed his reaction in a letter to *The Ipswich Journal*[61] and in a vitriolic broadside.[62] He saw Cobbold's action as one of 'tyranny and usurpation', placing it in a larger context, thus:

> . . . the lower orders of the people are, in the altered and novel situation of this
> country, presented only with the gloomy prospect of being, for their long
> tried unshaken loyalty, and ardent zeal in the common cause of the civilised
> world, speedily reduced, by a restless force of absolute authority, to a wretched
> state of subjugation to the ruling powers . . .[63]

Small's diatribe continued as a powerful statement of radical disaffection. And yet his attacks seem to have missed their target. The Cobbolds did not reply, and there was no indication for example from their friends the Constables that they had been told of this minor eruption, although his mother had told John of Mrs Cobbold's providential survival after pitching head-first into a shop cellar.[64]

Attacks like these were probably considered to be beneath notice, spiteful effusions rather than the expression of a genuine and therefore dangerous political radicalism. In the depression of the later 1810s the political uncertainty of the next decade was finding only sporadic expression, and Abram Constable must have been one amongst many to have considered the hard times the farming interest began to experience as the unavoidable counterpart to the boom they had been enjoying hitherto. When, in 1815, in an early expression of that unrest which was to become endemic, a mob attacked Sir William Rowley's house at Stoke by Nayland, Abram Constable's diagnosis was that 'these are awkward times, I hope they will mend'.[65] Riotous assemblies were no novelty, and experience told that they tended to quieten down. If a depression was to come, then everyone had to tighten their belts and suffer together, rich and poor alike, as Abram Constable's letters, written as the post-1815 depression took a grip, reveal.

In February 1817 he reported on the early spring: 'We have most uncommon fine weather for the season, we look like April, more than February—it is fortunate for the poor people that their labours are not interrupted.'[66] Good weather allowed work on the fields to proceed. Had it been otherwise, the poor would have been on the parish. Abram did not question this, partly because he, too, had been hard put on by the post-war depression. He accepted it philosophically: '. . . lets hope patience will bring a good year. Till then beleive me I will not *lavish* my money in unnecessary expenses . . .'[67] As the hard times continued, he maintained this attitude. 'My father had sad times to contend with, in early life, he got through & so may I', he wrote in January 1821,[68] adding that the advantage of living off the beaten track down at Flatford was that beggars gave them no trouble. He could not see the depression as anything but temporary. Collett wrote about the demise of paternalism and the destruction of traditional rural social structures in 1824; but neither Abram nor John showed any awareness of this.

The latter's pre-1822 landscape revealed an exceptionally sanguine view of East

238. 1813 sketchbook Pencil
3½ × 4¾ (8.9 × 12). London, Victoria
and Albert Museum (R.121) p. 69 *A
threshing machine* (d. 28 Sepr.); *St.
Mary-on-the-Wall, Colchester* (d. 29
Septr.)

Bergholt, perhaps encouraged by his choosing to find the village a 'safe and calm retreat'. However, his paintings did show a concern with and understanding of what went on in the countryside, while his iconography reflected the values of the farming interest. This is powerfully imparted by Constable's capacity to depict particular images unconscious of their substantial political charge.

Two such examples are a drawing in the 1813 sketchbook (Fig. 238) and the oil sketch, *Spring Ploughing* (Fig. 240). The drawing features a horse-powered threshing machine. It shows how early such machinery was established around East Bergholt, and evidences Constable's continuing concern with agricultural machinery of all kinds. In the agrarian disturbances of 1816, 1822, and 1830, threshing machines, a major cause of winter unemployment, were a favourite target for destruction.[69] The threshing machine was partly symbolic of that agricultural capitalism which had so painfully disrupted rural society: but not for Constable. He was not insensitive; it was merely that the class to which he belonged saw it as just another implement, like a plough, and useful because it reduced the need for labour, and, consequently, wages.

That brilliant sketch *Spring Ploughing* (Fig. 240), painted in April 1821,[70] records the ploughing of the recently-enclosed East Bergholt common. The Hammonds' assertion that, more than anything else, enclosure of common land pauperised the rural poor is now debated; but the process undeniably had a damaging aspect, for once common land became fields it was taken from the landless who had been able to graze animals on it or gather fuel from it. That passage from Young cited above encourages the view that enclosure of commons could hurt the rural poor.

Constable, however, was unaware of this. He found the enclosure itself an occasion in which the poor took no part:

> . . . our Common . . . is now being divided, besides many exchanges which are
> now taking place. I hope all will end amicably, but where so many interests
> are brought together, some may peradventure clash. We have little to do with
> it, though I have an allotment about the size of this room which I shall give to
> my brother Golding . . . Some amongst us have shown such extreme
> greediness and rapacity to 'lay feild to feild' as to make themselves obnoxious.
> That thank God is not our case, so that if poverty has its discomfortures it also
> has its comforts.[71]

Thus in 1816 Constable managed both to condemn the greediness of some in terms learned from the bible ('lay field to field' is from Isaiah 5:8) and to have imagined himself afflicted with poverty. He was detached from the process of enclosure, but would not have thought to question the rightness of its taking place. *Spring Ploughing* was painted five years on, probably from drawings done on the site, and its very contemporaneity with *The Hay Wain* suggests that the latter still embodied the essence of Constable's relation with his native scenes. On his rare visits he reacted to East Anglia with pleasure:[72] and because he maintained his idea of place until 1821 the change both in this and his idea of landscape, which occurred while he was painting the versions of *A View on the Stour near Dedham* come increasingly to appear both sudden and fundamental.

While at work on this painting Constable would have been made aware how incongruous his portrayal of a georgic Stour Valley had become. He had been cushioned from the grimmer side of post-war Bergholt life simply by being in London, and was, as he said, wonderfully happy there. Yet, in the 1820s, even Constable might have noticed the depression entering, particularly in East Anglia, a new and worrying phase. As late as 1817 it had seemed, as Abram Constable himself thought, that the hard times would be weathered. Mileson Edgar, Commander of the Suffolk Yeomanry Cavalry, had that February proclaimed that 'no county

preserved more real patriotism than did the County of Suffolk, nor was there any part of the country where the invaluable blessings of our glorious and happy constitution were more duly appreciated'.[73]

A warning knell of the changing mood of the times was, however, sounded in 1820, when Ipswich went Whig. It had fallen to a party which in the view of the Tory *Ipswich Journal* aimed at 'the subversion of all the most sacred institutions of our hitherto most happy country'.[74] This was the period when the scandal of the Queen was at its height. For *John Bull* she was a radical leader,[75] for Constable, the 'Royal Strumpet', and a 'rallying point . . . for all evil-minded persons'. To make things worse, Abram was to report that Revans, their old and trusted steward, was 'quite a Queen's Man'.[76]

By now all was clearly not well. Already in 1820 isolated instances of arson had occurred in Suffolk: an outhouse and clover stack at Boyton were burned on 9 October, and a barn at Nettlestead Hall on Christmas Day. Further incidents were recorded through 1821.[77] By January 1822 they had begun to appear part of a larger movement of social unrest both in Suffolk (where arson was rife) and Southern Norfolk (which predominantly experienced riotous assembly and machine-breaking) (Fig. 239). On 29 December 1821 a barn and stacks had been fired at Buxhall; on 3 January 1822 there was a stack fire at St Mary Stoke, Ipswich, and on the 8th a mill at Ramsey near Harwich was robbed and fired. Between the 5th and 12th a gang destroyed harness at Erwarton Hall, and there was another fire at Buxhall, in which village two stacks of corn, the property of a clergyman, were burned on the 21st, while at Gislingham the same night there was a fire, forecast in a threatening letter.

These January incidents, involving arson, threatening letters, and the destruction of cart harness, covered the range of expression of rural protest, but were as nothing compared with what was to happen. Over the twenty-eight days of February there were at least twenty-two incidents. Threatening letters proliferated; the troubles had spread into Southern Norfolk, and gatherings of labourers were beginning to play an important rôle. On the 16th two hundred men assembled at Diss, and the Riot Act was read to them; on the 25th mobs at Eye and Occold in Suffolk dragged threshing machines into the street, but left them undamaged, repeating their performance the following day. On the 28th the Reverend Mr Betham of Stonham had a stack fired, and on 7 March was to find his cow-crib, cow-house, and stable in flames. On 4 March more than a hundred marched to Attleburgh, destroying twelve threshing machines, the Laxfield mob wrecking a further seven. The following day saw a riotous assembly at Hoo Green (between Woodbridge and Yarmouth), and that evening the Suffolk Yeomanry Cavalry were to march to Diss, to relieve the Eye troop to go to Harling, where further trouble had been threatened. En route they confronted an estimated six hundred rioters at Buckenham, seizing twenty, and committing seven to Norwich Gaol. On the 6th the local troops disbanded as the 16th Lancers marched from Romford to Diss.

Riotous activity consequently died down, although arson continued rife, and, from time to time, machines were destroyed. On 10 April labourers did assemble and wreck a machine at Wootton, and by the 20th the same had happened at Wrentham and Badingham. After April, however, the disturbances had spent their force, and there were only isolated incidents until July, when on the 1st a threshing machine was destroyed at Botesdale, and on the 5th a riotous assembly wrecking another (where is not stated), with the same happening to a further one at Beddingfield on the 7th. This was the labourers' way of suggesting the nature of their disapproval should the farmers think of using machines rather than muscle to thresh the harvest which was about to be gathered in.

The sources suggest that these disturbances were no insignificant expression of

Incendiarism recorded at that place.

Incendiarism recorded in that neighbourhood.

Machine-breaking, or destruction of property.

Riotous Assembly.

Riotous Assembly & machine-breaking.

Threatening letter found.

NORWICH

NORFOLK

DISS

EYE

BURY
ST. EDMUNDS

STONHAMS

SUFFOLK

SUDBURY

IPSWICH

COLCHESTER

ESSEX

239. Map of East Anglia showing incidence of agrarian disturbances, December 1821–July 1822 (drawn by Séverine Roberts)

popular disaffection, and there are grounds for suspecting that while an impressive number of incidents is recorded, others are not. Some occurred around East Bergholt in mid-April, when there was 'never a night without seeing fires near or at a distance'.[78] None of these is mentioned in newspapers or the Home Office Correspondence, although nightly fires imply a good quantity of stacks at least turning to ash. It seems probable that documentary sources give a good but incomplete idea of the disturbances' extent.

An anonymous letter of late March[79] was forwarded to Peel. It makes interesting reading. Complaining of profiteering, particularly amongst brewers, it suggested that its recipient, Francis Seekamp, imagine

. . . an honest man ploding on in the vocation he is placed in earning barely

208

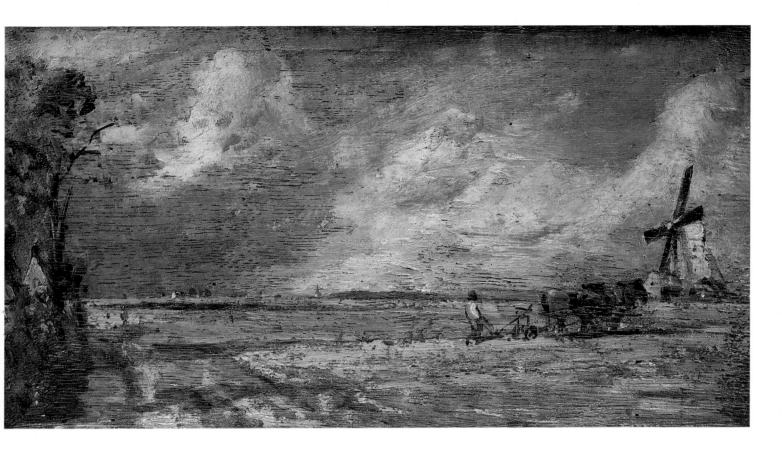

240. *Spring Ploughing* 1821 Oil on panel 7½ × 14½ (19 × 36.2). London, Victoria and Albert Museum (R.122)

sufficient to maintain his family and cloathing them in prosperous times—what must be the case you think now, when Parish *Rates* rise [?] so high . . . Turn over what Act of Parliament you please and see if it was whether it was ever the intention of the legislative body to *rate* or *tax* a man situated as above, one who is within six days of Pauperism himself . . . What is the consequence think you? Why are they now men fit for the darkest purposes . . . the Evil is to come . . . our numbers are great and are men capable of doing upon the Plan we act upon as wonders without discovery—more *Fires* shall be witnessed . . .

It was signed by the 'Secret Avenger'. Although this cousin of Swing threatened actions that needed little organisation to achieve such letters must have had at least a temporarily chilling effect on their recipients. And the sending in of the troops suggests that the disturbances were taken with a proper seriousness.

On 20 April a County meeting, with the Duke of Grafton (the Lord Lieutenant) in the chair, was called at Stowmarket, to discuss ways of dealing with the riots. It occupied itself with loudly condemning the diabolical and atrocious acts which had been perpetrated. There were many who not only agreed with this, but saw them in a more politically threatening light.

The *Colchester Gazette* in a long report of 16 March remarked that 'the farming labourers of Suffolk, in particular, have hitherto been most excellent in their general demeanour' (which means that Constable had not been alone in failing to notice any latent discontent). This made the current outrages even more shocking; and the paper thought, furthermore, that they were the 'result of something like organisation and pre-concert'. This theme was taken up by a Caroline Barrett, in a letter to Robert Peel of 27 March: '. . . I wished to point out to you verbatim, Sir, that the very same methods adopted by the French, previously to the Revolution to bring that Country to Republicanism, are carrying on here with unabated vigour and spirit . . .'[80] Her shocking equation with France had been made by others.

A riotous assembly was terrifying in itself. Samuel Quilter, an ultra-right wing agriculturist, sent Peel on 31 March 'An Account of the Outrages recently

committed about Ipswich'.[81] Included in the acts of 'insubordination and outrage' described were these:

> At Lavenham Fire (Black Lion) the Constables were compell'd to drive the populace away to make room for those who would assist in supressing it . . . Great rejoicing was expressed at Mr Byles fire of stack and outbuildings on Thursday last at Ipswich . . .
>
> . . . regular watchmen are kept throughout the night upon several farms . . . Surely such acts as these forbodes the most disastrous consequences for the Empire . . .
>
> These among the many desperate acts and fires in the Counties of Norfolk and Suffolk so properly alluded[?] to by the learned judge in his charge to the Grand Juries as nearly approaching open revolution appear to me of the highest consideration with His Majesty's Government . . .

'Open revolution' interpreted events blackly, and measured Quilter's judgement of their gravity. It must constantly be borne in mind that to him revolution would mean something like what had happened in France, something bloody, in which it was not the proletariat which stood to lose its land. The poor had begun to express their resentment towards landowners who, in the name of rational economics, had turned them into a class which stood to *lose* if there was a good harvest.

Many reacted seriously to the disturbances. The normally placid Mileson Edgar saw in them the acts of 'Men who wish to throw this country into Confusion, at least the plans are theirs'.[82] Gooch the M.P. wrote to Peel 'I believe all the mischief to proceed from great bodies of unemployed poor . . . they are *perhaps* urged on to these diabolical acts by *political* incendiaries';[83] a theme taken up by the *Ipswich Journal* on 6 April:

> Fires are kindled in all directions, individuals are denounced . . . in a spirit of bold and systematic defiance of authority . . . Incendiary outrage is the almost necessary consequence of inflaming the passions and demoralising the habits of the poor . . . we feel much better warranted in imputing these dreadful effects to those who regardless of their revolutionary tendency would hazard *experiments to alter*, than to those who wishing to preserve the distinction between right and wrong and to remove the blessings of our laws and religion to their posterity, conscientiously *uphold* the present system of Government.

The continuation of the disturbances from January to May must have made these months uncomfortable for those most under threat: farmers, millers, and the like. Furthermore, the 1822 disturbances were not the customary bread riots, and had a different character to previous upsurges, one precedented in 1816; for they constituted a form of social protest for those too inarticulate otherwise to get a hearing.

Between January and April 1822 Constable was, in stops and starts, painting *A View on the Stour near Dedham*, creating eventually a landscape intermediary between the ideas to which he had still been faithful in 1821, and those which were to find their full expression in 1824. He certainly knew how bad things were in Suffolk. He was reading *John Bull*,[84] which reported the disturbances, at times in detail,[85] and he must have become starkly aware of the fundamental change which had taken place in country society.

There is evidence that Constable was upset by these disturbances. For instance he did not write to John Fisher, which, besides meaning that he was busy painting, could also indicate a state of psychological upset.[86] Indeed, he may have been seeking refuge in creation, for it was after *A View on the Stour* had gone to exhibition that he felt as if he had lost his arms. After Fisher had enquired in a letter of 25 March

'what is doing in Suffolk: and whether these riotous proceedings are to be dreaded',[87] Constable did not reply until 13 April.[88]

> My brother is uncomfortable about the state of things in Suffolk. They are as bad as Ireland—'never a night without seeing fires near or at a distance'. The *Rector* and his brother the *Squire* (Rowley & Godfrey) have foresaken the village—no abatement of tithes or rents—four of Sir William Rush's tenants distrained next parish—these things are ill timed.[88]

Constable blamed the collapse largely on the leaders of East Bergholt society, censuring the rector and squire for not dropping their tithes and rents, and for leaving the village. They had betrayed a trust. They had not exercised, as was their duty, firm government over unruly elements, and the result could be anarchy. Besides this social breakdown, Constable catalogued the fires seen nightly from Bergholt.

All this must have affected one who considered the village 'a safe and calm retreat'. Abram's letter, which Constable quoted, no longer exists, and it is possible that he destroyed it as he was asked to do with other upsetting letters from Abram[89] (and as he probably did with Maria Bicknell's outraged reply to his unenthusiastic response to the prospect of marriage).

By the 1820s Constable's politics had moved far to the right. We have noted his sentiments towards whigs and radicals. In 1813 he had been 'anxious for a sight' of Lord Byron, but when the poet died in 1824, the world was 'well rid' of him. His one recorded opinion on the labouring mass, offered in 1825, is self-explanatory:

> . . . almost every mechanick—whether master or man—is a rebel and blackguard—dissatisfied—in proportion to his abilities—he is only made respectable by being kept in solitude and worked for himself or by one master—whom he has always served—but directly he is *congregated* with his brethren his evil dispositions are fanned and ready to burst into flame—with any plan for the injury of the great—that may be ripe—this—this—remember I know these people well—having seen so many of them at my father's . . .[90]

Constable identified the enemy: the one which in 1822 had denied all he found valuable in the East Anglian landscape and the society it supported.

The ultra-tory response to the 1822 disturbances was expressed by Samuel Quilter (see above, pp. 209–10) for whom Abram Constable was to be instrumental in arranging both a subscription for silver plate and a presentation dinner in 1829.[91] Constable would have seen in such disturbances the portents of revolutionary disorder, and a disruption of a society and constitution which had once been perfect. Yet he had still been interpreting the appearance of the East Anglian landscape in the old way in 1821: *Spring Ploughing* documented the appearance of the terrain and the society it supported, the iconography showing the subject to have significant value.

If this ploughman then burnt ricks and destroyed machines, so complacent a vision could no longer be credible; and one of the salient features of Constable's art in the 1820s is that motifs, like barges, which had earlier been tokens of complex cultural value, ceased to function in this way. The harmonious and mutually benefitting interaction between subject and landscape had been destroyed, and , as we have seen, in most important respects Constable's Stour Valley came to deny what had gone before. There was no attempt at a naturalism of appearance in *The Leaping Horse*, yet there was such a naturalism in contemporary Brighton oil sketches and the contrast emphasises that the lack of any emotional tie with a place could be instrumental in affecting Constable's capacity to portray it.

The very closeness of his concern with the appearances of the East Anglian landscape had confirmed the value he placed on the deeper and more complex entity

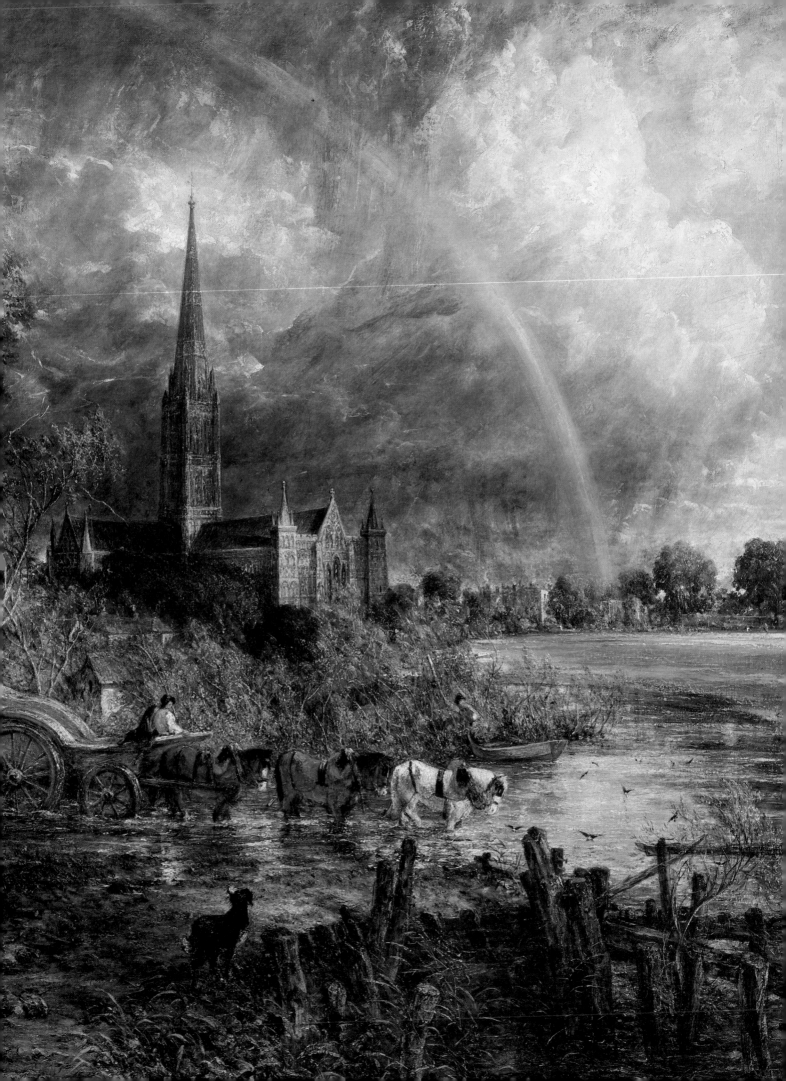

they mirrored. The increasing tendency to avoid this terrain in reality, but instead to remould it during intense sessions in the studio, suggests at least what Constable's account of the events of the early 1820s had demonstrated, that his earlier, reassuring view of 'Britannia' could no longer be tenable. And if that was shattered, then so too was the possibility of that view being made manifest through the appearances of nature. Reynolds had provided the method for attaining a natural painture, and had also argued for the social necessity of art providing moral exemplars. He wished this to be the province of history painting, but Constable had instead invested the Stour Valley landscape with all the seriousness with which he found so lacking in this genre. If the content became incredible, then it is arguable that the formal vocabulary through which this was transmitted (one which depended on a conservative and traditional aesthetic basis) also ceased to have credibility, and it was time to look for alternatives. Constable's pictorial experimentation may signify precisely this.

Indeed Constable would, in particular respects, have found the 1820s so bewildering a decade as increasingly to force him back on his own invention. In October 1822 John Fisher was perturbed at the turn the rural economy had taken:

> Nothing heard of here [Osmington, Dorset] but Farmers breaking & Sales . . .
> Yet the greatest plenty of provision of all sorts. In short a strange anomaly Ruin
> & prosperity walking hand in hand. Property will change hands: the present
> set of Farmers & Gentlemen will give place to a new race; large farms will be
> broken down into small ones; the little yeoman will appear again & things will
> go smooth once more . . .[92]

This was a world turned upside-down. The values in which men like Constable and Fisher believed seemed no longer to apply, and the former's pictorial experimentation of the 1820s may have been partly an attempt to create for himself an acceptable alternative: 'I have a kingdom of my own—both fertile & populous—my landscape and my children.'

The 'March of Mind' and advance of a new society would have appeared to Constable both unstoppable, and morally incomprehensible. From creating his own world, he went on to deny, in *The Cornfield*, any value to the old one. The picturesque he espoused between 1826 and 1828 could be associated with an East Anglia of his youth, for the nearest predecessors of these works are the 1802 oil studies. Yet *The Glebe Farm* was elegiac, and if *Parham's Mill* celebrated a picturesque to which there would soon be an end, then so picturesque a landscape as *Dedham Vale* was already retrospective, a landscape of memory. It was an historical but fictive vision in the same sense as were Claude's landscapes of the Golden Age. Constable was commemorating a world which had been lost and supplanted by an alternative he considered to be without value, something which will gain a particular charge when we come to discuss his 1831 *Salisbury Cathedral from the Meadows* (Fig. 255).

If his turn to a conventional picturesque had initially been at least in part a defiant gesture, a demonstration of what little meaning subject had for him, an awareness of this might account for Constable's stressing his concern with such intangible and unpaintable phenomena as breezes or freshness. Nevertheless, painting a world he no longer recognised was restricting and after Maria's death Constable's landscape achieved a considerable range in type and character. To an extent we can watch him making a retrospective critique of his *oeuvre*, while at the same time consciously seeking out new subjects.

CHAPTER EIGHT
The Last Years

After Maria's death, Constable came increasingly to feel a general sense of hopelessness, losing his conviction that his art was worth pursuing. Although it would be ingenuous to attribute Constable's depressed state during the 1830s to her death in 1828, it is, nevertheless, the case that his correspondence imparts an increased sense of Constable being a lonely and not very optimistic man.

Fisher apologised for not visiting, and suggested that he try painting: 'Some of the finest works of art have been the result of periods of distress'.[1] Early in 1829 Constable was to write 'my greivous wound only slumbers', continuing, 'could I get afloat on a canvas of six feet, I might have a chance of being carried away from myself'.[2] He had yet to try Fisher's therapy, although the phrasing, in particular the idea of 'getting afloat', points up how, in a real sense, painting could serve as an escapist activity. Despite the depression, in 1829 Constable pulled out all the stops, and sent *Hadleigh Castle* (Figs. 245, 247) to the Academy. 'I am greivously nervous about it—as I am still smarting under my election' he wrote to Leslie, adding 'I am in the height of agony about my crazy old walls of my Castle'.[3] Constable mentioned to Fisher that he had 'sent up the great Castle, such as it is'.[4] His nervousness must have been fueled by the degree to which the picture looked unfinished, together with his awareness that some thought him not worthy his R.A. Of the two versions of this composition, that in the Tate (Fig. 243) is as expressionistic as anything Constable had painted. Paint is savagely worked across the canvas, and is thickly impasted. In the painting shown at the Academy, things were subdued, and Constable shaped lumps of paint into plausible imitations of cows or cliffs, creating, in the sombre extent of his chiaroscuro, effects reminiscent of a Rembrandt—as, indeed, the composition recalls that of *The Mill*.[5]

Hadleigh Castle (which can seem a transformed *Hampstead Heath*) (Figs. 204, 242) is a tremendous exercise in the sublime. It is a painting charged with an obvious and foreboding intensity, onto which Constable projected the blackness of his own emotions at that time. It is hard to know why he should have picked Hadleigh in particular for this. He had visited the spot in 1814 and had then both made drawings (Fig. 244), and written to Maria about how impressive a site it was.[6] Perhaps he had come to associate her with Hadleigh, or had been re-reading their correspondence, and had been struck by that letter in particular.

Compared with earlier East Anglian work, this was a 'desert' to match Constable's despair. In the R.A. catalogue he quoted lines 165–70 from Thomson's *Summer*:

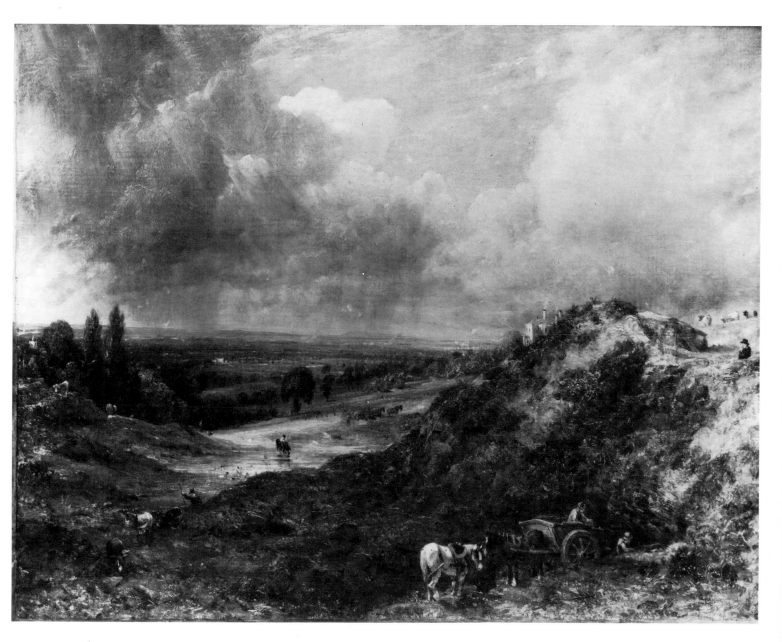

242. *Branch Hill Pond, Hampstead*
exh. 1828 Oil on canvas $23\frac{1}{2} \times 30\frac{1}{2}$
(59.6 × 77.6). London, Victoria and
Albert Museum (R.301)

> The desert joys
> Wildly, through all his melancholy bounds
> Rude ruins glitter; and the briny deep,
> Seen from some pointed promontory's top,
> Far to the dim horizon's utmost verge
> Restless reflects a floating gleam.

They have almost uncanny descriptive closeness to what the painting shows. This time, though, Constable had chosen his poetry more carefully than two years previously. They culminated a paean to the sun and its light,[7] and the verses immediately preceding Constable's tag root it firmly in this context.

> The very dead creation, from thy touch
> Assumes a mimic life. By thee refin'd,
> In brighter mazes the reluctent stream
> Plays o'er the mead. The precipice abrupt,
> Projecting horror on the blacken'd flood,
> Softens at thy return. The desert . . . (160–5)

This suggests that Hadleigh Castle is not only an exercise in the sublime, but also

215

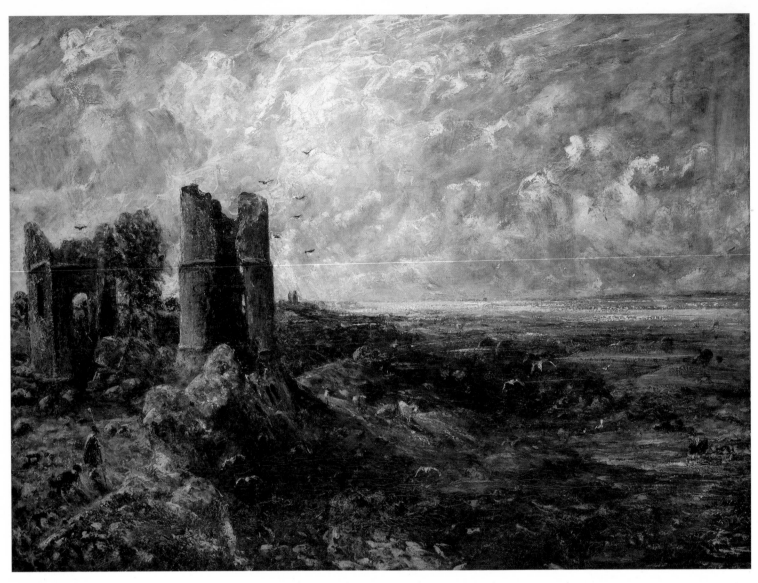

243. *Hadleigh Castle* 1828–9 Oil on
canvas $48\frac{1}{4} \times 65\frac{7}{8}$ (122.5 × 167.4).
London, Tate Gallery

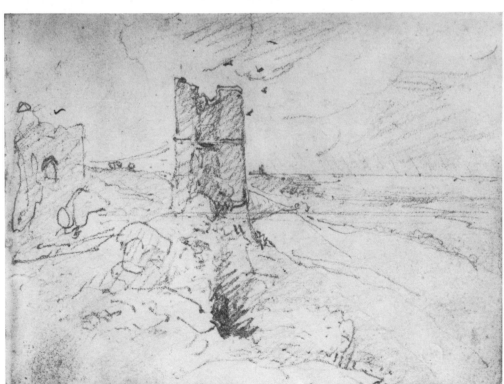

244. *Hadleigh Castle* 1814 Pencil
$3\frac{1}{4} \times 4\frac{3}{8}$ (8.1 × 11.1). London, Victoria
and Albert Museum (R.127)

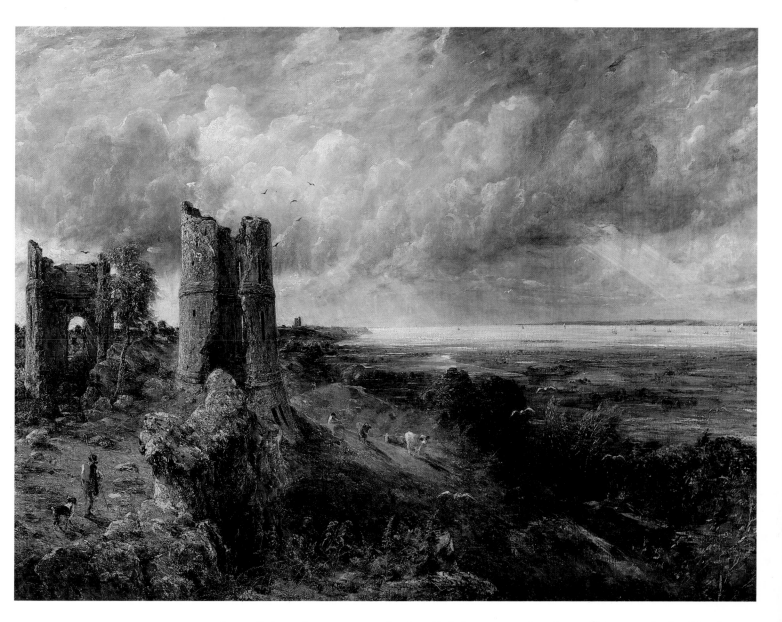

245. *Hadleigh Castle* 1828–9 Oil on canvas 48 × 64¾ (122 × 164.5). New Haven, Yale Center for British Art, Paul Mellon Collection

about light. Thomson emphasises light's power, for through its touch the 'dead creation . . . assumes a mimic life'. It gives an illusion of revitalising the landscape.

Constable was one, we remember, who now lived by shadows, for they were to him realities; and in *The Lock* he had done a picture the light of which could not be put out, for it was the light of nature. *Hadleigh Castle* developed this concern with light most interestingly . Its handling allows it to appear a mosaic of multifaceted reflecting surfaces, abstracted into patches of colour. This it shares with the earlier, 'expressionist' paintings. Constable, however, also had his light coming from the north-east, to fit both his exhibition subtitle, 'morning after a stormy night', and Thomson's description, this being appropriate to sunrise around midsummer, the moment when the 'very dead creation assumes a mimic life'. This is an illusion of animation, and, rather than see, as I suggested above, the shifting lights and shadows as but the faint reflections of some more embracing reality, they are the only things which allow one to think in any terms of living reality at all. And then the life assumed is 'mimic'.

It is worth pointing out what kind of scope *Hadleigh Castle* would have afforded the Constable of the 1810s. He could have shown the estuary alive with shipping, which, as this is the mouth of the Thames, would have carried a real georgic message. And the isolated shepherd and dog (related to that in *The Cornfield*) might have acted as a pastoral counterpoint, the ruins themselves effectively and favourably contrasting

217

the present with the past. As it is, the shepherd, the cattle and the shipping, are all equal elements with every other in the landscape, an integration which the broken roughness of Constable's style helps achieve. So they too are brought to mimic life by light, and we can argue that Constable now finds meaning in nothing. If, as surely is the case, *Hadleigh Castle* partly sublimated his grief at the death of Maria, it also measured the extent of his despair. Ronald Paulson has written

> When I look at the late landscapes I am reminded of passages like this one in Burke's *Third Letter on a Regicide Peace* (1797): 'All the little quiet rivulets, that watered an humble, a contracted but not an unfruitful field, are to be lost in the waste expanse, and boundless barren ocean of the homicide philanthropy of France'.[8]

In this late painting there is just such a 'waste expanse', and 'boundless barren ocean'; and to apply Burke's political metaphor adds to the sense of anarchy and hopelessness that the landscape imparts, and strengthens that implied contrast with the georgic possibilities that such a scene could once have afforded Constable. It suggests again that, having lost a landscape of meaning, he had not found a replacement.

And if light now only imparts surrogate life, instead of being the essence of landscape; then *Hadleigh Castle* must terminate that series of increasingly abstracted landscapes begun with *A View on the Stour*. We shall see how some of Constable's later works are even more stylistically expressionist, and there is as well a marked fluctuation both in the artist's moods, and in what he expressed of them. A May 1830 letter to Fisher supports the notion of *Hadleigh Castle* ending one line of development: '. . . I have filled my head with certain notions of *freshness—sparkle—brightness*—till it has influenced my practice in no small degree, & is in fact taking the place of truth so invidious is manner in all things . . .'[9] Ostensibly this rejects the 1820s, and returns to the ideals of 1802. Yet it is but one amongst many effusions of failure dating from the 1830s.

In general, from Maria's death onwards, Constable manifested a depression which varied only in its degree of darkness. He progressed to feeling that his career had been wasted, not only writing in 1834 that he had 'cut my throat' with the palette knife,[10] but also exhibiting the larger version of *A Cottage in a Cornfield* (Fig. 119), which he had 'licked up . . . into a pretty look';[11] having taken up a canvas painted mostly in 1815, and added the tree to the right. At the 1833 British Institution he exhibited another old painting, the picturesque and depressing *Helmingham Dell* (Fig. 246). It can appear that Constable had become unconcerned about what he exhibited. He could write that he still aimed to capture 'light', 'dews', 'breezes', 'bloom', and 'freshness' in paint,[12] and yet, in 1834, that '. . . the trees and clouds all ask me to do something like them—and that is no small reward for a life of labor.'[13] Elsewhere he called his pictures 'abortions'.[14] If his landscapes remained his children, then they were miscarried. He had failed as their creator: and some of his East Anglian drawings of the 1830s are of sad quality (Fig. 229). And on a proof of the mezzotint after *The Glebe Farm* Constable wrote to Lucas, 'I have added a "Ruin", to the little Glebe Farm—for, *not* to have a symbol in the book of myself, and of the "Work" which I have projected, would be missing the opportunity.'[15] He was being unfair to himself, but his language shows his mood.

In a sense, as well as proposing himself (in the mezzotints' title) as the latter-day equivalent to Gainsborough as well as a worthy rival to Turner, these prints were a retrospect of what Contable had done, attempting to show publicly his range and worth as an East Anglian artist. In view of his high stake in the public exhibition of large canvases, it is significant that he turned to sketches rather than finished paintings for his images. The plate known as *Summer Morning: Dedham from Langham* (Fig. 248)

218

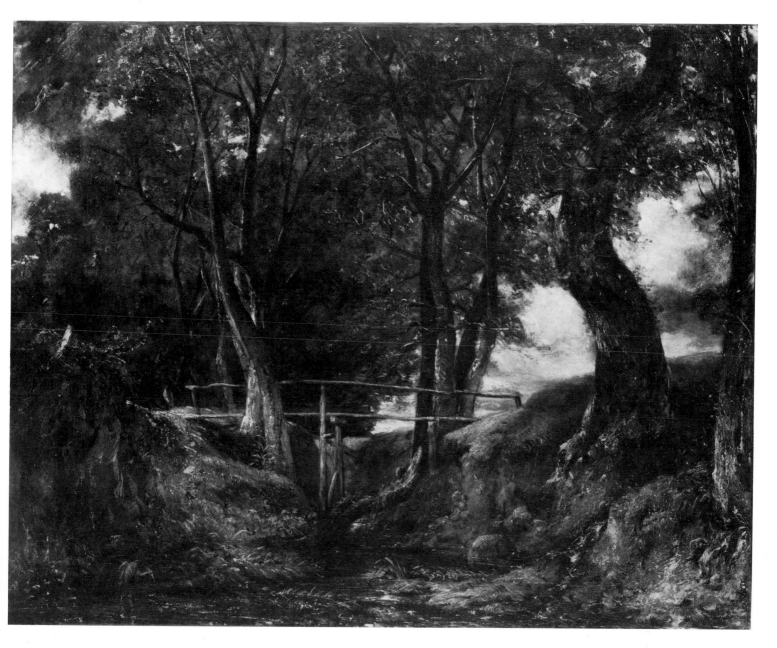

246. *Helmingham Dell* 1825–6 Oil on canvas 27⅞ × 36 (70.8 × 91.5). Philadelphia Museum of Art, John G. Johnson Collection

247 (over page). Detail from *Hadleigh Castle* (Fig. 245)

was a version of the wide view of which two oil sketches (Figs. 62, 63) have been mentioned above, and a third is in the Victoria and Albert Museum (Fig. 249). It is likely that they were all done on the spot at times over *c*. 1812–17. But certain versions the oil sketches of *Stoke by Nayland* (Figs. 250, 251) may be forgeries: why in an oil sketch (recording the momentary) would Constable have repeated his composition so ostentatiously?[16]

Perhaps Constable felt that oil sketches, rather than studio canvases, encapsulated his response to nature when it was least complicated. For the *Stoke* he did a marvellous sepia drawing (Fig. 252), apparently in an attempt to translate the oil's polychromy into monochrome, for the benefit of Lucas, but also showing how he could find inspiration in his own work: a complicated state of affairs. The mezzotints obviously mattered to Constable himself. They were works in which he had a heavy emotional stake, and which he created *through* Lucas, rather than having the latter simply translate the oils into a different medium.[17] 'If I do not see you soon I shall craze myself and you too, about '*the Book*'. A fearfull change is *determined* upon by myself—a *new plate* must be immediately put in hand . . . without the fair, genuine & unbiased [care] which you will not fail to give, I shall do nothing.'[18]

In depressed moods, though, Constable treated Lucas to abuse of a kind which

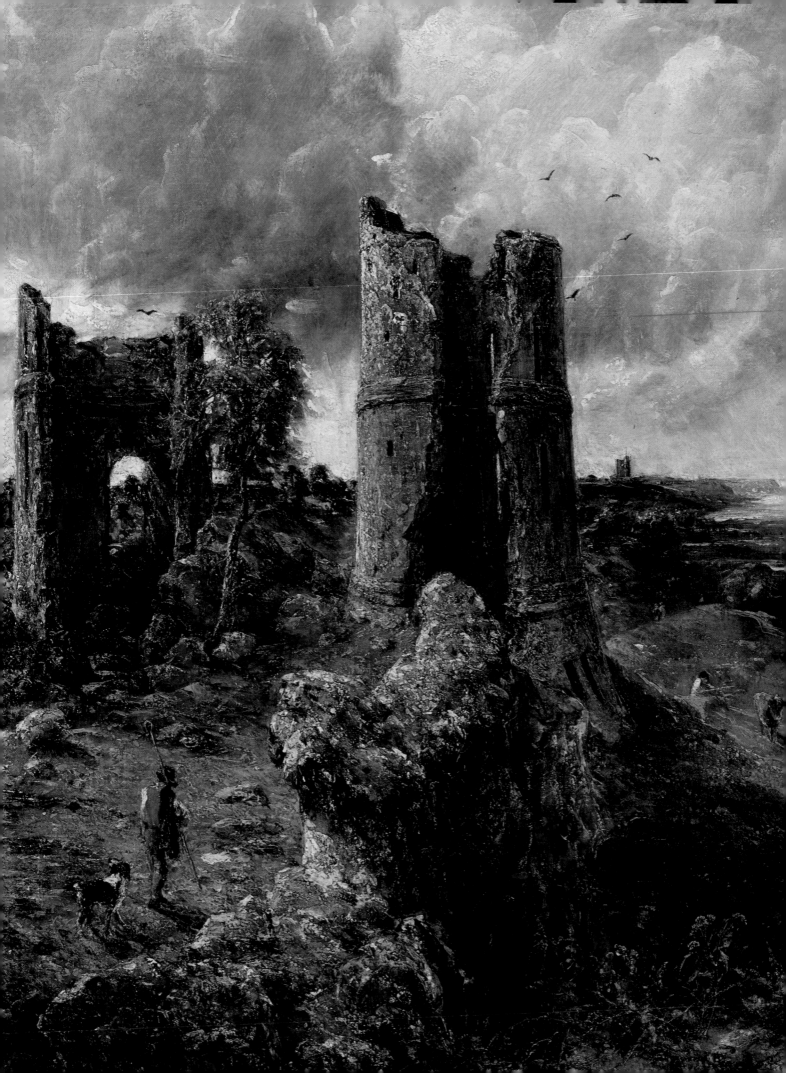

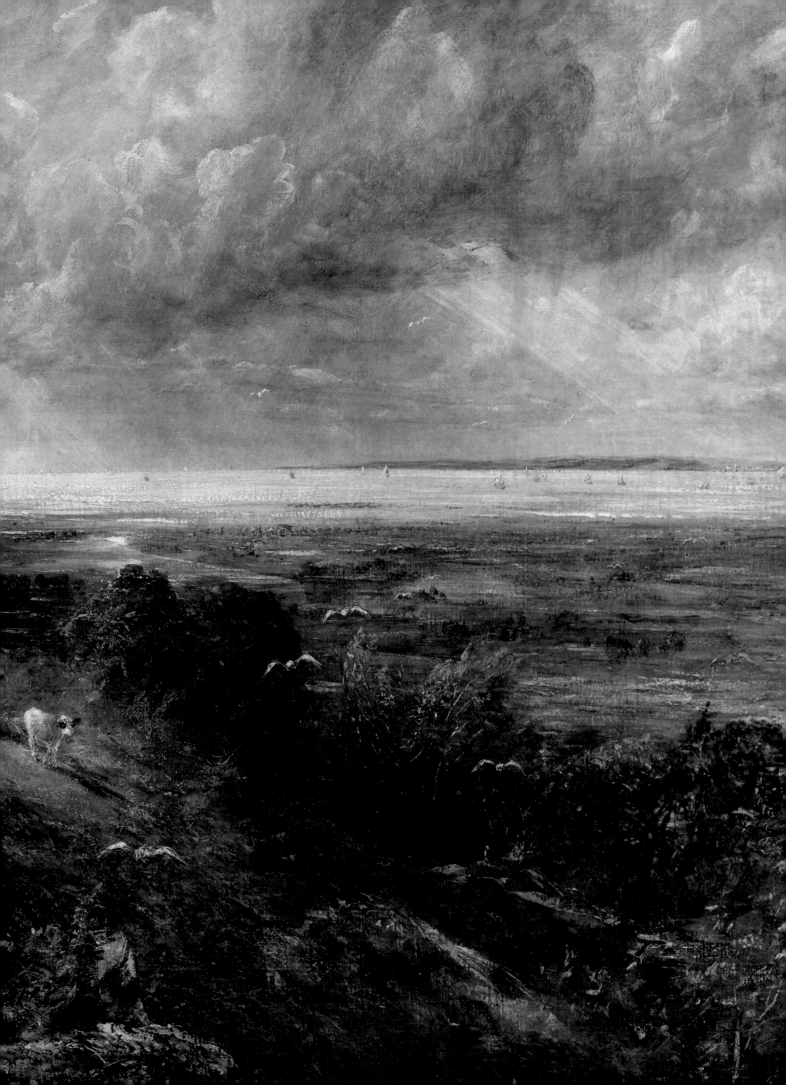

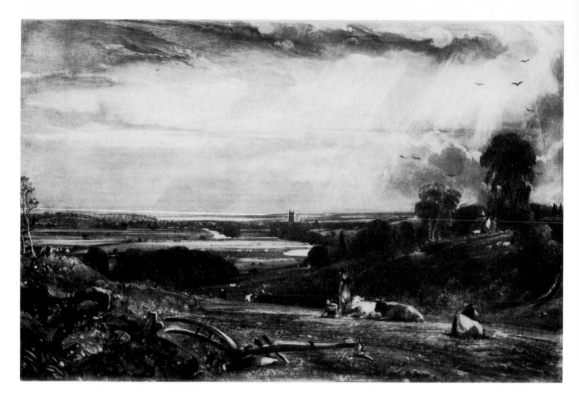

248. *Summer Morning, Dedham from Langham* Mezzotint by David Lucas after Constable

249. *Dedham from Langham* ?1810–17 Oil on paper 8½ × 12 (21.6 × 30.5). London, Victoria and Albert Museum (R.332)

250. *Stoke-by-Nayland* ?1809–17 Oil on paper 9¾ × 13 (24.8 × 33). London, Victoria and Albert Museum (R.330)

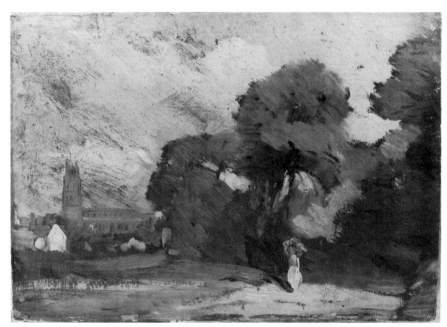

251. *Stoke-by-Nayland* ?1809–17 Oil on canvas 7⅛ × 10⅜ (18.1 × 26.4). London, Tate Gallery

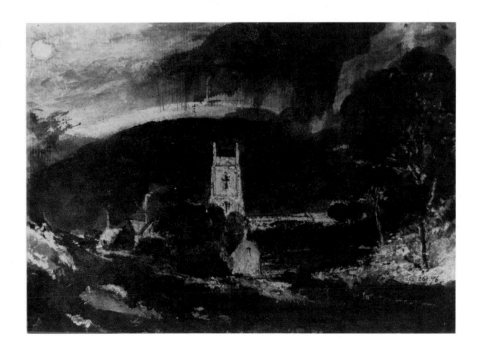

252. *Stoke-by-Nayland c.* 1830 Sepia 5 × 7¼ (12.7 × 18.3). London, Victoria and Albert Museum (R.331)

253. *Salisbury Cathedral from the North West* 1829 Pencil 9¼ × 13 1/16 (23.4 × 32.7). Cambridge, Fitzwilliam Museum

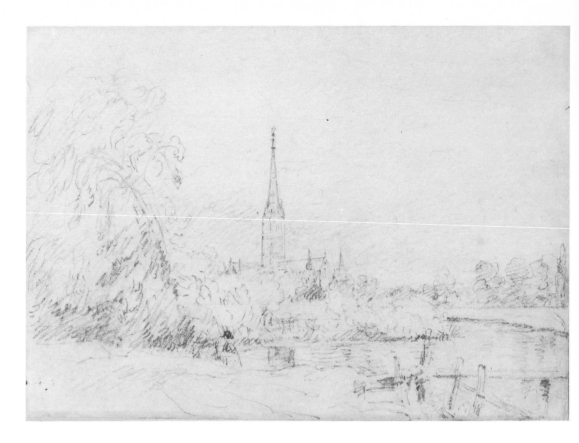

254. *Salisbury Cathedral from the Meadows* c. 1830 Oil on canvas 14⅜ × 20⅛ (36.5 × 51.1). London, Tate Gallery

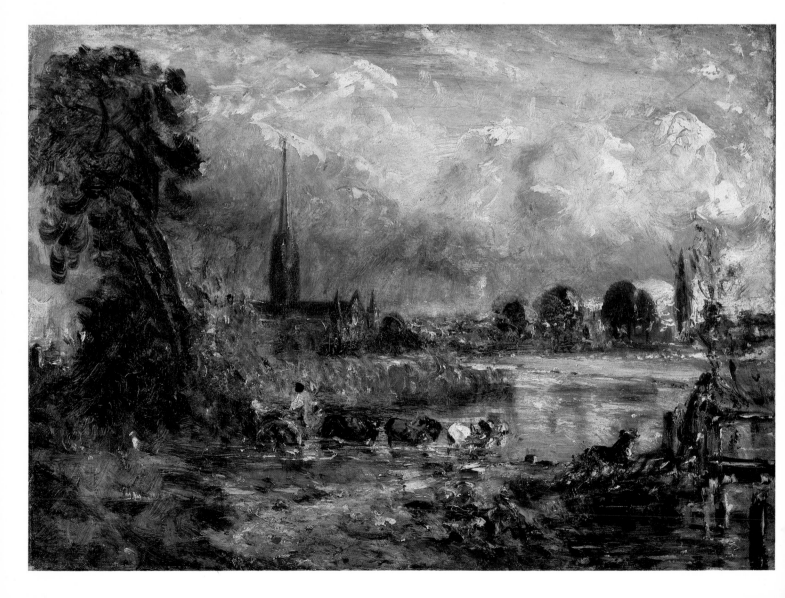

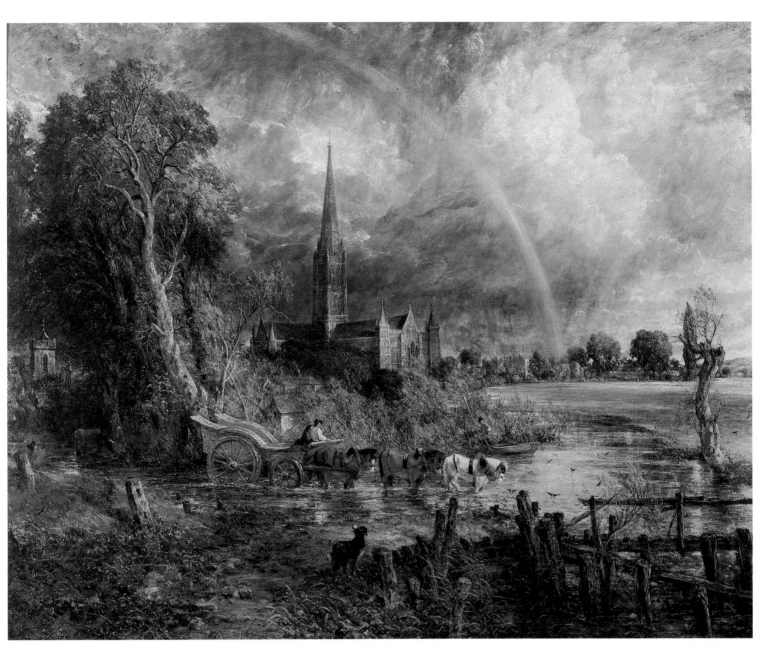

255. *Salisbury Cathedral from the Meadows* 1831, 1833, 1834 Oil on canvas 59¾ × 74¾ (151.8 × 189.9). Private Collection

maybe he heaped on to his own head when things went wrong. '*You do nothing right*', he wrote in April 1833,[19] 'nothing *correct comes from your press* . . . The great quantity of worthless & bad proofs, which, you have sent . . . (and of course charged for) should have been burnt by you, 'from the press' . . . And I do consider the book a heavy visitation, a real curse, upon me for my sins . . .' It says something for Lucas that he stood this. Perhaps it was the customary way of addressing tradespeople, and therefore something to which he was accustomed.

The mezzotints dissipated much of Constable's energy, and more time was involved in composing an explanatory Letterpress to them.[20] This Letterpress shows this most figural of painters resorting to language to explain his art, and failing to do so (in a way similar to the ageing Hogarth). Partly because the mezzotints were, on the whole, not done from recent work, partly because Constable was writing for his public, and not an intimate like Fisher or Leslie, his Letterpress imparts an impression of having been written to cater for what the artist imagined his audience might wish to hear. Thus, we read in the *Introduction*:

In Art as in Literature, however, there are two modes by which men endeavour to attain the same end, and seek distinction. In the one, the Artist,

intent only on the study of departed excellence, or on what others have accomplished, becomes an imitator of their works . . . in the other he seeks perfection at its PRIMITIVE SOURCE, NATURE.

Certainly Constable believed this until 1822: however his return to an aesthetic which had not much altered from 1802 might signal his public espousal of ideas which he felt must be valid, and a further index of the degree to which his art was undergoing a crisis. It is natural to turn to an artist's writings when seeking understanding of his or her art, yet Constable is here not very helpful.

He stated for instance that in these prints he had aimed to 'direct attention' to one of the most 'efficient principles' of art—'. . . the "CHIAR-OSCURO OF NATURE", to mark the influence of light and shadow upon landscape . . . to show its use and power as a medium of expression, so as to note "the day, the hour, the sunshine, and the shade".' And this is all the explanation Constable was to give of a principle vitally important to his later painting, and the nature of which has so far been inferred via the correlation of paintings and correspondence. On other occasions he provided learned notes on changes of weather, or the histories of ancient buildings. Although interesting enough in themselves, there are times when one suspects the artist almost to have been struggling for something to write. It is noticeable that his description of East Bergholt should have been couched in the language of property advertisements, and appeared to refer to other conventionalised local descriptions.[21]

Although his letterpress revealed how knowledgeable a local and natural historian Constable was, it was not informative on his painting. Yet this was an artist seldom at a loss for words. Turning to this new medium may partly have been an attempt to counter the hopelessness Constable sometimes felt about painting:

> Good God—what a sad thing it is that this lovely art—is so wrested to its own destruction—only used to blind our eyes and senses from seeing the sun shine, the fields bloom, the trees blossom, & to hear foliage rustle—and old black rubbed-out dirty bits of canvas, to take the place of God's own works.[22]

Despondency apart, the main impression given by Constable in the 1830s was of someone lacking any settled direction.

It is certainly true that what comments Constable did make about painting rather suggest aimlessness, a sense that here he was in his fifties, surveying a career which had left nothing certain, not even the primacy of instinct. In Arundel in 1834 he was struck by the scenery: 'I never saw so much beauty in *natural landscape* before. I wish it may influence what I may do in future, for I have too much preferred the picturesque to the beautifull—which will I hope account for the *broken ruggedness of my style*.'[23] And it was this same year that Constable's approach to the production of an exhibition canvas for 1835 was virtually nonchalant—'The difficulty is to find a subject fit for the largest of my sizes. I will talk to you about one, either a canal, or a rural affair, or a harvest scene—which I know not, but I could hardly choose amiss—certainly not if, as Wilkie says, it should be "painted well".'[24] This insouciance alternated with the old arrogance—'. . . I may yet make some impression with my "light"—my "dews"—my "breezes"—my *bloom* and my *freshness*—no one of which qualities has been perfected on the canvas of any painter in this world,'[25] he had written to Leslie the previous year. Art had become a devil Constable could not shake off: he continued to paint, and he continued to exhibit.

In 1829 Constable had visited Fisher at Salisbury, producing some oil sketches and, quite possibly, at least beginning work on *Watermeadows near Salisbury* (Fig. 256), rejected by his fellow Academicians the following year. We have already mentioned the control that drawings done at this time display, in stark contrast with the lack of it apparent in East Anglian work. Equally, this is a remarkably disciplined

256. *Watermeadows near Salisbury*
1829 Oil on canvas $18 \times 21\frac{3}{4}$
(45.7×55.3). London, Victoria and
Albert Museum (R.321)

painting. The predominant green is natural to such a scene. The technique (save for some impasting around the river bank) is tight, and if compared say, with *Boat Building*, a strictly stylistic appraisal would induce one to date *Watermeadows* far earlier than it actually is. It is no wonder the Academicians did not recognise its authorship. The conclusion that, for a painter as neurotically sensitive as Constable, place and its associations had become instrumental in affecting his artistic responses, becomes inescapable. At Salisbury he could be reminded of happier times, and of holidays: the associations would surely have been of a cheerful kind, hence the calmness of his style. And yet, when, in 1831 (ten years after *The Hay Wain*) he was to exhibit the greatest of his Salisbury landscapes, *Salisbury Cathedral from the Meadows* (Figs. 241, 254, 255, 257), although the composition was based on work done since 1829, Constable's style had returned to that evocative expressionism, and the image was grand, terrifying, composed in vortices which allow the eye no rest, but suck it into the frightening blackness around the Cathedral.

It has been recognised that *Salisbury Cathedral* refers openly to the canal scenes and has, moreover, an element of political allegory.[26] The relation of architecture, ground and water is similar to that in *The White Horse*, while the combination of

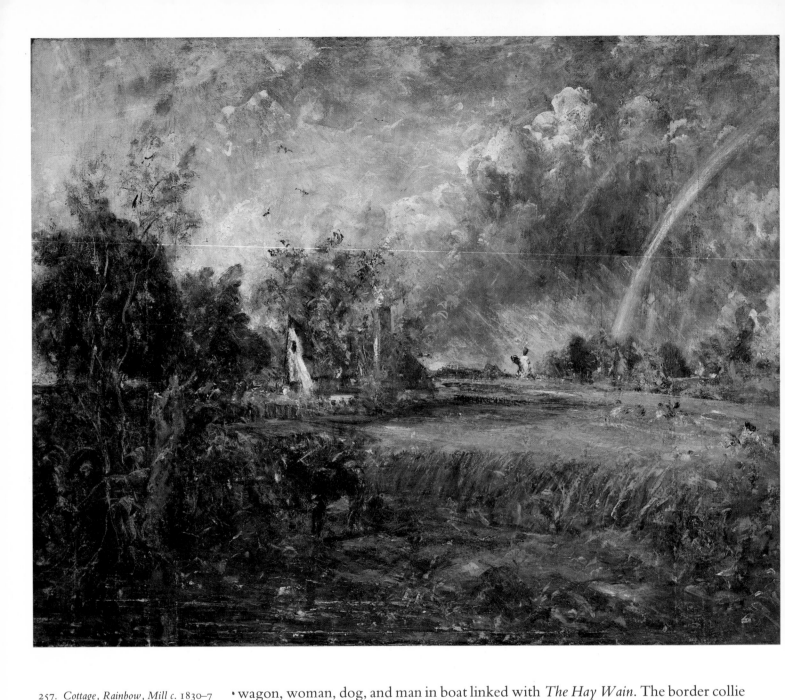

257. *Cottage, Rainbow, Mill* c. 1830–7
Oil on canvas 34½ × 44 (87.6 × 111.8).
Port Sunlight, Lady Lever Art
Gallery

258. *Scene on a River* c. 1830–7 Oil on
canvas 24 × 31 (61 × 78.7)
Washington, Phillips Collection

259. *Scene on a River* c. 1830–7 Oil on
canvas 10 × 13¾ (25.4 × 34.9).
London, Victoria and Albert
Museum (R.403)

• wagon, woman, dog, and man in boat linked with *The Hay Wain*. The border collie
came from *The Cornfield*. The organisation of the timber bridge recalled *The Lock*
(which made Salisbury Cathedral a substitute for Dedham Church); the willow was
the one from *The Leaping Horse*; and low-flying swallows had been portents of bad
weather in *Flatford Mill*. And, from the same painting, as in 1830 Constable
explained to Lucas,[27] derived the elms behind the wagon, having made an
intermediary appearance in *The Leaping Horse*.

The painting has disturbing features. There is an imbalance between the boat and
wagon, which, as in *The Hay Wain* it had been authentically Suffolk, is now
authentically Wiltshire. There are frightening shifts of scale, from the dwarf houses
in the undergrowth to the dog the size of a pony and the giant in the boat. In some
places the paint seems to proceed in random trails across the picture surface, and the
storm is overwhelming and destructive. Not the least of this painting's disquieting
features is the resetting of Stour Valley motifs (which in themselves had in the earlier
1820s played a large part in the development of the canal scenes) in the context of a
Salisbury Cathedral being struck by lightning.

Writing of this work, Leslie stated that 'this he considered as conveying the fullest

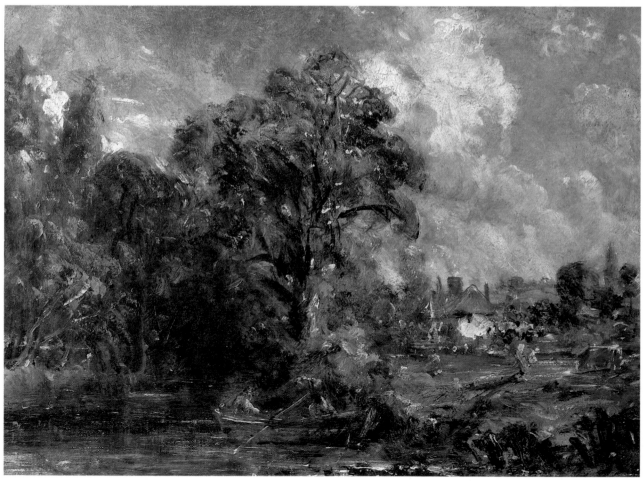

260. J. Van Ruisdael *The Cemetery*
Oil on canvas 55⅞ × 74⅜ (142 × 189).
Detroit Institute of Arts

impression of the compass of his art. But it met with no purchaser.'[28] Who would be surprised, given the availability of the comforting sublimities of John Martin? This *Salisbury* took longer than usual to reach completion. The earlier work dates from 1829, and Fisher wrote during that August that 'I am quite sure that the "Church under a cloud" is the best subject you can take. It will be an amazing advantage to go every day & look afresh at your material drawn from nature herself',[29] not only inferring that Constable's Salisbury studies might have been made with a view to a large canvas,[30] but also indicating an iconography of threat to the Church itself. This tied in with the anguish which Constable was not alone in feeling at the prospect of Parliamentary Reform;[31] although it was not until June 1832 that a third Reform Bill was to be passed, the first was introduced to the Commons on 1 March 1831. Constable was acutely disturbed by the whole episode.

> What makes me dread this tremendous attack on the constitution of the country is, that the wisest and best of the Lords are seriously and firmly objecting to it—and it goes to give the government into the hands of the rabble and dregs of the people, and the devil's agents on earth—the agitators.
>
> Do you think that the *Duke of Wellington* & the Archbishop of Canterbury . . . and the best & wisest men we have—would all have opposed it, if it was to have [done] good to the country? I do not.[32]

When, on 26 November 1831, Constable wrote that 'That infernal machine Brougham has ruined the art as well as everything else—& I who am in landscape fell first of all',[33] he intimated that painting and politics had become intertwined in his mind.

A consistent feature of Constable's descriptions of radicals and their ilk was his attribution of their activity to diabolical agency. In 1825 (above, p. 143) he had gone on to blame popular insubordination on 'Brougham and old Hume—the Devil's viceregents on earth',[34] while in 1833 he was to feel that 'the Devil himself could only have dictated' some lines Byron had addressed to Rogers.[35] In 1831, Constable's easy pairing of the Archbishop of Canterbury with the Duke of Wellington indicated his instinctive coupling of Church and Constitution meant (for Church and State were indissolubly wedded) that to attack one was to attack both. In this instance the lightning striking Salisbury Cathedral might symbolise the diabolical attacks of the reformers; countered by the rainbow imparting its traditional message of divine hope. (It has been shown that a rainbow could not have occurred in such a position; as Constable was a knowledgeable meteorologist, it was presumably therefore inserted deliberately[36])

In the 1830s Constable was keen on rainbows (one had appeared in the *Stoke-by-Nayland* mezzotint of 1830), particularly in the context of Wiltshire landscapes. Notable among these are a watercolour of Old Sarum exhibited in the 1834 R.A.,[37] and a view of Stonehenge of two years later.[38] Old Sarum, which Constable had drawn in 1829 (Fig. 227), had formed the subject of a mezzotint Lucas had made the same year. It has been pointed out that the subject has political overtones, for Old Sarum was one of the rottenest of the boroughs the Reform Bill sought to abolish,[39] and it has been noted, too, that in his Letterpress to the print Constable borrowed heavily from what John Britton had written in the Wiltshire volume of his *Beauties of England and Wales*.[40] While Stonehenge had less contemporary relevance (although Louis Hawes suggests some inspiration in Constable's political worries[41]) it was, perhaps more than Old Sarum, a site where ancient remains contributed significantly to the character of the landscape itself, and given Constable's knowledge of Britton, this aspect of the Wiltshire terrain would have been of consequence to him.[42] In Britton he would have read of the association of the county with 'the far famed Arthur, and the still more illustrious Alfred'[43]

261. P. P. Rubens *Rainbow Landscape*
after 1635 Oil on panel. 53¼ × 92
(135.25 × 233.68). London, Wallace
Collection

230

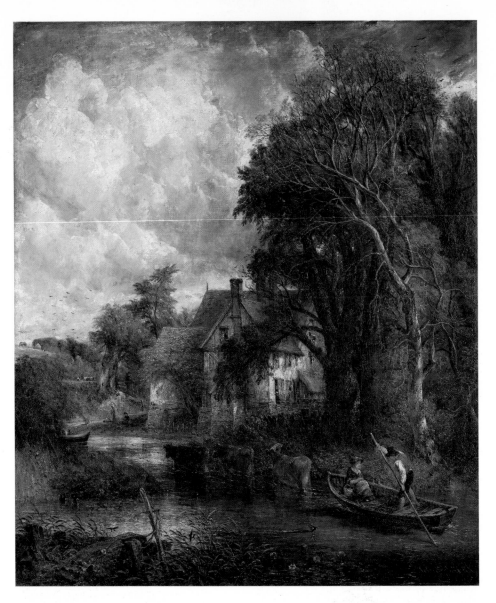

262. *The Valley Farm* 1835 Oil on canvas 58 × 49½ (147.3 × 125). London, Tate Gallery

263. *Stoke-by-Nayland* ?1834–7 Oil on canvas 49 × 66 (124.4 × 167.6). Art Institute of Chicago

264. (facing page) *East Bergholt Church* ?1817 Pencil 12½ × 9⅜ (31.7 × 23.8). London, Courtauld Institute of Art (Spooner Bequest)

(Constable had named his third son Alfred), or how the Conqueror had introduced the feudal system at Sarum:[44] a point which the painter himself had picked up—

> This proud and 'towered city', once giving laws to the whole kingdom—for it was here our earliest parliaments on record were convened—can now be traced but by vast embankments and ditches, tracked only by sheep-walks . . . It was on this spot the wily Conqueror, in 1086, confirmed that great political event, the establishment of the feudal system . . .[45]

After the 1832 Reform Bill, Old Sarum no longer returned two members, and an antique tradition came to an end. The watercolour of 1834 shows the mound of the city embroiled in storms, with a rainbow just visible to the right, the only figure, as in several of Constable's pictures, from *Hadleigh Castle* onwards, being the solitary shepherd in isolation. It is roughly contemporary with Constable's retouchings of his great landscape of New Sarum, *Salisbury Cathedral from the Meadows* in early 1833 and August 1834,[46] and it would be reasonable to associate these Wiltshire landscapes both with Constable's frequently depressed state during the 1830s, and his pictorial relation with the old England which that county exemplified, but which had now been changed beyond recognition.

Reform apart, in the early 1830s Wiltshire itself experienced, throughout November and into December 1830, dramatic agrarian unrest[47] on a large scale, perhaps inflaming the artist's distress and unease. With Maria dying in 1828, and Fisher in 1832, Constable as the 1830s progressed might increasingly have found himself both alone and alienated in a rapidly developing industrial world, one where the results of progress opposed what he once had valued in the landscape of agricultural improvement. Writers on Constable have noted that the increasingly stormy skies of his paintings reflect a mood which fluctuated only in its degree of depression, as the artist was himself to explain to Leslie, in December 1834:

> . . . though my life and occupation is useless, still I trifle on in a way that seems to myself like an occupation, and the delusion . . . still keeps me going, and my canvas soothes me into a forgetfulness of the scene of turmoil and folly—and worse—of the scene around me. . . . Can it . . . be wondered at that I paint continual storms? . . . still the 'darkness' is majestic, and I have not to accuse myself of ever having prostituted the moral feeling of art, but have always done my best.[48]

Constable had once called the sky the chief '*Organ of Sentiment*', the key to mood in a landscape; and like Hogarth in his last print, *The Bathos*, Constable, in his old age, has come to inhabit a world of little light, where only the darkness is majestic.

The technique, the colouring, and the stormy weather of *Salisbury Cathedral from the Meadows* disclose (as much as his letters) something of Constable's relation with and reactions to his world. He was one of the most intellectual of artists, and it would be wrong not to take Leslie's remark, that this painting 'he considered as conveying the fullest impression of the compass of his art' very seriously. One of its anomalous features is the combination of the Salisbury terrain with a foreground which refers both to Stour Valley and canal scenes, in particular *The Hay Wain* and *The Leaping Horse*. Constable's composition recalls the old format for the country-house portrait without invoking its iconography, for the motifs both of his pre-1822 East Anglia and of the canal landscape he evolved after that date are under the tremendous threat represented by the storm and lightning playing about the Cathedral itself.

It is nevertheless hard to guess precisely what Constable meant to convey. Although he was to be disparaging about Ruisdael's attempts at allegorical landscape, the latter's *Cemetery* (Fig. 260) displays a comparable combination of

234

rainbow, church, water, and tree. Indeed, an inversion of the composition (which would follow a precedent set in earlier references to Claude) would place the wagon in the same relative position as Ruisdael's tombs. The inference would be that Constable found little alive in his world, and a general connection of his and Rubens's rainbows (Fig. 261) could increase the irony, for the latter's generally arch behind scenes of bucolic plenty.[49] Yet the deliberate insertion of this rainbow, plus the movement of the storm away from the West, both suggest a less pessimistic iconography, something Constable apparently stressed in the quotation from *The Seasons* which he inserted in the 1831 R.A. Catalogue:

> As from the face of heaven the scatter'd clouds
> Tumultuous rove, th'interminable sky
> Sublimer swells, and o'er the World expands
> A purer azure. Through the lightened air
> A higher lustre and a clearer calm
> Diffusive tremble; while, as if in sign
> Of danger past, a glittering robe of joy,
> Set off abundant by the yellow ray,
> Invests the fields, and nature smiles reviv'd.

(*Summer* 1223–32)

As Thomson writes, the rainbow is itself 'set off abundant by the yellow ray'. It is a 'sign of danger past', then, which is created by light. As, in quoting Thomson with *Hadleigh Castle*, Constable had referred to light's capacity to invest landscape only with mimic life, we must doubt what optimism there is here, while at the same time acknowledging the rainbow and its symbolism to be crucial. If the attack of Reform on Church and Constitution appeared to Constable in terms of evil versus good, or the forces of darkness versus those of light, then without that rainbow demoniacal chaos would be inevitable.

This was one canvas on which Constable continued working, and into which he put all his efforts. Yet alternating with this commitment was that hopelessness which inspired such remarks as 'The difficulty is to find a subject fit for the largest of my sizes', or his deciding that he had 'too much preferred the picturesque to the beautifull'. This mood perhaps explains why, during the 1830s, Constable would sometimes not bother to produce a new painting for exhibition, but show old ones (see above p. 218). In 1834 he sent a version of *The Lock* (Figs. 188, 190) for exhibition at Worcester. The works he painted with exhibition in mind (Figs. 24, 262) are troubled and difficult.

Yet the artist, on his own admission, was unable not to paint—'I am however busy on a large landscape. I find it of use to myself, though little noticed by others'[50]—and could not leave the great *Salisbury* alone. This reminds us of Constable's procedure in the mid-1820s when, developing the canal scenes, he had continued working on existing canvases, painted fresh versions of *The Lock*, and had possibly produced smaller but publicly unacceptable variants on these themes. Bearing this precedent in mind, it is interesting that there are at least three oil paintings (Figs. 257-9) which, although unexhibitable, nevertheless, as Graham Reynolds has written, embody 'the finest characteristics of the last phase of his art'. In a brilliant analysis Reynolds has noted the 'creative way' in which Constable was 'working his way towards an abstraction from his normal style'.[51] The range of colour and extremity of technique create a variety along the picture-surfaces which excitingly contrasts with the painfully-worked *facture* of exhibition canvases like *The Valley Farm* (Fig. 262). However, a relation between this composition and those smaller canvases which show water, trees, and a distant cottage (Figs. 258, 259) is accepted.[52] The format equally connects with the composition of *Salisbury*

Cathedral from the Meadows, the compositional structure of which compares interestingly not only with *The Valley Farm*, but also with the superlative *Cottage, Rainbow, Mill* (Fig. 257) now at Liverpool.

The connection extends beyond their common wild and stormy skies, for as the *Salisbury* relates to Constable's earlier work, so does *Cottage, Rainbow, Mill* make, as Charles Rhyne pointed out in a lecture in 1976, similar references. While the composition itself may depend on an 1817 drawing of a cottage seen across a cornfield (Fig. 144), both these features plus the donkey are transposed from *A Cottage in a Cornfield* (Fig. 119) (which was being touched up for exhibition in 1833),[53] while the original for the mill and rainbow is, perhaps, in an oil sketch of 1812 (Fig. 66). The painting, then, recalls figurative elements from Constable's earlier work around East Bergholt, and when these wonderful 'expressionist' canvases were tamed for public consumption they were realised in the form of paintings like *The Valley Farm*, where the punt is glued to the water (over which the swallows still skim), where Willy Lott's farm has become brooding and picturesquely ornate, and a giant is about to enter the gate which bars the grounds around the house from the ploughman and cornricks beyond, and which rehearses a landscape Constable had first attempted in the 1810s (Figs. 77, 78).

These were landscapes of memory, but hardly the consequences of emotion recollected in tranquillity. By working through the old subjects, Constable, by defining them in paint, might have sought to affirm their continuing existence in a world which allowed them no value. If we see them as paintings of an isolated man, it may explain why Constable was most successful when he was least fettered, and could paint 'continual storms' or realise the 'majestic' darkness, and why *The Valley Farm* shows such evidence of the problems he found in working it to an exhibitable standard. Passages of faltering work here may parallel weaknesses which have been observed in the Chicago *Stoke-by-Nayland* (Fig. 263), but which do not necessarily preclude their authenticity.[54] Another memory of his 'own places', based on oil sketches (Figs. 250, 251), *Stoke* is a wild and vibrating rendering of what Constable, in 1835, described as

> July or August at eight or nine o' clock, after a slight shower during the night, to enhance the dews in the shadowed part of the picture, under
>> 'Hedge row elms and hillocks green'
> Then the plough, cart, horse, gate, cows, donkey &c. are all good paintable material for the foreground, and the size of the canvas sufficient to try one's strength, and keep one at full collar.[55]

Like a straining workhorse the artist wished to be kept at 'full collar', and the canvas was really a field on which he might try his strength. Despite possible thematic connections between this portrayal of Stoke church and his landscapes of Salisbury Cathedral, the picture surface is more striking as evidence of Constable having eschewed discipline and having allowed the act of painting to dictate and follow its own forms and logic. He had come to see that nature was simple—'the trees and clouds all seem to ask me to do something like them'—but the realisation of his sensations seems to have become fraught with complications.

Nevertheless such late works represent Constable's continuing search for fresh subjects when he could no longer value or find significance in his old ones. While we might suspect that the moral conflict exemplified by *Salisbury Cathedral from the Meadows* had left the artist isolated, the fact that the conflict was so crucial must remind us that an artist is never an island. A painter's landscape always will be created from more than the simple perception of natural appearances. Constable had once found 'endless beauties' in a 'happy country', had gone on to experience breezes and exhilaration, and in his old age was beset by 'continual storms'.

265. D. Maclise *Constable Painting* 1830s Pencil $5\frac{1}{2} \times 4\frac{1}{4}$ (14×10.8). National Portrait Gallery

Photographic Acknowledgments

Photograph courtesy of Thomas Agnew & Sons Ltd 53; Bath Museums Service, Victoria Art Gallery 227; By kind permission of the Marquess of Tavistock and the Trustees of the Bedford Estates 166, 232; Courtesy of the Museum of Fine Arts, Boston (48.266, Purchased, William W. Warren Fund) 95 (detail), 103; The Bridgeman Art Library 178 (detail), 181, 255; Trustees of the British Museum 87, 124, 196, 197, 248; Reproduced by permission of the Trustees of the Chatsworth Settlement 50; Collection of the Art Institute of Chicago 263; Photograph courtesy of Christie's 81, 164; The Corcoran Gallery of Art, Washington, D.C. (Anonymous Loan) 58; N.J. & L. Cotterell (Photographers) 139, 140; Courtauld Institute of Art, London (Witt Collection) 36, 37, 50, 77, 93, 198, (Spooner Bequest) 264; Courtesy of the Detroit Institute of Arts 260, (Gift of Mrs. Joseph B. Schlotman) 215, (Gift of Julius H. Haass in memory of his brother Dr. Ernest W. Haass) 260; Copyright the Frick Collection, New York 148 (detail), 156; The Greater London Council as Trustees of the Iveagh Bequest, Kenwood 11, 233; Manor Kay & Foley (Photographers) 20; The Metropolitan Museum of Art, Bequest of Mary Stillman Harkness, 1950 (50.145.17) 234; Reproduced by Courtesy of the Trustees, The National Gallery, London 4, 22, 24, 28, 29, 33, 104, 111, 141, 153, 171, 173, 174, 175 (detail), 206, 208 (detail), 210, 230; National Gallery of Victoria, Melbourne (Acquired 1959) 8; National Gallery of Art, Washington D.C. (Widener Collection) 12, 152; Nationalmuseum, Stockholm, deposited at Nyköpings Museum (photo: Nyköpings Museum) 13; Sydney W. Newbery (Photographer) 41, 53; Art Gallery of Ontario, Toronto (Gift of Reuben Wells Leonard Estate, 1936) 23; Philadelphia Museum of Art (The John G. Johnson Collection) 43, 246, (The John H. McFadden Collection) 189; University of Reading, Institute of Agricultural History and Museum of English Rural Life 88, 89, 123; Sotheby Parke Bernet & Co. 151; Victoria and Albert Museum (Crown Copyright) 1, 5, 6, 15, 18, 19, 26, 27, 30, 31, 34, 35, 44, 56, 59, 60, 64, 66, 68, 69, 71, 72, 73, 74, 75, 76, 78, 85, 86, 96, 97, 98, 99, 100, 101, 102, 105 (detail), 107, 108, 109, 110, 113, 119, 121, 122, 129, 133, 137, 138, 142, 143, 144, 145, 147, 149, 150, 158 (detail), 162, 170, 172, 179, 180, 183, 191, 192, 194, 195 (detail), 209, 210, 216, 221, 222, 223, 225, 228, 229, 238, 240, 242, 244, 249, 250, 252, 256, 259; Virginia Museum of Fine Arts (The Williams Collection) 204; Reproduced by permission of the Trustees, The Wallace Collection, London (Crown Copyright) 261; The Walker Art Gallery, Liverpool 257

Notes

ABBREVIATIONS USED IN THE NOTES

AA	*Annals of Agriculture and other Useful Arts* (ed. A. Young), London and Bury St. Edmunds 1784–1806
ERO	Essex Records Office
FD	Farington Diary
F-W	I. Fleming-Williams *Constable Landscape Watercolours and Drawings* London 1976
H	R. Hoozee *L'opera completa di Constable* Milan 1979
IJ	*Ipswich Journal*
JCC	*John Constable's Correspondence* ed. R. B. Beckett, Ipswich 1962–8
JCC I	*The Family at East Bergholt* 1962
JCC II	*Early Friends and Maria Bicknell* 1964
JCC III	*C. R. Leslie* 1965
JCC IV	*Patrons, Dealers, and Fellow Artists* 1966
JCC V	*Various Friends* 1967
JCC VI	*The Fishers* 1968
JCD	*John Constable's Discourses* ed. R. B. Beckett, Ipswich 1970
JCFDC	*John Constable. Further Documents and Correspondence* ed. I. Fleming-Williams *et al.*, Ipswich and London 1975
Leslie	C. R. Leslie *Memoirs of the Life of John Constable* London 1951
P	L. Parris *The Tate Gallery Constable Collection* London 1981
PRO	Public Records Office
R	G. Reynolds *Catalogue of the Constable Collection in the Victoria and Albert Museum* 2nd ed. H.M.S.O. 1973
Reynolds	G. Reynolds *Constable the Natural Painter* London 1965
Rosenthal	M. Rosenthal *Constable and the Valley of the Stour* PhD dissertation, University of London 1977
SROI	Suffolk Record Office (Ipswich)
T	Tate Gallery *Constable. Paintings, Watercolours & Drawings* 1976

NOTES TO CHAPTER ONE

1. *JCC* IV p. 387.
2. This has been discussed by Norman Scarfe in *JCFDC* pp. 343–4.
3. *JCFDC* pp. 80–1.
4. *JCD* p. 81.
5. For Turner's touring see J. Gage *Colour in Turner, Poetry and Truth* London 1969; *Turner. Rain, Steam, Speed* London 1972. Tate Gallery *Turner 1775–1851* 1975. G. Reynolds *Turner* London 1969. For touring in general see C. Hussey *The Picturesque* London 1927; E. Moir *The Discovery of Britain* London 1964; L. Parris *Landscape in Britain c. 1750–1850* London 1973; M. Clarke *The Tempting Prospect* London 1981; P. Bicknell *Beauty, Horror and Immensity* Cambridge 1981; M. Rosenthal *British Landscape Painting* Oxford 1982. P. Bicknell and R. Woof *The Discovery of the Lake District 1750–1810* (exhibition catalogue) Dove Cottage 1982.
6. *JCC* I p. 47.
7. *JCC* I pp. 78, 150.
8. SROI E.I. I. 394/1 15 May 1808.
9. It seems possible that there were some landscapes Constable did not portray, because relations between his family and the relevant landowers would not have been good enough to allow him leave of passage over their ground.
10. *JCC* I p. 70.
11. Constable's father's renewal of his game certificate was recorded in one of the September *Ipswich Journals* from 1788 on (i.e. 11 Feb. 1786, 13 Jan. 1787, 5 Sep. 1788 and so on).
12. T. Ruggles 'Picturesque Farming' *AA* IX No. 49 (1788) p. 14. For the question of both Ruggles's and other conservative writers' attitudes to the poor see N. Everett's exemplary treatment in 'Country Justice' PhD Cambridge 1977 pp. 1–13, 48, 62ff., 212–53.
13. See ERO D/DB T1063 Settlement on the Marriage of Peter Firmin Esq. with Miss Jane Masters, 10 May 1793, which allowed Firmin 'all those four undivided fifth parts of a moiety, or one half part . . . in one water corn mill called Dedham Mill . . . [now] . . . in the tenure of Golding Constable his undertenants . . .'.
14. SROI FB/190/A1/3. *IJ* 2 Dec. 1782.
15. For an account of this, see A. J. R. Waller *The Suffolk Stour* Ipswich 1957.
16. If *Boat Building* (Fig. 107) is juxtaposed with the Enclosure Map (Fig. 106), it can be seen that Constable showed a scene on Constable land. It seems reasonable to infer that these were Golding's barges, and that he used them on the river trade. See also T132, and A. Smart and C. A. Brooks *Constable and his Country* London 1976 p. 67.
17. *JCC* I p. 52.
18. SROI FB/191/F1/2 Valuation of the Parish of East Bergholt for the Purposes of making a Rate 1817.
19. F. Shoberl *The Beauties of England and Wales* XIV London 1813 p. 225.
20. A. F. J. Brown *Essex People 1750–1900*

Chelmsford 1972 p. 32.

21. *IJ* 13 Aug. 1791.

22. When, for instance, in 1811 John was contemplating marriage, his father warned 'as a single man I fear your rent and outgoing, on the most frugal plan, will be found quite equal to the produce of your profits', *JCC* I p. 73, which shows how he could treat personal affairs as a business transaction.

23. *IJ* 10. Nov. 1810.

24. *IJ* 16 Aug. 1806.

25. *IJ* 31 Oct. 1807.

26. See SROI FB 191/A2/2 East Bergholt Vestry Order Book 1757–1836 and FB 191/E12/1 East Bergholt Churchwardens' Accounts 1801–87.

27. *JCC* I p. 86 although in January 1811 (*JCC* I p. 57) Ann Constable noted that her family alone had not been invited to a dance at Lawford. See also P pp. 26–9.

28. *JCC* I p. 28.

29. *JCC* I p. 35. For other examples see *JCC* I pp. 55, 65, 66 etc.

30. *JCC* I p. 75.

31. *JCC* II pp. 109–10. For J. Constable and a moral view of life see also *JCC* II pp. 76, 84, 99 etc.

32. Rosenthal pp. 24–5.

33. A. Young 'On the Pleasures of Agriculture' *AA* II No. 12 (1784) pp. 456ff.

34. *JCFDC* p. 70.

35. For the aesthetics of farming interest see J. Barrell *The Idea of Landscape and the Sense of Place* Cambridge 1972, and Chapter Seven, below.

36. S. C. Roberts *A Frenchman in England* Cambridge 1933 pp. 172–3.

37. W. Cobbett *Rural Rides* London 1853 II p. 225.

38. Live and dead stock put up for sale in 1819 was listed as 5 cart mares and geldings, 3 cows in calf, 1 do. and calf 8 weeks old, 1 do. calf off, 1 do. fit for butcher, 19 fat downs, 10 hogs, good road wagon, 1 tumbrel, market cart, timber carriage, ploughs, harness, rolls, and cart and plough harness. Information from *IJ* 6 March 1819.

39. T 9; F-W p. 15.

40. *JCC* I p. 52.

41. See J. D. Chambers and G. E. Mingay *The Agricultural Revolution 1750–1880* London 1966.

42. *Ibid.* p. 56. Orbell Ray of Tostock in Suffolk was using the Norfolk 4-course by 1769 (and probably before)—see P. Russell *England Displayed* London 1769 p. 309.

43. Roberts *loc. cit.*

44. R. Andrews 'On the Advantages of mixing Lime with Dung' *AA* IV (1785) p. 47.

45. This was first noticed by H. Potterton in *Reynolds and Gainsborough* London 1976 p. 12.

46. *IJ* 17 March 1810. For threshing machines elsewhere at this period see E. J. Hobsbawm and G. Rudé *Captain Swing* London 1969.

47. Rosenthal p. 10.

48. A. Young 'A Five Days tour to Woodbridge' *AA* II (1784) p. 113; *A General View of the Agriculture of the County of Suffolk* London 1797 p. 175, London 1813 pp. 52ff, p. 194.

49. *JCC* I p. 52–3.

50. *JCC* VI p. 70.

51. Leslie p. 4.

52. Young *op. cit.* 1797 p. 26, 1813 p. 32; G. E. Fussell *The Farmer's Tools 1500–1900* London 1952 pp. 42–4.

53. *JCC* II p. 102.

54. *JCC* II p. 158.

55. Leslie p. 25.

56. *Ibid.* pp. 46–7.

57. *JCC* I p. 103.

58. *JCC* I p. 90.

59. *JCC* II p. 172.

60. *JCC* II p. 80.

61. For a good account of this painting see P pp. 26–9.

62. *JCFDC* pp. 114–16. For Constable and the Dysarts see *JCC* IV pp. 47–81, *JCFDC* pp. 134–8.

63. *JCC* II p. 80.

64. *JCC* II pp. 85–6.

65. *JCC* I p. 85.

66. Ruggles *loc. cit.*

67. Young *op. cit.* 1797 pp. 42–3.

68. Young 'On the Pleasures of Agriculture' *loc. cit.*

69. *JCC* II p. 199.

70. See J. Harris *The Artist and the Country House* London 1979, Plates 203, 221, 275, 280, 298d, 300, 301, 323, 324, 328, 336, 349, 398, 400.

71. *JCC* II p. 199.

72. *JCC* II p. 85.

73. For example from the Reverend Mr Barnwell at Brightwell in Suffolk see *JCC* IV pp. 86–7; I Fleming-Williams 'John Constable at Brightwell: a newly-discovered painting' *Connoisseur* CCIV (June 1980) pp. 130–3. On 4 October 1815 Barnwell wrote to Constable that he recalled 'with much pleasure the agreeable hours spent in your company'. For a further instance of Constable's East Anglian milieu see Chapter 2 Note 3.

74. *JCC* I p. 35, and *JCC* II pp. 98, 126.

75. A. Young *General View of the Agriculture of the County of Essex* London 1807 p. 251.

76. For portraits of Captain Western see T 122.

77. Sir William Rowley was a nephew of Mrs Godfrey (*JCC* II p. 91). He and Golding Constable were both on a committee of the Stour Navigation Commissioners in 1796, and would presumably have met on other occasions (SROI E1 1 394/1). Rowley, Golding Constable, and Peter Godfrey were amongst those involved in the proposed navigation of the Box (*IJ* 31 Oct. 1807). See also *JCC* I pp. 118, 280. For Constable himself visiting Stoke see R 121 pp. 13, 15, 17; R 132 pp. 21, 23, 24, 39, 40, 41, 43 etc.

78. *IJ* 22 June 1805.

79. FD (I) 15 September 1794.

80. W. Gilpin *Observations on Several Parts of . . . Cambridge, Norfolk, Suffolk, and Essex* London 1809 pp. 85–6.

81. A. Young 'A Fortnight's Tour in East Suffolk' *AA* XXIII (1795) p. 48.

82. A. Young *General View of the Agriculture of the County of Essex* London 1807 p. 43. Young's views seem to have enjoyed wide currency. His description was copied into *The Harwich Guide* Ipswich 1808 p. 59, and in 1813 Shoberl dedicated his Suffolk volume of *The Beauties of England and Wales* to Young. For the influence of Young in general see C. Veliz '*Arthur Young and the English Landed Interest 1784–1813*' PhD. dissertation, University of London 1957.

83. For this see, *inter alia* Parris *op. cit.*; Bicknell *op. cit.*; C. White *English Landscape 1630–1850* New Haven 1977; Arts Council *The Shock of Recognition* 1971; Hussey *op. cit.*; J. Gage *A Decade of English Naturalism 1810–1820* (Exhibition Catalogue) London and Norwich 1969.

84. *JCC* I p. 101.

85. Rosenthal pp. 78–81, and M. Rosenthal *George Frost 1745–1821* Sudbury 1974.

86. *IJ* 23 Nov. 1813.

87. *The East Anglian, a Magazine* printed and published by John King (Ipswich) IV 1814 p. 210.

88. The significance of the painting's subject is discussed in Chapter Three below.

89. See W. Gilpin *Observations . . . on . . . Cumberland and Westmoreland* London 1786 p. 7.

90. R. Payne Knight *The Landscape* 2nd ed. London 1795 p. 45.

91. Ruggles *op. cit.* pp. 182–4.

92. *Ibid.*

NOTES TO CHAPTER TWO

1. *JCFDC* pp. 199–201.

2. Rosenthal pp. 52–4.

3. Because they were either East Anglian, or known friends of Constable, the following may have been persuaded by him to subscribe to *Remarks on Rural Scenery*: Lady Affleck; Henry Berners Esq., Holbrook; Robert Bradstreet Esq., Higham, Suffolk; John Constable Esq.; Mrs Cobbold, Ipswich; William Franckes Esq., Beach Hill, Hadley (Hadleigh?); James Gubbins Esq.; Miss Hurlock, Dedham, Essex; Mr P. Rogers, Colchester; Mr Thane; David Pike Watts, Esq.; Ben Strutt, Colchester; Mrs Mason, Colchester. Out of these, D. P. Watts was Constable's uncle. Mrs Mason was the wife of a Colchester lawyer. For R. Bradstreet see *JCC* I p. 145, *JCC* II pp. 10, 100, 352–3; Mrs Cobbold *JCC* I pp. 27, 28, 32, 43, 49, 87, 165, 168, 171, 172, 186, 196, 221; W. Thane *JCC* I pp. 20, 46, 48; Miss Hurlock *JCC* II pp. 18–21; H. Berners *JCFDC* p. 295 (where Constable writes of procuring subscriptions from Berners and Mrs Mason).

4. See *JCC* II pp. 3–17, *JCFDC* pp. 292–6.

5. J. T. Smith *Remarks on Rural Scenery* London 1797 p. 8.

6. FD 25 Feb. 1799.

7. M. Rosenthal *George Frost 1745–1821* Sudbury 1974.

8. For instance, *Landscape with a Woodcutter and Milkmaid* (Fig. 232) has Ipswich in its background, and the Stoke mills can be spotted in several Gainsborough landscapes.

9. *JCC* II p. 16.

10. *IJ* 8 April 1837.

11. I.e.: entries for 2 March, 16 April, 9 May, 25 May, 29 June, 1799; 29 Jan., 29 May 1800.

12. FD 25 May 1799.

13. FD 22 May 1800.

14. *JCC* II pp. 25, 26 ('it is difficult to find a man in London with even common honesty').

15. *JCC* II p. 25.

16. FD 13 July 1801.

17. D. Taylor 'New Light on an early Painting by John Constable' *Burlington Magazine* CXII (Aug. 1980) pp. 566–8.

18. *JCC* V p. 32 'I preferred to see Sir Joshua Reynolds's name and Sir George Beaumont's once more in the catalogue for the last time in the old house'. He was referring to this being the last exhibition to be held at Somerset House. In the Catalogue Constable inserted Wordsworth's inscription for the monument, which ends 'Admiring, loving—and, with grief and pride, / Feeling what England lost when Reynolds died.'

19. Malone's edition of Reynolds's *Works* was published in 1797. Constable owned the second edition of 1799 (*JCFDC* p. 35. For his admiration of Reynolds see *JCC* II pp. 105–6.

20. Reynolds *op. cit.* I p. 24. cf. also D. Webb *An Inquiry into the Beauties of Painting* 2nd ed. 1761 p. X, Dialogue I.

21. *Ibid.* p. 22.

22. FD 2 June 1801.

23. *JCC* II pp. 27–8.

24. *JCC* II pp. 29–30.

25. For an account of this see *JCC* VI pp. 6–7.

26. *JCC* II pp. 31–2.

27. Reynolds *op. cit.* I p. 11.

28. *Ibid.* p. 108.

29. *Ibid.* II p. 267ff.

30. *Ibid.* II p. 111.

31. *Ibid.* pp. 263–5.

32. *Ibid.* p. 108. See pp. 100–8 for the whole argument.

33. *Loc. cit.*

34. In *Art and Illusion* various eds.

35. Smith *op. cit.* p. 11.

36. S. Gessner *Letter on Landscape Painting* in *Works* London 1797 pp. 238–50. For Constable's knowledge of this see *JCFDC* p. 31; *JCC* II pp. 7–9.

37. *JCC* VI pp. 117, 232.

38. For the picturesque see Chapter One Note 5 above, and also E. Manwaring *Italian Landscape in eighteenth-century England* New York 1925; W. Hipple *The Beautiful, the Sublime and the Picturesque in 18th-century British Aesthetic Theory* New York 1957; N. Everett 'Country Justice. The Literature of Landscape Improvement and English Conservatism with particular Reference to the 1790s' PhD dissertation. University of Cambridge 1977; P. Funnell 'Visible Appearances' in M. Clark and N. Penny (eds.) *The Arrogant Connoisseur* Manchester 1982 pp. 82–92.

39. For the grouping of the paintings see Rosenthal pp. 73–4.

40. D. Howard 'Some eighteenth-century English Followers of Claude' *Burlington Magazine* CXI (Dec. 1969) pp. 726–33.

41. *JCC* II p. 293.

42. W. Gilpin *An Essay upon Prints; containing Remarks upon Picturesque Beauty* London 1768.

43. *JCFDC* pp. 32–5. Constable's library contained four of Gilpin's books, Price's *Essay on the Picturesque*, and Payne Knight's *Analytical Enquiry into the Principles of Taste*, but not *The Landscape*. See also Hipple *op. cit.* pp. 192–201, and C. W. Barbier *William Gilpin* Oxford 1963.

44. For instance J. Austen *Sense and Sensibility* (1811) I xvii, or *Northanger Abbey* (1818) I xiv.

45. These are the strikingly green R 39, and the 'beautiful' (in the Burkeian sense) sunset over Mrs Roberts's lawn (Fig. 26).

46. U. Price *An Essay on the Picturesque* London 1796 I pp. 184–9.

47. *Ibid.* p. 241.

48. Quoted by Hussey *op. cit.* pp. 71–2.

49. Reynolds p. 21; R 33; R. Gadney *Constable and his World* London 1976 p. 12.

50. Howard *loc. cit.* D. Bull *Classic Ground* New Haven 1981 pp. 1–9. See also D. Solkin *Richard Wilson* (Exhibition Catalogue) London 1982.

51. Gessner *op. cit.* pp. 244–5.

52. *Windsor-Forest* (1713) 42.

53. For a discussion of this see J. Barrell *The Idea of Landscape and the Sense of Place* Cambridge 1972 pp. 7–11.

54. R. Payne Knight *An Analytical Enquiry into the Principles of Taste* London 1805 p. 74.

55. W. Gilpin *Remarks on Forest Scenery* London 1791 pp. 166–7.

56. W. Gilpin *Observations ... on ... Cumberland and Westmoreland* London 1786 II p. 44.

57. For this see Rosenthal pp. 36–47; J. Barrell *The Dark Side of the Landscape* Cambridge 1980; Everett *op. cit.*; I. Christie *Wars and Revolutions* London 1982 pp. 215–34.

58. J. Billingsley *General View of the Agriculture of the County of Somerset* 2nd ed. London 1798 pp. 36–7.

59. See Chapter Seven below.

60. See Chapter Seven below.

61. For this see Barrell *op. cit.* pp. 89–129 on George Morland.

62. *Ibid.*

63. For stylistic problems caused by the confusion of Frost with Constable see J. Hayes *The Drawings of Thomas Gainsborough* London 1970 pp. 71–6, 'The Drawings of George Frost (1745–1821' *Master Drawings* (Nov. 1966) pp. 163–8; C. Holmes *Constable, Gainsborough and Lucas* London 1921; M. Rosenthal *George Frost 1745–1821* Sudbury 1974; 'On the Waterfront. Ipswich Docks in 1803' *Antique Collector* (Nov. 1974) pp. 41–2; M. Rosenthal *Constable's Country* Sudbury 1976; F-W pp. 24–5.

64. For an example of typical Watts see his 'poor opinions ... of a mere observer without any knowledge of the art', the extended annhilation of his nephew's Nayland Altarpiece, *JCC* IV pp. 20–3.

65. J. Austen *Pride and Prejudice* (1813) Ch. 27.

66. See Bicknell *op. cit.* Nos. 87–94, 102–8, 136–7; Clarke *op. cit.* p. 35; Hussey *op. cit.*; P. Bicknell and R. Woof *The Discovery of the*

Lake District 1750–1810 Grasmere 1982.

67. Leslie pp. 18–19.

68. R. B. Beckett (ed.) *'Correspondence . . . of John Constable'* typescript in V & A Library, II p. 100.

69. *JCC* II p. 127.

70. *JCC* II p. 129.

71. In their Catalogue, *Lionel Constable*, Tate Gallery 1982, Ian Fleming-Williams and Leslie Parris attribute *Keswick Lake* (Mellon Collection. Yale Center for British Art) and *Leathes Water (Thirlmere)* (Tate Gallery) to Lionel Constable. It would seem, on stylistic grounds, that the *Lake District Scene* (National Gallery of Victoria, Melbourne) may be by the same hand. For Lionel Constable see also C. Rhyne 'Lionel Constable's East Berlin Sketchbook' *ART news* 77 9 (1978) pp. 92–5, I. Fleming-Williams, L Parris 'Which Constable?' *Burlington Magazine* CXX (1978) pp. 566–79; H. 566–99, T. 343–46.

72. R 79a 'Borrowdale 4 Octr 1806 Noon Clouds Breaking away after Rain'.

73. R 80.

74. W. Wordsworth *The Prelude* I 337–8, 586–7.

75. FD 3 April 1809.

76. Beckett *op. cit.* XX p. 24.

NOTES TO CHAPTER THREE

1. *JCC* I p. 24. FD 1 June 1804. *JCFDC* pp. 114–6.

2. *JCC* I p. 29.

3. *JCC* II p. 126.

4. *JCC* I p. 54.

5. *JCC* I p. 40.

6. *JCC* II p. 55.

7. In a lecture at the Courtauld Institute on 2 March 1982.

8. For instance on 6 September 1812 he wrote to Maria 'I have not resumed my Landscape studies since my return [to Bergholt]—I have not found myself equal to that vivid pencil that that class of painting requires' (*JCC* II p. 84) or *JCC* II pp. 68–69 14 May 1812 'I may leave my painting room without much loss of time as I am not capable of much application'. For mood and productivity, the years from 1822 provide striking illustrations, which are to be discussed below.

9. *JCC* II p. 70.

10. We know of none of the ones recorded as having been done at East Bergholt in 1817 (*JCC* I p. 166).

11. See T 99, P 7.

12. Leslie p. 21.

13. *Ibid.* See also Constable's illustration to Stanza V of the 1834 London edition of the *Elegy* (*JCFDC* pp. 41–2). The theme of contemplation in a churchyard may ultimately connect with Gainsborough's soft-ground etching of a very similar subject. See J. Hayes *The Drawings of Thomas Gainsborough* London 1970 No. 189, Plate 300. And Note 11 above.

14. *JCC* II p. 106 (13 May 1813).

15. See R. Cohen *The Art of Discrimination* London 1964, in particular Appendix 1 'A Check List of Editions of *The Seasons*' which shows just how long-lived this poem's popularity was.

16. *JCC* II p. 61.

17. *JCC* II p. 210.

18. See Maren-Sofie Røstvig *The Happy Man, Vol. II: Studies in the Metamorphoses of a Classical Ideal 1700–1760* Oslo (1958).

19. *JCC* II p. 104.

20. *JCC* II p. 70.

21. *JCC* II p. 65

22. *JCC* II pp. 65, 76.

23. Obviously the term 'georgic' is derived from Virgil's poem *The Georgics*. The form was adapted to British literature in the eighteenth century, and the term 'georgic' took on peculiarly British connotations. For this see J. Barrell *The Dark Side of the Landscape* Cambridge 1980; J. Barrell *The Idea of Landscape and the Sense of Place* Cambridge 1972; J. Barrell and J. Bull *The Penguin Book of English Pastoral Verse* London 1974 pp. 221–424; J. Chalker *The English Georgic* London 1969; R. Paulson *Literary Landscape: Turner and Constable* New Haven and London 1982 pp. 22–3, 33–4, 117–18, 130–3. See also Dryden's translation of *The Georgics* (various eds.).

24. *IJ* 13, 20, 27 May, 3, 24, June, 1, 8, July, 3 August 1786.

25. *JCC* II p. 78.

26. *JCD* p. 98.

27. *IJ* 11 Dec. 1784, 5, 12 Mar. 9 April, 7 May, 4 June, 9 July, 6 Aug., 3 Sept., 8 Oct., 12 Nov. 1785.

28. For this see, in particular, N. Everett 'Country Justice: The Literatures of Landscape Improvement and English Conservatism with particular Reference to the 1790s', PhD, University of Cambridge 1977, which brilliantly demonstrates how intimately connected were certain classes of ideas on the aesthetic *values* of particular kinds of landscape, with certain types of conservative political writing, which were advocating a society founded on a plan surprisingly close to the paternalist model Thomson proposed in *The Seasons*. For 'georgic' values in landscape-aesthetics at this period, see also Barrell *opera cit.*; R. Paulson *Literary Landscape: Turner and Constable* New Haven and London 1982, particularly pp. 130–3; S. Daniels 'Landscaping for a manufacturer: Humphrey Repton's commission for Benjamin Gott at Arnely in 1809–10' *Journal of Historical Geography* 7. 4. (1981) pp. 379–96, and 'Humphrey Repton and English Romanticism' read to the Durham Conference on Literature and Landscape 2–4 October 1981, along with J. Appleton 'Richard Payne Knight and the Georgics' read at the same conference. Both of these are abstracted in *Landscape Research* 7. 2. (Summer 1982) pp. 13–14.

29. Told by C. R. Leslie and Tom Taylor *Life and Times of Sir Joshua Reynolds* London 1865 I p. 325. Quoted by E. Panofsky *'Et in Arcadia Ego' Meaning in the Visual Arts* London 1970 pp. 340–67.

30. *Loc. cit.*

31. J. Barrell *The Idea of Landscape and the Sense of Place* Cambridge 1972 pp. 1–63. See also D. Solkin *Richard Wilson* (Exhibition Catalogue) London 1982 pp. 83–4.

32. A. Pope *Windsor-Forest* (1713) 7.

33. *Ibid.* 11–12.

34. See Barrell *op. cit.* pp. 12–20.

35. *Windsor-Forest* 14.

36. For examples see Barrell *loc. cit.*; R. Dodsley *Agriculture* (1754) Edinburgh 1795 p. 87; R. Jago *Edge-Hill* in *Poetical Works* Edinburgh 1795 pp. 681, 682; W. Hurn *Heath-Hill* Colchester and London 1777; J. Hurdis *The Favorite Village* Bishopstone 1800 p. 32; T. Batchelor *Village Scenes* London 1804 130–56. See also Solkin *op. cit.* Ch. IV.

37. *Summer* 1408–9.

38. For a full account of this painting and its links with poetry see M. Butlin and E. Joll *The Paintings of J. M. W. Turner* New Haven and London 1977 No. 86.

39. *JCC* II p. 69.

40. *JCC* II p. 78.

41. *JCFDC* p. 55.

42. J. Kirby *The Suffolk Traveller* London 1764 p. 14.

43. A. Young 'Additional Notes to the Tour in Suffok' *AA* VI (1786) p. 219.

44. Leslie p. 22.

45. *JCC* II p. 51.

46. *JCC* II p. 52.

47. *JCC* II p. 53.

48. *JCC* II p. 54.

49. For this see T 96, 103; H 112–15, 124; I. Fleming-Williams 'John Constable at Flatford' *Connoisseur* CCIV (July 1980) pp. 216–19.

50. This was in two important lectures, 'The Substance of Constable's Art' read to the C.A.A.A. in San Francisco February 1981, and 'John Constable: The Technique of Naturalism', a lecture given at the Courtauld Institute on 2 March 1982. I am indebted to Professor Rhyne for very generously sending me a slide of the painting.

51. F-W p. 44. See also T 112–14.

52. JCC II p. 81.

53. Sir J. Reynolds *Works* (ed. E. Malone) London 1797 I p. 264.

54. *Ibid.* II p. 267.

55. JCC II p. 89 (25 Oct. 1812).

56. E.g. 'dear old Bergholt' on 13 July 1815; JCC II p. 146.

57. JCC II p. 83 (26 Aug. 1812).

58. JCC II p. 90 (5 Oct. 1812).

59. By Charles Rhyne, in a letter of 31 January 1981, which opines both that it is a copy, and that Graham Reynolds agrees with this judgement.

60. T 118.

61. H 172, 173. For drawings of Flatford Lock (Private Collection), and the elms (Fondazione Horne, Florence) see T. 116, 117.

62. JCC II p. 120.

63. JCC II pp. 109–10.

64. JCC II p. 153.

65. J. Thomson *The Seasons, Autumn* 43–7.

66. JCC I p. 101.

67. Private Collection. See T 129, P 9. This painting does feature Willy Lott's house, and is 'large'. There are oil sketches (R 373, 374) which relate to the composition, and may be serving their usual preparatory rôle, while pp. 31 and 70 of the 1813 sketchbook have linear drawings, out of character with others in the book, and which therefore may have been compositional sketches on spare pages of a sketchbook to which Constable was turning while doing his 'Landscape with the Ploughmen' (below). Also connected is a drawing in the Courtauld Institute.

68. M. Butlin and E. Joll *The Paintings of J. M. W. Turner* New Haven and London 1977 No. 60. Others are *Walton Bridges* 1806 Loyd Coll. (Fig. 155) Butlin and Joll 60; *Windsor Forest, Reaping* 1807, Tate, Butlin and Joll 202; *Harvest Dinner, Kingdom Bank* 1809, Tate, Butlin and Joll 90; *Walton Bridges* exh. 1807 Melbourne, National Gallery of Victoria, Butlin and Joll 63; *Dorchester Mead* 1810 Tate, Butlin and Joll 107.

69. JCC VI p. 21.

70. JCC II p. 110.

71. JCC II p. 66.

72. FD 6 May 1814.

73. JCC II pp. 121–2.

74. 1802: No.229 J. Arnald *The Farmer's Boy*. 1804: No. 132 Sir G. Beaumont *The Ghost; from Bloomfield's Farmer's Boy, Winter, Moonlight*. 1807: No. 10 J. Glover *Harvest—vide Bloomfield's Farmer's Boy*. 1812: No. 125 W. H. Pickersgill *The Shepherd Boy*.

75. See Chapter Seven below.

76. JCC II p. 131

77. A. Alison *Essays on the Nature and Principles of Taste* Edinburgh 1790. For an excellent account of the reception and influence of Alison's theories see P. Funnell 'Visible Appearances' in M. Clarke, N. Penny (eds) *The Arrogant Connoisseur* Manchester 1982 pp. 82–97.

78. Alison *op. cit.* p. 10.

79. *Ibid.* pp. 62–3.

80. *Ibid.* p. 134.

81. *Ibid.* pp. 127–8.

82. W. Wordsworth and S. T. Coleridge *Lyrical Ballads* in W. Wordsworth *Poetical Works* Oxford 1967 Preface of 1800 p. 734 To understand their point it is necessary only to read eighteenth-century poetry. The phenomenon has been discussed by Earl Wasserman in 'The English Romatics: the grounds of knowledge' *Studies in Romanticism* IV (1964–5) p. 20.

83. Cf. *The Seasons, Spring* 34–47. For artists quoting *The Seasons* see R.A. Catalogues 1801 Nos. 31, 179, 413, 416; 1802 Nos. 136, 162, 554, 558; 1813 Nos. 15, 43; 1814 Nos. 175, 305, 521; 1817 No. 118.

84. J. Aiken *An Essay on the Plan and Character of Thomson's Seasons* London 1788 pp. xxxv–xxxvi Constable's copy of Thomson reprinted this essay, JCFDC p. 43.

85. W. Mason *The English Garden* Dublin 1782 p. 6.

86. J. Thomson *The Seasons, Spring* 66.

87. See D. B. Brown *Augustus Wall Callcott* London 1981 pp. 75–6.

88. JCC II p. 160.

89. See notes 34, 36 above.

90. T. Ruggles 'Picturesque Farming' *AA* VI (1786) pp. 182–3.

91. FD 23 July 1814.

92. FD 30 July 1814.

93. Leslie p. 49.

94. JCC II p. 134.

95. JCC II p. 125, 5 June, when he wrote of 'these dear scenes which I must always prefer and love—to any other', and, 'I love the trees, and feilds, better than I do the people.' JCC II p. 129, 15 August, he wrote from Bergholt 'I am not even tolerably happy any where else'.

96. JCC II p. 133.

97. JCC II p. 131.

98. JCC II pp. 134–5.

99. One can be categorical about this because no other candidate for Constable's 1815 exhibit *View of Dedham* presents itself, and because on 30 June 1815, after the R.A. exhibition, Constable wrote that he was returning Mrs Fitzhugh's picture of Dedham (JCC II p. 145). See also T 133.

100. See I. Fleming-Williams 'A Run-over Dungle and a possible date for "Spring"' *Burlington Magazine* CXIV (July 1972) pp. 386–93. 'Dungle' as a phonetic spelling of the Suffolk pronounciation of 'Dunghill'. See also Paulson *op. cit.* pp. 130–1.

101. JCFDC p. 54.

102. JCC II p. 80.

103. With *Boat Building* we can connect pp. 55, 56, 57, and with the *View of Dedham*, pp. 54, 60, 62, 65, 68, 74, 81.

104. J. Grainger *The Sugar Cane* London 1764 I 219–20.

105. For instance J. Scott *Amoeban Eclogue* II (1782) in *Poetical Works* Edinburgh 1795 p. 743.

106. JCC I p. 28.

107. See Note 50 above.

NOTES TO CHAPTER FOUR

1. JCC II p. 155.

2. JCC II p. 156.

3. JCC II p. 149. See also JCC. II p. 149.

4. JCC II p. 169.

5. I. Fleming-Williams 'John Constable at Brightwell' *Connoisseur* CCIV (June 1980) pp. 130–3.

6. I. Fleming-Williams 'A Rediscovered Constable. The Venables Cottage in a Cornfield' *Connoisseur* CXCVIII (June 1978) pp. 134–7.

7. For 1815 drawings see R 138–45, T 139, 140, F-W Fig. 38.

8. E. L. Jones *Seasons and Prices* London 1964 pp. 160–1.

9. It measures $4\frac{5}{16} \times 7\frac{1}{4}$ inches, and Graham Reynolds (R p. 250) suggest that in 1815 Constable used a sketchbook of $4\frac{1}{2} \times 7\frac{3}{8}$ inches.

10. The argument is to be developed below in relation to the *Gardens*, and *The Quarters*, the former two measuring 13 × 20, the latter $13\frac{1}{4} \times 20\frac{3}{8}$ inches. We shall see that Constable seems to have preferred three canvas sizes for *plein-air* work, of which the '13 × 20' was the smallest. The others were *c*. 20 × 24, and *c*. 22 × 32.

11. JCC II p. 162. This is not the same donkey as in Fig. 120, neither is it precisely

the same as the one oil-sketched, related to *Dedham Vale, Morning*, and used in *The Cornfield* (R 287).

12. T 137.

13. M. Rosenthal 'Golding Constable's Gardens' *Connoisseur* (October 1974) pp. 89–91.

14. *JCC* II p. 156.

15. *JCC* II p. 159.

16. *JCC* II p. 160.

17. FD 3 April 1809 mentioned a 5 foot wide Borrowdale. This large painting was unlikely to be *Flatford Mill*, for reasons given below. See also P 14.

18. Information kindly supplied by Helen Hall of the Boston Museum of Fine Arts in a letter of 7 April 1981.

19. Leslie p. 72.

20. Le. 18 September 1814 (*JCC* II p. 132) 'I beleive we can do nothing worse than indulge in a useless sensibility–but I can hardly tell you what I feel at the sight from the window where I am now writing of the feilds in which we have so often walked a beautiful calm Autumnal setting sun is glowing upon the Gardens of the Rectory and adjacent feilds where some of the happiest hours of my life were passed—' For this see R. Paulson *Literary Landscape: Turner and Constable* New Haven and London 1982 pp. 127–9.

21. See M. Rosenthal *British Landscape Painting* Oxford 1982 Chapters 3 and 4.

22. J. Thomson *The Seasons, Autumn* 151–76.

23. S. Duck *The Thresher's Labour* London 1753.

24. J. Aikin *The Calendar of Nature* 2nd ed. London 1785 pp. 54–7.

25. R. Bloomfield *The Farmer's Boy* London 1800 *Summer* 113–286.

26. *JCFDC* pp. 71–2.

27. T. Ruggles 'Picturesque Farming' *AA* VI (1786) p. 179.

28. *Autumn* 169–70.

29. FD. 29 Sept. 1816.

30. *JCC* II p. 197

31. *JCC* II p. 199.

32. *JCC* II p. 200.

33. *JCC* II p. 201–2.

34. *JCC* II p. 203.

35. *JCC* II p. 203–5.

36. *JCC* II p. 205–6.

37. For a comprehensive account of the painting see P 14.

38. *JCC* II p. 196.

39. *JCC* II p. 197.

40. *JCC* II p. 196.

41. *JCC* II p. 206.

42. *JCC* II p. 199.

43. These measurements were kindly sup-plied by Mrs E. V. H. Ferber of the National Gallery of Art, Washington D.C., in a letter of 30 December 1980.

44. U. Price *An Essay on the Picturesque* London 1796 I pp. 179ff. See also G. Hibbard 'The Country House Poem of the Seventeenth Century' in M. Mack (ed.) *Essential Articles for the Study of Alexander Pope* Hamden, Conn. 1969; H. Erskine-Hill *The Social Milieu of Alexander Pope* New Haven and London 1975. Instances are to be found in Thomson's *Spring* 904–62; Dr Winter *Bury and its Environs, a Poem* London 1747 64–98; R. Jago *Edge-Hill* (1767) in *Poetical Works* Edinburgh 1795 pp. 681, 683; J. Reeve *Ugbrooke Park, a Poem* London 1776; *The Farmer's Boy, Autumn* 26off.; Chapter One, notes 21, 22 above.

45. See T 155.

46. *JCC* I pp. 140–74.

47. *JCC* I p. 166.

48. It measures $4\frac{1}{4} \times 7$ins. R, pp. 250–1, suggests a sketchbook of $4\frac{1}{2} \times 7\frac{3}{8}$ for 1812, and 1817; and $4\frac{1}{2} \times 7\frac{1}{8}$ for 1815 and 1816.

49. For *Dedham Mill* see R 184, P 17, which reproduce the variants.

50. Leslie p. 73.

51. R. B. Beckett (ed.) *Correspondence . . . of John Constable* (typescript, V & A Library) XX p. 34.

52. See T 165. Similar doubts about the Washington painting's authenticity were expressed by Michael Kitson in con-versation on 18 December 1980.

53. G. White *The Works in Natural History* I (*The Natural History of Selborne*) London 1802 pp. 40–1.

54. See R. Cohen *The Art of Discrimination* London 1964 Appendix I.

55. Cf. Frontispiece to *Summer*, J. Thomson *The Seasons* Perth 1793.

56. FD 2, 6 April 1819.

57. *JCC* II p. 246.

58. FD 1 April 1820.

59. FD 9 June 1820.

60. FD 21 November 1820.

61. FD 2 January 1821.

62. FD 9 April 1821.

63. *JCC* I p. 193.

64. *JCC* VI pp. 65–6.

65. Leslie p. 13.

66. *Summer* 352, 369–70.

67. Duck *op. cit.* p. 8.

68. R. E. G. Tyler 'Rubens and *The Hay Wain*' *Connoisseur* CLXXIX (August 1975) pp. 271ff; A. Smart and C. A. Brooks *Constable and his Country* London 1976 pp. 47, 83, 88.

69. J. Barrell *The Dark Side of the Landscape* Cambridge 1980 pp. 146–7.

70. See Paulson, *op. cit.* pp. 121–2 for a brilliant account of this.

NOTES TO CHAPTER FIVE

1. *JCC* VI pp. 70–72.

2. *JCC* VI p. 74.

3. Quoted in K. Badt *John Constable's Clouds* London 1950 p. 47. For the painting of sky studies in general see the catalogue of the exhibition *The Cloud Watchers* held at the Hebert Art Gallery, Coventry, in 1975.

4. See P 19.

5. *JCC* VI pp. 76–9.

6. *JCC* VI p. 76.

7. T. Gray *Ode on a Distant Prospect of Eton College* v.2.

8. J. Boswell *Life of Johnson* London, Oxford, New York 1970 p. 207.

9. P. Thicknesse *A Sketch of the Life and Paintings of Thomas Gainsborough* London 1788 p. 5. Constable seems first to have referred to this passage in 1799 or 1800, see *JCC* II p. 24.

10. *JCC* VI pp. 86–9.

11. *JCC* VI p. 91.

12. *JCC* II p. 133.

13. Leslie pp. 89–90, *JCC* VI p. 89.

14. *JCC* VI p. 89.

15. See R, Paulson, *Literary Landscape: Turner and Constable* New Haven and London 1982 pp. 121–2.

16. For the problems faced by the 'white painters', Turner and Callcott, see D. B. Brown's catalogue *Augustus Wall Callcott* London 1981 pp. 24–7.

17. *JCC* I p. 47.

18. *JCC* VI p. 92.

19. *JCC* VI pp. 97–9.

20. *JCC* VI p. 100.

21. *JCC* VI p. 117.

22. For an excellent but brief history of the early years of the British Institution, see P. Fullerton 'Patronage and Pedagogy: The British Institution in the early Nineteenth Century' *Art History* V 1 (March 1982) pp. 59–72; see also Brown, *op. cit.*

23. *JCC* VI pp. 105–7.

24. *JCC* VI pp. 112–13.

25. *JCC* VI pp. 115–17.

26. *JCC* VI p. 110.

27. *JCC* VI p. 56.

28. For this see Sir L. Woodward *The Age of Reform 1815–1870* 2nd ed. Oxford 1962 pp. 52–86.

29. *John Bull* 22 April 1822.

30. *JCC* VI p. 91.

31. *JCC* VI p. 112.

32. *JCC* VI p. 133.

33. *Ibid.*

34. *JCC* VI p. 135.

35. *JCC* VI pp. 137–8.
36. *JCC* VI pp. 139–41.
37. *JCC* II p. 290.
38. *JCC* II pp. 291–3.
39. *JCC* VI pp. 142–4.
40. *JCC* II pp. 293–4.
41. *JCC* VI p. 139 *JCC* II p. 297.
42. *JCC* II pp. 295–6.
43. *JCC* II p. 294.
44. *JCC* VI pp. 149–50.
45. *JCC* VI p. 146.
46. *JCC* VI p. 145.
47. Cf. *John Bull* 5 May 1823.
48. *JCC* VI pp. 145–8.
49. *JCC* II pp. 282, 283.
50. *JCC* VI pp. 155–6.
51. *JCC* VI p. 157.
52. *JCC* VI p. 168. Constable was probably thinking of *Tristram Shandy* I iv, and especially III xii, which is a brilliant satire on critics who judge only by the Rules. I am most grateful to Professor C. Rawson for pointing out these references.
53. See also Paulson, *loc. cit.*
54. *JCC* VI p. 186.
55. *JCC* IV p. 266.
56. *JCC* VI p. 161.
57. *JCC* VI pp. 167–8.
58. *JCC* VI p. 171.
59. *JCC* VI p. 172. For Constable, Hazlitt and 'something out of nothing' see Paulson *op. cit.* p. 108.
60. *JCC* VI pp. 174–6.
61. *JCC* VI pp. 177–9.
62. *JCC* VI p. 200.
63. *JCC* VI p. 179.
64. *JCC* VI pp. 180–3.
65. *JCC* VI pp. 184–7.
66. *JCC* VI p. 190.
67. *JCC* VI p. 191.
68. *JCC* VI p. 193.
69. *JCC* VI p. 198.
70. See T 239.
71. See A. Smart and C. A. Brooks *Constable and his Country* London 1976 pp. 104–5, 139. Colonel Brooks's identification of the sluice is plausible, but impossible considering that the central elm is developed from a drawing made for *Flatford Mill* (Fig. 137) which, if topography were any concern of Constable's would mean that the river had changed dramatically since 1817. Ronald Paulson has recognised that Constable invented his terrain—see Paulson *op. cit.* p. 122.
72. Leslie (1845) p. 51.
73. *JCC* II p. 385.
74. This was pointed out to me by Michael Helston, along with the relation of the trees in the 1831 *Salisbury Cathedral from the Meadows* to the ones in this painting.
75. F-W p. 86.
76. R p. 250.
77. *JCC* VI p. 200.
78. The most sensible account of Constable and Wordsworth has been given by J. R. Watson 'Wordsworth and Constable' *Review of English Studies* 13 (1962). I am grateful to John Barrell for his thoughts on what can appear a vexed question of connections between the two. Constable himself could cite Wordsworth in less exalted contexts; quoting from the *Thanksgiving Ode on the General Peace* while being patriotic (*JCC* VI p. 117 or *JCC* II p. 356). K. Kroeber's attempts to prove a connection in *Romantic Landscape Vision: Constable and Wordsworth* Madison and London 1975 are intriguing, sometimes brilliant, but not often historically convincing. Furthermore, paintings are misread. Willy Lott's house is called a 'mill' (p. 22), and the reaper in *The Cornfield* a 'hunter' (p. 129), and on the whole it avoids what Constable himself wrote. In parts it is good, though. See also M. L. Reed 'Constable, Wordsworth, and Beaumont: A new Constable Letter in Evidence' *Art Bulletin* LXIV (Sept. 1982) pp. 481–3.
79. *JCC* VI p. 180.
80. See T 312, 262.

NOTES TO CHAPTER SIX

1. *JCC* II p. 397.
2. *JCC* VI p. 204.
3. *JCC* II p. 397.
4. *JCC* VI pp. 207–9.
5. *JCC* VI p. 209.
6. *JCC* VI pp. 210–11.
7. J. Boswell *Life of Johnson* Oxford 1970 p. 185. I am grateful to John Barrell for pointing out the reference to me.
8. *JCC* IV pp. 177–211 discusses Constable and French dealers.
9. *JCC* VI pp. 216–18.
10. Leslie p. 153.
11. *JCFDC* p. 43.
12. Reynolds pp. 106–7.
13. E. K. Waterhouse *Gainsborough* London 1958 No. 898. The painting is at Worcester (Mass.) Art Museum.
14. R. Payne Knight *The Landscape* 2nd ed. London 1795 p. 42.
15. W. Marshall *A Review of the Landscape* London 1795 pp. 105–6.
16. *JCC* V p. 80.
17. Leslie p. 6.
18. W. H. Pyne *Engravings of Rustic Figures* London 1815 pp. 4–5.
19. *JCC* VI pp. 206–7.
20. A. Shirley *The Published Mezzotints by David Lucas after John Constable R.A.* Oxford 1930; *JCC* IV pp. 314–463; A. Wilton *Constable's English Landscape Scenery* London 1979.
21. *JCC* VI pp. 223–4.
22. See P 37 and 38.
23. See P 32.
24. *JCC* VI p. 230.
25. *JCC* II p. 440, 441.
26. *JCC* II p. 443.
27. F-W Fig. 66.
28. *JCC* VI p. 236.
29. *JCC* III pp. 10–16. T. 253.
30. *JCC* VI p. 236.
31. *John Bull* 20 May 1827.
32. *JCC* II p. 337.
33. *JCC* VI p. 240.

NOTES TO CHAPTER SEVEN

1. For watercolour exhibitions see J. Baynard *The Exhibition Watercolour 1770–1870* New Haven. Yale Center for British Art 1981.
2. For Turner see J. Gage *Colour in Turner. Poetry and Truth* London 1969 Part 3.
3. *JCC* VI p. 101.
4. Leslie p. 77.
5. *JCC* II pp. 325, 334–5.
6. *JCC* II p. 395.
7. Leslie pp. 113–14.
8. See D. B. Brown *Augustus Wall Callcott* London 1770 p. 22.
9. *JCC* VI 99. The first to suggest that external influences affected Constable were C. Shields and L. Parris *John Constable 1776–1837* Tate Gallery 1969.
10. J. Lindsay *J. M. W. Turner* London 1873 pp. 146–60.
11. This was suggested to me by Julian Gardner.
12. O. Goldsmith *The Deserted Village* London 1770 p. 22.
13. See U. Price in W. Whitley *Thomas Gainsborough* London 1915 p. 41.
14. *Ibid.* p. 291.
15. Sir H. Bate Dudley *A Sermon delivered at the Cathedral of Ely* Cambridge 1816 pp. 8–9.
16. See particularly J. Barrell *The Dark Side of the Landscape* Cambridge 1980, and R. Feingold *Nature and Society* Hassocks 1978.
17. See Barrel *op. cit.* pp. 65–86.
18. Goldsmith *op. cit.* p. 2.
19. G. Crabbe *The Village* London 1783 I 140–54, II 1ff.
20. *Ibid.* II 106–207.
21. E. J. Hobsbawm and G. Rudé *Captain Swing* London 1969 p. 15.

22. A. Collett *A letter to Thomas Sherlock Gooch Esq. M. P.* Halesworth 1824 p. 3.

23. A. Young 'General Enclosure' *AA* XXXVI (1801) pp. 210ff.

24. Collett *op. cit.* pp. 13–14.

25. And also by J. Barrell *The Idea of Landscape and the Sense of Place* Cambridge 1972; Feingold *op. cit.*; and C. Veliz *Arthur Young and the English Landed Interest 1784–1813* PhD dissertation, University of London 1957.

26. In *AA* XXIX (1797) pp. 367, 368.

27. *Ibid.* IX (1788), pp. 636–46.

28. *Ibid.* XII (1789) p. 55.

29. C. Lofft 'On the Gleaning Question' *AA* X (1788) p. 218.

30. T. Ruggles in *AA* XX (1793) p. 449.

31. A. Young 'Consequences of the Rioting on Account of the High Price of Provisions' *AA* XXIV (1795) p. 544.

32. For this see I. R. Christie *Wars and Revolutions. Britain 1760–1815* London 1978 pp. 215–34.

33. W. Clubbe *A Few Words to the Labourers of Great Britain* Woodbridge 1793 pp. 3–4.

34. *Ibid.* pp. 7–8.

35. *IJ* 5 Jan. 1793.

36. A. Young *An Enquiry into the State of the Public Mind amongst the Lower Classes* London 1798 pp. 29–30.

37. *Ibid.* p. 7.

38. W. Marshall *The Rural Economy of the Midland Counties* London 1790 II p. 47. See also I pp. 131–2.

39. W. Marshall *The Rural Economy of Gloucestershire* Gloucester 1789 I pp. 51–4.

40. See Barrell *op. cit.* pp. 25–31, M. Rosenthal *British Landscape Painting* Oxford 1982 pp. 92–6. For the historian's view of Stubbs's labourers see N. McKendrick, J. Brewer, J. H. Plumb *The Birth of a Consumer Society* London 1982 pp. 61–2.

41. By Clifford Brigden, when a student at Warwick University.

42. For this see *Report from the Select Committe of the House of Commons on Petitions relating to the Corn Laws of this Kingdom* London 1814.

43. Rosenthal *op. cit.* Chapter 4.

44. In *The Dark Side of the Landscape*, Ch. 2.

45. Among these were W. Collins *Memoirs of a Painter* London 1805; J. Hassell *Memoirs of the Late George Morland* London 1806; F. W. Blagdon *Authentic Memoirs of the Late George Morland* London 1806; G. Dawe *The Life of George Morland* London 1807; and an obituary in *The Gentleman's Magazine* 74 (1804) pp. 1976ff.

46. Dawe *op. cit.* p. 179.

47. Collins *op. cit.* p. 232.

48. *Ibid.*

49. *Ibid.* p. 234.

50. A. Young *The Farmer's Calendar* 6th ed. London 1805 pp. 502–9.

51. *Ibid.* p. 421.

52. R. Bloomfield *Wild Flowers* London 1809 p. 31.

53. A Young 'On the Pleasures of Agriculture' *AA* II (1784) pp. 476, 477.

54. *IJ* 9 Nov. 1811.

55. *IJ* 18 Jan. 1812.

56. *JCC* I p. 68.

57. SRO1 FB 191/A2/2.

58. *JCC* I p. 134.

59. SRO1 FB 191 E12/1.

60. *JCFDC* p. 56.

61. *IJ* 11 Feb. 1815.

62. *A Letter to J-C- Esq. Containing some Observations on his Late Conduct and Proceedings as Lord of the Manor* London 1816.

63. *Ibid.* p. 5.

64. *JCC* I p. 43.

65. *JCC* I p. 118.

66. *JCC* I p. 160.

67. *JCC* I p. 175.

68. *JCC* I pp. 190–3.

69. The 1816 Disturbances are chronicled by A. J. Peacock *Bread or Blood* London 1965, the 1822 ones in Rosenthal Appendix I, and those of 1830 by Hobsbawm and Rudé *op. cit.*

70. The painting is now dated 1821 on the basis of a drawing in the Hornby Library, Liverpool: therefore in 1821 the oil sketch may have been painted after Constable, in his old fashion, had used pencil to establish the lineaments of the scene.

71. *JCC* II p. 167.

72. *JCC* II p. 268.

73. *IJ* 15 Feb. 1817.

74. *IJ* 19 Aug. 1820.

75. *John Bull* 24 Dec. 1820.

76. *JCC* I p. 191.

77. See note 71 above.

78. *JCC* VI p. 88.

79. PRO HO 52/3/6a.

80. PRO HO 44/11/92.

81. PRO HO 40/17/104.

82. PRO HO 40/17/17a

83. PRO HO 40/17/40

84. *JCC* VI pp. 82, 85, 86.

85. See *John Bull* 4, 25 Feb., 4, 11 March, 1, 15 April, 6 May 1822.

86. A 25 March letter from Fisher (*JCC* VI p. 84) began 'Not having heard from you lately'. When he criticised Constable's copying himself on 2 October 1823 (*JCC* VI p. 135) the latter had not replied by 16 October (*JCC* VI p. 137) and was only teased into writing on 19 October (*JCC* VI p. 139). On April 17 1822 (*JCC* VI pp. 90–91) Constable asked Fisher to burn the letter with the news of the fires.

87. *JCC* VI p. 85.

88. *JCC* VI p. 88.

89. *JCC* I p. 211.

90. *JCC* II p. 403 (my transcription).

91. *IJ* 17 Jan., 9 May 1829.

92. *JCFDC* p. 119.

Notes to Chapter Eight

1. *JCC* VI pp. 239–40.

2. *JCC* III p. 18.

3. *JCC* III p. 20.

4. *JCC* VI p. 244.

5. B. Taylor *Constable Paintings, Drawings and Watercolours* 2nd ed. London 1975 pp. 29, 50–1, and M. Cormack 'Constable's Hadleigh Castle' *Portfolio* (Summer 1980) pp. 36–41 provide easily the best accounts of this painting. In addition is P33, in which it is shown that the Tate version had canvas added to it, but without offering a suggestion as to who, besides Constable, might have done this.

6. *JCC* II p. 127.

7. J. Thomson *The Seasons, Summer* 81–174.

8. R. Paulson *Literary Landscape: Turner and Constable* New Haven and London 1982 pp. 147–8.

9. *JCC* VI p. 258.

10. *JCC* III p. 87.

11. *JCC* III p. 94.

12. *JCC* III p. 96.

13. *JCC* III p. 107

14. *JCC* IV p. 368.

15. *JCC* IV p. 382.

16. For an interesting discussion of this see P11.

17. See Paulson *op. cit.* pp. 139–46 for an excellent discussion of *English Landscape Scenery*.

18. *JCC* IV p. 364.

19. *JCC* IV p. 395.

20. *JCD* pp. 7–27.

21. For example East Bergholt was introduced as a village 'pleasantly situated in the most cultivated part of Suffolk, on a spot which overlooks the fertile valley of the Stour, which river divides that county on the south from Essex.

'The beauty of the surrounding scenery, the gentle declivities, the luxuriant meadow flats, sprinkled with flocks and herds, and well cultivated uplands ... impart to this spot an amenity and elegance hardly elsewhere to be found.' For advertisements see *IJ* 8 Aug. 1801, for Cop Hall, near Bildeston, describing the house standing 'upon an emminence, commanding most

extensive and delightful views of a rich and luxuriant country, abounding with game', or 14 July 1804 for an unspecified estate at East Bergholt—'The situation of this estate is admirably adapted for a villa, which might be built on the freehold part of the land, as it commands a most enchanting view of the rich meadows, through which the navigable river Stour runs.'

For conventional village descriptions compare Constable's with E. Brayley's of Fakenham (in *Views in Suffolk . . . illustrative of the Works of Robert Bloomfield* London 1806 p. 41, and F. Shoberl *The Beauties of England and Wales* XIV London 1813 p. 185, and 1820 p. 185) as 'a small village . . . situated in a pleasant valley, which is watered and fertilized by a branch of the river Ouse. The meadows afford abundant pasture, and the neighbouring uplands are richly cultivated.'

22. *JCC* III p. 94–5.
23. *JCC* III p. 111.
24. *JCC* V p. 17.
25. *JCC* III p. 96.
26. See P 36; T 282; Paulson *op. cit.* p. 124. J. Walker *Constable* London 1979 p. 138; Reynold's p. 118.
27. *JCC* IV p. 336.
28. Leslie p. 237.
29. *JCC* VI p. 257.
30. For an account of the genesis of the composition see T 282, P 36.
31. This has been pointed out by the authorities cited in Notes 26 and 30 above, also in Reynolds, p. 118.
32. *JCC* III p. 49.
33. *JCC* III pp. 51–2.
34. *JCC* II p. 403.
35. *JCC* III p. 87.
36. P.D. Schweizer 'John Constable, Rainbow Science, and English Colour Theory' *Art Bulletin* LXIV 3 (Sept. 1982) pp. 424–55.
37. R 359. See also the entries to R 322 and T 311.
38. R 395. See T 331, and, in particular, L. Hawes's excellent *Constable's Stonehenge* London 1975, which covers some of the same ground as is discussed here.
39. See Note 37 above, Walker *op. cit.* p. 146.
40. J. Britton *The Beauties of England and Wales XV Wiltshire* London 1814. For the connection of this with Constable's Letterpress see T 311.
41. Hawes *op. cit.* p. 6.
42. Britton *op. cit.* p.v. states 'The county of Wilts . . . is a district peculiarly interesting to the topographer and antiquary. To the latter, indeed, it offers a wider and more varied field for research than perhaps any other county in England. The grand and mysterious monuments of Stonehenge and Avebury, and the numerous barrows which cover its plains, are relics of an age anterior to historical record, and of which the annals of the world do not furnish a parallel example.'
43. *Ibid* p.vi.
44. *Ibid* p. 22.
45. *JCD* pp. 24–5.
46. *JCC* III pp. 89, 112.
47. E. J. Hobsbawm, G. Rudé *Captain Swing* London 1969 Chapters 6, 10 Appendices I, III.
48. *JCC* III pp. 121–2.
49. Ruisdael's painting was in England. See *Jacob Van Ruisdael* (Exhibition Catalogue) The Hague 1981–2, which suggests that Constable referred to this painting. (See also *JCD* p. 64.) Ruisdael's iconography has been elucidated in E. Scheyer 'The Iconography of Ruisdael's *Cemetery*' *Bulletin of the Detroit Institute of Arts* 55. 3 (1977) pp. 133–46. For Constable and rainbows in Rubens see *JCD* p. 61.
50. *JCC* III p. 107.
51. Reynolds p. 129.
52. *Ibid.* See also T 328, 329; B. Taylor *Constable. Paintings, drawings and watercolours* 2nd ed. London 1975 p. 214, and R 403.
53. This was first suggested in the entry to T 239.
54. See P 41.
55. *JCC* V p. 44.

Select Bibliography

Unless otherwise stated, place of publication is London.

Abrams, M. H. *The Mirror and the Lamp* Oxford 1953

Adams, E. *Francis Danby, Varieties of Poetic Landscape* New Haven and London 1973

Addy, J. *The Agrarian Revolution* 1972

Aikin, J. *The Calendar of Nature* 2nd ed. 1972

—— *An Essay on . . . Thomson's Seasons* 1788

Alison, A. *An Essay on the Nature and Principles of Taste* Edinburgh 1790

Arts Council *The Shock of Recognition* (Exhibition Catalogue) 1972

Ashton, T. S. *An Economic History of England: the Eighteenth Century* 1972

Auerbach, E. *Mimesis* Princeton 1953

T. B. Esq. *A Call to the Connoisseurs* 1761

Badt, K. *John Constable's Clouds* 1950

Barrell, J. *The Idea of Landscape and the Sense of Place* Cambridge 1972

—— *The Dark Side of the Landscape* Cambridge 1980

Barrell, J. and Bull, J. *The Penguin Book of English Pastoral Verse* 1974

Barry, J. *Lectures on Painting by . . . Barry, Opie, and Fuseli* 1848

Barthes, R. *S/Z* Paris 1970; trans. R. Miller 1975

Barton, B. *The Triumph of the Orwell* Woodbridge 1817

Baskett, J. *Constable Oil Sketches* 1966

Batchelor, T. *Village Scenes . . . and other Poems* 1804

Bate Dudley, H. *A Sermon delivered at the Cathedral of Ely* Cambridge 1816

Bayard, J. *The Exhibition Watercolor 1770–1870* (Exhibition Catalogue) New Haven 1981

Bayne, W. *Sir David Wilkie, R.A.* 1903

Beckett, R. B. *John Constable's Correspondence* Vols. I–VI Ipswich 1962–8

—— *John Constable's Discourses* Ipswich 1970

—— 'Constable and France' *Connoisseur* CXXXVII (May 1956)

Bicknell, P. *Beauty, Horror and Immensity* (Exhibition Catalogue) Cambridge 1981

Blagdon, F. W. *Authentic Memoirs of the late George Morland* 1806

Bloomfield, R. *The Farmer's Boy* 1800

—— *Rural Tales, Ballads, and Songs* 4th ed. 1805

—— *Wild Flowers* 1809

—— *Remains* 1824

Board of Agriculture *The Agricultural State of the Kingdom* 1816

Bovill, E. W. *English Country Life 1780–1830* 1962

Brayley, E. W. *Views . . . illustrative of the Works of Robert Bloomfield* 1806

Brown, A. F. J. *Essex at Work 1700–1815* Chelmsford 1969

—— *Essex People 1750–1900* Chelmsford 1972

Brown, D. B. *Augustus Wall Callcott* (Exhibition Catalogue) 1981

Bryson, N. *Word and Image* Cambridge 1981

Bull, D. *Classic Ground* (Exhibition Catalogue) New Haven 1981

Burke, E. *Works* 16 vols. 1827

Burke, J. *English Art 1714–1800* Oxford 1976

Burlington, C. *The Modern Universal British Traveller* 1799

Butlin, M. and Joll, E. *The Paintings of J. M. W. Turner* New Haven and London 1977

Carey, W. *Some Memoirs of the Patronage and Progress of the Fine Arts in England* 1826

Chalker, J. *The English Georgic* 1969

Chambers, J. *Works* Ipswich 1820

Chambers, J. D. and Mingay, G. E. *The Agricultural Revolution 1750–1880* 1966

Christie, I. R. *Wars and Revolutions, Britain 1760–1815* 1982

Clare, J. *Poems descriptive of Rural Life and Scenery* 1820

—— *The Village Minstrel and other Poems* 1821

—— *The Shepherd's Calendar* 1827

Clark, K. *John Constable. The Hay Wain in the National Gallery* 1944

Clarke, M. *The Tempting Prospect* 1981

Clarke, M. and Penny, N. *The Arrogant Connoisseur* (Exhibition Catalogue) Manchester 1982

Clubbe, W. *A Few Words to the Labourers of Great Britain* Woodbridge 1793

Cobbold, E. *Poems* Ipswich 1825

Cobbett, W. *Rural Rides* 1830

Cohen, R. *The Art of Discrimination* 1964

Collett, A. *A Letter to Thomas Sherlock Gooch Esq., M.P.* Halesworth 1824

Colnaghi, P. D. & Co. *John Linnell and his Circle* (Exhibition Catalogue) 1973

Colquhoun, P. *A Treatise on the Wealth, Power, and Resources of the British Empire*

2nd ed. 1815

Compton, M. E. and Fussell, G. E. 'Agricultural Adjustments after the Napoleonic Wars' *Economic History* 4 (14) (February 1939)

Conisbee, P. *Painting from Nature* (Exhibition Catalogue) 1980

Cooper, J. G. *Letters concerning Taste* 1755

Cormack, M. 'Constable's *Hadleigh Castle*' *Portfolio* (Summer 1980)

Cowper, W. *Poems* 2 vols. 1813

—— *Letters* ed. W. Hayley 1812

Coxe, P. *The Social Day* 1823

Crabbe, G. *The Village* 1783

—— *Poems* 1807

—— *The Borough* 1810

—— *Tales* 1812

Craig, W. M. *A Course of Lectures on Drawing, Painting, and Engraving* 1821

Cumberland, J. *A Poem on the Landscapes of Great Britain* 1793

Davie, D. *Purity of Diction in English Verse* 1952

Davies, D. *The Case of Labourers in Husbandry* Bath 1795

Day, H. *Constable Drawings* Eastbourne 1975

Dayes, E. *Works* 1805

Deane, P. and Cole, A. W. *British Economic Growth 1688–1959* Cambridge 1952

Dodsley, R. *Poetical Works* Edinburgh 1795

—— *The Economy of Human Life* 1803

Duck, S. *The Thresher's Labour* 1753

Dugdale, J. *The New British Traveller* 1819

Dyer, J. *The Fleece* 1757

Eden, F. M. *The State of the Poor* 1797

Edwards, E. *Anecdotes of Painters* 1808

Edwards, R. *Thomas Jones* (Exhibition Catalogue) Marble Hill 1970

Einberg, E. *George Lambert* (Exhibition Catalogue) Kenwood 1970

Everett, N. 'Country Justice: The Literatures of Landscape Improvement and English Conservatism, with particular reference to the 1790's' PhD Dissertation, University of Cambridge 1977

Farington, J. *Diary* (in course of publication) 6 vols. New Haven and London 1978 *et seq.*

Fawcett, T. *The Rise of English Provincial Art* Oxford 1974

Feingold, R. *Nature and Society* Hassocks and New Jersey 1978

Fleming-Williams, I. 'A Runnover Dungle and a possible date for "Spring"' *Burlington Magazine* CXIV (1972)

—— *Constable Landscape Watercolours & Drawings* 1976

—— 'A rediscovered Constable: the Venables *Cottage in a Cornfield*' *Connoisseur* CXCVIII (June 1978)

—— 'John Constable at Brightwell: a newly discovered Painting' *Connoisseur* CCIV (June 1980)

—— 'John Constable at Flatford' *Connoisseur* CCIV (July 1980)

—— and Parris, L. 'Which Constable?' *Burlington Magazine* CXX (1978)

—— and —— *Lionel Constable* (Exhibition Catalogue) 1982

—— , —— and Shields, C. *Constable Paintings Watercolours & Drawings* (Exhibition Catalogue) 1976

—— , —— and —— (eds.) *John Constable. Further Documents and Correspondence* Ipswich 1976

Ford, J. (ed.) *The Suffolk Garland* Ipswich 1818

Du Fresnoy, C. A. *De Arte Graphica* trans. W. Mason 1783

Fussell, G. E. *The Farmer's Tools 1500–1900* 1952

Gadney, R. *Constable and his World* 1976

—— *John Constable R.A. 1776–1837. A Catalogue of Drawings . . . in the Fitzwilliam Museum, Cambridge* Cambridge 1976

Gage, J. *Colour in Turner, Poetry and Truth* 1969

—— *A Decade of English Naturalism 1810–1820* (Exhibition Catalogue) Norwich and London 1969

Gash, N. *Politics in the Age of Peel* 1964

Gessner, S. *Works* 1797

—— *Letters* 1804

Gilpin, W. *An Essay on Prints* 1768

—— *Observations on the River Wye* 1782

—— *Observations . . . on the Mountains and Lakes of Cumberland and Westmoreland* 1786

—— *Remarks on Forest Scenery* 1791

—— *Three Essays* 1792

—— *Observations . . . on the Highlands of Scotland* 1798

—— *Observations on the Western parts of England* 1798

—— *Observations . . . on . . . Cambridge,*

Norfolk, Suffolk and Essex 1809

Gisborne, T. *Walks in a Forest* 3rd ed. 1797

Glyde, J. *Suffolk in the Nineteenth Century* Ipswich and London 1856

Goldsmith, O. *The Deserted Village* 1770

—— 'The Revolution in Low Life' in *Collected Works* ed. Friedman, Oxford 1966

Gombrich, E. H. *Art and Illusion* various eds.

Gonner, E. C. K. *Common Land and Enclosure* 1912

Goodwin, A. *The Friends of Liberty* 1979

Gowing, L. *Constable 1776–1837* 1960

Graham, M. *Memoirs of the Life of Nicholas Poussin* 1820

Grainger, J. *The Sugar Cane: A Poem* 1764

Gray, T. *Complete Poems* ed. Starr and Hendrickson, Oxford 1964

Greenacre, F. *The Bristol School of Artists* (Exhibition Catalogue) Bristol 1973

Hammelmann, H. and Boase, T. *Book Illustration in eighteenth-century England* New Haven and London 1975

Hammond, J. L. and B. *The Village Labourer* 2 vols. 1948

Hardie, M. *Watercolour Painting in Britain* 3 vols. 1966–8

The Harwich Guide Ipswich 1808

Hassell, J. *Memoirs of the Late George Morland* 1806

Hawes, L. 'Constable's Sky Sketches' *Journal of the Warburg and Courtauld Institutes* XXXII (1969)

—— *Constable's Stonehenge* 1975

—— *Presences of Nature. British Landscape 1780–1830* (Exhibition Catalogue) New Haven 1982

Hay, D. (*et al.*) *Albion's Fatal Tree* 1975

Hayes, J. *The Drawings of Thomas Gainsborough* 2 vols. 1970

—— *Gainsborough's Prints* 1971

—— *Gainsborough* 1975

—— *Thomas Gainsborough* (Exhibition Catalogue) 1980

Herrmann, L. *British Landscape Painting of the Eighteenth Century* 1973

Hipple, W. J. *The Beautiful, the Sublime, and the Picturesque* Carbondale 1957

Hobsbawm, E. J. and Rudé, G. *Captain Swing* 1969

Hollis, P. (ed.) *Class and Conflict in nineteenth-century England 1815-1850* 1973

Holloway, J. and Errington, L. *The Dis-*

covery of Scotland (Exhibition Catalogue) Edinburgh 1978

Holmes, C. J. *Constable* 1901

Horn, P. *The Rural World 1750–1850* 1980

Hoskins, W. G. *The Making of the English Landscape* 1955

Howard, D. 'Some eighteenth-century Followers of Claude' *Burlington Magazine* CXI (1969)

Hoozee, R. *L'Opera completa di John Constable* Milan 1979

Hunt, L. *The Months* 1821

Hunter, A. *Georgical Essays* 1803

Hurdis, J. *Poems* 1808

Hurn, W. *Heath-Hill, Dedham, Essex . . . a descriptive Poem* Colchester and London 1777

Hussey, C. *The Picturesque* 1927

Hutcheson, F. *An Enquiry into the Original of our Ideas on Beauty and Virtue* 1726

Jacob, W. *Considerations on the Protection required by British Agriculture* 1814

—— *An Enquiry into the Causes of Agricultural Distress* 1816

Jago, R. *Poetical Works* Edinburgh 1795

Jobson, A. *Victorian Suffolk* 1972

Jones, E. L. *Seasons and Prices* 1964

Jones, T. 'Memoirs' (ed. A. P. Oppé) *Walpole Society* XXXII (1946–8)

Kent, N. *Some Particulars of the King's Farm at Windsor in 1798* Oxford 1802

Kitson, M. 'John Constable 1810–16, a chronological Study' *Journal of the Warburg and Courtauld Institutes* XX (July–Dec. 1957)

—— *Turner* 1964

—— *The Art of Claude Lorrain* (Exhibition Catalogue) 1969

Knight, R. P. *The Landscape* 2nd ed. 1795

—— *An Analytical Inquiry into the Principles of Taste* 1805

Kroeber, K. *Romantic Landscape Vision Constable and Wordsworth* Madison and London 1975

—— *Images of Romanticism: Verbal and Visual Affinities* New Haven 1980

A Land Agent. *Thoughts on the Effects of Peace on Landed Property* 1815

Langhorne, J. *Poetical Works* 1804

Leslie, C. R. *Memoirs of the Life of John Constable* 1951

Lindsay, J. *J.M.W. Turner* 1973

—— *Thomas Gainsborough. His Life and Art* 1981

Lipking, L. *The Ordering of the Arts in eighteenth-century England* Princeton 1970

Longrigg, R. *The English Squire and his Sport* 1977

Mack, M. *The Garden and the City* London and Toronto 1969

Malins, E. *English Landscaping and Literature* 1966

Malthus, T. R. *Observations on the Effects of the Corn Laws* 1815

—— *An Inquiry into the Nature and Progress of Rent* 1815

Marshall, J. D. *The Old Poor Law 1795–1834* 1968

Marshall, W. *The Rural Economy of Gloucestershire* 2 vols. Gloucester 1789

—— *The Rural Economy of the Midland Counties* 2 vols. 1790

—— *The Rural Economy of Norfolk* 2 vols. 2nd ed. 1795

—— *A Review of the Landscape* 1795

—— *Planting and Rural Ornament* 1796

—— *On the Appropriation and Inclosure of Commonable Lands* 1801

—— *The Review and Abstract of the County Reports to the Board of Agriculture* 5 vols. York 1818

Martyn, T. *The English Connoisseur* 1766

Mason, W. *The English Garden* 1772

Mingay, G. E. *English Landed Society in the Eighteenth Century* 1963

Mitchell, B. C. and Deane, P. *Abstract of British Historical Statistics* Cambridge 1969

Mitchison, R. 'The Old Board of Agriculture (1793–1822)' *English Historical Review* 74 (1959)

Moir, E. *The Discovery of Britain* 1964

Morse, D. *Perspectives on Romanticism* 1981

—— *Romanticism, a structural Analysis* 1981

Nicholson, B. *Joseph Wright of Derby* 2 vols. London and New York 1968

Ogden, H. V. S. and M. S. *English Taste in Landscape in the Seventeenth Century* Ann Arbor 1955

Ogilvie, W. *An Essay on the Right of Property in Land* 1782

Opie, J. *Lectures on Painting* 1809

Owen, F. *Sir George Beaumont, Artist and Patron* (Exhibition Catalogue) 1969

—— 'Sir George Beaumont and the Contemporary Artist' *Apollo* LXXXIX (1969)

Owen, R. *Observations on the Effect of the Manufacturing System* 1815

Parker, R. A. C. *Coke of Norfolk* Oxford 1975

Parris, L. *Landscape in Britain c. 1750–1850* (Exhibition Catalogue) 1973

—— *The Tate Constable Collection* 1981

—— and Shields, C. *John Constable* 1969

—— and —— *Constable, the Art of Nature* (Exhibition Catalogue) 1971

Paulson, R. *Emblem and Expression* 1975

—— *Literary Landscape. Turner and Constable* New Haven and London 1982

Peacock, A. J. *Bread or Blood* 1965

Peckham, M. *The Triumph of Romanticism* Columbia, S. Carolina 1971

Pevsner, N. *Studies in Art, Architecture and Design* 2 vols. 1968

Phillips, J. *Cyder. A Poem* 1708

Playfair, W. *A Letter on our Agricultural Distresses* 1821

Ploughman, P. *A Letter to the Farmers and Tithe-Payers of Suffolk* Ipswich 1832

Pope, A. *Poetical Works* ed. H. Davis 1967

Pott, J. H. *An Essay on Landscape Painting* 1782

Pratt, S. J. *Cottage-Pictures; or the Poor* 3rd ed. 1803

Price, U. *An Essay on the Picturesque* 1794

—— *Thoughts on the Defence of Property* Hereford and London 1797

—— *A Dialogue on . . . the Picturesque and the Beautiful* 1801

Prior, M. *Poetical Works* 2 vols. 1779

Prothero, R. E. *English Farming Past and Present* 2nd ed. 1917

Pyne, W. H. *Etchings of Rustic Figures* 1815

Ransome, J. A. *The Implements of Agriculture* 1843

Reeve, J. *Ugbrooke park, A Poem* 1776

Reitlinger, G. *The Economics of Taste* 1961

Reynolds, G. *Constable the Natural Painter* 1966

—— *Catalogue of the Constable Collection in the Victoria and Albert Museum* 2nd ed. 1973

Reynolds, J. *Works* ed. Malone. 2 vols. 1797

Rhyne, C. 'Lionel Constable's East Berlin Sketchbook' *ARTnews* 77 9 (1978)

—— 'Constable Drawings and Watercolors in the Collection of Mr and Mrs Paul Mellon' I & II *Master Drawings* XIX 2 & 4 (1981)

Ricardo, D. *An Essay on the Influence of a Low Price of Corn on the Profits of Stock* 1815

Richards, G. *The Aboriginal Britons. A Poem* Oxford 1791

Richardson, G. *Iconology* 1773

Richardson, J. *Works* 1773

Riches, N. *The Agricultural Revolution in Norfolk* 2nd ed. 1967

Rickard, G. O. *Constable's Country. A Guide to the Vale of Dedham* Colchester 1948

Roche, H. *A Suffolk Tale: or, the Perfidious Guardian* 1810

—— *The Sudburiad, or Poems from the Cottage* 1813

de la Rochefoucauld, F. *Mélanges sur L'Angleterre* trans. S. C. Roberts Cambridge 1933

Rose, M. *The English Poor Law 1780–1930* Newton Abbot 1971

Rosenthal, M. *George Frost 1745–1821* (Exhibition Catalogue) Sudbury 1974

—— 'On the Waterfront. Ipswich Docks in 1803' *Antique Collector* (November 1974)

Røstvig, M-S. *The Happy Man* 2 vols. Oslo 1954, 1958

Ruddick, W. *Joseph Farington. Watercolours and Drawings* (Exhibition Catalogue) Bolton 1977

Ruskin, J. *Works* 39 vols. 1903–12

Russell, P. *England Displayed* 1762

Schapiro, M. *Words and Pictures* The Hague 1973

Scott, J. *Poetical Works* Edinburgh 1795

Select Committee of the House of Commons *Report . . . on Petitions relating to the Corn Laws* 1814

Shenstone, W. *Poetical Works* 1795

Shirley, A. *The Rainbow, a Portrait of John Constable* n.d.

—— *John Constable R.A.* 1948

—— *The Published Mezzotints of D. Lucas after John Constable R.A.* 1930

Shoberl, F. *The Beauties of England and Wales* XIV 1813

Small, R. *A Letter to J— C—, Esq.* 1816

Smart, A. and Brooks, C. A. *Constable and his Country* 1976

Smart, C. *Poems on Several Occasions* 1752

Smith, J. T. *Remarks on Rural Scenery* 1797

Solkin, D. *Richard Wilson* (Exhibition Catalogue) 1982

Somerville, W. *The Chace* 1733

—— *Hobbinol, or the Rural Games* 1740

Spencer, N. *The Complete English Traveller* 1771

Stratton, N. *Poems on Various Subjects* Cambridge 1824

Sturt, G. *The Wheelwright's Shop* Cambridge 1923

Sunderland, J. *Constable* 2nd ed. Oxford 1980

Taylor, B. *Constable Paintings, Drawings & Watercolours* 2nd ed. 1975

—— *Stubbs* 1971

Taylor, D. G. 'New light on an early Painting by John Constable' *Burlington Magazine* CXXII (Aug. 1980)

Taylor, I. *Poems, chiefly Pastoral* 1766

Taylor, R. E. G. 'Rubens and *The Hay Wain*' *Connoisseur* CLXXXIX (Aug. 1975)

Thicknesse, P. *A Sketch of the Life and Paintings of Thomas Gainsborough Esq.* 1788

Thirsk, J. and Imray J. *Suffolk Farming in the Nineteenth Century* Ipswich 1968

Thompson, E. P. *The Making of the English Working Class* 1963

—— 'The Moral Economy of the English Crowd in the Eighteenth Century' *Past and Present* 50 (Feb. 1971)

—— *Whigs and Hunters* 1975

Thompson, F. M. L. *English Landed Society in the Nineteenth Century* 1963

Thomson, J. *The Seasons* 1730 revised ed. 1744

Tranter, N. *Population since the Industrial Revolution* 1973

Turnbull, J. *A Treatise on Ancient Painting* 1740

Turner, J. *The Politics of Landscape* Oxford 1979

Tusser, T. *His Good Points of Husbandry* ed. Hartley 1931

Vancouver, C. *General View of the Agriculture of the County of Essex* 1797

Veliz, C. 'Arthur Young and the English Landed Interest' PhD Dissertation, University of London 1957

Virgil *Works* 4 vols. trans J. Dryden 1782

Walker, J. *John Constable* 1979

Waller, A. *The Suffolk Stour* Ipswich 1957

Wassermann, E. 'The English Romantics: the Grounds of Knowledge' *Studies in Romanticism* IV (1964–5)

Waterhouse, E. K. *Gainsborough* 1958

—— *Painting in Britain 1530–1790* 1962

Watson, J. R. 'Wordsworth and Constable' *Review of English Studies* 13 (1962)

—— *Picturesque Landscape and English Romantic Poetry* 1970

Webb, J. *Haverhill, a Poem* 1810

Wells, R. 'The Revolt of the South-West 1800–1801: A Study in English Popular Protest' *Social History* 6 (Oct. 1977)

Wharton, J. *The Enthusiast, or the Lover of Nature* 1744

Whately, T. *Observations on Modern Gardening* 6th ed. 1801

White, C. *A short and plain Letter on Agricultural Depression* 1816

White, C. *English Landscape 1630–1850* (Exhibition Catalogue) New Haven 1977

White, G. *The Natural History and Antiquities of Selborne* ed. J. W. White 1813

Whitley, W. T. *Art in England 1800–37* 2 vols. 1930–2

Whittingham, S. *Constable and Turner at Salisbury* 1972

Williams, J. *The Climate of Great Britain* 1806

Williams, R. *The Country and the City* 1973

Wilton, A. *British Watercolours 1750–1850* Oxford 1977

—— *Constable's English Landscape Scenery* 1979

Dr Winter *Bury and its environs, a Poem* 1747

Wordsworth, W. *Poetical Works* ed. de Selincourt and Darbishire, Oxford 1940–54

Wright, T. *Some Account of the Life of Richard Wilson* 1824

Young, A. *A Six Weeks' Tour through the Southern Counties of England and Wales* 1768

—— *A Six Months' Tour through the North of England* 1770

—— *The Farmer's Tour through the East of England* 4 vols. 1771

—— (ed.) *Annals of Agriculture and other useful Arts* 45 vols. London and Bury St Edmunds 1784–1808

—— *General View of the Agriculture of the County of Suffolk* 1797 revised ed. 1813

—— *An Inquiry into the State of the Public Mind among the Lower Classes* 1798

—— *The Farmer's Kalendar* 1805

—— *General View of the Agriculture of the County of Essex* 2 vols. 1807

—— *Autobiography* ed. M. Betham-Edwards 1898

Index